art          *document*

# Photography's
# multiple roles

market          science

art

*document*

**market**

science

The Museum of
Contemporary
Photography,
Columbia College
Chicago

D.A.P.
Distributed
Art
Publishers, Inc.,
New York

# Photography's multiple roles

**Denise Miller**

**Eugenia Parry**
**F. David Peat**
**Naomi Rosenblum**
**Rod Slemmons**

**Mihaly Csikszentmihalyi**
**Ed Paschke**
**Franz Schulze**

with additional
contributions by
John Mulvany
and AnJanette Brush

*Photography's Multiple Roles: Art, Document, Market, Science* was published to showcase the distinctive permanent collection formed by The Museum of Contemporary Photography, Columbia College Chicago, since 1982. It has been made possible by the generous support of the Lannan Foundation and American Airlines. The book is dedicated to John Mulvany, founder of the museum.

Published by The Museum of Contemporary Photography in association with D.A.P./Distributed Art Publishers, Inc. 155 Sixth Avenue, 2nd Floor, New York, New York 10013-1507 Tel: 212-627-1999 Fax: 212-627-9484

Publication coordinated and edited by Terry Ann R. Neff, t. a. neff associates, inc., Tucson, Arizona Designed and typeset by studio blue, Chicago Separations by Professional Graphics, Inc., Rockford, Illinois Printed by Meridian Printing, East Greenwich, Rhode Island

ISBN 0-9658887-1-1 (clothbound)
ISBN 0-9658887-2-X (paperbound)

Library of Congress Cataloging-in-Publication Data

Museum of Contemporary Photography (Columbia College (Chicago, Ill.))
Photography's multiple roles: art, document, market, science.
p. cm.
Includes bibliographical references and index.
ISBN 0-9658887-1-1 (hardcover: alk. paper). – ISBN 0-9658887-2-X (pbk.: alk. paper)
1. Photographic criticism. 2. Photography – United States. 3. Museum of Contemporary Photography (Columbia College (Chicago, Ill.)) – Photograph collections – Catalogs. 4. Photograph collections – Illinois – Chicago – Catalogs. I. Title.
TR187.M87  1998
770'.1–dc21          98-26380
                     CIP

Front cover: Aaron Siskind, *Untitled #99* from the series *Pleasures and Terrors of Levitation* (1954–65), 1961; silver gelatin print, 9 $7/8$ x 9 $7/8$ inches; Museum purchase; © The Aaron Siskind Foundation, courtesy Robert Mann Gallery, New York

Back cover: Catherine Wagner, *Sequential Molecules*, 1995 (detail); silver gelatin print, 24 x 20 inches; Museum purchase

Frontispiece: Chuck Close, *Roy II*, 1996; ink jet print, 37 $1/2$ x 30 $7/8$ inches; Museum purchase; © the artist, courtesy PaceWildensteinMacGill, New York

# Contents

The founding of what was to become The Museum of Contemporary Photography was motivated by both pragmatic and poetic concerns. By 1975 Columbia College Chicago's photography department was recognized as one of the leaders in the photography renaissance that had started in the early 1960s. For some time the department had been regularly exhibiting the work of noted photographers in their print finishing room. These exhibitions had grown out of a strong faculty conviction that there was a need for such shows, and that the college had a responsibility to promote and support contemporary photographers whose work would teach and inspire our students. In addition, we wished to develop a broader audience for photography and further encourage its acceptance as a contemporary art and as a force for learning, understanding, and perhaps even changing the world.

Our success was as much a surprise to us as it was to anyone else. To build upon it further, in the spring of 1975 we rented two adjoining vacant offices on Ohio Street to create The Columbia College Gallery. To achieve a gallery ambiance, the college's carpenter cut arches at each end of the wall that separated the offices. Our first exhibition included work by all the photographers currently teaching in Chicago colleges who wished to participate.

# Foreword

John Mulvany
Chairman of the Museum Governing Board

**Time present and time past**
**Are both perhaps present in time future**
**And time future contained in time past...**

(T. S. Eliot, *Four Quartets*, 1943)

Our early accomplishments called for a statement of purpose or mission that would articulate and guide our continuing efforts. Briefly stated, we took seriously the idea of an expanded definition of contemporary photography, using it to go beyond the traditional "art photography" boundary to include all applications of the medium. The result over the years has been major exhibitions of photography from documentary, marketing, and the scientific fields, as well as images that might be considered exclusively art. What has bound them together has been the attempt to engage the mind and delight the eye.

In 1976 when Columbia College moved into its own building on Michigan Avenue, a new and larger gallery was given its own space. Although the original concept remained intact, the name was changed to The Museum of Contemporary Photography in the expectation of expanding the scope of our commitment. At that time there was scant opportunity to see a steady run of exhibitions devoted exclusively to what was of immediate importance in photography. A major turning point for the museum came in 1986 with the appointment of Denise Miller as the director. Through her brilliant leadership we achieved full museum accreditation from the American Association of Museums in 1988, and have become what we are today. It is with deep gratitude that I acknowledge her contributions.

The artistic, historical, and social value of the permanent collection of The Museum of Contemporary Photography will continue to grow, providing present and future viewers with an opportunity to appreciate the works and their contextual background. We hope that this book on our collection succeeds in going beyond simple description of the photographs to enrich the overall understanding of and pleasure in the cultural importance of the field as a whole.

The Museum of Contemporary Photography embarked on the ambitious publication (and accompanying touring exhibition) *Photography's Multiple Roles: Art, Document, Market, Science* as a contribution to the field. The project endeavors to enlighten audiences on the function of photography in independent, but also interrelated, areas of cultural interpretation. It affords the opportunity to share the museum's commitment and point of view with an international audience. All of the book's plates are works from the museum's permanent collection focusing on American and US-resident photography produced since 1959, the United States publication date of Robert Frank's seminal work *The Americans*.

Each year the museum presents and collects a wide range of provocative, innovative works in recognition of photography's multiple roles: as a medium of communication and artistic expression, as a documenter of life and the environment, as a powerful commercial industry, and as a tool in the service of science and technology. Herein lies this publication's profile. The book's introduction advances the museum's approach to collecting contemporary photography as art

# Acknowledgments

Denise Miller
**Director**

and idea. The subsequent four essays by Eugenia Parry, distinguished author and adjunct professor in the Department of Art and Art History at the University of New Mexico; Naomi Rosenblum, author of the renowned book *A World History of Photography*; Rod Slemmons, professor at the University of Washington, commercial photographer, and former curator of photography at the Seattle Art Museum; and F. David Peat, independent research scientist and author of publications on art and science, provide insight into the roles of photography as art, document, market, and science. To maintain a flexible outlook, the museum welcomes learning what individuals outside the field of photography think about the medium. Almost annually the museum invites a guest curator from another field to select an exhibition of work from the permanent collection. The curator's accompanying essay, guided by his or her own particular vision and expertise, is intended to provide a fresh understanding of the images and objects the museum is collecting. The book's three Viewpoint essays, by social psychologist Mihaly Csikszentmihalyi, painter Ed Paschke, and architectural historian Franz Schulze, demonstrate this practice. It is with the most sincere appreciation that I acknowledge all the contributing authors for their eloquent and illuminating writing.

The growth, care, and usefulness of the museum's collection is a continuing project supported by a great number of people who have contributed in a variety of ways. In particular, I wish to thank the dynamic backing of founding Collection Committee members Sonia Bloch, Arnold Gilbert, Jack A. Jaffe, and David C. Ruttenberg, and subsequently joining benefactors including the late James J. Brennan, whose extraordinary donations are now memorialized in a dedicated Print Study Room, as well as William L. Hood, Vicki and Tom Horwich, James A. Klein, Richard S. Press, Lawrence K. Snider, Bob Thall, and Helena Chapellín Wilson. Their discerning counsel, not only on acquisitions but on all museum programs, continues to play a vital role in building a collection with focused direction and distinguished strength. The collection has grown substantially through the generosity and support of Columbia College Chicago, and numerous patrons, artists, collectors, dealers, and private foundations, in addition to special granting programs for acquisitions. On behalf of the museum board and staff, I extend genuine gratitude.

The exhibition and publication programs of The Museum of Contemporary Photography have been enthusiastically supported by John Mulvany, Chairman of the Museum Governing Board, President John B. Duff, and Provost and Executive Vice President Albert C. Gall of Columbia College Chicago, and the college's Board of Trustees. I value their high regard for our programming and thank them for their professional and financial contributions, as well as those by R. Michael DeSalle, Vice President of Finance; Woodie T. White, Vice President of College Relations and Development; and the faculty of the college's art and design and photography departments.

The realization of this project would have been unthinkable without the skill and dedication of the museum's terrific team. I wish in particular to thank AnJanette Brush, Manager of Collections and Education, for impressively producing the book's extended captions and artist biographies, in addition to conducting research; and Leslie Martin, former graduate intern (now managing editor at Aperture in New York), for her initial research on these elements. Collection assistants Amy Gilman, Deborah Peterson, and Corinne Rose are to be commended for their persistent attention to detail in research, updating collection records, coordinating manuscripts, general fact-finding, and cross-checking. I am indebted to Nancy Fewkes, Assistant Director, and Stephanie Graff-Santos, Manager of Exhibitions, for managing innumerable aspects of this publication's production, the preparation of the coordinating exhibition for international tour with the assistance of a cadre of steadfast interns, in addition to thoughtful editorial commentaries. Equally, I am grateful to Natasha H. Egan, Assistant to the Director, for the many long hours spent on research and museum correspondence that might otherwise have gone unanswered during the time the museum team focused on this book. Special thanks go to Thomas A. Nowak at Columbia's photography studio for producing transparencies for this publication (in addition to documenting annually the museum's exhibitions), and Thomas Shirley in the college's digital lab for his technical support throughout the year in collection documentation. I thank all for their unstinting devotion to standards of excellence.

For many years I have had the distinct honor and true pleasure of working with a perceptive and inventive group of professionals. I thank Terry Ann R. Neff, dear friend, who, yet again, skillfully managed and edited another fine museum publication; Kathy Fredrickson and Cheryl Towler Weese of studio blue, who produced a daringly provocative book design; Pat Goley and his colleagues at Professional Graphics, Inc., who are responsible for the extraordinary quality of reproductions; and Daniel Frank and the technicians at Meridian Printing, who saw to exquisite printing. With this our first collection book, I am grateful also to Sharon Helgason Gallagher and Avery Lozada at DAP, Inc. for a wonderful copublishing arrangement.

For their special services over the years, I wish to thank Iris Baum at Stuart B. Baum Photography, Chicago; Bonni Benrubi at Bonni Benrubi Gallery, Inc., New York; Stephen Daiter at Stephen Daiter Gallery, Chicago; Catherine Edelman at Catherine Edelman Gallery, Chicago; Carol Ehlers at Carol Ehlers Gallery, Chicago, and Shashi Caudill, now working privately; Terry Etherton at Etherton Gallery, Tucson, Arizona; Jeffrey Fraenkel and Frish Brandt at Fraenkel Gallery, San Francisco; Howard Greenberg at Howard Greenberg Gallery, New York; G. Ray Hawkins at G. Ray Hawkins Gallery, Santa Monica, California; Rhona Hoffman at Rhona Hoffman Gallery, Chicago; Edwynn Houk and Jenny Holder at Edwynn Houk Gallery, New York; Jane Jackson at Jackson Fine Art, Atlanta; Theresa Luisotti at gallery luisotti, Santa Monica, California; Peter MacGill at PaceWildensteinMacGill, New York; Robert Mann at Robert Mann Gallery, New York; Larry Miller at Laurence Miller Gallery, New York; Penny Pilkington and Scott Catto at PPOW, Inc., New York; Olivier Rénaud-Clement at Robert Miller Gallery, New York; Mary Sabbatino at Galerie Lelong, New York; and Martha Schneider at Martha Schneider Gallery, Chicago, among countless contemporary art dealers and the members of the Association of International Photography Art Dealers, located across the country.

The publication of this book and the preparation of the traveling exhibition were aided by donations and grants to The Museum of Contemporary Photography from numerous individuals and organizations. I would like to thank the staffs and reviewers for The Chicago Community Foundation of The Chicago Community Trust; The John D. and Catherine T. MacArthur Foundation; Sara Lee Foundation; the Institute of Museum and Library Services, a federal agency; the Illinois Arts Council, a state agency, and The National Endowment for the Arts for the award of general operating support grants. I also gratefully acknowledge the contributions of the museum's Collection Committee, American Airlines, and the Lannan Foundation for special financial assistance on this particular project.

The most invaluable collective contribution to The Museum of Contemporary Photography has come from the imagemakers themselves, not only through their own gifts, but also through their dedication to photography and responsiveness to the museum's work. I offer profound thanks for your images, objects, and ideas, not all of which could be represented in this first collection book, but are surely treasured by this and future generations.

To my family, Marilyn M. and William R. Miller; Kimberly, John, and sweet Eric Burke; and John R. Clark; and my dear friend John Mulvany, to whom this book is dedicated, thank you for everything else.

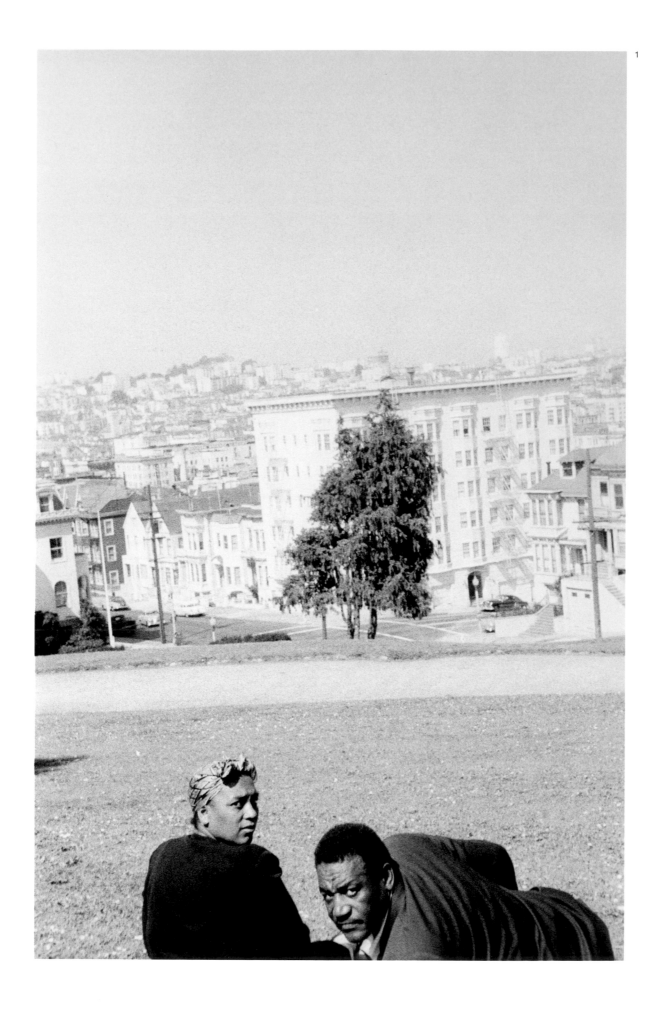

Collecting contemporary art of any kind is problematic, since the definition of what is contemporary undergoes continual reevaluation. At this point in time, contemporary American and US-resident photography, as interpreted and collected by The Museum of Contemporary Photography, is bound by two markers: the revolutionary vision of Robert Frank with his seminal work The Americans, and Alfredo Jaar with his conceptual installations of social and political content and commentary on the power of photographs. Interestingly both artists are émigrés – Frank from Switzerland and Jaar from Chile – and both reflect rebellion against tradition.

The Americans, published first in France in 1958 and then in the United States in 1959 (the benchmark for the permanent collection), is perhaps the most important and influential book of photographs produced since World War II. This publication's appearance caused an uproar; it was critically attacked and ridiculed. It has come, however, to mark a watershed in

# Collecting American and US-resident photography as

# art + idea

Denise Miller

the history of photography and has established Robert Frank as one of the most significant photographers of the twentieth century.

In the introduction to the American edition of the classic, Jack Kerouac wrote: "That crazy feeling in America when the sun is hot on the streets and music comes out of the jukebox or from a nearby funeral, that's what Robert Frank has captured in tremendous photographs taken as he traveled on the road around practically forty-eight states in an old used car (on Guggenheim Fellowship) and with the agility, mystery, genius, sadness and strange secrecy of a shadow photographed scenes that have never been seen before on film. For this he will definitely be hailed as a great artist in his field."[1]

Robert Frank's work first appeared coarse and critical, reflecting a sense of alienation and isolation that many members of the public did not necessarily care to have projected as American. The work emerged at a contradictory time of burgeoning American optimism following the positive impact of World War II for the United States, and rude awakening to the country's appalling injustices [see plate 1; Rosenblum, plate 5; and Schulze, plate 16]. Frank's radical vision and snapshot aesthetic struck a cord and have come to

1  Robert Frank
   **San Francisco**, 1956
   silver gelatin print
   13³⁄₈ x 8⁷⁄₈ inches
   Gift of Mr. and Mrs.
   Alan Koppel
   © Robert Frank, courtesy
   PaceWildensteinMacGill,
   New York

Robert Frank's photographs of America in the 1950s manifest a clarity and honesty unsettling to his audience at the time. In **San Francisco** the suspicion and veiled aggression characterizing many of these images are plainly written on the faces of the couple Frank photographed. A slightly askew composition adds to the tension in the image, which comments on race relations, public space, and the relationship between photographer and subject. See Rosenblum, plate 5 and Schulze, plate 16.

characterize a scrutinizing age, often cynical of culture, society, and politics. The Americans was published, after all, on the eve of the 1960s. Frank's continued antiformal observations in photographs and films and his sequencing of images transformed American photography and profoundly influenced successive generations of artists working in a variety of media over the forty years that now have passed. Robert Frank today is acclaimed as a great artist, and his photographs are collected not only for their historical significance, but also for their eloquence, honesty, and grace.

By contrast, in 1995 The Museum of Contemporary Photography presented the exhibition "Real Pictures," a commissioned installation by Alfredo Jaar that positioned just the opposite: concealed images questioning the very power of photography [see plate 2]. The work consists of various memorials geometrically constructed with stacked and repeated black-linen boxes, all closed with photographs inside, images taken by Jaar in 1994 on a journey to war-ravaged Rwanda. Simple, declarative descriptions of the images are silkscreened on the top of the boxes. The texts describe events, sites, people, and what they witnessed. Although they are not sealed shut, the boxes are not to be opened. The temptation, however, is great, and adds a further element of tension.

During the exhibition, viewers entered the main-floor gallery of the museum as a space of darkness punctuated by pools of light directed onto the cenotaphs (as historian Peter Hales pointedly referred to them in a subsequent lecture)[2] and introductory wall text which included a statement by the writer Vincenç Altaió, "Images have an advanced religion; they bury history." In his characterization of the project for the museum, Jaar wrote, "We live in a media landscape, saturated by images from many different sources simultaneously; without warnings; without mercy. Images in mass circulation create a 'new reality' that is the product of photographers, artists, and editors working in thousands of newspapers and magazines. Real Pictures is an experiment with representation. It is an essay investigating the translation of tragic world events into visual language. The piece marks the slippage between authenticity of descriptions – visual and textual."[3] Which is more powerful – the photograph or the word? Is a picture worth a thousand words?

**Art + idea**
**Miller**

The installation was also challenging by presenting at a photography museum an exhibition without visible photographs. It called into question whether images have lost their teeth or are so powerful that they have to be veiled. Jaar's texts confirmed this contradictory distrust of photography. The impact of war is certainly difficult to portray under any circumstances. Without pictures, Jaar's somber monuments evoked a stark and haunting visual image that was emotionally descriptive of the events to which he referred. The beauty of the installation, however, raised the issue of the appropriateness of aestheticizing the suffering of others, a question that has plagued Alfredo Jaar throughout his career (and has on occasion condemned museums for the presentation of such material).

Controversy is endemic to the nature, presentation, value, and financing of all contemporary art. The Museum of Contemporary Photography seeks to collect art across the spectrum, including formal, contextual, and conceptual photographs, photographic objects, and installations. Some of these have been referred to as controversial, but all have been most importantly selected for their aesthetic and philosophical perspectives; the collection contains renowned works and ground-breaking experiments.

The collection may be bracketed by the polar ideas of Robert Frank and Alfredo Jaar (although their positions could be considered conversely quite consonant as foreigners epitomizing discord in countries other than their own, and imposing a fine art/documentary, personal/political viewpoint), and the presence, real or implied, of photographic imagery, but it contains a range of positions in between. The permanent collection is housed in a college museum. It is a collection for study by the public and students examining the arts, communication, and public information. Therein, photography is collected and exhibited through its roles as a medium of artistic expression and communication, a documenter of life and the environment, a powerful commercial industry, and a tool in the service of science and technology. An overriding emphasis, however, is clearly placed on the power of the work in intention, artistry, and aesthetics.

The identifying labels – artist, photographer, or the more neutral and encompassing imagemaker – are consequential to the museum only when it is considered significant to the maker to be so distinguished, for photography has always been about a continual questioning of the medium itself and cross-fertilization. No wonder that the makers also position themselves inside or outside the edges, literally or figuratively, of peripheral vision. Throughout its history, photography has been in flux. Photography is complex; it can be identified with multifaceted conceptual, cultural, historical, political, and social ideas, as well as being a visual practice.

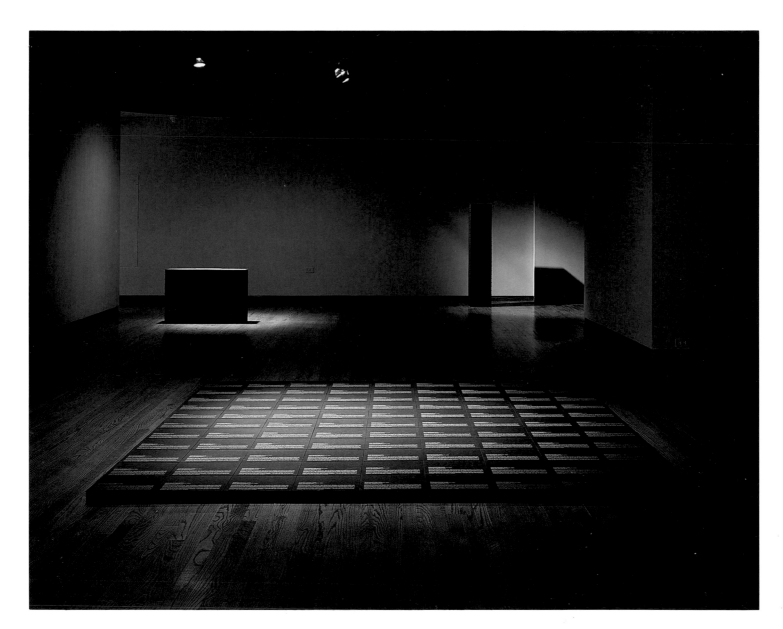

2  Alfredo Jaar
**Real Pictures**, 1995
The Museum of Contemporary
Photography exhibition
January 28–March 25, 1995
Installation view
Photograph by
Thomas A. Nowak

Alfredo Jaar seizes the chal-
lenge of making art out of
information most people
would rather avoid: the plight
of refugees, genocide, ethnic
and political violence. Rather
than offering information in
an expected or familiar form,
Jaar creates presentations
that demand reflection. The

installation **Real Pictures**,
for example, shows no pic-
tures, but offers text describ-
ing events in Rwanda during
the 1994 massacres. Viewers
are left to confront their own
expectations, both aesthetic
and political, as well as
Jaar's subject matter.

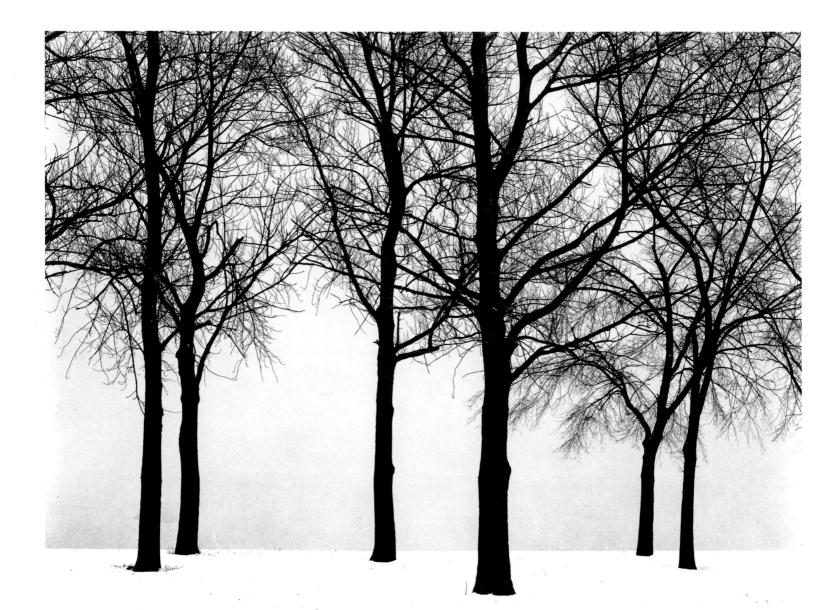

3  Harry Callahan
   **Chicago**, c. 1950
   silver gelatin print
   7 5/8 x 9 5/8 inches
   Museum purchase
   © Harry Callahan, courtesy
   PaceWildensteinMacGill,
   New York

Not only did Harry Callahan
document the city of Chicago
in a variety of scenes and
styles, he encouraged a num-
ber of students, now promi-
nent photographers, to see
the city afresh as well. His
views of the waterfront, archi-
tecture, and streets – occa-
sionally occupied by his

family – document an artist's
style as much as a place. A
Minimalist view of bare winter
trees at the edge of Lake
Michigan, **Chicago** is indica-
tive of Callahan's mastery
of technique and composi-
tion. See Schulze, plates 10
and 13.

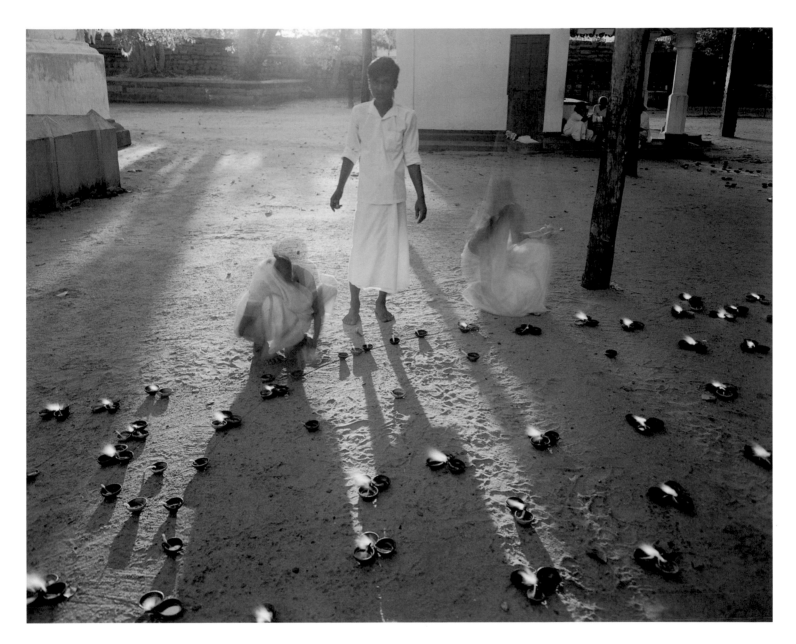

4  Linda Connor
**Ceremony, Sri Lanka**, 1979
gold-toned silver gelatin print
on printing-out paper
7 ¾ x 9 ⅝ inches
Museum purchase with
matching funds from
The National Endowment for
the Arts

Documenting megaliths and
ruins, petroglyphs and
caves, Linda Connor's work
has evolved into an investi-
gation of visual forms of
the sacred. Each new image
retains a remembrance of

previous ones, adding mean-
ing and a suggestion of inter-
connectedness. The
peacefully arranged flames
in **Ceremony, Sri Lanka** cap-
ture the timeless essence of
the cyclical and the spiritual.
In 1990 The Museum of Con-
temporary Photography
organized "Linda Connor,

Spiral Journey: Photographs
1967–1990," a retrospective
exhibition and accompany-
ing monograph of Connor's
work.

5   Joseph D. Jachna
    **Door County,**
    **Wisconsin,** 1970
    silver gelatin print
    8¹⁄₁₆ x 12 inches
    Gift of the artist

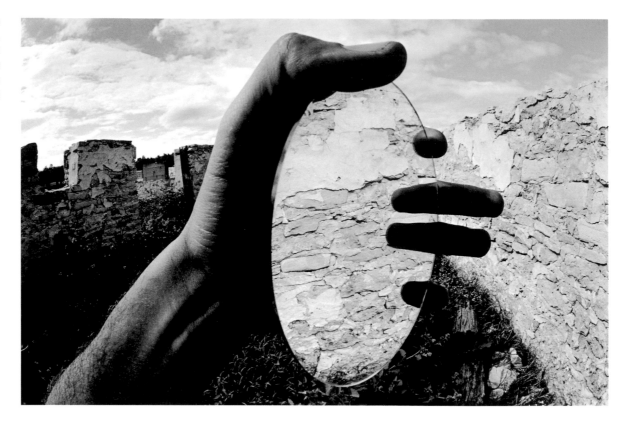

6   Kenneth Josephson
    **Untitled,** 1964
    silver gelatin print
    6 ¹⁵⁄₁₆ x 6 ¹⁵⁄₁₆ inches
    Gift of the Reva and
    David Logan Foundation

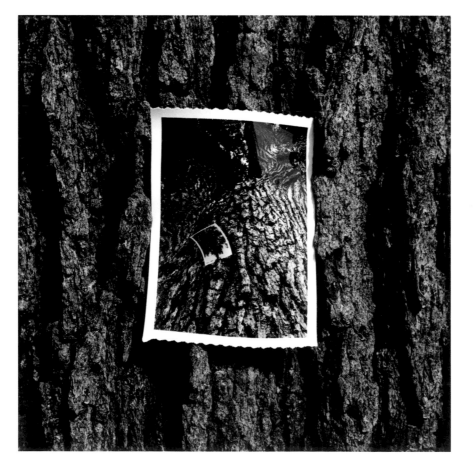

5 In **Door County, Wisconsin,** Joseph Jachna constructed an elegant spatial play through the simple use of a mirror; the photographer's obvious presence wittily alters the environment. Intelligent and poetic, Jachna's photograph constructs a landscape not normally visible to the human eye.

6 Kenneth Josephson often uses photographs within his photographs as constructs of the picture plane, as in this untitled image of a tree. His intriguing arrangements of layered images are quite simple: a boy holds his own photograph upside down in front of his face, a hand holds a postcard of a historical site in front of that very site, a ruler is shown in the foreground to imply that the background mountain is only inches wide. These images are about the difference between image and reality, and ultimately about photography itself.

**Art + idea**
**Miller**

**Local influence: intelligence and emotion** In 1937, with the establishment of The New Bauhaus by the artist László Moholy-Nagy, Chicago emerged as an important photographic center, soon matching its renown as an architectural metropolis. Numerous institutions in the area followed suit and established fundamental teaching programs in the medium, most notably The School of The Art Institute of Chicago; the School of Art and Design at the University of Illinois, Chicago; and Columbia College Chicago. As the critic Alan Artner wrote in 1997, "In the last 60 years, Chicago made its strongest and most lasting impression in a world arena not with painting or sculpture but with photography."[4] The Institute of Design (ID), the successor institution to The New Bauhaus (with an interim identity as the School of Design), joined the Illinois Institute of Technology in 1949. ID's history is itself tantamount to this potent viewpoint. Its faculty, now recognized as among the most prominent photographers of the late twentieth century, included Henry Holmes Smith, Nathan Lerner [see Schulze, plate 8], Arthur Siegel [see Peat, plate 2], Art Sinsabaugh, Harry Callahan [see plate 3 and Schulze, plates 10 and 13], and Aaron Siskind [see cover; Parry, plate 1; and Schulze, plates 11 and 12].

When Aaron Siskind joined Harry Callahan at the Institute of Design in 1951, the two fostered the most influential photography program in the United States. Callahan first arrived at the school in 1946 and continued teaching there until 1961 when he left for the Rhode Island School of Design (RISD). Siskind departed in 1971 to join Callahan at RISD. The Callahan-Siskind partnership in Chicago over the decade 1951–61 produced a generation of photographers educated in photography as fine art: Thomas Barrow, Barbara Blondeau, Vernon Cheek, Linda Connor [see plate 4], Eileen Cowin [see plate 11], Barbara Crane [see Peat, plate 16 and Schulze, plate 21], Joseph D. Jachna [see plate 5], Kenneth Josephson [see plate 6], Calvin Kowal, Ray K. Metzker [see plate 7], Richard Nickel [see Schulze, plate 1], Esther Parada, Keith Smith, Joseph Sterling, Charles Swedlund, Charles Traub, and Geoff Winningham, to name a few. They all became educators at postsecondary-school programs throughout the country and influenced succeeding generations.

Their reach was far and wide. The working method promulgated by Callahan and Siskind combined "the formal qualities of the camera's graphic objectivity with the poetic subjectivity with which the artist gives meaning to form."[5] Their photographic vocabulary evoked acuity and ambiguity, a blend of intelligence and emotion.

The permanent collection of The Museum of Contemporary Photography can be broken down by regionalism, as reflected in the development of ID, or the influence of significant contemporary photographers working in the United States, such as Callahan and Siskind, Ansel Adams [see Csikszentmihalyi, plate 1], Diane Arbus [see Paschke, plate 7], Walker Evans [see Rosenblum, plate 2 and Schulze, plate 3], Lisette Model, Minor White [see plate 8], Garry Winogrand [see Parry, plates 11 and 12 and Rosenblum, plate 7], and scores of

7  Ray K. Metzker
**Untitled**, 1969
silver gelatin print
9 x 6⅛ inches
Museum purchase

Ray Metzker's images question the nature of the photograph and photographic "reality." Through cropping, multiple imagery, and other formal inventions, his work explores options for transforming the vocabulary of the photograph. This untitled image illustrates the simple method of manipulating objective information through juxtaposition: two distinct women on the beach enter into a relationship of line and gesture in a pairing that indicates the sophistication of Metzker's visual language.

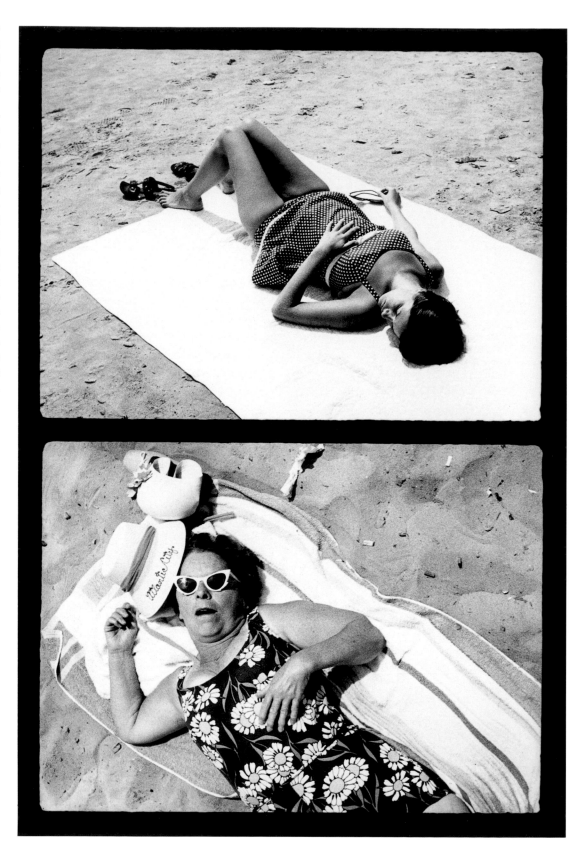

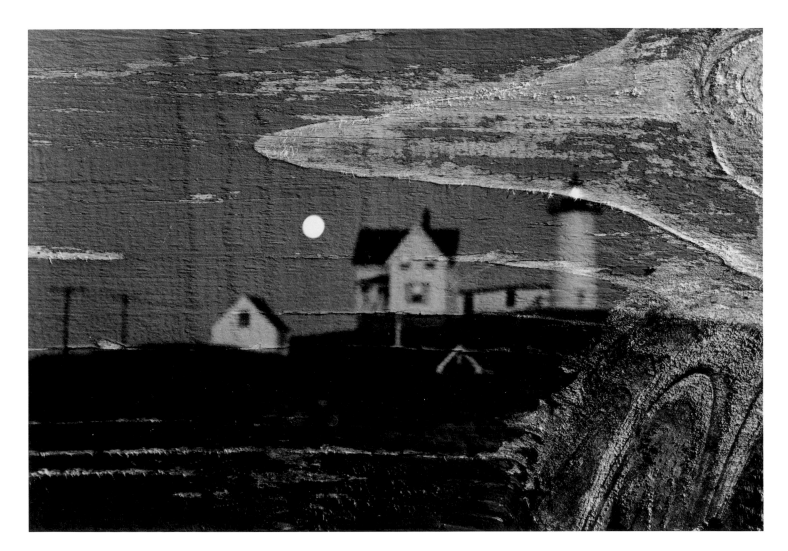

8  Minor White
**Lighthouse and Wood**, 1970
silver gelatin print
6 x 8¾ inches
Museum purchase
© 1998 by the Trustees of
Princeton University
Reproduction courtesy
The Minor White Archive,
Princeton University

Critic, mentor, teacher, and
influential photographer,
Minor White is known for his
sharply detailed photographs
of architectural elements,
landscape, and nude figures.
His technically perfect prints
reflect his engagement with
the spiritual in the aesthetic.
The contemplative quality of
his work is evident in the mul-
tiple image **Lighthouse and
Wood**, with its gestural
sweeps of painted wood, a
small but clearly defined
moon, and blurred buildings
in the background.

9 Ellen Carey
**Untitled**, 1988–89
nine internal dye
diffusion transfer prints
23 ⅝ x 19 ⅝
inches each
Gift of the artist and
Ricco/Maresca Gallery
in memory of her brother,
Dr. John T. Carey

Ellen Carey's photographs
investigate abstraction
and Minimalism through
the use of highly saturated
color and pure form. This
untitled grid of vibrant
patterns and shapes, both
figurative and abstract,
creates a conceptual col-
lage. A mapping of color
fields and forms, it implies
the proportional harmonies
found in nature, science,
and mathematics.

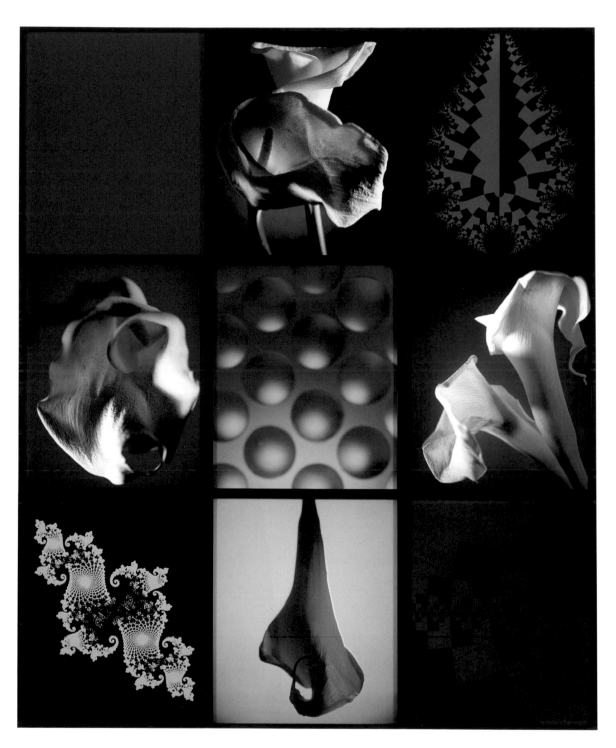

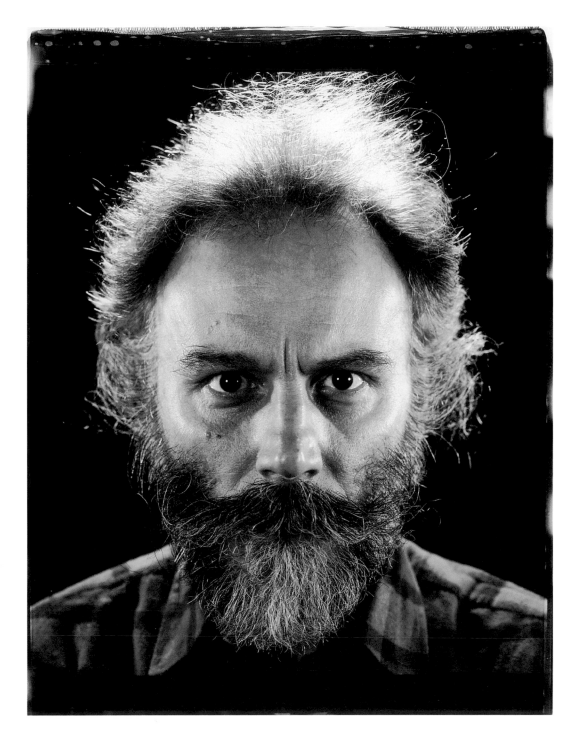

10  Chuck Close
**Lucas**, 1996
inkjet print
40 x 30½ inches
Museum purchase
© Chuck Close, courtesy
PaceWildensteinMacGill,
New York

Chuck Close began using
photography as a tool to
obtain images for his paint-
ings. When he started work-
ing with a large Polaroid
camera, his photographic
portraits began to approxi-
mate the enormous scale of
his paintings, particularly
when they are joined in
quadrant grids to form single
portraits. Close's inkjet prints,
such as **Lucas**, are exquisitely
detailed, capturing shifting
tones and shadows as well
as his subject's hairs and
wrinkles. See frontispiece.

11 Eileen Cowin
**Untitled (Magritte)**,
1988
silver dye bleach
(from color positive) print
62 x 49½ inches
Gift of the artist

With a skillful use of gesture and pose, Eileen Cowin creates mysterious scenarios. Blending the ecclesiastical allegory of the fifteenth century, the romantic vision of the nineteenth century, and the Surrealist trends of the twentieth, Cowin draws inspiration from European painting. Her work emulates poses seen in David, Van Eyck, Ingres, and Goya while adopting the styles of film noir and television. **Untitled (Magritte)** reveals Cowin's suspenseful manner and her recurring themes of privacy, victimization, and voyeurism.

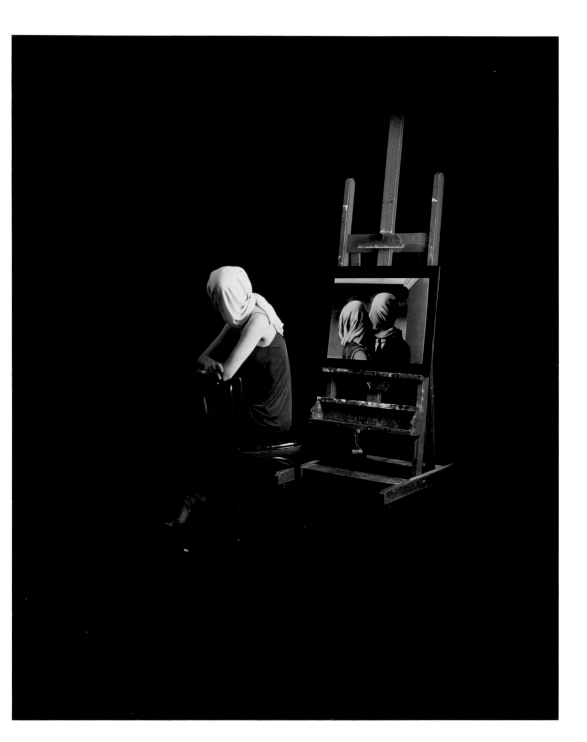

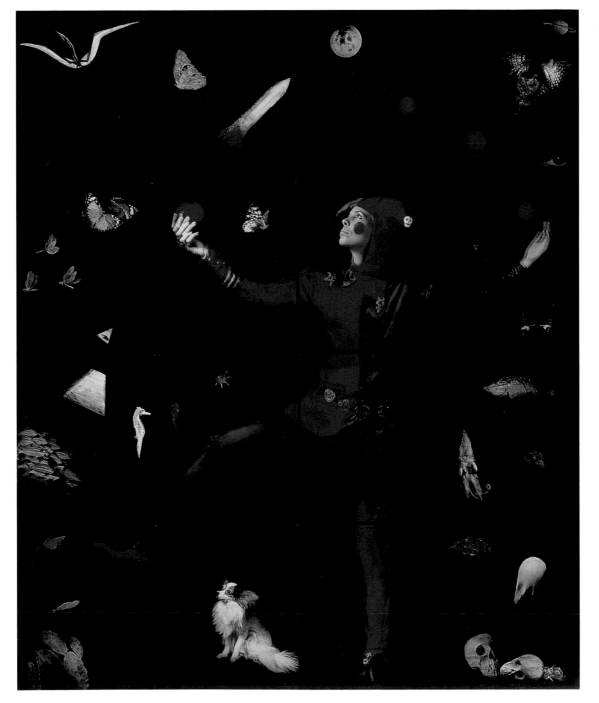

12  Judith Golden
**The Juggler**, 1989–93
sixteen internal dye
diffusion transfer
prints with oil paint
23 ¾ x 19 ¾ inches each
Museum purchase

An elaborate grid of individ-
ually painted photographs
makes up Judith Golden's
**The Juggler**. Influenced by
the provocative symbolism
of the ancient Tarot,
the mystical forerunner of
today's playing cards,
Golden drew on the trump
card figures of the joker, the
fool, and the magician to
structure this piece, creating
an atmosphere of myth,
magic, and dreams.

younger practitioners. It may also be differentiated by traditional genres of landscape, still life, and portraiture, or even labeled categories and diverse canons related to art movements such as Pictorialism, Surrealism, Modernism, and Postmodernism. Overall, however, the collection references the back-and-forth movement of photographers and other artists distinguishing a vision in a world of images and a history of art.

Breaking down hierarchies  **Because The Museum of Contemporary Photography is a college museum and looks at photography through its roles as art, document, market, and science, it has been able to break down further traditional hierarchies that might be presented at, and even created by, other museums. Likewise, the permanent collection, unique in its holdings of contemporary American and US-resident images, photographic objects, and installations, particularly focusing on these four roles, has created a niche for the institution to make a significant contribution to the field and for the public. The most illustrious collections of photography in the United States survey the history of the medium throughout the world. The focus of The Museum of Contemporary Photography's collection on late twentieth-century works by both established and emerging artists in the United States has positioned the institution as a harbinger of this country's vanguard photography.**

**The focus is certainly neither without precedence nor isolated. Van Deren Coke, an educator at the University of New Mexico from 1962 to 1988 and curator of photography at the San Francisco Museum of Modern Art from 1979 to 1987, produced numerous shows and developed a public collection (and consulted on many private collections) that demonstrated the interconnections between photography and prevailing art movements. His book** The Painter and the Photograph: From Delacroix to Warhol **was published by the University of New Mexico Press in 1972. During the 1960s, 1970s, and 1980s, other prominent curators, educators, and historians, such as Aaron Scharf, Peter C. Bunnell, A.D. Coleman, John Coplans, James Enyeart, Peter Galassi, Walter Hopps, André Jammes and Eugenia Parry (Janis), Nathan Lyons, Rosalind Krauss, and Abigail Solomon-Godeau wrote eloquent inquiries on how important precedents of painting were to the**

**Art + idea
Miller**

pioneers of photography, as well as the medium's metamorphosis.[6] **In 1987 Andy Grundberg and Kathleen McCarthy Gauss summarized the revolutionary revision of photography and its role in contemporary art. The exhibition and publication** Photography and Art: Interactions Since 1946 – **a forty-year survey of the unprecedented prominence photography attained in the art world with influence on painting, drawing, and printmaking – heralded imagemaking in the postwar period as a hybrid, mixed-media, interactive approach far removed from the purist aesthetics of Modernism.**[7]

**Since 1976 The Museum of Contemporary Photography has exhibited and in most cases subsequently collected the work of many of the artists these programs and authors highlighted, and others that continued the momentum, among them Paul Berger, Harry Bowers, JoAnn Callis, Ellen Carey [see plate 9], Chuck Close [see plate 10 and frontispiece], Eileen Cowin [see plate 11], Robert Cumming, John Divola, Robert Fichter, Judith Golden [see plate 12], Nan Goldin [see Slemmons, plate 3], Jan Groover [see plate 13], Betty Hahn, Robert Heinecken [see Peat, plate 3 and Slemmons, plate 19], Barbara Kasten [see plate 14], Barbara Kruger [see Slemmons, plate 18], Ellen Land-Weber, David Levinthal, MANUAL [see Peat, plate 4], Duane Michals [see Slemmons, plate 4], Patrick Nagatani [see Peat, plate 15], and Andree Tracey, Joyce Neimanas [see plate 15], John Pfahl, Doug Prince [see Peat, plate 17], Susan Rankaitis [see Peat, plate 12], Leland Rice, Holly Roberts, Lucas Samaras, Cindy Sherman, Sandy Skoglund [see Paschke, plate 8], Keith Smith, Eve Sonneman, Mike and Doug Starn [see plate 16], Larry Sultan, Val Telberg, Ruth Thorne-Thomsen [see plate 17], Jerry N. Uelsmann [see Csikszentmihalyi, plate 10], Andy Warhol, William Wegman [see Paschke, plate 9], Todd Walker, and Joel-Peter Witkin [see plate 18 and Parry, plate 13].**

**As photographers and other artists utilizing photography – most notably John Baldessari, Robert Rauschenberg, and Andy Warhol – broke molds, experimented in technique and process, fabricated settings, directed pictures, and appropriated and recontextualized imagery that itself was a replication of something else, a long history of straight photography also moved stridently forward with equal and increasing appreciation by institutions, the collecting community, and the public. The acceptance of photographic imagery was increasingly marked by great visual and intellectual latitude. The question – Is photography art? – is certainly a moot point. Interestingly and ironically, however, Postmodernist thought on the photograph as a statement about itself and the professional and general public embrace of the medium of photography laid the groundwork for photography also to be distinctively regarded as market, document, and science. Bitter divisions or disputes now center more on matters of critical and commercial positioning than on genuine aesthetic difference (although many enjoy debating aesthetic polarities).**

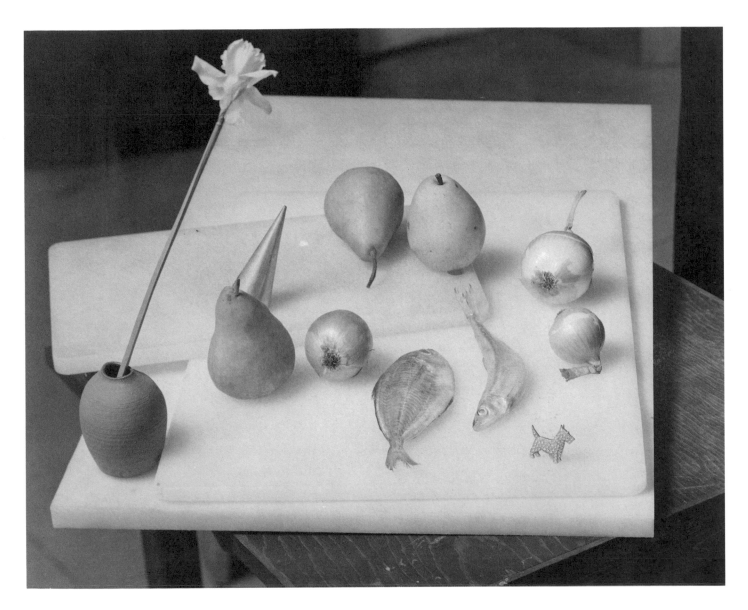

13   Jan Groover
**Untitled #1308**, 1983
platinum/palladium print
7 1/2 x 9 7/16 inches
Museum purchase

The aesthetic appeal of Jan Groover's still-life photographs is immediately obvious. There is, however, also an intellectual component in works such as this angular arrangement of fruit, fish, and a flower. A painter by training, Groover makes reference to art history, from Renaissance perspective drawings to Cézanne's tabletops. Using a variety of camera formats to affect perception and plane, Groover merges photography with art history.

14 Barbara Kasten
**Architectural Site #17,**
**The High Museum**, 1988
silver dye bleach
(from color positive) print
29 1/8 x 37 1/4 inches
Museum purchase with
matching funds from The
National Endowment for
the Arts

Influenced by The Bauhaus
and Constructivism, Barbara
Kasten explores modes of
reorganizing the visual envi-
ronment. With geometric
shapes, mirrors, architectural
elements, and a lighting crew
recruited from the film indus-
try, she creates abstract inter-
pretations of interior spaces.

Evident in **Architectural Site**
**#17, The High Museum**
is Kasten's use of super-
saturated color and dramatic
juxtapositions of line, angle,
and form.

15   Joyce Neimanas
**Heroicomic**, 1993
inkjet print
38 1/2 x 29 1/2 inches
Museum purchase

An example of a comic-book figure ironically standing in for a contemporary woman, the flying heroine in **Heroicomic**'s lower left panel states: "I dance topless in the **worst** part of New York City! I **know** how to defend myself!" Joyce Neimanas's digitally created montages of recognizable styles and signs suggest the ludicrous and the burlesque. **Heroicomic** is Neimanas's personal fiction, written with information garnered from the imagery of advertising, art history, and pop culture.

16  Mike and Doug Starn
**Double Rembrandt with
Steps**, 1987–91
toned silver gelatin prints
with mixed media
53 x 27 x 1¾ inches
Museum purchase

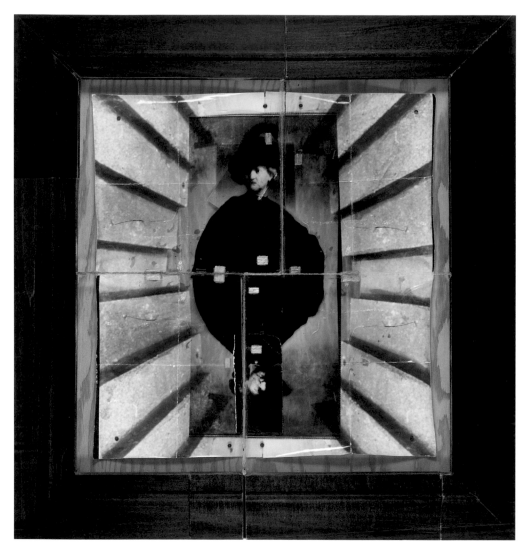

17  Ruth Thorne-Thomsen
**Head with Ladders,
Illinois** from the series
**Expeditions** (1976–84),
1979
toned silver gelatin print
4⅜ x 5 inches
Museum purchase

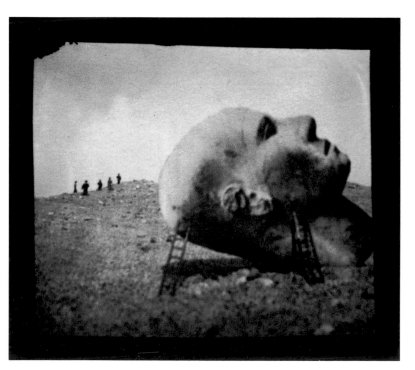

16 Manipulations of technique and form mark Mike and Doug Starn's photo-based mixed-media art. **Double Rembrandt with Steps** is one of their variations on a Rembrandt portrait presumably of the painter's father. In concept and materials – plywood, nails, transparency film, plexiglass, and wood molding – this piece refers to the Starns' own father, a man interested in architecture and woodworking, as well as to their status as twins. **Double Rembrandt with Steps** delicately transforms the art historical information that the Starns appropriate and salute.

17 Ruth Thorne-Thomsen has created an incredibly imaginative oeuvre using a pinhole camera. A variety of interpretations can be surmised from **Head with Ladders, Illinois**: the figures inspect the remains of a lost civilization, conduct a surgical procedure on an unearthly being, or contemplate a metaphorical climb toward knowledge. Lyrical and surreal, Thorne-Thomsen's photographs were the subject of The Museum of Contemporary Photography's 1993 exhibition and monograph **Within this Garden: Photographs by Ruth Thorne-Thomsen**.

18 Joel-Peter Witkin's dark imagination is fueled by art history – from Courbet to Seurat, Caravaggio to Redon – which he quotes in his photographed arrangements. In **The Fool, Budapest**, are elements from Titian's **Rape of Europa** and Velázquez's **Phillip IV on Horseback** with which Witkin composes his own mythological spectacle. See Parry, plate 13.

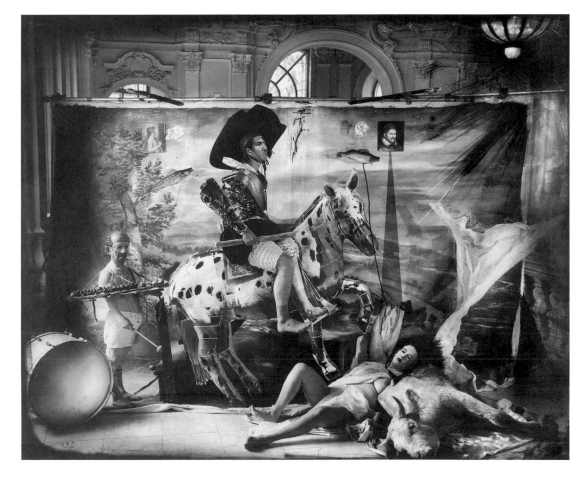

18 Joel-Peter Witkin
**The Fool, Budapest**, 1993
silver gelatin print
29 3/16 x 36 3/16
Museum purchase
© Joel-Peter Witkin, courtesy
PaceWildensteinMacGill,
New York

Artistic distinction relies upon the originality, lucidity, and intelligence of the maker's perception. Change is in the air when either simultaneously or in close succession, art institutions independently present analogous exhibitions that emphasize not only a continued breakdown in concept of photography and art, but photography as art and an instrument for the sale of goods and services, photography as an agent for social change and artful document of life and the environment, and photography as a tool in the service of science and technology and scientia artifex.

Photography and market   Since the early 1980s exhibitions have steadily appeared throughout the country highlighting the personal and professional work of contemporary commercial photographers. Chief among them have been special exhibitions and retrospectives of this arena's most distinguished practitioners, most notably Richard Avedon and Irving Penn [see plate 19 and Slemmons, plate 17]. The Museum of Contemporary Photography has been steadfast in support of professionals working for corporations, editors, and designers, and other clients, with exhibitions including the work of George Hurrell, Mary Ellen Mark, and Victor Skrebneski [see Slemmons, plates 7, 11, and 9], in addition to Annie Leibovitz [see Slemmons, plate 10], Robert Mapplethorpe, Sheila Metzner, Helmut Newton, Herb Ritts, and David Seidner, among others. In 1992 the museum displayed the contentious campaign of United Colors of Benetton, and in 1994, "Photography and Marketing," which incorporated The GAP, Inc.'s "Individuals of Style" and Liz Claiborne's "Women's Work" campaigns with educational programming, contracted essays, and a resource room on the progressive phenomenon of corporate cause-related marketing [see Slemmons, plates 1, 6, 10, and 18]. A response wall in the latter presentation posed numerous questions for public commentary on the influence of photography and the social conscience of big business: What is the power of photography in marketing? Is image everything? What does advertising do to you? What makes you buy? Are you a target? What are you buying (into)? In 1996 the museum introduced "Target Market: Professional Photography in Chicago," from which it assembled an archive of more than four hundred large-format transparencies and photographs by forty of the city's practitioners, including Tony Armour, Tony D'Orio, Paul Elledge, Marc Hauser, Barbara Karant, Dennis Manarchy, John McCallum, Jean Moss, François Robert, Chuck Shotwell, and Victor Skrebneski [see Slemmons, plates 2, 9, and 14].

These presentations emphasized the continued collapse of what may be referred to by some as high art dominance to revelry in the significance of image. Photographs made for marketing and advertising move viewers, generate discussion, and alter perspectives about the subject, the maker, the sponsor, and the art. These images reflect the social climate and design new attitudes. They are powerful in their skillful composition, mastery of provocation, and impressionable in individualized sensibility. They are even beautiful in a variety of definitions of beauty. Surely the most memorable commercial photographs are artful.

Photography and document   Over the past forty years (and especially in the 1990s), great significance has been placed on the return of art, specifically photography, from formalism and theoretical self-reflexivity to reengagement with the world. "Documentary" is highly regarded in its heritage of socially committed, humanistic, and concerned photography, but different types of social problems and concerns change over time. In large measure Robert Frank's sequencing of images and work on extended projects influenced successive generations to comment on their environment, not only on dilemmas but on experiences in general. As Frank wrote: "There is one thing the photograph must contain, the humanity of the moment. This kind of photography is realism. But realism is not enough – there has to be vision and the two together can make a good photograph. It is difficult to describe this thin line where matter ends and mind begins."[8] Artists began regularly to work in series and continue to explore a range of strategies: examining the contingency of identity constructed around race, gender, nation, class, or generation; observing the changing nature of American industry, labor, and the prevailing tenor in the home and on the streets; engaging in overtly political themes of mass consumption, historical consciousness, and bureaucratic corruption; and reasserting the relevance of nature in a country increasingly defined and motivated by man's intervention and technological change, among a multiplicity of approaches.

The collection is rich with examples of the visions of photographers working many years on a subject, as well as emerging artists surveying their history and breaking into yet new territory. As Philip-Lorca diCorcia comments on "the pathos which rules average life,"[9] Keith Carter continues a twenty-five-year study of "deep, abiding grace woven into daily lives"[10] [see plates 20 and 21]. As Mark Klett first rephotographed the sites of other explorers [see plate 22] and now seeks to reveal an individual perspective on the territory of

19  Irving Penn
**Chanel Feather Headdress (New York, September 19, 1994)**, 1996
platinum print
21 7/8 x 19 3/4 inches
Museum purchase
© 1994 by the Condé Nast Publications, Inc.

Irving Penn's fashion photographs – beginning with his notable 1950 series of the Paris collections – defined a new look for magazines. By placing models against plain backdrops, Penn removed the familiar clues to space or scale and allowed fashion to stand alone as the subject of his images. **Chanel Feather Headdress** demonstrates Penn's penchant for abstraction in his uncommonly rich and brilliantly composed prints. See Slemmons, plate 17.

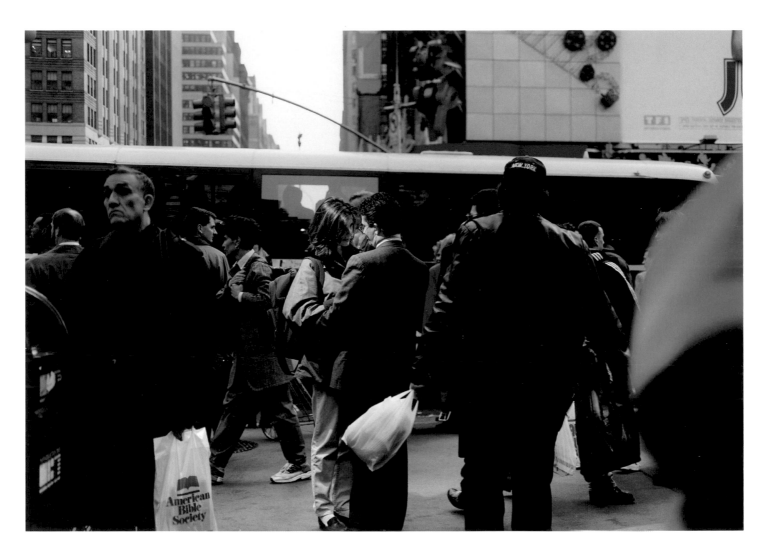

20   Philip-Lorca diCorcia
**New York**, 1997
chromogenic development
(from color negative) print
25 x 37 ¼ inches
Museum purchase
© Philip-Lorca diCorcia,
courtesy
PaceWildensteinMacGill,
New York

In **New York**, Philip-Lorca
diCorcia captured the subtle
play of an average moment,
the intimacy of a couple's
stance on a busy street corner.
His subtle and dramatic urban
scenes are gathered in the
1998 monograph **Streetwork**,
in which diCorcia stated his
interest in photography's

capacity to provide second-
hand experience, and his
focus on "that which was
never really hidden, but rarely
is noticed."

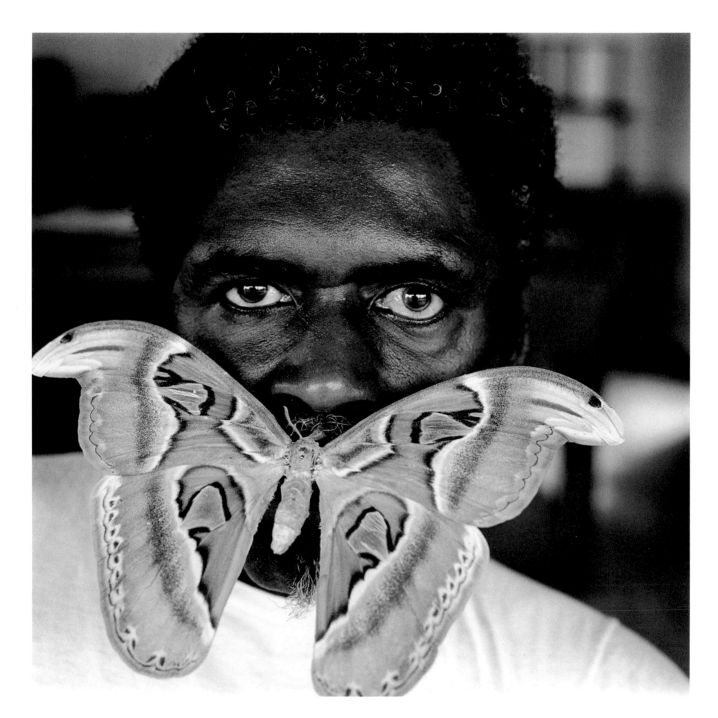

21  Keith Carter
    **Atlas Moth**, 1990
    toned silver gelatin print
    15 $^7/_{16}$ x 15 $^7/_{16}$ inches
    Gift of the artist

Strains of folklore, fiction, and religion can be seen in Keith Carter's beautifully sensuous photographs. **Atlas Moth** is typical of the casually offbeat but deeply ingrained elegance Carter perceives in the every-day. Whether of a lost dog, children playing, or an empty interior, his images are consistently imbued with beauty, nostalgia, and tranquillity.

22  Mark Klett
**Panorama of San Francisco**
from the portfolio
**California Street Hill** (1990),
1990
thirteen silver gelatin prints,
19 ³/₄ x 15 ¹⁵/₁₆ inches each
Museum purchase with
matching funds from
The National Endowment
for the Arts

In 1878 Eadweard Muybridge climbed with his cumbersome wooden view camera to the top of California Street in San Francisco to make a 360-degree panorama of the city. In 1990 Mark Klett remade the panorama. Klett's goal was to match Muybridge's photographs – something no longer possible from a single spot in 1990 because of the skyline created during the century spanning the two projects. These two carefully planned San Francisco panoramas, presented together in the accordion-fold book **One City / Two Visions** (1990), reveal the evolution of a city. The process of revisiting a site is familiar to Klett, the former chief photographer for the Rephotographic Survey Project (1977–79), which remade classic nineteenth-century views of the American West. See Rosenblum, plate 17.

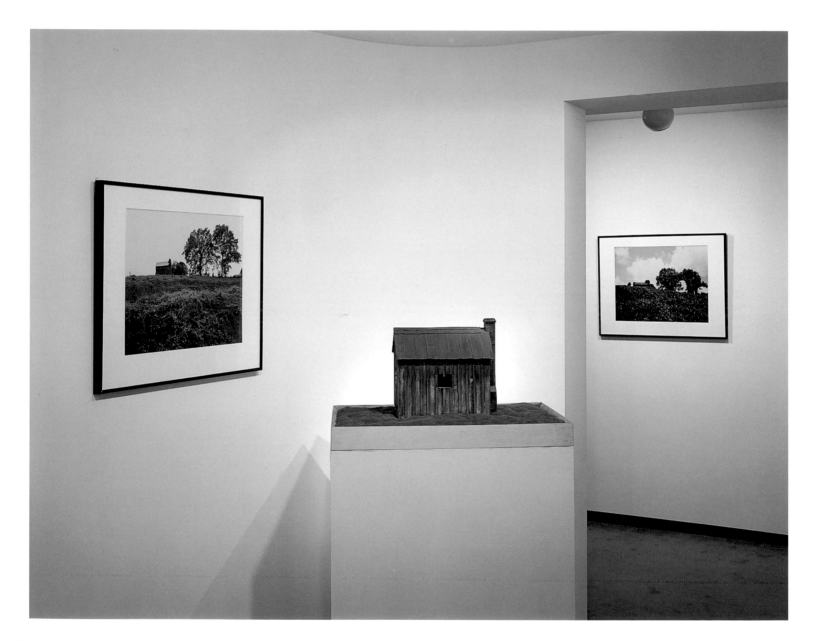

23 William Christenberry

**Kudzu and House, Tuscaloosa County, AL**, 1991 (left) chromogenic development (from color negative) print 17 1/8 x 21 13/16 inches Gift of the artist

**House, Tuscaloosa County, AL**, 1994 (center) mixed media 17 x 31 x 21 inches Museum purchase

**Kudzu and House, Tuscaloosa County, AL**, 1979 (right) chromogenic development (from color negative) print 17 5/8 x 21 3/4 inches Gift of the artist

This installation view shows three parts of William Christenberry's persistent visual investigation of a site in Alabama. Trained as a sculptor and painter, Christenberry is devoted to the heritage of the South and interprets it in a range of media. This series focusing on a small shack is a meditation on the passage of time, the ebb and flow of seasons, and the spirit of rural Southern life.

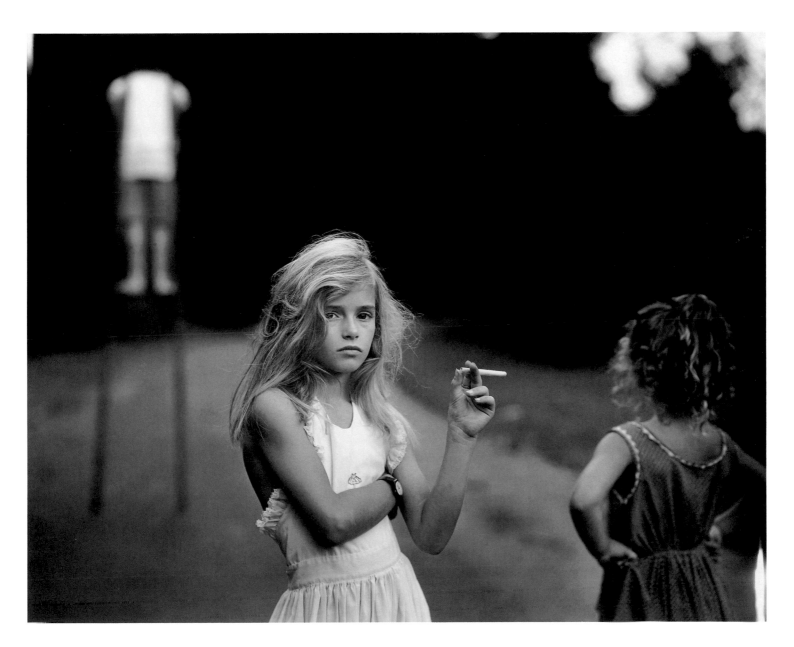

24  Sally Mann
**Candy Cigarette**,
1989
silver gelatin print
7 ⅝ x 9 ⅝ inches
Museum purchase
© Sally Mann, courtesy
Edwynn Houk Gallery,
New York

Sally Mann has used her view camera to record, among other subjects, her children's illnesses, playtime, accidents, and moods with an often unsettling directness. A combination of both careful planning and serendipity, Mann's provocative photographs of her family reflect the nuances of childhood as well as the richly dense landscape of the artist's native Virginia. **Candy Cigarette**, from the monograph **Immediate Family**, is a striking example of Mann's distinctive vision.

the Southwest [see Rosenblum, plate 17], William Christenberry continues to interpret the South through photographs and sculptures [see plate 23], following for more than twenty-five years in the footsteps of Walker Evans [see Rosenblum, plate 2 and Schulze, plate 3]. As Sally Mann tells "truths told slant" (as Emily Dickinson commanded), photographing the maturation of her children and the beauty of the landscape in and around her hometown of Lexington, Virginia [see plate 24], Dawoud Bey and Carrie Mae Weems deal with issues of identity, race, gender, and class, delving deeply into aspects of the African-American experience [see plates 25 and 26]. Fazal Sheikh travels to document Africa's refugee communities on Kenya's northwestern border with Sudan [see plate 27].

Since the late 1970s The Museum of Contemporary Photography has exhibited, and subsequently collected, the work of these and many other American photographers exploring private realities and the social landscape, and photojournalists documenting critical events and circumstances around the world. Among the projects originated by the museum, often with subsequent tours to other US and foreign venues, are "Frank Gohlke: Landscapes from the Middle of the World" [see Rosenblum, plate 15 and Peat, plate 18] and "This and Other Worlds," with works by Magnum photographers Susan Meiselas, Gilles Peress, Eugene Richards, and Alex Webb [see plate 28; Rosenblum, plates 19 and 22; Slemmons, plate 12; and Schulze, plate 19], both 1987; "The Secret War in the American West," 1989, with portraits by Carole Gallagher and text from oral histories of citizens in Utah, Nevada, and Arizona affected by the fallout of nuclear testing; "Raising Issues about Representing AIDS," 1990; "MANUAL: Forest\Products," 1992 [see Peat, plate 4], 1992; "The Insistent Subject: Photographing Time and Again," including among others, William Christenberry, John Coplans [see plate 29], O. Winston Link [see Csikszentmihalyi, plate 7], Nicholas Nixon [see Rosenblum, plate 23 and Paschke, plate 1], Lucas Samaras, Cindy Sherman, and William Wegman [see Paschke, plate 9], 1995; Robert Adams's "West from the Columbia: Views at the River Mouth" [see Parry, plate 9], presented in tandem with "Listening to the River: Seasons in the American West," organized by the Sprengel Museum, Hannover, Germany, 1996;

Art + idea
Miller

and forthcoming in September 1998, "There and Gone: Photographs by John Gossage" [see plate 30], coorganized by The Museum of Contemporary Photography and the Sprengel Museum.

In January 1998 the museum presented "Raised by Wolves: Photographs and Documents of Runaways by Jim Goldberg,"[11] from which it will acquire work for the collection in fall 1998. By addressing the social context of runaways from their own points of view, and combining these first-person accounts with the views of parents, social workers, doctors and police, "Raised by Wolves" not only depicts the circumstances of troubled lives, but also sheds light on the causes of the young people's alienation from families and other adults. The exhibition included not only photographs, but also video installations, found objects, and additional documents, including handwritten statements by the runaways themselves. This sort of multimedia documentary represents yet another approach for sociologically relevant photography, and suggests yet other meanings for the words "document" and "art."

Time and again photographers explore a subject over many years in a persistent manner that eventually chronicles both the physical and metaphysical nature of the subject or queries the logic of circumstance. The types of subjects treated by today's documentarians urge them into a state of unfinish and progression that plays out more dramatically and assertively in succession than in the idea of a single image. Documentary has proliferated from Robert Frank through the "new topographics"[12] and typologies,[13] and into the work of confessional documentarians who locate material in their own lives, their families, their heritage, and surroundings in a style that depends upon evocation as much as description, subjective interpretation and propaganda as much as fact. These photographs reflect an individual or cultural perspective and provoke, sometimes forcefully, new thinking. The subject matter and the realms of presentation are not without new challenge, however. Logistically and critically, photographers today face more threatening danger on the street; legal action on the rights of minors and privacy, and the portrayal of sexual behavior; disapproval with the photographer's exploitation of those outside his or her community; and a loss of control brought about by the digitization of photography and editorial purview. Punctuated by the new modes of working and the factors that bear on the process, the medium's history of manipulation and the various imagemakers' viewpoints emphasize that all photographs may be "truths told slant."

Photography and science  The paradoxical proliferation of simultaneous exhibitions continues of late with museums, art centers, and galleries across the United States presenting exhibitions on various aspects of photography and science. During 1997–98 alone, more than five different shows originated at The Ansel Adams Center for Photography in San Francisco, the International Center of Photography in New York, the Saint Louis Art Museum, and the Santa Barbara Museum

25   Dawoud Bey

**Sharmaine, Vicente, Joseph, Andre, and Charlie**, 1993
three internal dye-diffusion transfer prints
26½ x 22 inches each
Gift of the artist

Dawoud Bey is interested in using the portrait as a site of psychological and emotional engagement while expanding his own formal language of making photographs. The multiple panels of Bey's signature style, evident in this 1993 triptych, allow him to capture momentary changes in expression, fleeting gestures, and the subtle articu-lations of personality. His 1993 residency at Columbia College Chicago was part of a specialized educational outreach program of The Museum of Contemporary Photography, and enabled Bey to engage with Chicago's urban youth through a recip-rocal relationship between artist and subject.

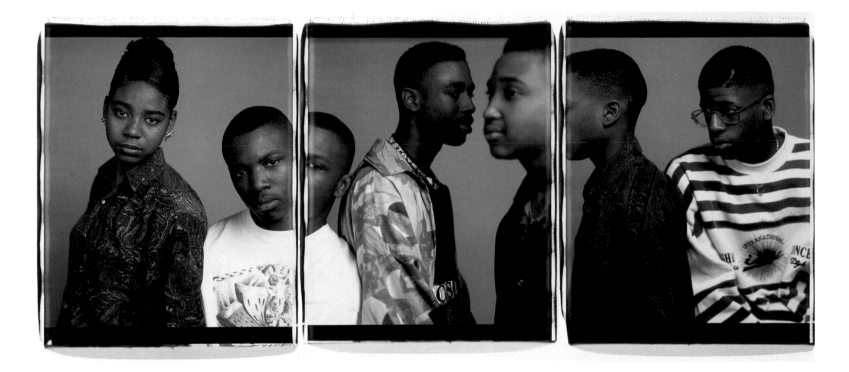

26  Carrie Mae Weems
**Untitled #2450**, 1990
three silver gelatin prints
26 ⅝ x 26 ⅝ inches each
Museum purchase

A simple kitchen table and an overhead lamp serve as the setting for the mother-daughter drama played out in Carrie Mae Weems's untitled triptych. Weems, known for her often biting use of humor to explore and explode stereotypes, employs narrative structures and a Minimalist choreography of props and characters. The resulting artwork offers a glimpse of the psychology and emotion of relationships, race, and gender.

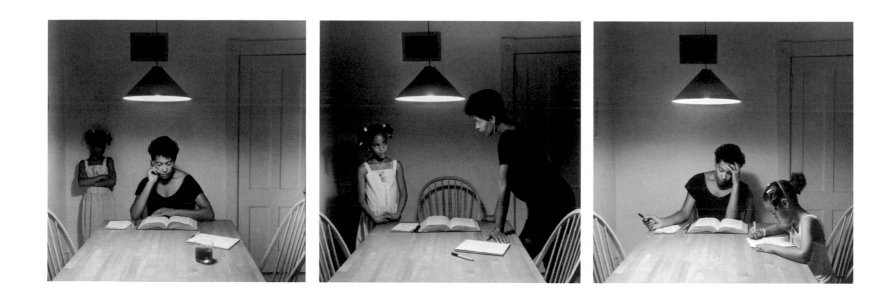

of Art in the United States, and the Musée des Beaux-Arts du Canada, Ottawa.

In April 1997 The Museum of Contemporary Photography opened "Scientia Artifex," which included the work of seventeen contemporary American photographers ranging from reprinted turn-of-the-century astronomical glass plates to digitally scanned NASA images of the moon's surface, microscopic botanical and entomological specimens to projections of the central nervous and musculoskeletal systems, close-ups of events in the reproductive and sustenance chains of life to visual interpretations of chaos theory, genetic engineering, and DNA. For this show the museum commissioned Todd Watts's installation Passenger Pigeon [see Peat, plate 13] and acquired a number of additional works: a portfolio of Berenice Abbott's depictions of various principles of physics originally created for an MIT textbook, Harold Edgerton's stroboscopic freeze of the action of an athlete, Alice Hargrave's abstractions and equivalences of the body's fluids and organs created from the tools of medical imaging, Susan Rankaitis's DNA #10, and Catherine Wagner's refined composition of laboratory instruments and tests [see back cover and Peat, plates 1, 7–9, and 12].

**Art + idea**
**Miller**

Both artists and scientists emphasize the roles of creativity and intuition in solving problems; although scientists necessarily give primacy to logic and evidence, they as much as artists rely on insight, analogy, and perception. Throughout the history of the medium, photographers have appropriated, aestheticized, documented, and reexamined scientific information based upon life, the body, the environment, and technology. In the simplest reading, their works reflect various branches of science: anatomy, astronomy, biology, botany, chemistry, geology, mathematics, microbiology, physics, physiology, and zoology. In broad scope, they pose larger questions about evolution, physicality and degeneration, the speed of technological advancements, and man's existential position within the universe.

In 1939 Berenice Abbott wrote: "There needs to be a friendly interpreter between science and the layman. I believe that photography can be this spokesman, as no other form of expression can be; for photography, the art of our time, the mechanical, scientific medium which matches the pace and character of our era, is attuned to the function. There is essentially unity between photography, sci-

ence's child, and science, the parent."[14] It was a call to arms for artists as recorders because science needed a means to communicate with people in terms they could understand. Abbott noted appropriately, "They can understand photography preeminently."

Itself a scientific process and the result of scientific investigation, photography not only changed the capacity for representing the world, it profoundly influenced art as well. Those individuals involved with photography's invention were scientists of some note: William Henry Fox Talbot, an inventor; Louis-Jacques-Mandé Daguerre, a mathematician who published papers on optical themes; and François-Jean Arago, a proficient astronomer and physicist. These men appreciated how their inventions could dramatically affect modes of representation; their discoveries, in fact, resulted in new and unusual forms of interaction between artists and science. Photographs that graphically reflect a principle or theory enlighten viewers. With their striking detail, commanding purpose, and individualized sensibility, photographs of scientific phenomena can also be regarded as art.

From light·time·focus to the digital moment   Essentially photography began, as Talbot referred to it, as a pencil of nature, based on fundamental principles of perception: light, time, focus. The camera as an artificial device utilizes these elements to mimic the process of natural vision: the aperture or camera-eye allows light to enter; the shutter regulates the time of exposure; the focus is controlled by adjustments of the lens. Instead of having an image formed in the brain, the image is registered via mechanical and chemical processes onto film or paper, or other surfaces treated with emulsion. Moholy-Nagy, the guiding force behind The New Bauhaus, wrote of eight varieties of photographic vision, emphasizing its character as a scientific technique.[15] This optical, physical, and chemical process has become the vehicle for indelible contemporary images.

Through the way the camera sees and records, and by way of cameraless approaches of photograms or light graphics, collage, and montage [see plate 31], the medium's practitioners explore the very essence of visuality and perception. Tersely orchestrating their pictures, many contemporary photographers explore the relationship between abstraction and representation, ambiguity in framing and composition, and the presence of light itself. Uta Barth, for example, shifts attention from a subject to the information one actually registers peripherally, but does not necessarily process until focused upon: the light in an out-of-focus foreground and edges of the field of vision [see plate 32]. Zeke Berman, by contrast, uses the background to emphasize meticulously ordered settings so lit at the edge that arrangements appear synchronously full yet pressed flat, grounded in a two-dimensional plane: photography as optical illusion and drawing [see plate 33]. Jeanne Dunning focuses so closely that disorientation sets viewers into thinking they are peering into dark caverns and looking

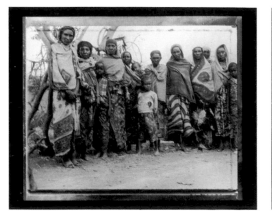 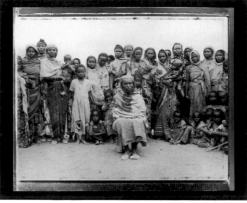 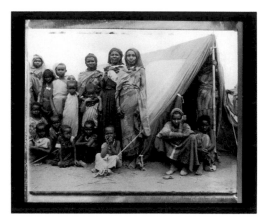

27 Fazal Sheikh
**Gabbra Matriarch, Seated
at Center, with Gabbra
Women and Children**, 1993
three tea-toned silver
gelatin prints
14 x 17 inches each
Museum purchase
© Fazal Sheikh, courtesy
PaceWildensteinMacGill,
New York

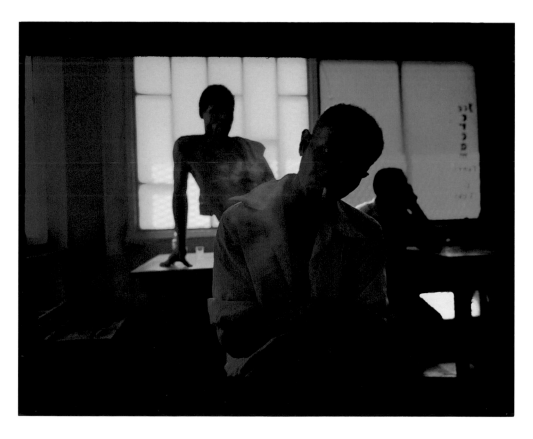

28 Alex Webb
**Grenada**, from the book **Hot
Light/Half-Made Worlds:
Photographs from the
Tropics** (1986), 1979
silver dye bleach
(from color positive) print
$12^{11}/_{16}$ x 19 inches
Museum purchase

27  Since 1992 Fazal Sheikh, the son of a Kenyan father and American mother, has documented individuals affected by governmental, tribal, and clan-based clashes in Ethiopia, Sudan, Somalia, and Mozambique. His portraits of refugees – from village elders to war widows and "unaccompanied minors" – do much to reveal his subject's individuality. **Gabbra Matriarch** reveals the ceremonial quality seen in most of Sheikh's portraits, which are created through time spent gaining the trust of the people he photographs.

28  Enthralled by the quality of light found in the Caribbean, Latin America, and Florida, Alex Webb has frequently photographed in these regions. The occasionally painful tone of his work is given a sensual edge through the vibrancy of color he achieves. In a small-town bar, Webb caught these men paused and staring, and they remained silent and unmoving while he photographed. **Grenada** is infused not only with color, but with a sense of heat and sadness.

29  When John Coplans began photographing his aging body as an anonymous headless form, he embarked on a documentation of age that is alternately humorous, reflective, and disquieting in the closeness of its observation. Seeing himself as an actor, Coplans examines various body parts closely, often quoting art historical postures with his sagging figure. **Self-Portrait, Three Times** is exemplary of his scrutinizing encounter with idealized expectations of the body and the self.

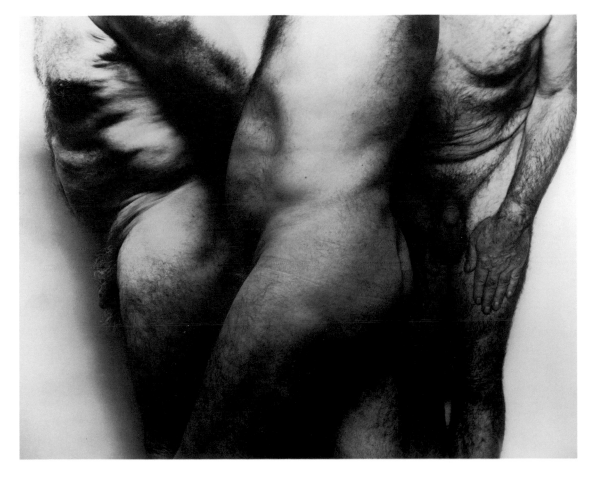

29  John Coplans
**Self-Portrait, Three Times**,
1987
silver gelatin print
24 7/16 x 30 3/4 inches
Museum purchase

30  John Gossage
**Checkpoint Charlie**
from the series
**The Illustrated Life
of Goethe** (1983–90), 1987
collage and silver gelatin print
20 x 16 inches
Gift of the artist

Berlin, a city filled with metaphor, was until recently divided by a powerfully visual reminder of its location in history and geography, the Berlin Wall. John Gossage began traveling to Berlin in 1981. His first body of work to emerge from his time there was **The Illustrated Life of Goethe**, which presents the city's recent past against the larger context of German history. The collage **Checkpoint Charlie** consists of the disparate elements Gossage utilized in this series: a photograph, a page from a 1915 biography of German author Johann Wolfgang von Goethe, and an ink tab used by German printers. In 1990 The Museum of Contemporary Photography presented Gossage's work in the exhibition "The Berlin Projects."

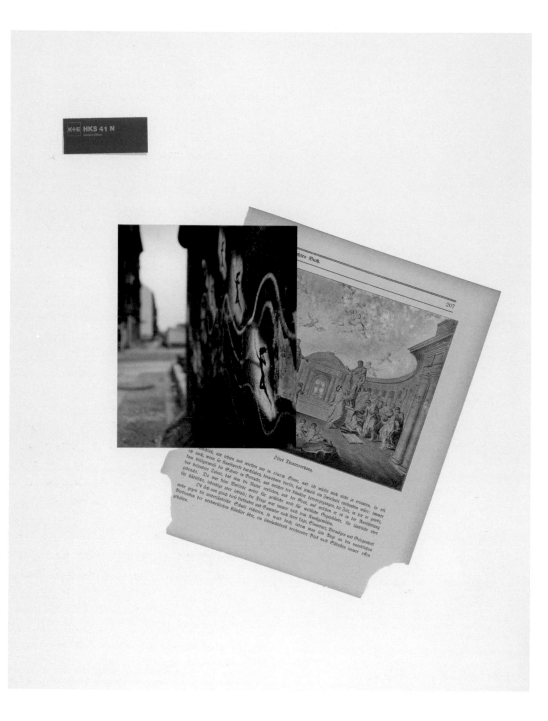

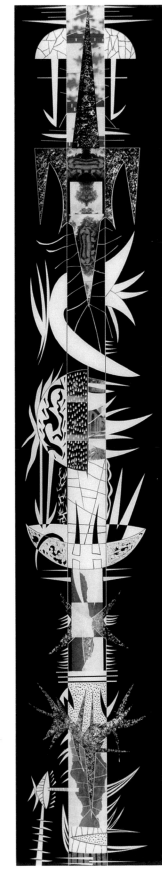

31  María Martínez-Cañas
**Totem Negro VIII**,
1991
silver gelatin print
53 1/2 x 9 1/2 inches
Museum purchase

María Martínez-Cañas
explores her relationship to
the land, religion, and his-
tory of her native Cuba
through highly charged col-
lages that echo Caribbean
rhythms. These images are
created by cutting intricate
designs into large sheets of
Amberlith, a masking mater-
ial, and carefully interweav-
ing the designs with other
negatives. The photographs
that result from these metic-
ulously crafted master neg-
atives show traces of
ancient and contemporary
symbolism.

over undulating hills and furrowed fields, when in fact they are in inti-
mate position with details of the body [see plate 34]. Artists such as
these reorganize the visual environment to create a new order, push-
ing reality and illusion by disjunctive associations. They have done so
largely with the techniques and processes inherent to photography
and the position of the lens.

Digital imaging presents both new opportunities for
imagemakers and a challenge to the medium. Computers and software
packages can carry out imperceptible alterations, combinations, and
distortions once laboriously completed inside the camera and the
darkroom. This factor has created panic for some, particularly with the
loss of jobs in photographically related industries, but perhaps more
critically in the potential for conversion in images for printing news
(already documented most notably in the journals National Geographic,
Time, Mirabella, and tabloid newspapers, and critiqued vigorously).

Digital imaging has essentially transformed photography,
and therein represents a transformation in the nature of visuality.
Electronic imaging is increasingly used in science and technology, in
the commercial and industrial sectors, and now extensively in formal
photographic education. The distinction between practitioner and
expert, technician and artist, however, is presently broad. Even the
most conceptually and aesthetically interesting works made today by
digital technology – by such American and US-resident artists as Aziz+
Cucher [see plate 35], Paul Berger, Nancy Burson [see Peat, plate 14],
Keith Cottingham, Robbert Flick, Doug Hall, Lynn Hershman, Martina
Lopez, MANUAL [see Peat, plate 4], Pedro Meyer, and Esther Parada,
to name a few – still imitate photography (utilizing photographic data
as input or photographic-looking objects as output).

As the linguist Marshall McLuhan observed, media is an
extension of media, but technology creates an aesthetic. Until artists
are more interested in what technology can be than in the technology
itself, the aesthetic does not advance. Throughout history, technologi-
cal advances and artistic innovation have gone hand in hand. Plays
beget films, photography begets digital; however, while the technical-
ities and technologies of plays, films, and photography have evolved an
aesthetic, digital has not done so completely; hence, this branch of
photography (some would argue it has yet to be fully articulated and
separately identified as a medium) currently relies heavily on a photo-
graphic presence.

Contemporary art by nature breaks down hierarchies with
a fluid embrace of the newest technologies. Museum audiences for
such art are also changing. There is a continuing democratization at all
levels: in the production of art, its interpretation, and its presentation
(even audience member from observer to interactive participant). The
Museum of Contemporary Photography is interested in the breakdown
of such hierarchies and the potential in digital and electronic imaging.
With the advent of digitization, the rise of "image" looms large. With-
out the camera, you have photograms. Without photographic paper,

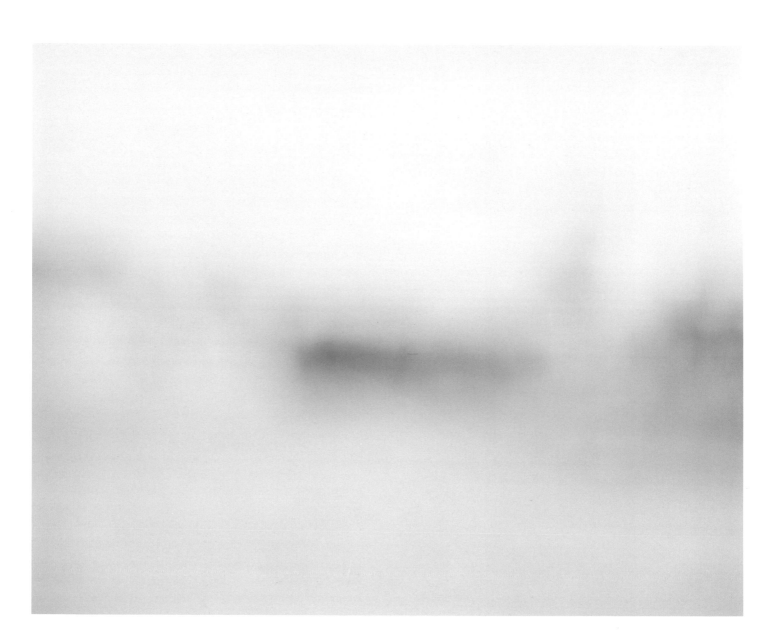

32 Uta Barth
**Field #13**, 1996
chromogenic development
(from color negative) print
22 7/8 x 28 1/16 inches
Museum purchase
© Uta Barth, courtesy
Bonakdar Jancou Gallery,
New York and ACME,
Los Angeles

Drawing attention to the
activity of seeing, Uta Barth
focuses her camera on an
absent subject. In vaguely
identifiable images, she
captures only the blurred
information of the
background. The resulting
photographs are evocative,

atmospheric, and indicative
of an intriguing relationship
between abstraction and
representation. Intuitive as
well as conceptual, works
such as **Field #13** explore
innovative mechanisms of
composition.

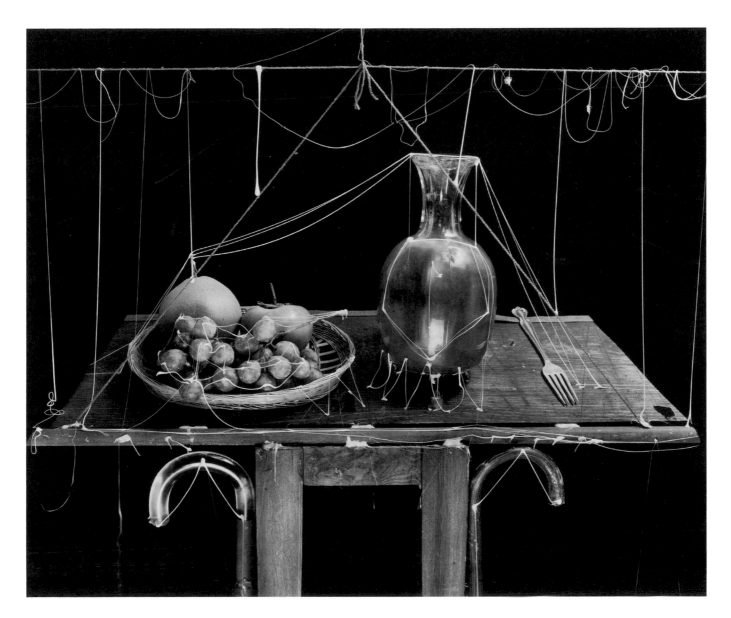

33  Zeke Berman
**Untitled (Fruit Basket)**,
1984
silver gelatin print
26 x 32 inches
Gift of Catherine Edelman
Gallery, Chicago

Zeke Berman's background as a sculptor is evident in his painstakingly fabricated arrangements for the camera. The resulting photographs, illusionistic still lifes, reflect Berman's engagement with the play of dimensionality and the structure of vision. Articulating the difference between what is seen by the eye and what is seen by the camera, **Untitled (Fruit Basket)** is an example of Berman's exercises in imagination and perception.

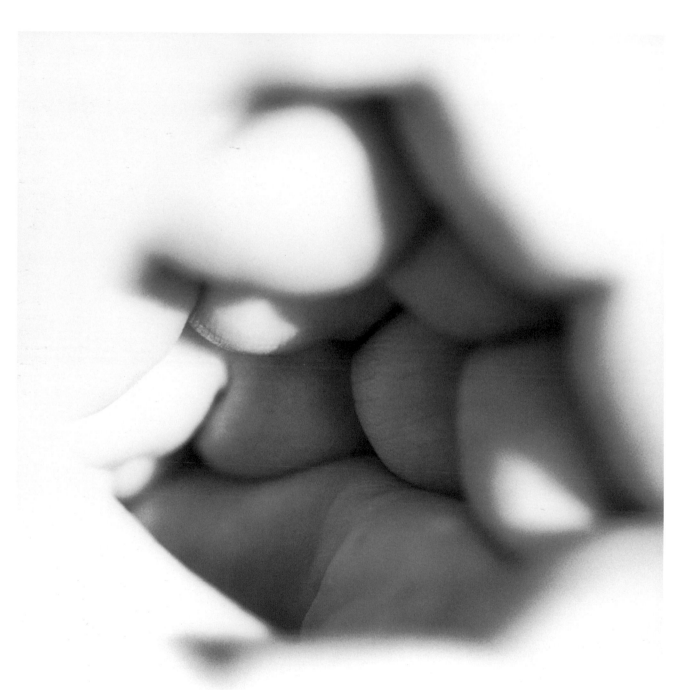

34  Jeanne Dunning
**Hand Hole**, 1994
silver dye bleach
(from color positive) print
25¼ x 23 inches
Museum purchase

Jeanne Dunning finds photo-graphic ambiguity in close-up perspectives of the body. By focusing tightly on nostrils, hands, hair, and other parts of the human form, she shapes warmly toned suggestions of landscapes such as **Hand Hole.** Elegant, erogenous, and mildly threatening, Dun-ning's photographs offer an intimate confusion of object, place, and scale.

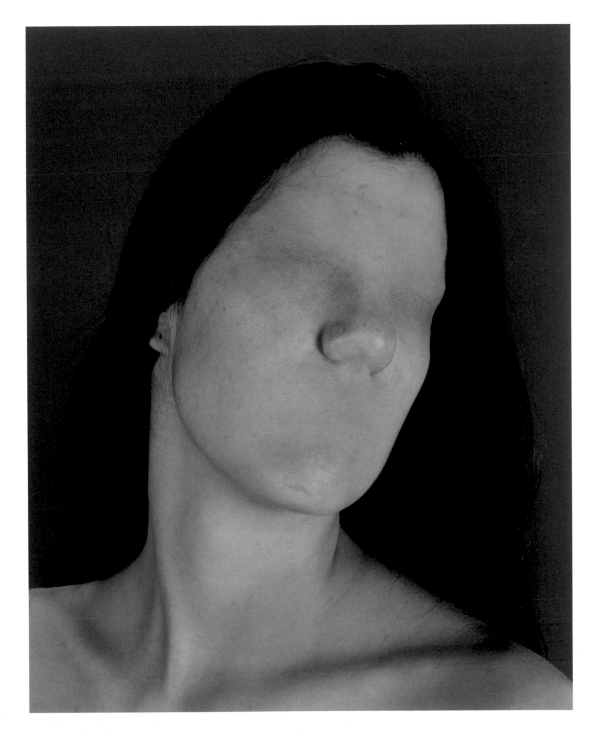

35  Aziz + Cucher
(Anthony Aziz and Sammy
Cucher)
**Maria**, 1994
digitized chromogenic
development (from color
negative) print
50 x 40 inches
Museum purchase

The large-format photographs
of the collaborative team
Aziz + Cucher present hermet-
ically sealed bodies and faces.
Using computer software, the
artists remove human features
while meticulously creating a
painterly illusion of depth and
volume where there used to
be eyes, mouth, and ears.
Disturbingly mute, **Maria** is an
eerie indicator of a meeting of
identity and technology,
undermining the familiar
genre of photographic por-
traiture as well.

you have a printout of an optical mechanical nature. Without this printout, you get electronic montage, photographic resolution animation, web sites, and new public spaces – cyberspaces, virtual worlds. But even these virtual worlds are the realm of the photographic image. Over the course of the history of photography, viewers have come to accept the image of photography (and film) as reality, but also have come to understand that this reality has always been subject to manipulation.

**Art + idea
Miller**

The Museum of Contemporary Photography actively collects contemporary American and US-resident photographs, photographic objects, and installations because it recognizes the value of the emotional and intellectual commitment involved in studying the works up close to obtain a critical strategy for understanding the world. It actually takes a long time to see a work of art, to appreciate the fullness, the richness, the subtlety, its sensuousness, rhetoric, politics, irony, metaphor, wryness, sweetness. Long looking and lots of glances are rewarding. A multiplication of interpretations ensues from concentration, conflict over observation, questions, criticism, clarifications, resolutions or even more indecision, not unlike the maker's working process. Today photography is still about decision in the decisive moment, but new and different determinations can be made on the production of that moment. The museum is interested in an expansive approach to photography in its four roles as art, document, market, and science, as well as the future prospects of digital imaging. Most importantly in these guises, the museum is interested in provocative vision: photography as art and idea. In 1969 Walker Evans wrote:

The meaning of quality in photography's best pictures lies written in the language of vision. That language is learned by chance, not system; and, in the Western world, it seems to have to be an outside chance. Our overwhelming formal education deals in words, mathematical figures, and methods of rational thought, not in images. This may be a form of conspiracy that promises artificial blindness. It certainly is that to a learning child. It is this very blindness that photography attacks, blindness that is ignorance of real seeing and is perversion of seeing. It is reality that photography reaches toward. The blind are not totally blind. Reality is not totally real.[16]

1 **Les Américains**, text selected and edited by Alain Bosquet (Paris: Robert Delpire, 1958). Reprinted as **Gli Americani**, with text selected and edited by Alain Bosquet and Raffaele Crovi (Milan: Il Saggiatore, 1959). Reprinted as **The Americans**, with an introduction by Jack Kerouac (New York: Grove Press, 1959). Revised and enlarged edition, New York: An Aperture Book, The Museum of Modern Art Edition, 1968. Revised edition, Millerton, New York: An Aperture Monograph, 1978. Reprinted, New York: Pantheon Press, 1986. Reprinted, Zurich, SCALO, in association with the National Gallery of Art, Washington, DC, 1993.

2 "Photography's Transgressive Authority: Alfredo Jaar and the Postmodern Crisis of Politics and Belief," a public lecture by Peter Bacon Hales, professor and university scholar, History of Art Department, University of Illinois at Chicago, October 19, 1995 at The Museum of Contemporary Photography, Columbia College Chicago.

3 The exhibition "Real Pictures: An Installation by Alfredo Jaar" was presented by The Museum of Contemporary Photography from January 28 through March 25, 1995.

4 Alan Artner, "Photographic Memory," **Chicago Tribune**, May 18, 1997, sec. 7, p. 13.

5 Anne Wilkes Tucker, **Unknown Territory: Photographs by Ray K. Metzker** (New York: Aperture and The Museum of Fine Arts, Houston, 1984), inside jacket cover.

6 See, among others, **The Art of Memory/The Loss of History**, essays by William Olander and Abigail Solomon Godeau (New York: The New Museum, 1985); A.D. Coleman, **Light Readings: A Photography Critic's Writings 1968–1978** (New York: Oxford University Press, 1979); **Contemporary Trends**, essays by Van Deren Coke, A.D. Coleman, and Bill Jay (Chicago: Center for Contemporary Photography of Columbia College, 1976); Arnold Gassen, **A Chronology of Photography: A Critical Survey of the History of Photography as a Medium of Art** (Athens, Ohio: Arnold Gassen Handbook Company, 1972); Kathleen McCarthy Gauss, **New American Photography** (Los Angeles: Los Angeles County Museum of Art, 1982); **Grids: Format and Image in 20th Century Art**, with an essay by Rosalind Krauss (New York: Pace Gallery, 1978); Rosalind Krauss, **The Originality of the Avant-Garde and Other Modernist Myths** (Cambridge, Massachusetts: MIT Press, 1985); Nathan Lyons, **Contemporary Photographers: Toward a Social Landscape** (New York: Horizon Press, and Rochester, New York: George Eastman House, 1966); Aaron Scharf, **Art and Photography** (Baltimore: Penguin, 1969); Peter C. Bunnell, "Photographs as Sculpture and Prints," **Art in America**, Sept./Oct. 1969, pp. 56–57 and 60–61; and Abigail Solomon-Godeau, "Winning the Game When the Rules Have Been Changed: Art Photography and Post-Modernism," and Christopher Burnett, "Photography, Postmodernism, Contradictions," in **New Mexico Studies in the Fine Arts** 8 (1983), pp. 5–13 and 21–27.

7 Andy Grundberg and Kathleen McCarthy Gauss, **Photography and Art: Interactions Since 1946** (New York: Abbeville Press with the Museum of Art, Fort Lauderdale and Los Angeles Country Museum of Art, 1987).

8 Robert Frank, quoted in Ben Maddow, **Faces: A Narrative History of the Portrait in Photography** (Boston: New York Graphics Society by Little Brown, 1979), p. 527.

9 **Philip-Lorca diCorcia: Streetwork 1993–1997**, with an essay by José Luis Brea and reflections by Philip-Lorca diCorcia, trans. Ann Barr (Salamanca: Ediciones Universidad de Salmanca, 1998), pp. 12–13.

10 **Keith Carter Photographs: Twenty-Five Years**, with an introduction by A.D. Coleman (Austin: University of Texas Press, 1997), book jacket cover.

11 The exhibition "Raised by Wolves: Photographs and Documents of Runaways by Jim Goldberg" was organized for tour by the artist with Philip Brookman, curator of photography and media art at the Corcoran Gallery of Art, Washington, DC, and Jock Reynolds, director of the Addison Gallery of American Art, Phillips Academy, Andover, Massachusetts. It is accompanied by a book of the same title published by Scalo, Zurich in 1995.

12 Topographics is a term coined in 1975 by William Jenkins, who organized the exhibition "New Topographics: Photographs of a Man-Altered Landscape" at George Eastman House, and refers to the photographers' pictorial commentary on human intervention in nature without emotional shading. Their style called for viewers to exercise their own discernment and to treat pictures as if they were of evidence still to be sorted. The photographers included Robert Adams (see Parry, plate 9), Lewis Baltz, Frank Gohlke (see Rosenblum, plate 15 and Peat, plate 18), Roger Mertin, and Stephen Shore, among others.

13 Typologies are a series of uninflected images of objects of the same sort that are arranged in arbitrary sequence that also avoids personal commentary about the subject matter at hand. Typology is reflected in the work of such artists as Edward Ruscha, the German photographers Thomas Struth and Bernd and Hilla Becher, and the Canadian-American Lynne Cohen (see Peat, plate 10).

14 **Berenice Abbott: A Modern Vision**, ed. Julia Van Haaften (New York: The New York Public Library, 1989), p. 58.

15 "The Eight Varieties of Photographic Vision. 1. Abstract seeing by means of direct records of forms produced by light: the photogram which captures the most delicate gradations of light values, both chiaroscuro and coloured. 2. Exact seeing by means of the normal fixation of the appearance of things: reportage. 3. Rapid seeing by means of the fixation of movements in the shortest possible time: snapshots. 4. Slow seeing by means of the fixation of movements spread over a period of time: e.g., the luminous tracks made by the headlights of motor cars passing along a road at night: prolonged time exposures. 5. Intensified seeing by means of: a) micro-photography; b) filter-photography, which, by variation of the chemical composition of the sensitised surface, permits photographic potentialities to be augmented in various ways – ranging from the revelation of far-distant landscapes veiled in haze or fog to exposures in complete darkness: infra-red photography. 6. Penetrative seeing by means of X-rays: radiography. 7. Simultaneous seeing by means of transparent superimposition: the future process of automatic photomontage. 8. Distorted seeing: optical jokes that can be automatically produced by: a) exposure through a lens fitted with prisms, and the device of reflecting mirrors; or b) mechanical and chemical manipulation of the negative after exposure." From László Moholy-Nagy, "A New Instrument of Vision" (1932), excerpted in **The Art of Photography 1839–1989** (New Haven and London: Yale University Press with The Museum of Fine Arts, Houston; Australian National Gallery, Canberra; and Royal Academy of Arts, London, 1989), p. 231. Extract from **Telehor** 1, 2 (1936).

16 Extract from **Quality: Its Image in the Arts**, ed. L. Kronenberger (New York: Atheneum, 1969).

EUGENIA PARRY

# A HUNDRED
# DIFFERENT
# STORIES

## THE ART
## OF PHOTOGRAPHY

...what a good picture does is demand your
attention.... You try to bring as much of
yourself to it as you can. In the course of a
lifetime you might make up a hundred
different stories about the same picture, all
of which are indefensible but each of which
is a kind of compliment.... Pictures ...
attract to themselves wonderful rich bodies
of speculation and superstition and fairy tale
that, for better or worse, are part of what
we're going to do to things that interest us.

John Szarkowski[1]

1  Aaron Siskind
*Untitled #56* from *Pleasures
and Terrors of Levitation*
(1954–65), 1956
silver gelatin print
9 ⅞ x 9 ⅞ inches
Museum purchase
© The Aaron Siskind
Foundation, courtesy
Robert Mann Gallery,
New York

See page 82 for extended
caption

# BOY ALOFT

## AS THE LETTER

# Z

My grandfather and his handlebar mustache came from Greece to Chicago for the 1893 World's Fair. He saw opportunities and stayed. He could hardly read or write. He terrorized his wife and children. He'd make them get up in the middle of the night to spade the garden. Because he felt like it. He saved the money he made selling fruit from a cart on Randolph Street and built his house on the South Side, right on Lake Michigan. The lake was a leaden band he could see from every window. Cold, indifferent, it stayed where he could keep an eye on it.

But at night, while he slept, it rose up and crept across his lawn, drowning his flower beds, warping his peach trees so their fruit tasted like stones, outraging him when he discovered it had climbed the stairs from the basement into the kitchen. The lake was a calculating enemy manipulating his brain. He built a large cement wall to keep it from devouring him.

In winter the waves of the lake froze in mid-air forming a colossal ice palace on his lawn. He stood like an arctic fisherman and had himself photographed: defiant exclamation point against the ferocious peaks. In spring when the palace melted, frightening fissures appeared in the wall. The lake's secret work. Every spring for thirty years the old man hunted the terrible cracks and plugged them with cinder blocks and fresh cement.

In summer he chased away trespassers, gangs of boys, who used his wall as a place from which to dive into the cold lake. He ordered his sons to drive them out with rakes and shovels. But the boys leapt into the air before the sons got near them. The mighty lake was nothing next to these lewd acrobats. He stared out his dining room window, hating their deftness at escaping him and his minions.

He wondered if the boys hadn't been sent to torment him by the defeated spirit of the lake. Their bodies against the sky unleashed unearthly powers. Divers, leapers made of wire, elastic, rubber, these twisted sky writers taunted him in messages from a crazy black-letter alphabet he didn't understand. One summer watching the boys from his armchair he had the stroke that killed him.

A Jewish photographer was in Jackson Park in Chicago in the 1950s, watching boys dive off the rocks into Lake Michigan. He pointed his twin-lens reflex toward the sky. He wasn't interested in local athletes. He didn't catch them falling like rebel angels. He let them write their bodies in scrolled black letters [plate 1].

I used to call this photographer affectionately, "Big A." He said his surname once meant Sweet Child, but his immigrant parents bungled it when they got to America. I asked why his pictures of signs and shadows, tar and paint and seaweed look like some kind of writing. He denied that they did.

It's a Jewish tradition, this iconoclasm, this abhorrence of representation. This veneration of the word, the book. You're not imitating modern drawing and painting, the way the critics say. You're a boundless seeker after script, I insisted. I know a Jewish photographer, he said, who saw swimmers in Pyramid Lake and made them disappear like travelers in the desert. That's not writing. It's Morse Code. OK. But look at the boys you photographed. In the air, they're an alphabet. Everything you photograph is. That's a crock, he tells me. My mother was illiterate.

# HEAVY
# BREATHING

In uptown Chicago, daylight enters through a window and joins the glow of a tilting table lamp [plate 2]. A boy has his arm around a girl. Pounding blood makes wavy patterns in his shirt. His face bumps hers. Pure instinct. Her head is a helmet of curlers. He's interrupted her private vanities in the cluttered room.

Rude valentine of desire, expectation, and fear, their back-seat kiss is an event for the girl. She yields, but her body is hard and stiff: her arm a right angle, her knees an anatomy lesson. She receives the boy's crude kiss with these gestures, grateful to be saved from starvation. All the while she diddles herself, twisting a ring on her marriage finger. Another girl, cocooned in the hum of a hair dryer, acts like she's not there but somewhere else. Jesus Christ on the wall is also absent, enthralled by rays of celestial light.

The photograph configures different kinds of breathing. The pulsing boy, gasping girl, the steady drone of the hair dryer, God as a gust of radiance. The lovemaking couple seems alone, but for an audience of one: the photographer-voyeur. Maybe he arrived with the boy. Or he's a friend of the girls. It doesn't matter.

He frames this makeshift beauty shop as a concoction of adolescent puppets and cheap bric-a-brac. In doing so, you can feel the presence of his breath. Slow and sexual, it's concentrated not in his groin but in his eye and finger pressing the shutter. Audible over the hair dryer, over the click of his machine, over the murmurings of the couple, the photographer's warm steady panting is the picture's heartbeat, its real subject.

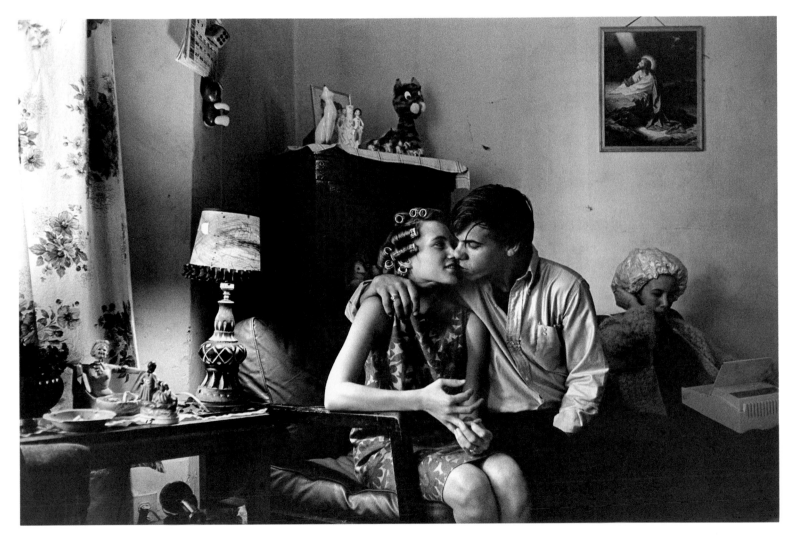

2   Danny Lyon                        © Danny Lyon, courtesy
    *Uptown, Chicago* from           Magnum Photos,
    the portfolio *Danny Lyon*       New York
    (1979), 1965                     See page 82 for extended
    silver gelatin print             caption
    8 ¾ x 13 inches
    Museum purchase

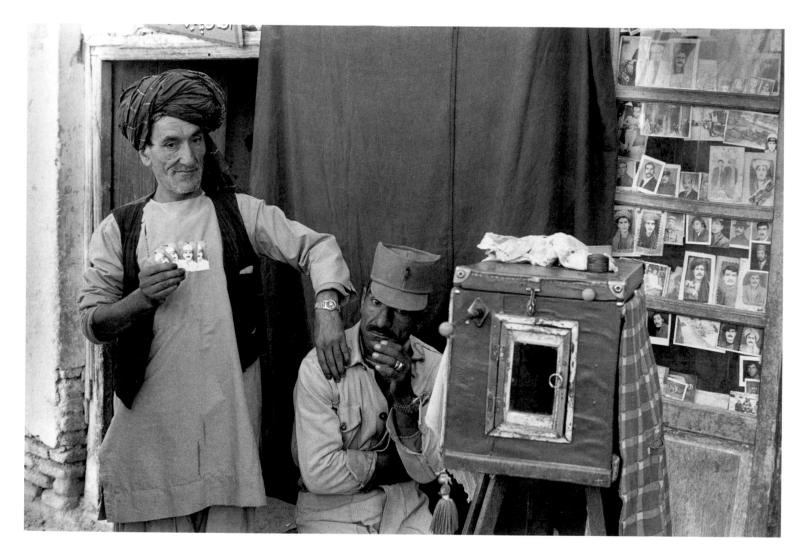

3  Elliott Erwitt
   *Herat, Afghanistan* from
   the portfolio
   *Recent Developments*
   (1978), 1977
   silver gelatin print
   8 x 12 inches
   Gift of Fred Stein
   See page 82 for extended
   caption

**Don't run around this world**
**looking for a hole to hide in.**
**There are wild beasts in *every* cave!**
**If you live with mice,**
**the cat claws will find you. . . .**

Photography doesn't belong in this world. Yet here it is. Some government came in and told the people: you must carry your picture with your papers so we'll know you exist.

**Live in the nowhere that you came from,**
**Even though you have an address here.**

But how? The forces of modern change are so great. These sons of Mohammed know they only really exist under the all-seeing eye of Allah. Before the American came along and raped them with his camera, they'd already joined the evil picture makers. Their postures are a perfect diagram of the fact.

The thirteenth-century poet Rumi, born in Afghanistan, cultivated this fitful condition. It had nothing to do with photography, of course, but with the perils of the soul:

**Live in the nowhere that you came from,**
**Even though you have an address here.**
**You have eyes that see from that nowhere,**
**and eyes that judge distances,**
**how high how low.**

**You own two shops,**
**and you run back and forth.**

**Try to close the one that's a fearful trap,**
**getting always smaller. . . .**

**Think that you're gliding out from the face of a cliff**
**like an eagle. Think you're walking**
**like a tiger walks by himself in the forest.**
**You're most handsome when you're after food.**

As glorious beasts, we're transcendent. Mere pictures of our faces only diminish us. "Spend less time with nightingales and peacocks," Rumi concluded. "One is just a voice, the other just a color."[5]

Perhaps the peacock in the turban is the photographer. He dominates the frame. But he panics, grabbing the shoulder of the seated man, as if to say to Allah's firing squad: "Punish us both!"

Something about these two men in Afghanistan looks squirrelly [plate 3]. They let the American photographer snap their picture, but in the moment of getting caught, their faces become portraits of their churning stomachs. Did the photographer see this discomfort, or was he simply happy to have discovered on his travels other professionals like himself? Impossible to tell.

Poets love these vague borders of feeling. "The moment bumbles against the infinite and dies of its self inflicted wounds," wrote Edmond Jabès,[2] pondering our negligible power against that of God. One of the men is a photographer who works the street. His big view camera is an important third party in the framed group. His wares, shelves of miniature portrait heads, create a blurred pictorial text, patent advertisement of transgression against the sacred tenets of Islam.

**"We are vile blasphemers," wrote a sage.**
**"We cynically interpolate into the Book of**
**God ever larger fragments of our own works."[3]**

The photographer has caught them at it. From a culture of the book he's extracted puzzled faces. The picture feels, at first, like a tourist's clever parting shot, but the men's "wrinkles...are not creases of skin, but perhaps lines of words in the last stage of being erased, when nothing can be read anymore."[4] Does the camera belong to the seated one? If so, he doesn't want us to know. His visor barely hides his eyes. With a hand on his mouth he looks perplexed, ashamed. Is the one in the turban the customer? He displays a photograph. Maybe of himself. He seems to look directly at the lens, but his restless eyes betray discomfort.

PARRY
ART

# CAT CLAWS

WILL FIND

# YOU

4 Abelardo Morell
*Pietà by El Greco*, 1993
silver gelatin print
17 3/4 x 22 3/8 inches
Museum purchase
See page 82 for extended
caption

# SPLIT OFF

## FROM THE

## COMMON TONGUE

The book in this picture is an open invitation [plate 4]. But there is nothing to read, and little to examine on its pages. Only shimmering gray light glares back, as when you look at a daguerreotype for the stern portrait fixed on the mirror and end up with your own perplexed face.

The photographer's image is recent, but its intention is older than photography. Old as the gods. The nothingness it proclaims is a meditation on origins: "Grey was the universe in its beginning."[6]

**Who among us will be able to describe what we know we have seen hidden in smoke? What calls out with its deep, haunting presence, yet stubbornly beats back our eyes?**[7]

The photographer wants us not to read this book, but to feel magic around every corner. Daguerreotypists knew about the haunting alchemy of silver reflections. But when this photographer spoke of magic he was thinking of mystics, like Meister Eckhart who was confident when he snapped a twig in the woods that Jesus would appear.[8]

The photographer once studied comparative religions. He makes the open book a watery pool to study what is "*gradually being written*,"[9] a form of revelation. His book could be called the Book of Mirrors or the Book of Water, which film director Peter Greenaway invented as being among the twenty-four books Shakespeare had Prospero, Duke of Milan, take from his library into hasty exile in *The Tempest*. As Prospero departed, Gonzalo threw the books into his leaky vessel. They were to instruct, to summon storms that would bring down the duke's enemies.

We might call the photographer's gleaming book the Book of Exile. Its pages feel like a body of water that beckons us to make the crossing: "Being a Cuban in Maine...seemed pretty strange, and although I wanted to fit in it wasn't easy because I felt isolated and scared....My parents never talked about how unreal it was coming to this country. As difficult as it was, the idea was to survive."[10] Prospero's power was in his books.

**Me. poor man, my library
Was dukedom large enough.**[11]

The photographer's library is as well.

In the film *Prospero's Books*, Greenaway gave the Book of Mirrors silvered pages. Some coated with mercury, he cautioned, would require special handling. Greenaway imagined they might reflect the

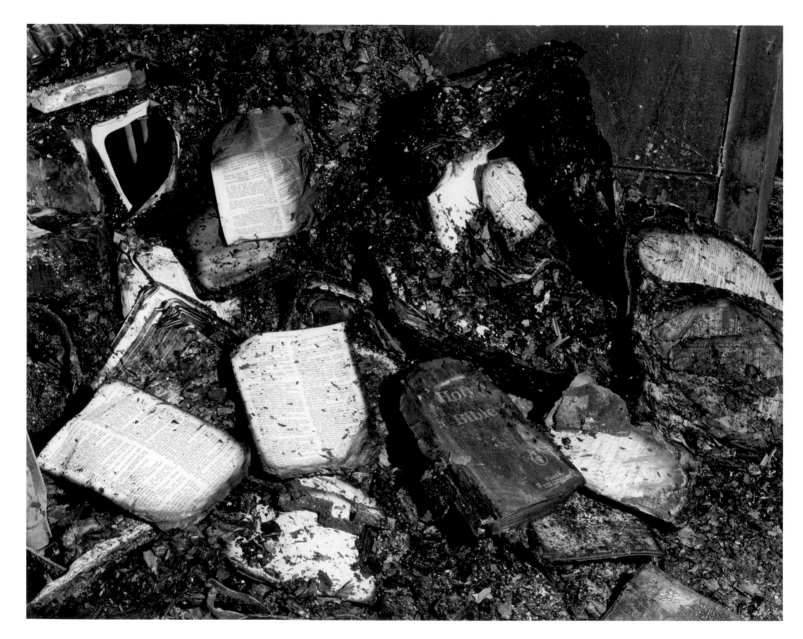

5  Margaret Stratton
   *Bibles*, 1995
   silver gelatin print
   28 $^1/_4$ x 36 inches
   Gift of the artist
   See page 82 for extended
   caption

When he boiled liquid in a frying pan it separated to form an effect of two facing pages – an Exile's Book of Whirlpools?[16] Did he think such roiling text would instruct him on his life's journey? Are we what we read? Or are we what we will not or cannot read?

We think of photographers as image guardians. But from the start they appointed themselves keepers of language. Talbot, one of the first photographers, was a linguist. Documenting his library shelves he made a self-portrait. The Cuban photographer's books share the same impulse. Rapt in studies of fluid light, he conjures dreams and wishes.

The photographer shot an open tome to look like a pyramid. He called it *Dictionary*. We shall call it the Book of Obstacles. He photographed Piranesi's etchings of Roman antiquities, *Le Antichità Romane*, and *Diversi Ornati Di Pompeia* showing a horseman. Books of Destiny? Another book shows Goya's *Naked Maja* enjoying her own image reflected on the opposite page like a mirror of Vanitas – Book of Just Deserts? The photographer is Prospero, whether he knows it or not.

When opened, Greenaway had Prospero's Primer of the Small Stars "twinkle with traveling planets, flashing meteors and spinning comets."[17] The photographer's own *Book of Stars* evokes the calm of infinite space. Light-worms cauterize the pages – Book of Wayward Souls. He photographed *The Boston Globe* rained on and dried out – Book of Cirrus Cloud Travel.

At the end of his film Greenaway had Prospero throw the Book of Mythologies into the sea. It scattered like a thousand white gulls. The Primer of the Small Stars exploded into a plume of smoke. The Book of Utopias became a fizz of bubbles.[18] Books as lost hopes. The notion has engaged more than one photographer. Margaret Stratton in 1994 was mesmerized by the charred remains of bibles which she framed to eliminate any feature of time or place [plate 5]. They were not her own books, but she made the burned pages a territory of something dark within herself.

The Cuban photographer of books never shows the means of their destruction. His alchemical volumes belong with the contents of the frying pan and other views he made of water overflowing pots, which evoke metaphysical landscapes. When he makes a distant, shadowy picture of himself, dominated in the foreground by his broken eyeglasses, is this also part of his story of interrupted reading? Let us consider it a page of an unfinished book, the Book of Photography Wondering about Itself.

reader: as he was three minutes previously; or how he might look in a year's time; or as a child, woman, monster, idea, a text, an angel. One mirrored page would lie constantly. Another would see the world backwards. Another upside down. One mirror would hold its reflections as frozen moments infinitely recalled. One would simply reflect another mirror across a page.[12] For Greenaway all of Prospero's imaginings would be in such terms. The terms of photography.

Here the photographer shows an art book. Among photographically reproduced paintings, he chooses El Greco's *Pietà*. "Someone important died in Christianity,"[13] he says, veiling El Greco's painted feeling, "paralyzing darkness" with "God's solar words.... Transparency, ah, there's the miracle."[14]

We shall call this photographer's book the Book of Mirages. El Greco's version of Christ's Passion, photographically reproduced, then rephotographed by the young Cuban, shows the holy fabric of light's reflection. "Framing and re-framing becomes like the text itself – a motif – reminding the viewer that it is all an illusion constantly fitted into a rectangle ...into a picture frame, a film frame."[15]

This Book of Mirages is not the photographer's only attempt at inventing a magical library.

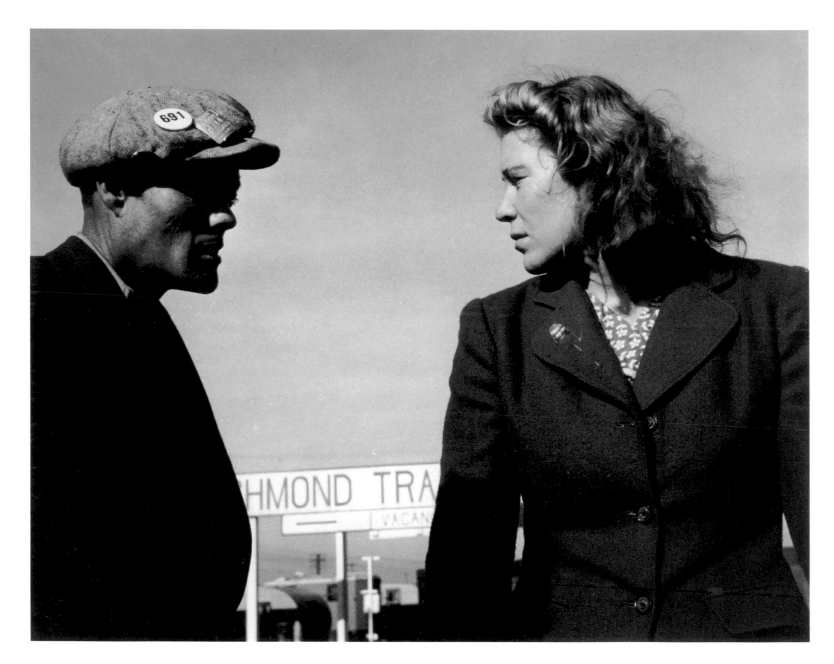

6  Dorothea Lange
   *Argument in a Trailer
   Camp, Richmond,
   California,* 1944
   silver gelatin print
   7 1/2 x 9 1/4 inches
   Gift of Katherine Taylor
   Loesch

© The Dorothea Lange
Collection, The Oakland
Museum of California,
City of Oakland,
Gift of Paul S. Taylor
See page 82 for extended
caption

7 Dorothea Lange
*San Francisco*, 1956
silver gelatin print
9 5/8 x 6 7/16 inches
Gift of Katherine
Taylor Loesch
© The Dorothea Lange
Collection, The Oakland
Museum of California,
City of Oakland,
Gift of Paul S. Taylor
See page 82 for extended
caption

PARRY
ART

# DON'T
# TOUCH
# ME

Craggy rock face, dry and harsh, split by a chasm of sky: a landscape that resembles a couple in a trailer park having a fight [plate 6]. The man is a raised cleaver. The woman a battering ram, leading with her shoulder, positioned squarely. Not in self-defense. She's secure. Determined not to lose. The space between their stand-off is a bold noise, a referee gloating over rageful silence.

A relative of mine in Chicago lives alone with many photographs. She acquired this one of the furious couple years ago. She couldn't explain its special attraction. But I remember when we were young she faithfully read a popular women's magazine for the column called "Can This Marriage Be Saved?" She had a hunger to study strangers wallowing in misery.

One day she confided that after twenty-five years with the same psychoanalyst, he was calling their sessions to a halt. She didn't know why. She hadn't the courage to ask him outright. He was mortally ill, or so he seemed to intimate. He's closing his office, she told me. He needs serious hospitalization.

After some time, I asked what finally happened to her doctor. Is he dead or alive? I don't know,

she said. Don't you want to find out? She positioned herself, beautiful, fierce, like the woman in the parking lot. Glaring at me, she said, You have a lot of anger, don't you? I see it in your twisted face. She's a dirty fighter, I told myself. I implored her to find out what had happened to the psychiatrist. I can't just call, she said. She needs to cling to the void. Have your sister call. After twenty-five years, he knows you better than your own family. Don't you want to know him?

Did you call? I inquired weeks later. My sister did, she said. And what did she find out? He's still practicing. She looks again like the woman in the parking lot. There's nothing wrong with him. He's seeing patients as usual. That's what his receptionist said. Her glance punishes me, as if I'd crushed the shell of her pet snail.

She has other photographs by Dorothea Lange in her collection. One called *San Francisco* shows a headless man in a dark overcoat stepping off a trolley [plate 7]. Not into the street. There is no visible place for him to step. He's dropping off the edge of a canyon into an abyss. The moment is one of supreme isolation. He steps with strange liberty into a world of no choices. Like him, my relative reserved the right to be alone with her images. She and I don't speak anymore.

8   Larry Clark
    *Untitled* from the portfolio
    *Tulsa* (1971), 1971
    silver gelatin print
    8 1/8 x 12 5/16 inches
    On extended loan from
    David C. and Sarajean
    Ruttenberg and the
    Ruttenberg Family
    Limited Partnership

© Larry Clark, courtesy
Luhring Augustine,
New York
See page 83 for extended
caption

# PRAYER

David Roper set his prayer down on dry leaves [plate 8]: "Police." He used a pencil. "Police (the ones that tore this house up.) 2/11/70" David Roper wrote on a flattened cardboard box. "If you Dick-Sucking Mother fuckers come back today..." He's dying for them to come back. He wants them to know "David Roper 2/12/71." To see his rage. To face the drama of his fervent wish. He strains to invent, with a bold scrawl, the most horrifying vision a poor white boy can think of.

"Don't get mad...." What he means is, **I**'m mad. **You**'ll never be as mad as **I** am right now. "Don't get mad if you find your Mother-Wife's inside...." Inside my house. Your Mother-Wife. You see, she got into my place. Don't ask how. She got there. Like you did. Your Mother-Wife. Your stay-at-home woman broke her chain and got loose. She's in my place you tore up.

David's ecstatic. How would you like that? Mother fuckers? How would you like to see your Mother-Wife, out of reach, plum out of control? Cuckolding you!... And you know who with? She's not sucking **your** dick, asshole. She's at **my** house. The one you tore up. That's where you'll find her. In my house..."sucking Nigger Dicks." You know. Those guys you beat the crap out of with your clubs. That's what she wants. And know what? Now she's got it!

David Roper set his prayer down on dry leaves. He gave it to the neighborhood. To the police. To the photographer who framed the fervently written, fantastic wish. In America 1971, no one knew much about how junkies grieved, except other junkies.[19]

He seeks out landscape and photographs it with trembling despair. To maintain "an affection for life" in "the modern disfigured world."[20] Those are the words he uses to explain why other photographers point their cameras at the fragile verdure. But really, he's talking about himself.

He's not satisfied to photograph. He feels compelled to write essays about photographic beauty "in defense of traditional values." One would think it wasn't necessary to explain again, the landscape photographer's decisions, but he does this as if he were the first to see the "individual framework of recollections and meditations" before nature that make a work "true."[21] He writes with clear and shameless idealism, warring against our current forgetfulness. That he repeats aesthetic platitudes must be forgiven. He's yelling into a sewer at the deaf and blind.

In springtime near Colton, California he found something that evidently surprised him [plate 9]. He has intense enthusiasms, even though practically everything he sees produces bitter anguish. Why does he "brake the car, grab the yellow instead of the green filter, wait out the cloud, and, at the second everything looks inexplicably right,...release the shutter?"[22]

Along the LA expressway he saw a stunning oasis of rampant growth. Rolling hills, velvet with lush grass and flowers, so thick they surpass being a carpet. Stepping onto the spongy floor one would simply drown. It's too beautiful for words. The photographer keeps his distance. "What we hope for from the artist is help in discovering the significance of a place,"[23] he writes, which hardly does justice to what he pictures here.

Above the grass are trees with clotted foliage escaping their trunks. Gestures of ecstatic maenads. Something mythical. But on examination, the greenery feels like hair undone, torn clothing, flailing women insane, distracted, arms raised in protests

of despair. Something about such pictures looks as intangible as photography's first desires. And not particularly American, though this is clearly an image of our country grasping at its lost virginity. "Whether those trees that stand are reassuring is a question for a lifetime. All that is clear is the perfection of what we were given, the unworthiness of our response, and the certainty, in view of our current deprivation, that we are judged."[24] "See what we've done to our Garden of Eden?" he cries, predicting the doom of The Last Judgment.

He's a photographer of the American West, a tradition of picture-making that is enduring and glorious. But his purpose is not to proclaim abundant wilderness. He's retrieving shreds of nature bankrupt. Counting survivors. Scanning the wailing trees he waited for shadows that would make them seem to have been drawn in charcoal, or cloudy mezzotint. His taste recalls the inconsolable longings of Romanticism.

The feeling was shared by French photographers who flocked to the forests in the last century. These cameramen of the 1850s, often former painters, made pictures with negatives of ordinary writing paper which gave the impression of artists' sketches. The nineteenth-century photographers didn't stand back. They burrowed under the trees, seeking mantles of comfort. Leafy green seemed to hold what remained mysterious, even transcendent at a time when science, which had given them the medium of photography, was the darling of modernity.

They were reading the poets: Victor Hugo, lamenting over how fatal progress was to the palpitating human heart, decrying how ugly progress was making the landscape. They rode the modern railroad trains that were carving up France to get to the ancient forests, as if these places harbored a cure for soul sickness: Fontainebleau, the woods of Vincennes and Boulogne, and those around famed cathedral towns where the government sent them to save the stones of the Middle Ages by turning them into pictures.

The modern photographer recorded trees with the same preservationist's instinct in 1982. "Intimations of mercy," he called them. "Implausible but real."[25] But the tradition of the first photographers, who knew their medium was not only a recording tool but could produce a different kind of art, invades every shadow. "Forests! Deep Woods! Solitudes! Asylums!" Hugo cried, frantic over the extension of the Rue de Rivoli gouging a ghastly highway into the secret meanderings of Old Paris.

I attributed such leaps of imagination to the first photographers when I wrote about them over a decade ago.[26] The pictures were not records, but cries and whispers. There were critics who thought I'd

# THE MOST
# ROMANTIC
# SCRIPT

grossly exaggerated not only the poetry of the pictures, but everything about what they might mean. I was ladling onto these French artists Hugo's "rays and shadows," Flaubert's "sunshine lighting up the skirt of the woods," smothering them with lumpy gravy. You see only art here. How miserably you've missed the point.[27]

I felt ashamed of my enthusiasm, my need to attribute meaning. I felt secure in my reading, but I'd wake in the middle of the night, thinking of how to defend this art of mournful shades. I considered sending the critic the rusty blade of a small hatchet I found in a barn of country junk, and asking her if she'd mistaken it for a pen. I restrained myself.

The photographer who stopped his car along an expressway in California to shoot the smoky shadows of trees as beautiful raised fists, who cast the here and now into shreds of gorgeous ancient memory, made his picture soon after I completed my text about the French photographers. We've never met, but I understand his old-fashioned idealism. What it is to yell into a sewer at the deaf and blind.

# IF MEN
## COULD GET
# PREGNANT

A photographer from the 1940s makes a fashion shot of a female model in a bathing suit near a swimming pool [plate 10]. As proscribed by her profession, she lighted it to death. Posing the living paragon next to a life-sized plaster Aphrodite, she pressed the point, that even in commercial narcissism we may find timeless, ageless beauty. Buy it if you will. What her picture means is – Feel the magic. Get that swim suit. Be that woman. What she has can be yours.

There's a cold, competent elegance in her fashion plate, as if she were trying to prove something about what's invincibly feminine by transforming a swimmer into a chrome hood ornament on an automobile. Paid by a consensus of corporate taste-makers, the photographer became an artist of light, with the color sense of a painter. (She began as one.) But she subsumes her real desire in photographing women into a mannerism that cons members of her own sex into looking like ornaments.

A male photographer worked the streets for decades looking for how the world would look like when it was photographed. That's what he said he was doing. He repeated the phrase, endlessly, to clarify his intention. It was a Modernist notion – to shrink everything into some version of a process.

In the course of his wanderings he shot pictures of women who interested him. He never asked their permission. He didn't need to. He wasn't working for anyone but himself. He got breasts, cleavages, perfect buttocks, flaxen hair. He barely missed grabbing the crotch of a woman approaching on a bicycle who brought her thighs together just before he pressed the shutter. Women's minds are fig leaves when they need to be.

Some of them saw the sucker coming and wanted to seduce him. The leers he got only mirrored his own. Other women he captured simply being themselves, marching at a rally. Smiles and breasts. Raised arms with signs: "Stop the World. We Want to Get On" [plate 11]. Amazons for sexual freedom: "If Men Could Get Pregnant Abortion Would Be a Sacrament." He was an earthy, passionate man who claimed to be in love with all women. But it was the category he loved. Elevating them by pressing them into his camera, he shrank them to the size of the little box.

He found one in sharply shadowed daylight standing on a curb near a hedge [plate 12]. A peroxide blond. Typical head-turner in tight Capri pants that defined the crack of her rump, the curves of which she concealed with a tunic. She felt the presence of the hunter. A distracted rabbit, she offered a furtive backward glance. The photographer was expert and could compose a frame in seconds. His picture is handsome. Clear light defines the hedge, power lines, and the edge of the curb, giving the woman a graspable scale.

That she's alone with the predator is revealed by the shadow at the bottom and side of the frame, which locates him. He means it to show he's grabbed her from a doorway or a car window. Bagged this rabbit. She's beautiful in the way that serial killers see beauty, obsessive when it squirms, hesitates, or out of simple curiosity, lingers to converse, to answer the stupid question in the time it takes the hunter to pull out his blade or nylon stocking.

That the photographer included this picture in a book called *Women are Beautiful* [28] makes us ponder about whether his naiveté is more lamentable than that of his subjects. He thought he knew what he was doing. He died before we could explain it to him.

10 Louise Dahl-Wolfe
*Night bathing*,
1939
silver gelatin print
10 $\frac{1}{16}$ x 10 $\frac{13}{16}$ inches
Gift of the artist

© The Estate of Louise
Dahl-Wolfe, courtesy
Staley-Wise Gallery,
New York
See page 83 for extended
caption

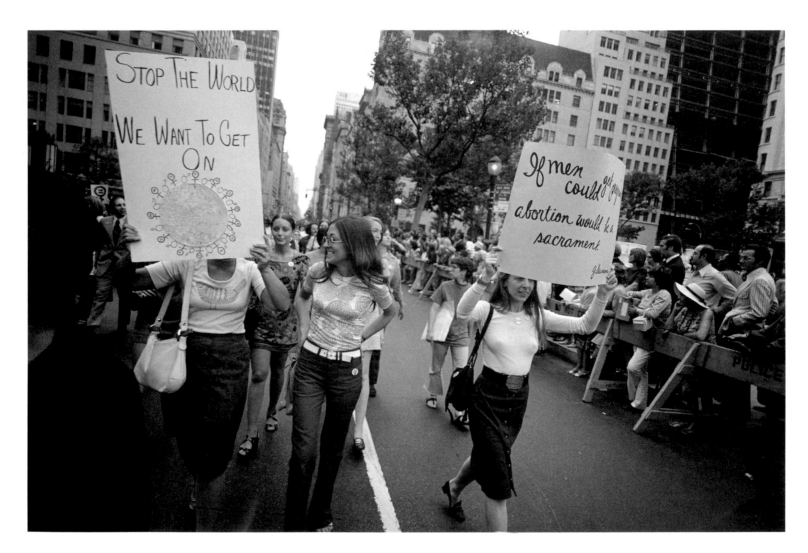

11 Garry Winogrand
   *Untitled* from the portfolio
   *Women are Beautiful*
   (1981), n.d.
   silver gelatin print
   8 ³/₄ x 13 ¹/₈ inches
   Gift of Jack A. Jaffe,
   Focus/Infinity Fund

© Garry Winogrand,
courtesy Fraenkel Gallery,
San Francisco
See page 83 for extended
caption

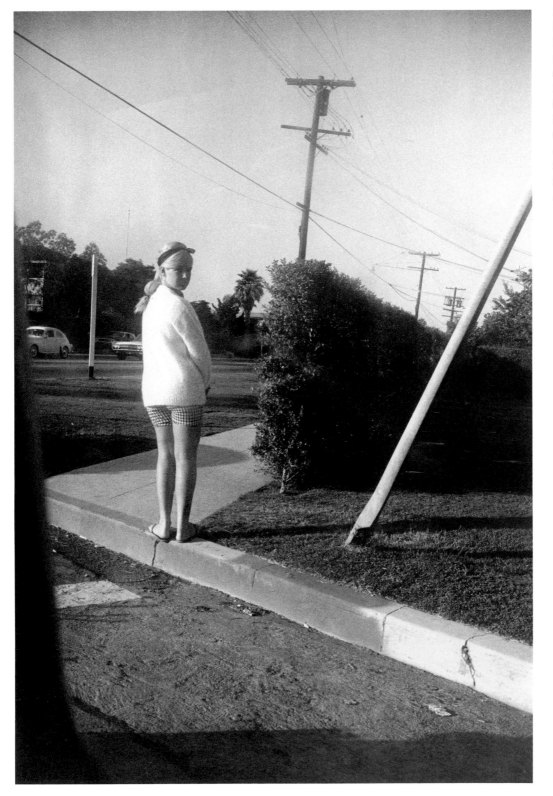

12  Garry Winogrand
*Untitled* from the portfolio
*Women are Beautiful*
(1981), n.d.
silver gelatin print
13 1/8 x 8 3/4 inches
Gift of Jack A. Jaffe,
Focus/Infinity Fund
© Garry Winogrand,
courtesy Fraenkel Gallery,
San Francisco
See page 83 for extended
caption

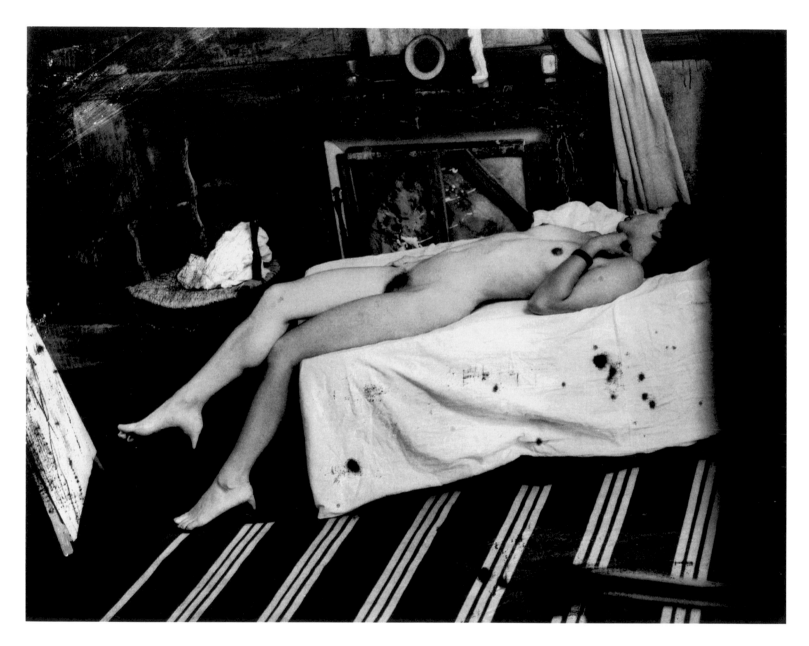

13  Joel-Peter Witkin
*Nègre's Fetishist, Paris*
from *Twelve Photographs*
(1993), 1990
photogravure
9 7/8 x 12 11/16 inches
Gift of James J. Brennan,
Brennan Steel

© Joel-Peter Witkin, courtesy
PaceWildensteinMacGill,
New York
See page 83 for extended
caption

# THANK YOUR
# FOOT
## FOR SEX

Nothing surprises him, no freak, diseased creature, or morgue specimen. They are his subjects, metaphors for a moralizing art of allegory. Fellow sufferers. Despite his attraction to aberrations, he is, like all innocents, not above being genuinely shocked.

He goes to a lot of trouble to make his pictures. He's fond of the theatrics of the Old Masters: elaborate settings, painted backdrops, preparatory sketches, floor plans, props, countless interviews with possible sitters vying to be his actors. He designs costumes for them to wear. He maintains a vast correspondence with countries where he's better understood than in his own. His fevered brain tries to control it all, supervising the infinity of details like a master of ceremonies. In a way the pictures have been made before they're taken.

It's more complicated than this. Sometimes he gets smitten. Something comes up, and his original idea is stolen, changed, taken over by the secret life of his characters. He has to let it happen: "I'm looking for collaboration between my phantasms and theirs."[29] Couched in a netherworld that conceals hidden rituals, these phantasms are their own festering brain, a tuber stored in the dark that over time begins sprouting buds, leaves, vines.

From all over the world he's deluged with things people send with notes that say: "You may be interested." A woman from LA plied him with so many books, articles, pictures, and literary citations that soon he was tossing them in the garbage before opening the packages. He was attracted to one thing that she sent: a book – *The Sex Life of the Foot and Shoe*.[30] While he was engrossed in "The Foot You Never Knew," "Walking Is a Sex Trap," "Podocosmetics," "The Talking Foot," and "The Sensuous Stilts," a photographer friend sent him a chromolithograph of a woman's feet that had sprouted high heels [figure 1].

At the same moment a French woman offered herself to him as a potential sitter by sending a vial of cotton soaked with her own blood. He consigned this gift to the trash, fearful of the epidemic it

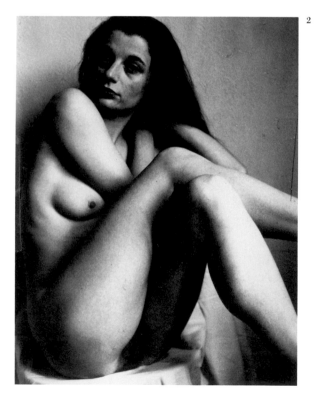

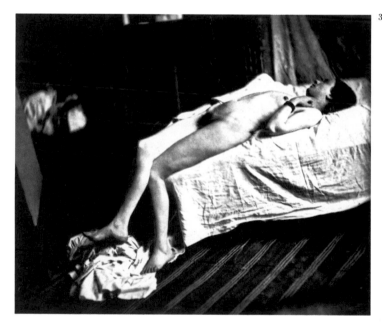

might contain. Then she sent a picture of herself naked so he could get a good look at her sex [figure 2]. She was a nurse or hospital administrator with a flagrant fantasy life. She'd persuaded other photographers and artists to depict her and mounted an exhibition of herself in various media.

On a visit to France he decided to have her pose for him. He couldn't help it. He found her enormously attractive. They went to the country house of his French dealer with a crew of assistants. The woman "got into it," he said. She walked around naked while they painted the room brown. He was amazed by her complete naturalness which was that of a beautiful cat. When she lay on the bed, her slender grace made him think of a nude he loved. An exceptional nude by the early French photographer Charles Nègre, who'd specialized in medieval architecture and the landscapes of the Midi. On a rare occasion he photographed a slender dark-haired girl lying on a bed [figure 3].[31] The French woman was practically asking that he remake Nègre's photograph. Bewitched by her allure, he did [plate 13].

Thinking of the high-heeled feet in the chromolithograph, he had latex heels built for his model to wear as if she'd sprouted them. He and his wife brought to the sitting several sizes and skin shades of the heels to match to her own skin, so they'd seem like completely natural "sensual stilts."

He shot his fetishist from the hallway, outside the room, from the vantage point of a passer-by, or a prostitute's client, and called the picture *Nègre's Fetishist*. Enlarged, it looks like a nineteenth-century salon picture. "Sometimes I have the feeling my photographs are more intelligent than I am," he confided.[32] It sounds like an indictment. But he's utterly sincere.

**figure 1**
Artist unknown
*Untitled*
*(Woman's Feet Sprouting
High Heels)*, n.d.
reproduction of a
chromolithograph
dimensions unknown
Collection of
Joel-Peter Witkin,
photograph courtesy
the author

**figure 2**
Photographer unknown
*French Model for
Nègre's Fetishist*, n.d.
snapshot
dimensions unknown
Collection of
Joel-Peter Witkin,
photograph courtesy
the author

**figure 3**
Charles Nègre
*Nude Study
(Académie)*,
c. 1850
silver gelatin print
7 1/4 x 23 3/4 inches
National Gallery
of Canada, Ottawa,
Gift of Joseph Nègre,
Cannes, France, 1976

We may look too quickly and lose something important. Or dwell over trash. It's all the same. "'If I were asked which of all the mysteries will forever remain impenetrable,' the poet Edmond Jabès has someone write, 'I would not hesitate to answer: *the obvious*.'"[34] The shame of our misreadings is only grist for the spiteful. We may be proved wrong, but one feeling doesn't exclude another.

John Szarkowski mused at the outset of these stories that in creating our hundred stories about what a photograph contains, we pay it the highest compliment. His own confessed errors illustrate the point. Once he thought Dorothea Lange's *End of an Era* showed a woman

**in her chauffeur-driven elegant automobile looking down at the pedestrian through that beautiful round window, with the hand protecting her nose from any possible offense in the street. I thought that was marvelous, the way the photographer had pinned her to the specimen board like a moth.**

After he learned that the picture's whole title was *End of an Era, Funeral Cortege in a Small Valley Town*, his "philosophical sense of…the content…was absolutely totally destroyed, instantly. The picture didn't change, and my love of the picture and my pleasure… didn't change."[35]

There's always more in a work than the author gives us, especially in photographs. With so many around to play with, we can't help but invent, even when constrained by a definitive caption. We contrive from the merest scrap. E. H. Gombrich called this faculty of mental projection "The Beholder's Share."[36] And if our imaginations yearn obsessively for meaning before certain photographs, who then is the author? Our participation hardly lessens the medium's ability to dazzle. We merely color the configuration with more light and shade.

As for a photographer's intentions, Aaron Siskind couldn't say why he pointed at boys in the sky. I don't know if Danny Lyon wove his own beating heart into the Chicago living room. That's my version. As for Larry Clark, what made him decide that David Roper's letter to the cops needed photographic rubrics? It wouldn't help to ask. We respect it with our own explanation, deriving the myths we need in order to live.

If this seems subversive, or the sure road to art historical chaos, we have only to reflect on Italo Calvino's hero of *Mr. Palomar*. Palomar, named after the giant telescope, quested after knowledge in a world shown to be ridiculous and sublime – a world not unlike that in certain photographs. It is not surprising that Calvino's brief chapters often feel like snapshots.

PARRY
ART

## WHICH IS
# MINE?

I don't need to tell you that there is an art of photography. The argument was settled long ago. One hundred-and-fifty years of photographic practice amply demonstrate that plenty of people using cameras have been capable of stunning us with naked facts, as well as the most subtly arranged expressive questions. We respond, curious, amazed. Our lives as we know them end with a single glance. Or we begin revising our histories, based on some photographed thing we can't let out of our sight.

The situation is more complicated than the erotics of looking. Photographic viewers have discovered that works without the slightest artistic claims can take up permanent residence in the imagination. In the early 1980s I thought Roland Barthes was absurd when he saw a house photographed in the Alhambra and his only response was wanting to live there.[33] I've since changed my mind. Whether such desires are due to calculated artistic intentions or to the psychoanalytical theories Barthes explained doesn't matter. We will do with the picture what we will.

When Mr. Palomar visits ancient ruins in Mexico, he is led by an expert in Pre-Columbian civilizations. This know-it-all can recite beautiful legends about Quetzalcoatl. Every stone becomes "a cosmic tale, an allegory, a moral reflection."

At the ruins a group of schoolchildren arrive with their teacher who gives the facts of a place or statue, always concluding, "We don't know what it means." Viewing Chac-mool, a reclining figure with a tray that experts unanimously declare held the bleeding hearts of human sacrificial victims, the teacher says, "This is Chac-mool. We don't know what it means." Mr. Palomar is enthralled by the knowledge of his guide. But the unveering doubter also attracts him.

We can try to describe and define a stone, figure, sign, or word as they appear to us, but "whether…they also have a hidden face, is not for us to know." In trying to confer meaning, perhaps we take on too much. "To guess is a presumption, a betrayal of that true, lost meaning."

The teacher: "We don't know what they mean."

The guide: "Yes we do! It's the continuity of life and death; the serpents are life, the skulls are death. Life is life because it bears death with it, and death is death because there is no life without death…." He can't contain his need to turn form into words, to build new monuments of his own imaginings. It is impossible, not to think, not to find meaning.[37] We do this endlessly with photographs.

Last year book designer Chip Kidd decided to use *Hacked to Death II*, a morgue photograph by Andres Serrano, on the cover of a publication of *The New Testament* [figure 4].[38] Did he make a mistake? Or was he contriving his own story of the Passion, by conflating Christ's sacrifice with the brutality of modern life? Kidd's book jacket thrusts "Christ" in our faces. Vacant brown eyes, face streaked with blood, unlike any Man of Sorrows from the usual crucifixes or altars. But what has happened to the New Testament's abiding promise of redemption through the mysterious gift of the Resurrection? The designer found the Christ he needed for our times. A partial reading, perhaps, but in my house we have two copies of this book. *Hacked to Death* sits on each of our night tables – its stunning physiognomy the latest version of the ancient theme.

"It's not true what the gentleman said," Calvino's teacher cautions the schoolchildren, insisting on silence in a secular world that is drunk on feedback, sated by banquets of information. "We don't know what they mean." Despite the author's reverence for this philosophical position, the tactic is strangely perverse. It begs for stories, for our meddling interference.

figure 4
Andres Serrano
*The Morgue
(Hacked to Death II),*
1992

Cover illustration from
*The New Testament,*
trans. Richmond
Lattimore, 1996
© 1996 by Alice B.
Lattimore. Reprinted
by permission of
North Point Press, a
division of Farrar,
Straus and Giroux, Inc.

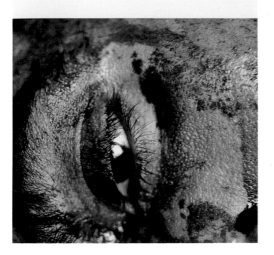

THE NEW TESTAMENT

*translated by*
RICHMOND LATTIMORE

# NOTES

1 Quoted in Eugenia Parry Janis and Wendy MacNeil, *Photography within the Humanities* (Danbury, NH: Addison House Publishers, 1977), pp. 93 and 95.

2 "At the Mercy of the Threshold," *The Book of Shares*, trans. Rosmarie Waldrop (Chicago: The University of Chicago Press, 1989), p. 80.

3 Ibid.

4 "Faces," *The Book of Shares* (note 2), p. 78.

5 "Tending Two Shops," *The Essential Rumi*, trans. Coleman Barks with John Moyne, A. J. Arberry, and Reynold Nicholson (San Francisco: Harper, 1995), pp. 74–75.

6 "Grey Tint," *The Book of Shares* (note 2), p. 30.

7 Ibid., p. 29.

8 Abelardo Morell, *A Camera in a Room, Photographs by Abelardo Morell* (Washington and London: Smithsonian Institution Press, published in association with Constance Sullivan Editions, 1995), pp. 9–10.

9 "Custom," *The Book of Shares* (note 2), p. 70.

10 Morell (note 8), p. 5.

11 Peter Greenaway, *Prospero's Books, A Film of Shakespeare's "The Tempest"* (New York: Four Walls Eight Windows, 1991), p.72.

12 Ibid., p. 17.

13 Morell (note 8), p. 9.

14 "Grey Tint" (note 6), p. 29.

15 Greenaway (note 11), p. 12.

16 See Morell (note 8), plates. All works by Abelardo Morell referred to here are illustrated in this publication.

17 Greenaway (note 11), pp. 17 and 20.

18 Ibid., pp. 161–62.

19 Larry Clark, *Tulsa* (New York: Rapoport Printing, Inc., 1971), n. pag., includes several portraits of David Roper in addition to his "Prayer."

20 Robert Adams, "Truth and Landscape," *Beauty in Photography, Essays in Defense of Traditional Values* (New York: Aperture, 1996), pp. 14 and 19.

21 Ibid., p. 15.

22 Ibid.

23 Ibid., p. 16.

24 Robert Adams, "Introduction," *Los Angeles Spring, Photographs by Robert Adams* (New York: Aperture, 1986), n. pag. The work discussed here is the frontispiece to this book.

25 Ibid.

26 See André Jammes and Eugenia Parry Janis, *The Art of French Calotype with a Critical Dictionary of Photographers, 1845–1870* (Princeton, NJ: Princeton University Press, 1983), *passim*.

27 For Abigail Solomon-Godeau's doomsday obsession with the "Politics of Aestheticism," see "Calotypomania: The Gourmet Guide to Nineteenth-Century Photography," *Photography at the Dock, Essays on Photographic History, Institutions, and Practices*, foreword by Linda Nochlin (Minneapolis: University of Minnesota Press, Media and Society 4, 1991), pp. 4–27. Originally published in *Afterimage* 11, 1/2 (Summer 1983).

28 *Women are Beautiful, Photographs by Garry Winogrand*, with an essay by Helen Gary Bishop (New York: A Light Gallery Book, Farrar, Straus and Giroux, 1975).

29 Quoted in Frank Horvat, "Joel-Peter Witkin," *entre vues* (Paris: Editions Nathan, 1990), p. 276 (my English translation).

30 William A. Rossi, *The Sex Life of the Foot and Shoe, An Occasionally Indecent Exploration of the Sexual History of Feet and Footwear* (Hertfordshire, England: Wordsworth Editions, Ltd., 1989), *passim*.

31 The original image by Nègre, *Nue allongé dans l'atelier de l'artiste* (Nude Reclining in the Artist's Studio) (1848), has survived only as a waxed-paper negative and appeared illustrated as such in the catalogue *L'Invention d'un regard (1839–1918)*, an exhibition of early photography organized by the Réunion des musées nationaux, the Musée d'Orsay, and the Bibliothèque nationale, catalogue by Françoise Heilbrun, Philippe Néagu, and Bernard Marbot (Paris: Editions de la Réunion des musées nationaux, 1989), p. 26, pl. 189. In the exhibition the image was paired with a contemporary positive print made by Claudine Sudre. Witkin knew it from the catalogue as a negative.

32 Horvat (note 29), p. 262 (my trans-
lation).

33 Roland Barthes, *Camera Lucida,
Reflections on Photography*,
trans. Richard Howard (New
York: Hill and Wang, A Division
of Farrar, Straus and Giroux,
1981). "An old house, a shadowy
porch, tiles, a crumbling Arab
decoration, a man sitting against
the wall, a deserted street, a
Mediterranean tree (Charles Clif-
ford's 'Alhambra'): this old pho-
tograph (1854) touches me: it is
quite simply *there* that I should
like to live" (p. 38).

34 "Source Language Target Lan-
guage," *The Book of Shares* (note
2), p. 32.

35 Janis and MacNeil (note 1),
p. 92.

36 E. H. Gombrich, *Art and Illu-
sion, A Study in the Psychology
of Pictorial Representation*
(Princeton, NJ: Princeton Uni-
versity Press, Bollingen Series
XXXV. 5, third printing, 1969),
p. 179; and "The Image in the
Clouds," pp. 181–202. See also
the more recent David Freedberg,
*The Power of Images, Studies in
the History and Theory of
Response* (Chicago: The Univer-
sity of Chicago Press, 1989) for a
prodigious treatment of image
apprehension that addresses
meditation, devotion, arousal by
image, censorship, and icono-
clasm, which is perhaps more
relevant to what I am attempting
to point out here.

37 Italo Calvino, "Serpents and
Skulls," *Mr. Palomar*, trans.
William Weaver (San Diego, New
York, and London: A Harvest
Book, A Helen and Kurt Wolff
Book, Harcourt Brace
Jovanovich, Inc. Publishers,
1985), pp. 95–98.

38 *The New Testament*, trans. Rich-
mond Lattimore (New York:
North Point Press, A Division of
Farrar, Straus and Giroux, 1996).
Jacket design by Chip Kidd
from a photograph by Andres
Serrano, *The Morgue (Hacked to
Death II)* (1992), silver dye
bleach print, silicone, and plexi-
glass, 49 1/2 x 60 inches, edition:
3. Courtesy Paula Cooper Gallery,
New York.

# CAPTIONS

The extended captions that appear here and throughout the book were written by AnJanette Brush.

1   In Aaron Siskind's series *Pleasures and Terrors of Levitation*, the formal vehicle for the photographer's abstract expression is the human figure, silhouetted as a kinetic shape floating in a field of white which can be read as infinite space. Breaking with the camera's emphasis on authenticity to emphasize its associative powers, Siskind's work is intimately allied with painting. See Schulze, plates 11 and 12 and front cover.

2   The substance of Danny Lyon's art is humanity – though usually its grittier side. Here, in a rough urban environment typical of his subjects, he has arrested a sweet gesture at a random moment. The backdrop to this kiss, a space elegantly askew, completes the balanced composition. See Rosenblum, plate 20.

3   For over three decades, Elliott Erwitt, a master of the visual pun, has turned his camera on a variety of ironic juxtapositions, strange alignments, and minor occurrences. He possesses a keen eye for humor, and his photographs are never simple. Whether observing intimate moments, political situations, or multilayered street scenes such as these photographers with photographs, Erwitt's images convey a keen charm and wit.

4   After starting a family and spending more time at home, Abelardo Morell looked to his everyday surroundings for subject matter. The process led him to examine common objects such as toys, water, and books. Through a variety of photographs, including *Pietà by El Greco*, Morell produced unusual definitions of pictorial space and revelations about the artificiality of book reproductions. His art draws attention to the mysterious sensation of vision and the complexities of imagery. See Peat, plate 6.

5   Margaret Stratton chronicles bibles as ruins, debris, remains. Many photographers – including Abelardo Morell (plate 4) – as well as other visual artists – Buzz Spector, Tim Rollins and K.O.S. – use and manipulate books to create complex and allusive works of art. Stratton's richly textured pile of charred sacred texts warrants questions about blasphmeny, censorship, politics, and motive.

6   Dorothea Lange's social documentary work in the 1930s and 1940s was enhanced by her eye for symbolism and her reflection of attitude. Beyond recording a specific time and place, this image of young workers during World War II, angry and miserable in a town to which they have been transplanted, conveys frank emotion. The woman stands solidly within the frame, turning to face the darker and less grounded profile of her companion. It suggests that Lange's sympathies were perhaps expressed through subtle compositional choices as well as through overtly political content. See plate 7 and Rosenblum, plate 1.

7   Lange caught a man suspended, a pause, an instant that would normally escape us. In this rather unassuming photograph of a moment between moments, she pushed her lifelong consideration of form to the brink of abstraction. See plate 6 and Rosenblum, plate 1.

8   *Tulsa*, the series from which this image is taken, was published as a book in 1971. In it, Larry Clark's stark portrayal of the drug culture in which he was not only observer but participant was shockingly frank. This untitled photograph offers words that are disturbingly graphic, rather than the raw scenes of drug users in many other images in the series. By presenting a photograph of text as an element of a visual project, Clark amplified his portrait of a subculture and foreshadowed the heavier use of text in photography in the 1980s. See Rosenblum, plate 18.

9   Though Robert Adams's photography offers views of natural landscapes harshly transformed by their intersection with civilization, his work is as much concerned with beauty and form as it is with environmental issues. Somber and calm, his images are an aesthetic articulation of a concern with man's widespread use and misuse of land. Like most of his photographs, *Expressway near Colton, California* shows discreet traces of man's presence. Adams's art is devoted to the belief that all land, no matter what has been done to it, retains an enduring beauty.

10  The documentary and fashion photographer Louise Dahl-Wolfe developed distinct and creative notions about color, form, and design. In *Louise Dahl-Wolfe: A Photographer's Scrapbook* (1984), she declared, "I was much more interested in painters or looking at a Degas than I'd be looking at most dresses done by third-rate designers." *Night bathing* demonstrates Dahl-Wolfe's singular sense of composition as well as her understanding of photography as the act of painting with light. Isolated by illumination, the model is formally related to the classical statue yet highlighted as separate and special. See Slemmons, plates 5 and 8.

11  From hundreds of photographs by Garry Winogrand, John Szarkowski, then curator of photography at The Museum of Modern Art, selected eighty-five images featuring women. The resulting book, *Women are Beautiful* (1975), offers a random collection of women caught on the street, in parks, getting into cars, at parties, marching in parades, skinny-dipping in ponds. Is it the elucidation of an attraction, of style, of activity, or of gender in an era of transition? Here Winogrand observed the politics of the day, with a tilted view of women at a protest demanding equal rights. See plate 12 and Rosenblum, plate 7.

12  In an image revealing a darker side to Winogrand's look at women on the street, this photograph shows his subject in a pose and atmosphere reminiscent of Hollywood B-movies. Looking uncertainly over her shoulder, this particular woman appears vulnerable, perhaps even stalked, the photographer's prey. See plate 11 and Rosenblum, plate 7.

13  Drawing from a rich body of sources – literature, myth, and Renaissance and Baroque painting – Joel-Peter Witkin creates elaborate photographic tableaus that address the morbid, the perverse, the erotic, and the religious. His darkly fantastic vision is further shaped by deliberate manipulation of the photographic surface to make it appear aged. *Nègre's Fetishist* appears in the book *Twelve Photographs* (1993), which pairs Witkin's photogravures with a lengthy poem by Galway Kinnell. This image illustrates how Witkin's work draws from the histories of art, photography, and even theater. See Miller, plate 18.

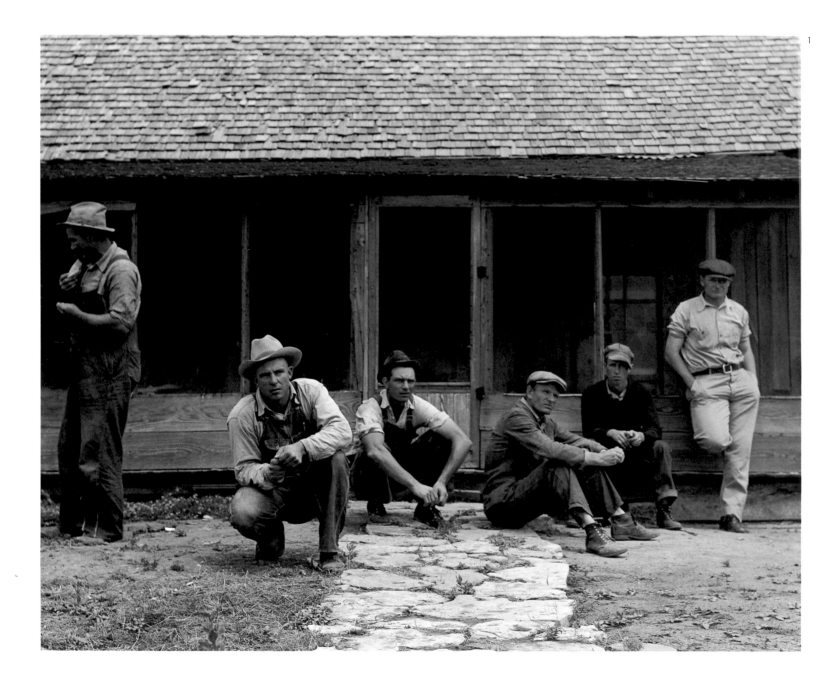

Dorothea Lange is best known for her work for the Farm Security Administration's documentation of the Depression. However, she also pursued her own work dealing with themes of social justice and labor issues. In collaboration with her husband, the economist Paul S. Taylor, she published **An American Exodus** (1939) in which a different version of this group portrait appeared, accompanied by quotations from the subjects. The men in this image were further identified as "displaced tenant farmers, none able to vote because of Texas poll tax. All on WPA. They support an average of four persons each on $22.80 a month." See Parry, plates 6 and 7.

# DOCUMENTARY PHOTOGRAPHY

## PAST AND PRESENT

*NAOMI ROSENBLUM*

There can be little question that photographic documentation has effected a revolution in human perception and understanding. Whether experienced as still images in printed publications or as moving pictures on cinema and video screens, photographs have made all classes of people in industrialized societies aware of how they and others live. Of course, photographers also may create unreal worlds by imaginatively manipulating the process, but it is the descriptive aspect of camera work that has been the medium's defining characteristic over the past century and a half.

In its infancy, photography was perceived as a mechanical process obedient to the laws of nature. Besides being considered more accurate in representation, camera images seemed free of the personal feelings and the idiosyncrasies associated with the hand-made visual arts. As negative and positive print technologies evolved, actual events, objects, and scenes could be photographed more easily in the world outside the studio, reinforcing the belief that still photographs were authentic documents of ordinary if discrete segments of reality. Their accuracy of detail and sense of immediacy convinced politicians, colonizers, urban developers, social scientists, journalists, and reformers that photographs might serve as credible visual evidence, whether the aim was to keep an archive of descriptive records, publicize "good works," educate and change public attitudes, or effect a combination of these goals.

A brief history of social documentation   From its inception, photographic documentation affected perceptions of social status. In the British Isles, calotypes of working people by William Henry Fox Talbot and by David Octavius Hill and Robert Adamson accurately depicted the apparel and (to a lesser extent) the activities of the lower social order. When the new collodion negative and albumen print technology and the cheaper, small-format carte-de-visite became widespread after the 1850s, working people could afford images of themselves, further democratizing the medium. As the effects of industrialization and urbanization became apparent during the second half of the century, portraying laborers and domestics may also have satisfied a need to keep visual

records of traditional social hierarchies.[1] The urge to assemble archives to memorialize vanishing customs, provincial dress, and arcane rituals persisted until well into the twentieth century, providing one of the rationales for such important projects as that organized in 1936 in the United States by the Farm Security Administration (FSA).[2]

Other agendas for portraying people and their habitats satisfied a taste for the picturesque. Photographs of humble types – tradespeople, street musicians, and peddlers, for the most part – were sold to travelers and settlers in the dominions controlled by the major Western European powers. Such images were regarded as authentic depictions, although they usually represented Western European or North American perceptions of native peoples and customs. Besides satisfying a thirst for a knowledge of "exotic" societies, images of ethnic populaces and documentations of landscape and built environments in Asia, Australia, New Zealand, and on the Indian sub-continent were also designed to assure the home-bound public of the necessity for a "civilizing" presence in these places.[3] The documentations of architecture, landscape, and work-related activities – collected in albums and publications – forecast the role camera

**DOCUMENT**
**ROSENBLUM**

documentation would play in later, more rigorously conceived ethnographic projects.[4]

Similarly, nineteenth-century efforts to transform society's thinking through the documentation of social conditions prefigured later endeavors in this area. One such project was initiated to demonstrate the thesis that heavy labor engendered better health in women than did idleness.[5] Another was meant both to keep records and provide publicity for ongoing fundraising efforts in a campaign to alleviate the plight of poor children.[6] Documentary projects undertaken under the aegis of paternalistic governments and institutional entities – exemplified by Charles Nègre's depictions of the workers' hospital at Vincennes – usually clothed their social purpose in seeming objectivity.[7] In similar fashion, nineteenth-century landscape imagery of the American West, which depicts it as pristine and grand, helped make possible greater control over, as well as exploitation of, the physical and social environment that Americans considered part of their "manifest destiny."[8]

Photographic documentation was from the first closely bound up with life in cities and has remained so up until the present (see Schulze, "The City: Harbor of Humanity"). It was called upon to record both the destruction and growth of urban neighborhoods in major Western cities.[9] The original motives for commissioning such photographs were ambiguous, sometimes embracing elements of nostalgia as well as scientific record-making, but documentations of slum areas also found a role in the agitations for better urban conditions.

Documentation and print media **Documentation and what came to be called photojournalism have always been closely related. Indeed, the appearance in the early nineteenth century of inexpensive popular print periodicals constituted a vital spur to camera documentation of all kinds. The recognition that illustrative material might satisfy the cravings of the newly literate for drama impelled mid-century magazines to include greater numbers of visual illustrations (as well as livelier writing).[10] Photographs immediately became the basis for much of this illustrative artwork and continued to fulfill this role until well into the twentieth century, with artists either copying the information or engraving directly from camera images printed on woodblocks. Notwithstanding the skillfulness of many of these translations, experiments with methods of reproducing photographs in printers' ink continued throughout the century. The development in the late 1880s of halftone engraving techniques opened up an era during which photographs would gain greater acceptance as forceful surrogates of reality.[11]**

Faith in the innate truthfulness of the camera image helped shape the documentary purpose, but social reformers recognized the need for written explication as well. From the 1850s until recent times, the aim in social documentation usually has been to humanize the lowest portion of the social hierarchy through a combination of text and

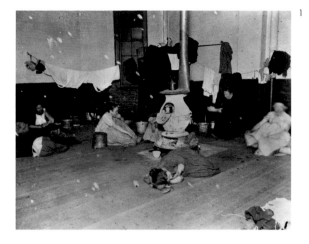

1

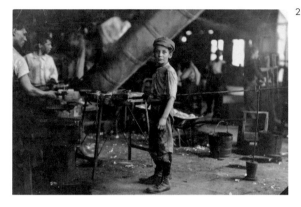

2

figure 1
Jacob A. Riis
Public Station Lodgers,
West 47th Street,
c. 1890
silver gelatin print
4 x 5 inches
Courtesy the Museum of
the City of New York

figure 2
Lewis Hine
Factory Boy, Glassworks,
1909
silver gelatin print
4 7/16 x 6 1/2 inches
Courtesy George
Eastman House,
Rochester, New York

illustration. By showing the working-class poor as benign and non-threatening, social planners hoped to change middle-class opinions and impel action to improve their living conditions.[12] Jacob A. Riis [see figure 1] and Lewis W. Hine [see figure 2] – the main proponents in the United States of social documentation – held that knowledge of unjust conditions in and of itself would prompt people to choose reasonable and morally correct alternatives, and that pressure on the political apparatus by those so instructed would force entrenched interests to give way before enlightenment. These ideas reached their zenith during the Progressive Era (1890–1914) and again in the 1930s, after a partial eclipse of some twenty years, prompting government and semi-private bodies to commission photographs for reasons of social policy.[13]

Documentary photography    Hine had called his work "social photography," but in its 1930s incarnation "documentary" became the term used to categorize images meant to arouse a sympathetic response to those victimized by social circumstances beyond their control. Documentary, as then defined, connoted a truthful yet poetic visual record of social conditions – that is, a view of reality that the maker had transmuted into art by choice of moment, vantage point, and lighting.[14] Exemplified by Dorothea Lange's Displaced Tenant Farmers, Goodlet, Hardeman Co., Texas [plate 1], documentary images appear to describe actuality, but they also invite an emotional response; in this case the passive poses of idle farmers (who the title informs us have lost their farms) seen against the dark vertical shapes are suggestive of their despondent state. In a later documentation of the shameful round-up and internment of Japanese-Americans in relocation camps, Lange demonstrated the same ability to endow social displacement with poetic feeling.

The term "documentary" soon invited a variety of interpretations. FSA photographer Walker Evans, whose views of New York in the late 1920s had been strongly influenced by the stylistic approach promoted as the "new vision" [see plate 2], held that "documentary style" (as he called it) was not at all socially useful; indeed, like all art, it was "useless."[15] Moreover, by the late 1940s, the documentary mode had become a tool for contravening negative perceptions of the industrial establishment.[16] Photographers reacted to the uses to which documentary was being put, and to the more conservative political climate generally, by calling for new directions in social documentation.[17]

By the 1970s documentary photography had become associated in some minds with the exploitation of the lower class by the more fortunate and the genre was seen as "a palliative…[that] assuages stirrings of [liberal] conscience."[18] According to this view, the form itself needed to be associated with more radical agendas, both in terms of meaning and style, in order for its message to be unmistakable. These voices maintained that to reach viewers sensitized to the mass media, the photographer with a social agenda should draw upon advertising

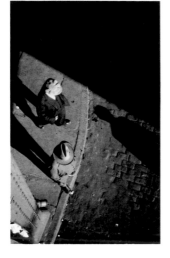

2   Walker Evans
**New York City,**
1928/29
silver gelatin print
2½ x 1⁹⁄₁₆ inches
Anonymous gift
© Walker Evans
Archive, The
Metropolitan
Museum of Art,
New York

3   Yasuhiro Ishimoto
**Untitled** from the series
**Chicago, Chicago,**
c. 1960
silver gelatin print
14 x 11 inches
Gift of Roberta and
Jack A. Jaffe

2 Walker Evans rejected the developing commercial and fine-art forms of American photography in the 1930s to become an influential figure in the shaping of the modern American documentary tradition. Enlisted to photograph for the Farm Security Administration in its survey of rural America, Evans later collaborated with the writer James Agee to produce **Let Us Now Praise Famous Men** (1941), a treatise on the plight of Southern tenant farmers.

Evans's economical and unpretentious style of recording his surroundings drew great acclaim. He subsequently created images of even greater immediacy. This elegant glimpse of a New York street corner is such a view of an ordinary moment. It is imbued with mystery and quiet drama, and demonstrates Evans's more unrestrained mode of working. See Schulze, plate 3.

3 The documentary photographer is forced to be part of the time and place of his subject, a fact of the medium that is simultaneously restrictive and beneficial. Moving through Chicago as both citizen and visitor, Yasuhiro Ishimoto was able to create documents that speak eloquently for the culture of the

city in the 1950s and 1960s. His photographs present highly original visual spaces, which nonetheless suggest the politics, mentality, and history of the city. This untitled image shows Ishimoto's strict sense of form and distinctive vision that can absorb such obvious urban phenomena as a plethora of advertisements. See Paschke, plate 10.

**DOCUMENT**
ROSENBLUM

practice for ideas about juxtapositions, sequencing, testimonials, and various interrelationships of text and image.

The ultimate result of combining images, voices, and artifacts has sometimes been to confuse fact and fiction.[19] Critics also held that the acceptance of documentary photographs in the art marketplace had transformed the humanizing approach (for example, of Hine and Lange) from weapons for social change to commodities, thereby depriving them of their social force.[20]

Documentary photography and the public During the 1930s and 1940s, the various government and private agencies that supported documentary projects took advantage of then existing media structures to place visual images and written texts in popular periodicals, in books, and in localities frequented by ordinary people.[21] Between 1938 and 1940, documentary photographs were reproduced in about 175 newspapers and magazines nationally, not counting the large metropolitan dailies. This deployment helped prepare the way both for the fusion of social documentation and photojournalism and for the acceptance of socially motivated images in exhibition galleries and museums. In fact, in some minds the modern photographer had become a photojournalist whose interest no longer lay in the photographic print, but in the printed page (whether periodical, book, billboard, car card, or poster).[22]

Life and Look – the well-financed popular picture magazines that made their reputations with picture essays featuring social phenomena – recognized that documentary style had, as it were, "passed into the bloodstream of photojournalism."[23] One salient difference between documentary and photojournalistic practice resided in the fact that government-funded commissions had been for single images that were expected to provide in-depth coverage, whereas magazines usually looked for a linear essay – for a narrative sequence that "had a life of its own."[24]

Documentary photography achieved museum acceptance largely under the aegis of the Photography Department of The Museum of Modern Art, but this sponsorship and the changed political climate of the immediate post–World War II years altered perceptions of social documentation.[25] "The Family of Man" – a thematic exhibition of work by documentarians, photojournalists, street photographers, and pictorial or aesthetic photographers, arranged in a three-dimensional journalistic format – diluted the purposive intent of the social documentary genre while emphasizing its humanist aspect. In the years immediately following, as private visions and explorations of the inner self became paramount concerns, relatively few social documentation projects were commissioned by institutional authorities.[26] Photographs relating to the issues of the day – civil rights, economic disparities, individual freedoms, and unpopular wars in Asia and Latin America – continued to be made, but were now more often commissioned by the press.

4   David Avison
    **Bathers in Lake Michigan,**
    1976
    silver gelatin print
    12¾ x 33⅝ inches
    Gift of Sonia and
    Theodore Bloch

In this and much of his other work, David Avison chose to examine the "in-between" moments of leisure. The panoramic format that Avison specializes in skims along the water at the edge of the city; the extended line of the photograph mimics the lake's horizon where the Chicago skyline abruptly drops off into surf, swimmers, and sail-boats. Avison's study of the water's edge playfully confuses the viewer's eye – the clouds meet the lake not only at the natural horizon, but also at the artificial perimeter of the man-made shore where their reflection seems at first glance to be the breaking surf on sand.

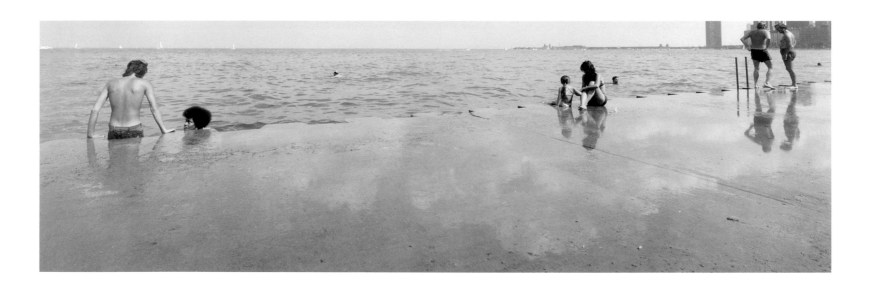

5   Robert Frank
**Political Rally, Chicago,**
1956
silver gelatin print
14 x 11 inches
Museum purchase
© Robert Frank, courtesy
PaceWildensteinMacGill,
New York

Robert Frank ushered in a
new era of photographic
observation. In this classic,
iconic photograph of a politi-
cal rally, he selected the face-
less conventioneers rather
than focusing in on the stan-
dard podium shots of candi-
dates. This image highlights
the isolating style for which
Frank became known. The
composition allows no escape
from the pull of the tuba's
throat, a gaping hole in the
center of the frame. Minor
details of the patriotic
bunting and a campaign
sticker for Adlai Stevenson
help to locate the viewer at
a political event, but more
importantly, the isolated,
faceless figure conveys
shocking emptiness and
alienation, yet not without
an element of humor. See
Miller, plate 1 and Schulze,
plate 16.

6   Lee Friedlander
**Phoenix**, 1975
silver gelatin print
11 x 14 inches
Museum purchase

7   Garry Winogrand
**Untitled**, from
the portfolio
**Women are Beautiful**
(1981), n.d.
silver gelatin print
11 x 14 inches
Gift of Jack A. Jaffe,
Focus/Infinity Fund
© Garry Winogrand,
courtesy
Fraenkel Gallery,
San Francisco

6   As a documentor of the urban landscape, Lee Friedlander introduced a style remarkable for its interest in the seemingly unremarkable. His book **The American Monument** (1976) covers most of the United States, documenting the motifs and symbols of public memory that go unnoticed, lost in the quotidian landscape. Photographing plaques and statues dedicated to an unending variety of servicemen, poets, statesmen, Indians, and Puritans, Friedlander collected thousands of images of these lonely, silent markers as one might glimpse them while walking or driving by. In **Phoenix**, for example, the frame is placed without apparent center or subject, save for the monument, which sits unobtrusively, camouflaged by a tree and cacti.

7   "Whenever I've seen an attractive woman, I've done my best to photograph her," says Winogrand in the foreword to his book **Women are Beautiful** (1975). The image reproduced here, a woman ecstatic, caught in the act of eating an ice cream cone, is typical of Winogrand's snapshot-influenced style. See Parry, plates 11 and 12.

**DOCUMENT**
**ROSENBLUM**

Street photography as documentation     **Changes in photographic technology, especially since the 1880s, have been as significant in the formation of contemporary documentary practice as the relation of the photograph to print media. Hand cameras, dry film in sheets or rolls, and the emergence of more advanced industrialized processing procedures geared to amateurs as well as professionals made possible the casual depiction of endless aspects of street or public life, often with working-class individuals as subjects. A largely urban phenomenon, "street photography," as it came to be called, began to attract greater numbers of photographers in American and European cities just before the turn of the century.[27] Following the appearance of the Leica camera in the mid-1920s and energized by the example of Europeans such as Henri Cartier-Bresson, street photography flourished in America during the late 1930s and 1940s, most notably in the work of Louis Faurer and Helen Levitt. Other catalysts were the Photo League, which organized projects to depict street life in working-class neighborhoods in New York, and the WPA, which commissioned street views in a number of American cities.**

**After the end of World War II, the spread of photographic instruction — the result of the GI Bill — along with the general state of economic well-being which put cameras into many more hands, made street photography even more attractive. Street photographers whose temperaments had been formed during the Depression era — and who usually were working outside of photojournalistic precincts — continued to be motivated by the idealism inherent in the traditional documentary mode. Among them, Roy DeCarava's experiences as a black American coming of age in a nation that not only was racially divided but actively engaged in violence against African-Americans undoubtedly imbued his images, including those with such unlikely subjects as** Dancers, New York**, with a somber rather than upbeat humanism. DeCarava and Gordon Parks were just about the only African-American photographers accorded recognition by the photographic establishment through most of the 1960s. Then photographers of color began to research their history and publish their contemporary documentary work. These efforts impelled American-Indian, Chicano, and Latino photographers to become more conscious of their particular ethnic groups.[28]**

**To varying degrees, expressionist street photographers working in the 1950s and 1960s were influenced by the "new vision" — avant-garde ideas regarding the formal organization of pictorial space — which had earlier reached the United States from Europe largely through the agency of the Institute of Design in Chicago.[29] Yasuhiro Ishimoto's vision of Chicago [see plate 3], which reveals the anomalies of life in the United States as seen by one who was both a native and an outsider, is imbued with an exceptional formal rigorousness, gained from study at the Institute of Design. Views of the Chicago waterfront by David Avison [see plate 4] display a similar balance between the humanistic**

and the formal; likewise a respect for geometry and formal order imbue the street photographs of Bob Thall with their special interest.

For the most part, however, the new attitude replacing the more or less cohesive humanist outlook that had characterized earlier American (and European) street photography was one of alienation. The sense of disjunction that emerged in the 1950s in response to the illiberal climate of the times — a climate that combined cold-war ideology with conformity to conventional middle-class ideas decreed by family, media, and government — impelled a number of artists and writers to view American life against the grain (others turned inward and substituted private for social vision). The impulse to focus in on the quirks and warts of American society had long attracted visitors to the United States. However, the mordant view of society revealed by Swiss émigré photographer Robert Frank, who had arrived in New York in 1947, differed considerably from the amused affection manifested by earlier émigrés such as John Gutmann. Frank's images, made on a cross-country trip in 1955–56, depicted the realities hidden behind the glossy advertising spreads and Hollywood fictions. Political Rally, Chicago [plate 5], with the tuba viewed head-on effacing its player seen standing beneath a

strip of bunting, can be taken as a metaphor for the windy rhetoric of American patriotic fervor. Frank's sense of distance, his ability to convert the banal into irony, and his inattention to received ideas about proper focus, composition, and print quality seen in his 1959 publication The Americans, exerted a cogent influence on later street photography.[30] His concentration on cars, roads, and signage stimulated later photographers not only to range throughout the countryside themselves, but to look closely at automobile culture and its effects on American life.

By the 1960s the expressionist intention at the heart of humanist street photography also was being displaced by an emphasis on "Perception...and Description" — on seeing something and operating the camera to make a record of what was seen.[31] Walker Evans may have been one of the first to have consciously put into practice the "purity of the record method" by photographing subway riders who happened to come into the range of his hidden camera.[32] Works as disparate as Lee Friedlander's Phoenix [plate 6], which depicts both the organic and the built as somehow artificial and inelegant, and an untitled image from the portfolio Women are Beautiful [plate 7] by Garry Winogrand, in which a laughing woman, seen against a store window displaying a headless male figure, creates an ambiguous but amusing statement, exemplify this direction. Both are examples of their makers' efforts to describe the American scene without sentimentality and at the same time come to grips with the contemporary "social landscape" through visual metaphor.[33] By this time, also, the use of color materials in street photography had become widespread, if not yet entirely accepted in photojournalism or the art market. William Eggleston was one of the first to take advantage of color for his uneventful documentations of the banal; he was soon followed by American scene photographers Joel Meyerowitz [see plate 8], Stephen Shore, and William Christenberry. Joel Sternfeld's color images of sites where catastrophes have occurred are so uneventful that they require texts to explain their significance.

From the 1970s on, images depicting social interactions have often claimed to be matter-of-fact, casually composed documentations of "the way we live now." Actually they are no more objective than the heroicized pictures of displaced persons in earlier social documentary practice, but they do invite more ambiguous responses. Larry Fink's depiction of a working-class birthday party in rural Pennsylvania [plate 9] focuses on the nonevents surrounding this celebration, leaving the viewer to sense the by-plays that characterize all such occasions. In capturing Appalachian mountain folk in states of awkwardness or puzzlement, Shelby Lee Adams seems intent on counteracting any idealizing sentiment; as a result, the meaning of images such as The Home Funeral [plate 10] depends as much on the viewer's mindset as on the photographer's intent. Jed Fielding uses lenses and camera angles that distort

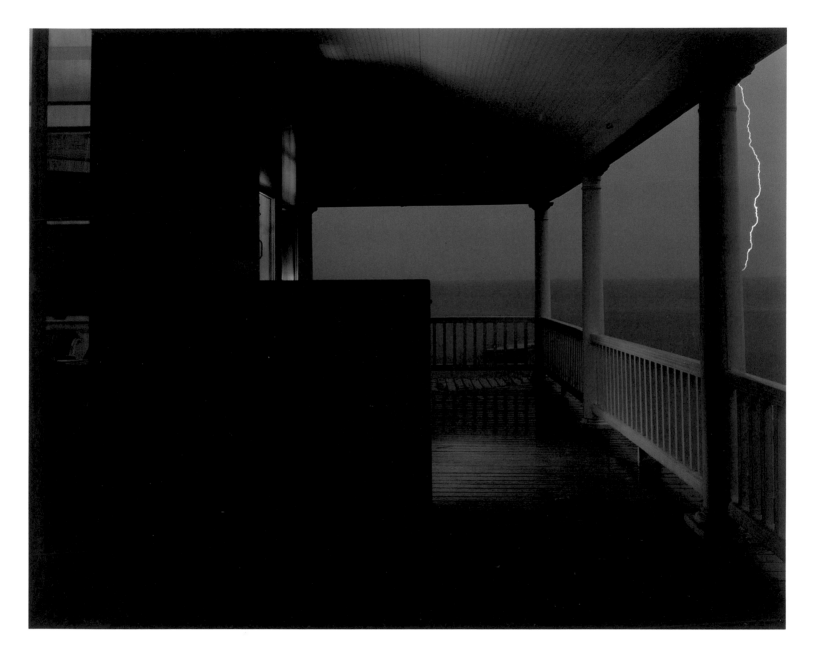

8   Joel Meyerowitz
**Porch Lightning,**
**Provincetown**, 1977/85
chromogenic development
(from color negative) print
15¼ x 19¼ inches
Museum purchase
© Joel Meyerowitz, courtesy
Bonni Benrubi Gallery,
New York

Joel Meyerowitz made his mark in the documentary tradition with his early use of color in street photography, beginning in 1963. With an astute eye for the social landscape, Meyerowitz has photographed mundane events across America. **Porch Lightning, Provincetown** is from the body of work for which Meyerowitz is most recognized: graceful studies of the weather, water, and light of Cape Cod, where he has photographed for years. By exploring the point at which the sky meets the sea, and investigating the many facets of the horizon, Meyerowitz unveils his subject. This image also demonstrates his technical virtuosity in capturing such elusive atmospheric events as lightning.

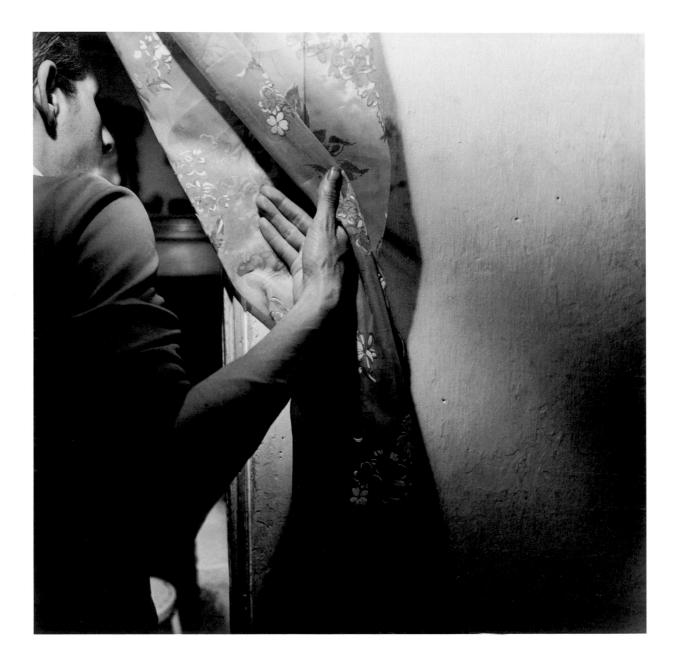

9  Larry Fink
   **Pat Sabatine's Twelfth**
   **Birthday Party, May, 1981,**
   1981/83
   silver gelatin print
   13 ⅝ x 14 inches
   Gift of Jerri Zbiral and Alan
   Teller and Organizers of the
   1991 Chicago Photographic
   Print Fair

In his book **Social Graces**
(1984), Larry Fink mentions
the strong human desire to
document in photographs
our personal as well as our
shared realities: "It is a
profound aspect of our
culture, this compulsion for
proof. It allows me to wade

into a party." Fink's images
range from black-tie events
in New York to celebrations
of his working-class
neighbors in Pennsylvania.
**Pat Sabatine's Twelfth**
**Birthday Party, May, 1981**
features neither the
celebrating child nor what
Fink refers to as the "holy
mess" of the Sabatine family

kitchen, but simply an
anonymous hand and the
geometry of a gesture.
Such intimacies underscore
Fink's belief that all of his
subjects, regardless of social
status, share the same
undercurrents of emotion,
politics, and alliance.

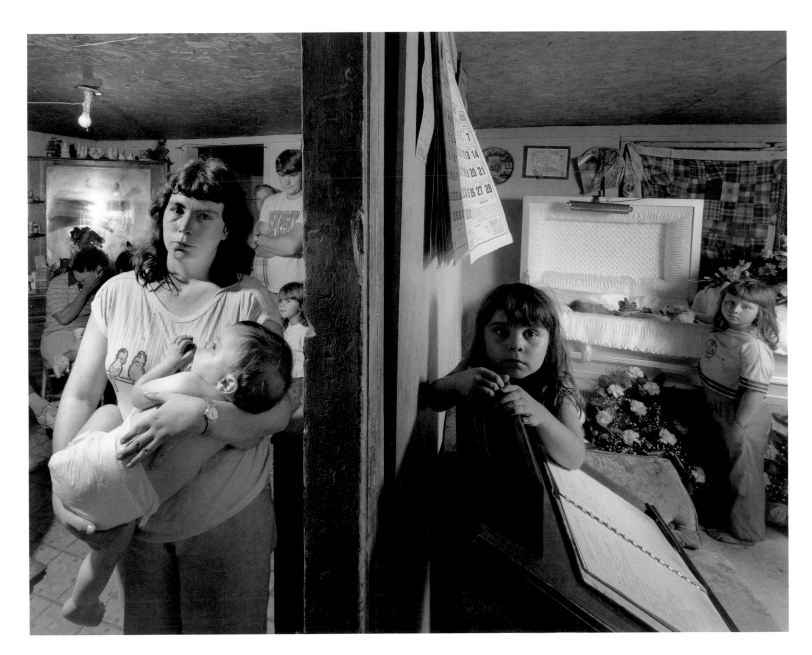

10  Shelby Lee Adams
    **The Home Funeral,**
    1990
    silver gelatin print
    16 x 20 inches
    Museum purchase

The influence of classic pho-
tographers and Southern
writers and others who have
documented the Appalachian
region is clear in the work of
Shelby Lee Adams. An image
such as **The Home Funeral**,
however, crystallizes the
familiar shacks, lined faces,
and extended families into

something unexpected.
Adams's composition – the
sharp division of space and
the clarity of detail from the
wall-calendar to the stark
bulb on the ceiling and ferns
above the coffin – places the
viewer in the role of omnis-
cient visitor to this otherwise
private moment. Adams him-
self, having grown up in Ken-

tucky and familiar with the
mountain culture, is both
an insider and an outside
observer – a dichotomy the
documentary photographer
must frequently confront.

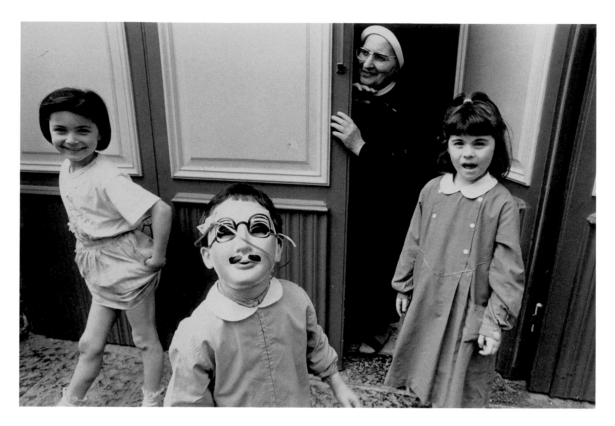

11  Jed Fielding
**Naples #729,**
1995
silver gelatin print
12 5/8 x 19 inches
Gift of Ginny Sykes
and John Goldsmith

12  Stephen Marc
**Untitled** from
**Urban Notions** (1983),
1979
silver gelatin print
11 x 14 inches
Gift of the artist in
honor of Eli Weingard
Chicago Grant

11 "I've been looking for this city my whole life," is the thought that struck Jed Fielding, standing in the middle of a small piazza, on his first trip to Naples in 1977. Since then, Fielding has returned almost every year to this city, which has become his primary focus, to record the particularities of its street life. Fielding has become attached to the experience of walking around Naples to record its playful, posing, curious, tense, and ambiguously gathered denizens – such as the watchful nun and precocious children in this image. In the end, his photographs clearly show a mastery of the photographic concept of framing, and evoke a portrait of the city by focusing on the forms, activities, and passions of its people.

12 Throughout his work Stephen Marc has investigated the forms of individual expression – in style, in gesture, in action – that develop within a given community. In his first book, **Urban Notions** (1983), Marc states his intention to capture the "gestures, symbols, and codes" of the black urban environment. In this untitled image, the pavement becomes a canvas for the familiar markings of play in the city. Marc's presence as photographer is not felt within the image, thus allowing the viewer the privilege of stepping into the scene as witness and fellow observer of an undisturbed moment of idyllic urban childhood. See Schulze, plate 22.

his subjects to suggest the vitality of children on the streets of Naples, Italy, taking this strategy a step further [see plate 11].

Not all street photographers are motivated by exactly the same urgencies. Combining the metaphorical with the affective Urban Notions [see plate 12], Stephen Marc's long-term documentation of black inner-city areas in Chicago, more directly evokes both the jazziness of street life and its imprisoning atmosphere. The streets of Chicago and other Midwest cities also provide a banal but relentless backdrop for Thomas Frederick Arndt's somber views of the homeless, the bus riders, political demonstrators [see plate 13], and working people, whom he sees without irony or sentimentality, but with considerable empathy.

One result of Frank's quixotic view of American culture was to make humor acceptable in serious photography. From gentle but pointed spoofs by photojournalist Elliott Erwitt to the sharper attempts at satire in Peter Bacon Hales's Cocktail Party, Heart Ball, Chicago Hilton [plate 14] – which draws as much from Diane Arbus as from Frank – photographers were unafraid to poke fun at American culture.

Another Frank legacy was to reopen the landscape of the American West as a viable subject for those who recognized the inappropriateness of the transcendental feelings about nature that earlier had inspired Ansel Adams's grand approach. In the 1970s, as different topographical issues became relevant, Robert Adams, Lewis Baltz, and Frank Gohlke [see plate 15], among others, explored the intersections of natural landscape, tract and industrial development, and ecology under the rubric "the new topographics," producing images that appear as if made "without author or art."[34] Furthermore, as air and space travel increased, a small number of photographers, most notably William Garnett and Marilyn Bridges, viewed the landscape from above [see plate 16], revealing a vastly different and much more abstract view of topography than that seen from the vantage point of the lone photographer on foot. The Rephotographic Survey Project, initiated by Mark Klett and others, sought to avoid Adams's rhetoric of the sublime while raising contemporary conceptual issues about the nature and purpose of Western landscape documentation [see plate 17].[35]

The voyeuristic eye **Efforts to focus in on "real life" with all its grittiness, as opposed to the idealized world visible in print ads and on television, increased the voyeuristic tendencies that had always been inherent in photography.[36] The visual exploration of unconventional people and activities became more open in the work of Diane Arbus. By the 1980s themes formerly considered inappropriate in serious photography attracted greater numbers of photographers who probed even further behind the facades erected by convention to hide dysfunctional aspects of American life. In their efforts to bring to light secret urges and unaccountable rituals, they instituted a new kind of voyeurism that**

13 Thomas Frederick Arndt
**Farmer's Rally, State
Capital, St. Paul, Minnesota**
from the project
**Farm Families**, 1986
silver gelatin print
16 x 20 inches
Gift of Jack A. Jaffe,
Focus/Infinity Fund

Thomas Frederick Arndt is a photographer following in the tradition of most early American documentarians. Concerned with investigating life on the city streets, the working poor, and the common man and woman in the United States, Arndt has an eye for the essential detail placed carefully within a simple, journalistic frame. In this image a group of farmers, somewhat dwarfed in the middle of an institutional plaza, appear to be gathered together in a face-off against a imposing bronze forefather looming authoritatively in the background.

14　Peter Bacon Hales
**Cocktail Party, Heart Ball,
Chicago Hilton** from
**Changing Chicago** (1989),
1988
silver gelatin print
16 x 20 inches
Gift of Jack A. Jaffe,
Focus/Infinity Fund

At extremes of the documen-
tary range, there are pho-
tographs of the very poor and
photographs of the very rich.
Both are concerned with
human behavior outside the
average, and both are reveal-
ing of our culture in different
but equally fascinating
ways. Peter Bacon Hales, in
the **Changing Chicago** proj-
ect, documented the season

of high-society balls, bene-
fits, and cocktail parties.
Here the furrowed brow of a
passing gentleman, the
satiny rump of a society lady,
and the wide girth of her
tuxedoed escort signify the
potentially absurd character-
istics of extreme wealth.

15 Frank Gohlke
**Grain Elevator, Series III,
Bison, Oklahoma**, 1973
silver gelatin print
9⅛ x 9¹⁄₁₆ inches
Gift of the Reva and David
Logan Foundation

Whether photographing a
landscape featuring a mun-
dane object such as this grain
elevator or one marked by the
drama of a natural disaster,
Frank Gohlke imbues his
images with restraint. Bring-
ing near and far evenly into a

single plane, **Grain Elevator,
Series III, Bison, Oklahoma**
is a document of a landmark,
a structure central to the
communities in which it is
found and pervasive in the
Midwestern landscape. In
Gohlke's hands, the US land-
scape in all its manifestations

becomes a well-ordered
arena dominated by poetry,
light, and motif. See Peat,
plate 18.

16 Marilyn Bridges
**Farmer's Edge, Badlands, South Dakota D#4,** 1984
silver gelatin print
15 7/8 x 19 7/8 inches
Museum purchase

Marilyn Bridges works in the highly specialized field of aerial photography. Her images document the patterned geometry of our earth's topography and the marks that humans have left upon it. This photograph of a plowed field contributes a unique perspective on a common subject in the American documentary tradition: the farmer and his relationship to the land. The random abstraction of natural geography in contrast to the measured lines drawn in the soil by human hands and man-made machinery highlights the complicated dialectic of human being and earth.

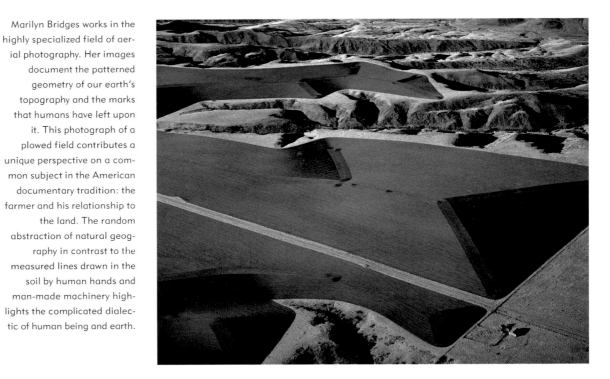

17 Mark Klett
**Looking Through the Snow Tunnel Above Goat Lake, Sawtooth Range**, 1981
silver gelatin print
16 x 20 inches
Museum purchase

Trained as a geologist, Mark Klett established his artistic perspective on the Western American landscape as the chief photographer for the **Rephotographic Survey Project** (1977–79), which rephotographed scenes visited by the first surveys of the West in the 1860s and 1870s. Nineteenth-century photographers found transcendence in the vastness of the American West; **Looking Through the Snow Tunnel Above Goat Lake, Sawtooth Range** is a contemporary celebration of the region's grandeur. Klett's image also gently intrudes on the experience of this pristine site with the inclusion of a tiny human figure, complete with pet. See Miller, plate 22.

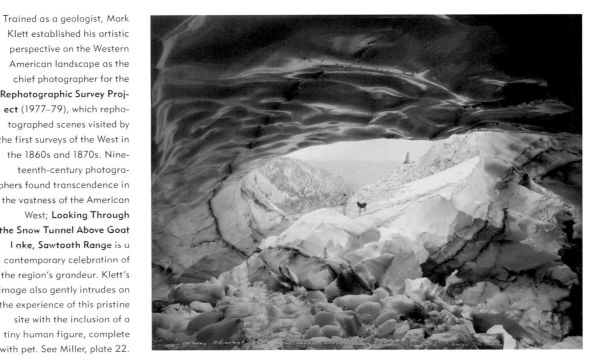

18 Larry Clark
**Untitled** from the portfolio
**Tulsa** (1971), 1971
silver gelatin print
14 x 11 inches
On extended
loan from David C. and
Sarajean Ruttenberg and
the Ruttenberg Family
Limited Partnership
© Larry Clark, courtesy
Luhring Augustine Gallery,
New York

The images from Larry Clark's
series **Tulsa** persist as power-
ful documents of a fringe
lifestyle that continues to
wield fascination in
today's culture. The image
presented here of a young
junkie tapping a vein
is representative of the
unflinching, gritty, subjective
documentary style that
Clark, along with Danny Lyon
and Bruce Davidson, helped
to pioneer. See Parry, plate 8.

soon became acceptable as honest documentations of human foibles and weaknesses. One of the earliest and most unsettling of these personal explorations is Larry Clark's portfolio Tulsa [see plate 18], which depicts aspects of addiction and sexual experiences with all the casualness of the "snapshot." This documentation, and later works by Nan Goldin of a similar nature, may function as therapy for its makers, but unlike earlier exposés of addiction and poverty, the images themselves serve mainly to arrest the eye and to titillate, rather than to invite sympathy or initiate corrective action.

Social documentation and photojournalism    The changes that took place in the practice of social documentation during the 1960s can be seen in the way images of the civil rights struggles of the time were handled. In an era when television had not yet completely preempted picture magazines and newspapers as a source of news, picturing this aspect of American social behavior became the province mainly of photojournalists.[37] The justification for photographing this struggle was not substantially different from that of earlier documentations of, say, child labor or agricultural dislocation. Just as Lewis Hine had hoped "to bring into view what cannot be seen," so Martin

**DOCUMENT**
**ROSENBLUM**

Luther King noted that photographs (of the brutality visited upon blacks) provided the "luminous glare revealing the naked truth" to the world.[38] And just as Hine had been enlisted in 1908 for the emerging campaign against child labor, so Danny Lyon was recruited to picture the activities of militant African-Americans in the South.[39] Nevertheless, despite extensive documentation of the range of activities occurring around the struggle, "the media's greediness for the most valuable of photographic commodities – the image of extreme violence" determined what newspapers and magazines featured.[40]

Attitudes among photojournalists were altered by this struggle as well as by the upheavals in the social fabric caused by the unpopular war in Southeast Asia and the controversial United States role in the popular uprisings in Central America. For some, disaffection with conventional magazine work brought them closer to the earlier documentary tradition. Aiming for an in-depth representation of the civil struggle in Nicaragua in the late 1970s, Susan Meiselas became dissatisfied with the ideology she was expected to support as well as the picture layouts and captioning ordained by the editors of the large picture magazines.[41] As a result, she sought outlets for her work in alternative periodicals and books. The angular shapes of the fleeing woman, the awkwardly held naked child, the shadow, and the bundle, heightened by the color of the verdant landscape, give Fleeing the Bomb to Seek Refuge Outside of Esteli [plate 19] its sense of uneasiness and tension. In recent times color has been used much more frequently by photojournalists both to express emotional tenor and capture the exotic otherness of a situation, as in Mitch Epstein's work in India.

The resurgence of social documentation    Despite the criticism aimed at the social-documentary tradition and in the face of the dominant role played by electronic media and, more recently, digitally produced imagery, photographic documentation as a means to change ideas and/or prompt action was never entirely abandoned by still photographers; indeed, some were able to find federal and state funding for such projects. For instance, portrayals of life in single-room-occupancy hotels and of the urban environment were underwritten by The New York State Council of the Arts during the 1970s.[42] Almost forty years after Marion Palfi photographed child poverty in the United States, the photographer Stephen Shames produced a work on the same subject for The Children's Defense Fund.[43] Labor unions occasionally underwrote endeavors that threw light on work-related problems while publicizing their own efforts at correction.[44]

Nevertheless, in the absence of significant government patronage during the 1950s and 1960s, photographers found it necessary to pursue projects of their own devising. On his own initiative, Danny Lyon photographed inmates and activities in six separate prisons of the Texas Department of Corrections. Clearing Land, Ellis Unit,

19  Susan Meiselas
    **Fleeing the Bomb to Seek
    Refuge Outside of Esteli**
    from the book **Nicaragua**
    (1981), n.d.
    silver dye bleach
    (from color positive) print
    16 x 21 inches
    Gift of the artist

Directly political and fiercely
concerned with a revolution
counter to American foreign
policies of the day, Susan
Meiselas's documentation of
the atrocities and tragedies
of daily life in the midst of
political turbulence belong to
a fervent branch of con-
cerned photojournalism.

Meiselas spent a year docu-
menting the 1978–79 San-
danistan revolution in
Nicaragua from a point of
view decidedly sympathetic to
the rebel forces. This image
of a woman fleeing with a
naked baby in tow is tragic,
but not nearly as visceral as
much of Meiselas's docu-
mentation of violence and

torture from the same series.
Meiselas operates under the
photojournalistic principle of
photographer as public con-
science and of the photo-
graph as evidence of realities
that most people would
rather ignore.

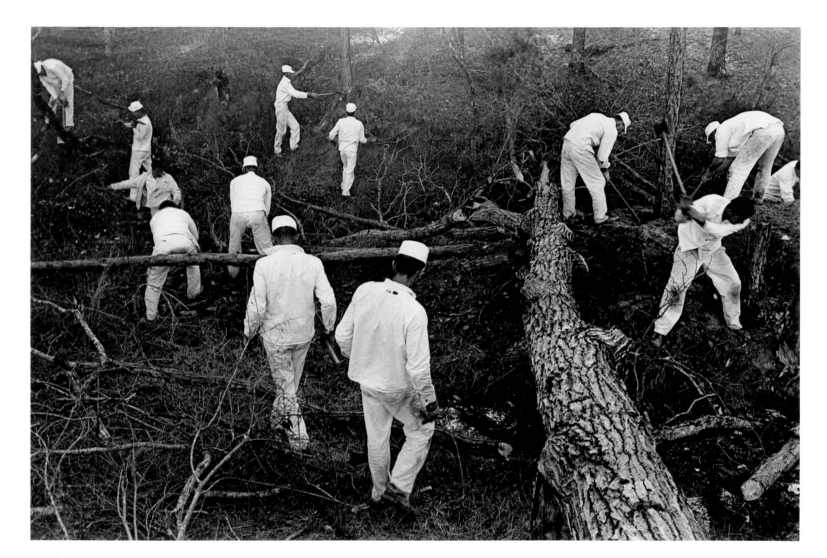

20 Danny Lyon
**Clearing Land, Ellis Unit,**
**Texas** from the portfolio
**Conversations with the**
**Dead** (1983), 1967/69
silver gelatin print
11 x 14 inches
Museum purchase
© Danny Lyon, courtesy
Magnum Photos, New York

Danny Lyon's photojournalis-
tic style is marked by its
staunch pursuit of the unem-
bellished moment. **Clearing**
**Land, Ellis Unit, Texas**, a pic-
ture of a prison work gang,
is part of a series on prison life
that later became the book
**Conversations with the Dead**
(1971). Continuing his inter-
est in the communities that
develop – voluntarily or other-

wise – on the outskirts of
mainstream society, Lyon
photographed the
daily routine and rituals
that evolve in prison and
within which issues of race,
masculinity, and class
coalesce. See Parry, plate 2
and Paschke, plate 4.

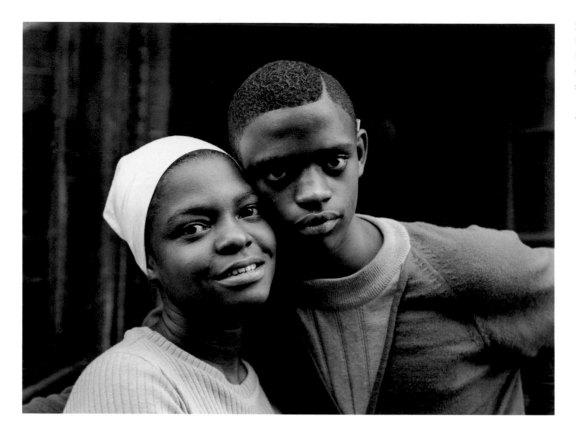

21  Bruce Davidson
**Untitled** from
**East 100th Street**
(1970), 1970
silver gelatin print
11 x 14 inches
Museum purchase

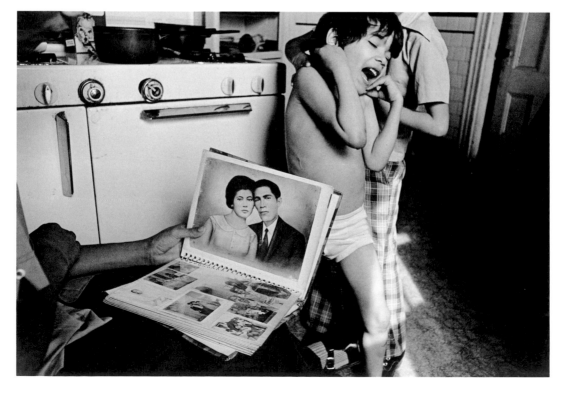

22  Eugene Richards
**Family Album,
Dorchester,
Massachusetts,** 1976
silver gelatin print
11 ⅞ x 17 ½ inches
Museum purchase

21  Bruce Davidson spent two years photographing in the apartments, on the streets, and in the lives of the people of East Harlem. This project, published as **East 100th Street** (1970), uncovers a cross-section of a diverse American social landscape. The portrait reproduced here is relatively simple and straightforward: the tenuous smile of the young woman contrasts with the guarded glare of her boyish companion, speaking to both the normalcy and particular stresses of life in the urban environment.

22  In the tradition of concerned documentary photography, Eugene Richards strives to broadcast the plight of individuals. Like his colleague Susan Meiselas, Richards might be thought of as a soldier with a camera, coming face to face with the difficult and the deadly: poverty in Arkansas, racial violence, political refugees, the drug culture of North Philadelphia, the criminally insane, the experiences of cancer patients. **Family Album, Dorchester, Massachusetts** reflects Richards's personal and political involvement in Dorchester, the deteriorating working-class neighborhood outside of Boston where he grew up. The squirming boy in the background and anonymously held family album in the foreground represent the levels and reach of family — past and present, permanent and evolving.

**DOCUMENT**
**ROSENBLUM**

Texas **[plate 20]**, one of a series meant to show the "free world what life in prison is like," was published in Conversations with the Dead.[45] **The series** East 100th Street **[see plate 21] was a personal odyssey of discovery for Bruce Davidson in addition to being a portrayal of the vulnerability of Latino immigrants living in ethnic ghettos in New York, as were the photographer's later documentations of the New York subways and of Central Park.[46] Starting with a series made in Dorchester, Massachusetts, in 1978 and continuing to the present, Eugene Richards's extensive documentations of life in inner-city ghettos and hospitals, which can be seen in books and exhibitions as well as in the periodical press, are personally motivated projects [see plate 22]. Nicholas Nixon embarked on a familial documentation of the year-by-year changes in the appearances of his wife and her sisters, but broadened out to also portray black family life in the North and South [see plate 23] and later, the world of the sight-impaired. The problems of ordinary working people in agriculture were addressed by Ken Light and Debbie Fleming Caffrey [see plate 24]. Combining portraiture and sociological investigation, photographers have on their own produced numerous documentations of the conditions of the homeless and those with AIDS.**

**During the 1980s those interested in photographing the social scene (along with critics of the medium who had emerged in the wake of an expanding art market for photographs) further enlarged the parameters of social documentation to include more complex ideological issues. Resurgent feminism, for one, inspired a variety of portrait documentations, among them those by Judy Dater and Anne Noggle. As the title of her work indicates, Noggle's unglamorized frontal portrait suggests how common media-driven perceptions about older women in American society affect self-image [plate 25]. The related issue of domestic violence prompted photojournalist Donna Ferrato not only to initiate an in-depth documentation of this ugly phenomenon, but also set up a foundation to aid victimized women. The ever-increasing despoliation of the land by industrial pollution has engaged Robert Glenn Ketchum and Richard Misrach [see plate 26], while the continuing presence of dangerous and deteriorating nuclear facilities has furnished Emmet Gowin and Barbara Norfleet [see plate 27] with their themes. Even the old terminology has returned to usage; photojournalist Mary Ellen Mark, who regards her commissioned magazine work as a means of supporting self-motivated projects, refers to herself as a "social-documentary" photographer.[47]**

**Perhaps the clearest signal of a return to the traditional documentary purpose has come from Chicago. Aided by a fund set up by Jack A. Jaffe, whose own photographs of industrial sites around the city demonstrate his appreciation of the genre as it had been traditionally practiced, the project aimed to document a broad spectrum of ordinary life in Chicago. Thirty-three photographers, working in black and white and in color, were commissioned to contribute to** Changing Chicago,

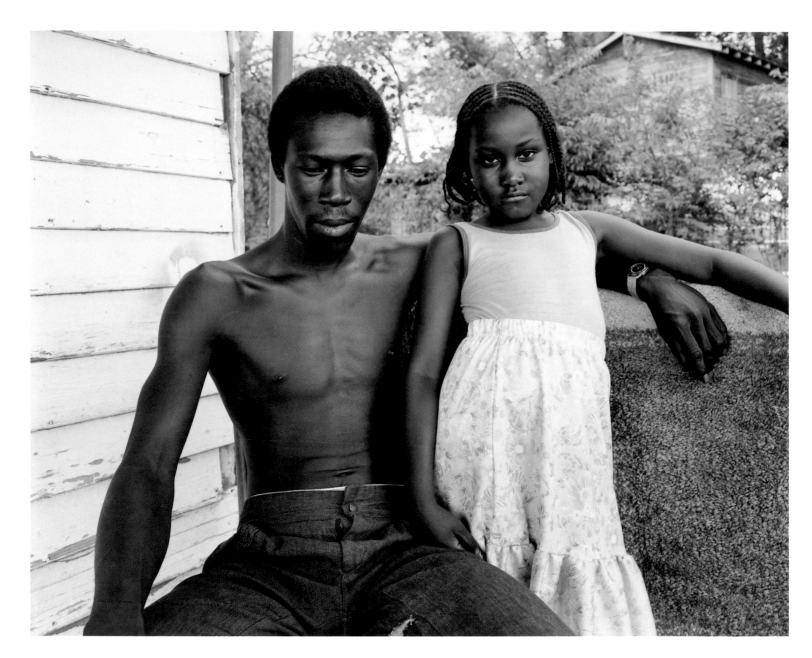

23    Nicholas Nixon
**Yazoo City, Mississippi,**
1979
silver gelatin print
8 x 10 inches
Museum purchase
© Nicholas Nixon,
courtesy Fraenkel Gallery,
San Francisco

Although best known for his
ongoing portrait series of his
wife and her sisters, Nicholas
Nixon addresses almost the
entire gamut of traditional
documentary subjects – the
dignity of the poor, the family,
the elderly, the ill – essentially
pictures of people of all and

any type. Using an 8-by-10-
inch camera, Nixon captures
the essential textures, tonali-
ties, and expressions of the
people he photographs.
This portrait of a man and
his daughter exudes a fragile
tension. The young girl,
draped protectively across
her father, steadily meets the

photographer's gaze. Mean-
while, her father's downcast
eyes, caught in an off-guard
second between expressions,
appear spent and exhausted.
See Paschke, plate 1.

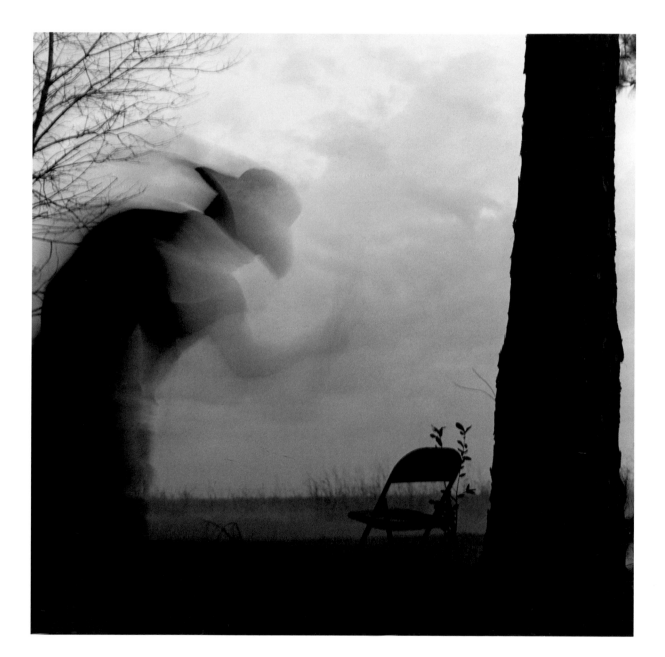

24  Debbie Fleming Caffrey
    **Burning Pine Needles**, 1988
    silver gelatin print
    10 x 10 inches
    Purchase through the
    Museum Membership
    Fine Print Program

Since the early 1970s, Debbie Fleming Caffrey has photographed workers from the sugarcane fields and sugar mills in rural Louisiana, where she was born. Her sensitive use of light, shadow, texture, composition, and form shapes romantic portraits of field workers, men, women, children, and the elderly. Images such as **Burning Pine Needles**, with its ghostly worker representing both activity and absence, are documents that belong to the realm of photographic abstraction as much as to reportage.

25  Anne Noggle
**Self Image**, 1981
silver gelatin print
13 x 8¾ inches
Gift of Jeanne and
Richard S. Press

Choosing portraiture as her
specialty, Anne Noggle cre-
ates documents of extraordi-
nary sincerity. She refers to
her self-portraits as her "saga
of fallen flesh," and in them
offers witty and engaging
versions of herself: wearing
pearls under water, wearing
denim in the desert, flying, in
the darkroom, recuperating
after a face-lift, or – as here –
simply looking grim behind
the imprisoning lines of
a shadow. This saga uses
images of the self to look
unabashedly at aging, a
process all of Noggle's
photographs handle with
humor, honesty, and respect.
See Paschke, plate 3.

26  Richard Misrach
**Stranded Rowboat,**
**Salton Sea**, 1983
chromogenic
development (from color
negative) print
20 x 24 inches
Museum purchase

Richard Misrach's dedication
to the Southwest's desert at
first seems to echo a land-
scape documentary tradition
more than social-documen-
tary work. Yet Misrach's life-
time project, the **Desert**
**Cantos** series, with its individ-
ual segments divided up

between the terrain, events
(the landing of a space shut-
tle, military testing), floods,
and fires, has as much to
do with social issues as with
man's presence within
nature. The Salton Sea, pic-
tured here, an ancient, dried-
up lake, was purposely
reflooded in the early twenti-

eth century as part of local
land-management policies.
Misrach uses the lush desert
palette to paint an elegant
picture of the strangeness
and upset balance of human
activity in an alien landscape.

27  Barbara Norfleet
**Space Museum,**
**Alamogordo, New Mexico,**
1988
silver gelatin print
8 ½ x 12 ½ inches
Purchase through the
Museum Membership Fine
Print Program

In an offshoot of war
photography, some contem-
porary American photogra-
phers have turned to
documenting the military-
industrial complex purport-
edly designed to maintain
this country's preparedness
for conflict. Barbara Norfleet,
who has long been interested
in the social history of the

United States, channeled
her involvement with the ver-
nacular to examine various
sites around the country
linked to the culture of com-
bat, such as this New Mexico
museum. **The Aesthetics**
**of Defense**, the project that
produced **Space Museum,**
**Alamogordo, New Mexico**, is
an investigation of a world
where lethal and threatening

objects and scenes can often
appear innocuous and beau-
tiful. Here the bright desert
sunlight captures the mun-
dane quality of this missile.
Norfleet has evoked an
uneasy vision of contempo-
rary American civilization.

28  Susan Crocker
**Raising Gang Preparing
to Connect Steel** from
**Changing Chicago** (1989),
1987
silver gelatin print
18 x 18 inches
Gift of Jack A. Jaffe,
Focus/Infinity Fund

The rise of the modern
American city, with its mes-
merizing steel-and-glass sky-
scrapers, has been preserved
by the best of American doc-
umentary photographers.
Susan Crocker contributes to
this ongoing tradition with an
image that becomes an
abstraction of giant puzzle
pieces being fitted together
to raise the structure. Just

visible in the background are
the upper levels of the
Chicago skyline as they are
surpassed by the new archi-
tectural addition. This classic
moment encompasses the
essential American ideals of
individual bravery and the
continual quest for progress –
defined as bigger and better.

as both the resulting exhibition and publication were known.[48] They focused on neighborhood architecture and street life, skyscraper construction, ethnic enclaves and food stores, women's activities, and how the dysfunctional were treated, with the majority of the works portraying people in their homes, streets, and workplaces. Besides the already mentioned Chicago photographers David Avison, Peter Bacon Hales, Stephen Marc, and Bob Thall, eight women participated. Melissa Ann Pinney and Angela Kelly were drawn to themes traditionally associated with women's interests, but Kathleen Collins and Susan Crocker tackled the activities of male workers involved in factory and construction jobs [see plate 28].

This documentation, as well as many of the others mentioned above, reached the public in book format. The popularity of the picture magazines and, after the 1950s, of television helped create an appetite for photographically illustrated books, while improvements in the techniques of reproduction and the spread of photographic instruction also contributed to promoting this modality. By the 1990s the photograph in reproduction – most commonly in printers' ink and both in monochrome and in color – had become the form in which most people experienced the camera image. This was especially true of documentation, whether of a social or personal nature. One difference between the old and new documentary mode is the relationship of image to text. From being the more significant aspect of the combination from the 1870s through the first decade, through being more or less in balance through the 1930s and 1940s, the texts have become secondary as more and more viewers are expected to understand the metaphorical meaning of the images without explication. Thus, besides short captions, only a historical survey of the genre and a paean to the city appeared in Changing Chicago.

Images that embrace social goals and emphasize humanist values have played a distinctive and at times vital role in the history of social action in the Western industrialized nations, and they remain as testaments to the passion and commitment of visionary photographers and reformers. The recent resurgence of the documentary impulse, coming at the same time as an antithetical fancy for imaginatively fabricated camera images, attests to continuing curiosity about the built and organic structures of the real world. It suggests that as long as social relationships produce social problems, the camera will be used to document them.

**DOCUMENT**
**ROSENBLUM**

1 Examples of such records are the portraits of domestics, laborers, and gentry by Heinrich Tönnies, who worked in Aalborg, Denmark between 1864 and 1902; the project to portray the social structure of his era undertaken by August Sander between 1904 and 1959; Lewis W. Hine's series entitled **Work Portraits** started in the 1920s.

2 In 1867 British merchant Benjamin Stone started collecting photographs and took up the medium himself, eventually creating the National Photographic Record; see **Sir Benjamin Stone, 1838–1914** (London: The National Portrait Gallery, 1974). The Historical Section of the Farm Security Administration was only one of the federally sponsored projects that made use of photographers; others included the WPA (Works Projects Administration), the TVA (Tennessee Valley Authority); the REA (Rural Electrification Administration). In addition, state and private agencies, such as the American Red Cross, commissioned documentary projects and established archives.

3 As early as 1854, the East India Company made arrangements to employ as photographer Captain Linnaeus Tripe of the Twelfth Madras Native Infantry to provide the Madras government with images of "edifices, sculptures, and inscriptions." The relationship between imperialism and (as feminists might note) documentation is made manifest in Samuel Bourne's plea for photographers "from the five corners of the globe" to show "the places the camera has penetrated." From the mid-1850s through the 1870s, British photographers in particular – among them Antonio Beato, Samuel Bourne, Francis Frith, Willoughby Wallace Hooper, William Johnson, James Robertson, John Thomson, and Tripe – produced such documentations.

4 One of the most inclusive of these surveys – the four volumes of images published in 1873–74 by John Thomson as **Illustrations of China and Its People** – opened up what the photographer believed to be "a window to the orient."

5 Arthur Munby's collection of **carte-de-visite** photographs of women workers in mines and brickworks. See Michael Hiley, **Victorian Working Women: Portraits from Life** (London: Gordon Fraser, 1979).

6 The London-based missionary Dr. Thomas Barnardo had photographs made of the more than 50,000 homeless children who passed through his juvenile homes. The record portraits have the look of uninflected documents (similar in nature to the portraits of "criminals" advocated for police work by Alphonse Bertillon in France), while those intended for fundraising emphasize emotional values by playing on the sympathy of the viewer through the adroit management of pose and expression. See **The Camera and Dr. Barnardo** (Hertford, England: Barnardo School, n.d.).

7 This institution had been established by the French imperial government for war invalids and working men. Other examples of seemingly neutral but actually idealized documentation of the expanding industrial infrastructure are by Edouard Baldus, of the French railroad system, and by Philip Henry Delamotte, of the building of the Crystal Palace in London.

8 Largely produced between 1862 and 1875 by William Henry Jackson, Eadweard Muybridge, Timothy O'Sullivan, and Carlton E. Watkins.

9 As in the projects undertaken by Charles Marville between 1854 and 1878 to document the old and rebuilt Paris and by Glasgow photographer Thomas Annan in 1868 to photograph slums slated for demolition in the city's central district.

10 The **Illustrated London News** was founded in 1842, **L'Illustration** (Paris) and **Illustrierte Zeitung** (Munich) in 1844, **Frank Leslie's** in 1855, and **Harper's Weekly** in 1857.

11 The halftone plate involved photographing the camera image through a divided screen onto a metal plate that was subsequently etched and then locked in place and inked with the type, thereby reducing the cost of reproduction.

12 The first publication to combine photographic images (translated into engravings) and texts in this manner was **London Labour and London Poor**, initially issued as articles in the London daily press and then published in two volumes in 1851; see Peter Quennell, ed., **Mayhew's London: Henry Mayhew** (London: Bracken Books, 1984). It was followed by Adolphe Smith and John Thomson, **Street Life In London** (London: Sampson Low, Marston, Searle and Rivington, 1878) which made use of Woodburytype reproductions of Thomson's photographs.

13 In the mid-1930s, Rexford Guy Tugwell and Roy Stryker of the US Department of Agriculture concluded that photography might play a role in arousing an educated public to pressure authorities to ameliorate unjust and unhealthy conditions.

14 See Beaumont Newhall, "Documentary Approach to Photography," **Parnassus** 10 (March 1938), p. 5. The term "documentary" later became subject to extremely broad interpretation; e.g., **Sex Objects: An American Photographic Documentary** by Erik Kroll.

15 "Documentary: That's a sophisticated and misleading word....The term should be documentary style… a document has use, but art is really useless." Walker Evans, quoted in Leslie Katz, "Interview with Walker Evans," **Art in America**, March–April 1971, p. 87.

16 As director of a photographic project for Standard Oil of New Jersey, Stryker applied the FSA precepts toward improving the image of a company that since the days of John D. Rockefeller had symbolized rapacious American industry. For an extensive portrayal of all aspects of the oil industry, he hired eleven photographers experienced in documentary work, resulting in an archive of some hundreds of thousands of pictures.

17 At a symposium entitled "What is Modern Photography?," held at The Museum of Modern Art on October 30, 1950 and taped for radio station WNYC, photojournalist Homer Page noted the trend "away from the old documentary standby of objective reporting toward a more intimate and subjective way." Tape of proceedings in Museum Archives, The Museum of Modern Art, New York.

18 Martha Rosler, "The Context of Meaning," **Critical Histories in Photography**, Richard Bolton, ed. (Cambridge, MA: MIT Press, 1989), p. 307.

19 A recent exhibition and book entitled **Raised by Wolves: Photographs and Documents of Runaways by Jim Goldberg** is an attempt to document the lives of two children using artifacts, interviews, and photographs, which "interweaves fact and fiction." See **SFMOMA News**, May–June 1997, p. 4.

20 Among critics who have expressed similar views are Andy Grundberg, Maren Stange, Sally Stein, and Alan Sekula.

21 FSA photographs were shown at the California Pacific International Exposition in San Diego in 1936; the Texas Centennial Exposition, Dallas, 1936; the Great Lakes Centennial Exposition, Cleveland, 1936; the International Photographic Salon, Grand Central Palace, New York, 1938; see Lynn Lopata Lewis, "The F.S.A. Project: Its Effect on Photojournalism in the Sixties," Masters Thesis, University of Missouri School of Journalism, 1967.

22 Irving Penn expressed this view in "What is Modern Photography?" (note 17).

23 Beaumont and Nancy Newhall, "Dorothea Lange," In **Masters of Photography** (New York: George Braziller, Inc., 1958), p. 140.

24 W. Eugene Smith, quoted in Lewis (note 21), p. 99.

25 The attitude of Edward Steichen, director of the Department of Photography at The Museum of Modern Art from 1948 to 1962, towards collecting social documentary images was not consistent. In 1952 he had turned down the Lewis Hine collection offered by the Photo League, although a few years later he was to mount "The Family of Man" exhibition, which included works made as social documentation; in 1962 he organized "The Bitter Years," an exhibition of FSA photographs.

26 An exception to the lack of sponsorship of social documentary photographs was the Rosenwald Foundation, which supported documentation by photographer Marion Palfi in 1946 of civil rights abuses.

27 Casual street photography attracted patricians such as the Italian count Giuseppe Primoli, proletarians like English journeyman printer Paul Martin, bohemians like French former actor Eugène Atget, and middle-class Americans like Alice Austen. The images covered a spectrum from carefully posed documentation to vivacious, unposed "snapshots," but for the most part, neither social change nor compassion for the down-trodden were prime motivations of these photographers.

28 See **Kamoinge Workshop Portfolios 1 and 2** (1964–65); **Black Photographers Annual 1–4** (1972–80); Deborah Willis Thomas, **An Illustrated Bio-Biography of Black Photographers, 1840–1940** (New York and London: Garland Publishing, 1989). See also **Strong Hearts: Native American Voices and Visions** (New York: Aperture, 1995).

29 The Institute of Design was established in Chicago in 1937 by László Moholy-Nagy as The New Bauhaus; it closed in 1938 and was reopened in 1939 as the School of Design. The name was changed to the Institute of Design in 1944; in 1949 it joined the Illinois Institute of Technology.

30 Unable at first to interest an American publisher, the book appeared in 1958 in French as **Les Américains**; when it was published in the United States by Grove Press a year later, **The Americans** was greeted with antagonism by establishment critics.

31 Garry Winogrand, quoted in Jonathan Green, **American Photography: A Critical History, 1945 to the Present** (New York: Harry N. Abrams, 1984), p. 97. Winogrand's position was persuasively put forth by John Szarkowski, director of the Department of Photography at The Museum of Modern Art from 1962 until 1992.

32 Walker Evans, quoted in Judith Keller, **Walker Evans: The Getty Museum Collection** (Malibu, CA: J. Paul Getty Museum, 1996), p. 182.

33 See Nathan Lyons, ed., **Contemporary Photographers: Toward a Social Landscape** (Rochester, NY: Horizon Press in collaboration with George Eastman House, 1966).

34 William Jenkins, "Introduction," **New Topographics: Photographs of a Man-altered Landscape** (Rochester, NY: George Eastman House, 1975), p. 6. The term "topographics" refers to the topographical surveys of the post–Civil War years undertaken under the aegis of the federal government surveying teams and the railroad companies, and carried out by Thomas O'Sullivan, W.H. Jackson, and others.

35 Besides Klett, the photographers who initiated the project were Ellen Manchester and JoAnn Verburg; Gordon Bushaw and Rick Dingus also worked on the project, which unlike the nineteenth-century topographical surveys it mimicked, was not funded by the federal government.

36 Pornographic and erotic daguerreotypes appeared soon after the photographic process was announced, and erotic and sexual subject matter continued to be commercially viable into the twentieth century. Images of male and female nudes also appeared under the heading of art studies, although they probably were collected by those interested in erotica as well as by artists.

37 In 1953 fewer than half of American households had television sets; three years later eighty-three percent had sets; in 1962 the Telstar Communications satellite made video images available worldwide.

38 Lewis Hine, quoted in Alan Trachtenberg, "Ever the Human Document," **America and Lewis Hine** (Millerton, NY: Aperture, 1977), p. 130; Martin Luther King, quoted in Steven Kasher, **The Civil Rights Movement: A Photographic History, 1954–68** (New York: Abbeville Press, 1996), p. 8.

39 Hine was hired by Arthur Kellogg of **Charities and Commons** magazine (later **Survey Graphic**). James Forman, head of the Student Non-violent Co-ordinating Committee (SNCC), hired Lyon. Some forty others, including at least five African-Americans, photographed the struggle over a period of years.

40 Kasher (note 38), p.13. Relatively few books about the struggle were published at the time; one exception is **America in Crisis** (New York: A Ridge Press Book, Holt, Rinehart and Winston, 1969). **Memories of the Southern Civil Rights Movement by Danny Lyon** (Chapel Hill: The Center for Documentary Studies, Duke University and The University of North Carolina Press) was not published until 1992.

41 See Susan Meiselas, **Carnival Strippers** (New York: Farrar, Straus and Giroux, 1976); **Nicaragua: June 1978–July 1979** (New York: Pantheon Books, 1981); see also Harry Mattison, ed., **El Salvador: Work of 30 Photographers** (New York: Pantheon Books, 1983).

42 See, for example, portfolios by Laurence Salzmann, **Neighbors on the Block: Life in Single Room Occupancy Hotels** (NYSCA, 1971) and Arthur Tress, **Open Spaces in the Inner City: Ecology and the Urban Environment** (NYSCA, 1971).

43 Stephen Shames, **Outside the Dream: Child Poverty in America** (New York: Aperture Foundation and The Children's Defense Fund, 1991).

44 A series on mine workers by Earl Dotter was supported in part by the United Mine Workers Union; his documentation of the effects of brown lung disease was made under the aegis of the United Textile Workers; a documentation of hospital workers in New York by Georgeen Comerford was underwritten by Local 1199 of the Health and Hospital Workers Union.

45  Danny Lyon, **Conversations with the Dead: Photographs of Prison Life with the Letters and Drawings of Billy McCune #122054** (New York, Chicago, and San Francisco: Holt, Rinehart and Winston, 1969), p.13.

46  "I felt the need to belong when I took pictures – to discover something inside myself while making an emotional connection with my subjects." In Bruce Davidson, "Introduction," in **Bruce Davidson Photographs** (New York: An Agrinde/Summit Book, 1978), p. 9.

47  Mary Ellen Mark, quoted in Melissa Harris, Interview: "Mary Ellen Mark," **Aperture** 146 (Winter 1997), p. 48.

48  See **Changing Chicago: A Photodocumentary**, published in conjunction with the Chicago Historical Society and the Focus/Infinity Fund (Urbana and Chicago: University of Illinois Press, 1989). The fact that documentary photography, photojournalism, and street photography had come together in Jaffe's thought can be ascertained from his mention in the Preface of the work of Lange, Smith, and Cartier-Bresson as the inspiration for the project. Photographers were asked to submit their particular themes so that the varied aspects of life in the metropolis would be covered; eventually meetings were held to discuss the project. Exhibitions of the work were held simultaneously in five different venues in the city.

Professional journalism, studio portraiture, and advertising are normally called "commercial work" to distinguish them from other categories of expressive, or artistic, photographic work. But it is increasingly difficult to keep contemporary photography corralled within such classifications. Workers using photography as a persuasive commercial medium add to their bag of tools equally in the rarefied atmosphere of the art gallery and the rough and tumble of competitive professional life. And, of course, photo-based artists very often use their craft skills in the commercial world to make a better living (or a living at all!). Hybridization and cross-pollination between areas of contemporary photography are the norm, not the exception.

More recently this blurring of boundaries once considered inviolate has infiltrated traditional institutional thinking. For example, The Museum of Contemporary Photography has regularly presented exhibitions during the 1990s dealing with professional photography, including work commissioned by Liz Claiborne, United Colors of Benetton, and The GAP [see plate 1]. In 1996 the museum mounted a large exhibition, "Target Market: Professional Photography in Chicago," that contained hundreds of examples of high-quality professional / commercial work [plate 2].

It is possible to sit through years of art history classes about painting without once hearing a

Rod Slemmons

# **professional** and **commercial** photography

discussion of painting houses. But it is impossible to deal with photographic imagery used for any specific purpose without accepting that its uses for **all** other purposes will be accessed by the viewer on the slightest of allusive pretexts. This fact is utilized in a controlled way by good advertising photographers and expressive art photographers alike, and ignored to their despair. In this respect photography as a picture-making tool is much more like verbal language than other similar tools. Certain imagery retains a positive or negative charge from previous use that it can release unexpectedly into a new context, much like words recombined into poetry. In the 1970s and 1980s, cultural philosophers such as Roland Barthes and others suggested a more profound connection between photographic imagery and language by applying principles of semiotics to its analysis. The analysis was valuable, but thinking of photographs as language, complete with dialect and syntax, was not new. Great magazine designers such as Alexey Brodovitch had made the connection decades before [see below].

1  "Photography and Marketing"
The Museum of Contemporary Photography exhibition
April 9–June 4, 1994
view of the Resource Room
Photograph by
Thomas A. Nowak

The 1994 exhibition "Photography and Marketing" presented work created by prominent artists and photographers in advertising campaigns for The GAP, Inc. and Liz Claiborne, Inc. The exhibition of images from these two campaigns – The GAP: Individuals of Style and Liz Claiborne, Inc.: Women's Work – included a "response wall" for audience feedback in the museum's Resource Room, seen in this view. Highlighting the creative connection between art and commercial work, the exhibition created a dialogue concerning the power of photography in marketing and advertising, trends in commerce and culture, and the economic and social impact of advertising. See plates 6, 10, and 18.

2  "Target Market:
   Professional Photography
   in Chicago"
   The Museum of Contemporary
   Photography exhibition
   November 11, 1995–
   January 13, 1996
   Installation view
   Photograph by
   Thomas A. Nowak

The exhibition "Target
Market: Professional Photog-
raphy in Chicago" celebrated
the significant contributions
of Chicago professionals
to the commercial photogra-
phy industry. Featuring
photographs, transparencies,
commercial film reels, and

printed matter such as
annual reports and tear
sheets, the exhibition show-
cased the work of forty of the
city's leading commercial
photographers. This view of
the museum's West Gallery
shows the installation's dra-
matic wall of lightboxes
with continually changed

8-by-10-inch transparencies
by the participating photog-
raphers in a simulation of
an advertising agency envi-
ronment. See plate 14.

The distinction between professional and art photography follows a hilly path through the history of photography. Across the turn of the century, both the Linked Ring in Britain and Alfred Stieglitz's Photo Secession in the United States went through phases of indignant railing against making pictures for money. In 1899 Sadakichi Hartmann, writing about the professional photography of Eva Watson in the **Photographic Times**, reflected the current feeling among artist-amateurs: "...Messrs. Stieglitz, Day and Keiley are artistic photographers: like the true artist they only depict what pleases them, and not everybody who gives twenty-five dollars in return."[1] A few years earlier, in 1892, an elite group of amateurs formed themselves into the Linked Ring in Britain, with the express purpose of distinguishing themselves from both scientific and professional photography. The attitude of this group, and the editorial position of **American Amateur Photographer** magazine, for which Stieglitz worked in the early 1890s, would affect American art photography circles for years to come.[2]

David Haberstich, head of photography at the National Museum of American History, Washington, DC, responding in 1997 to a series of questions on an Internet art photography list, noted that there is still a defensive atmosphere surrounding the distinction between commercial and artistic photography. "Unfortunately, each term carries with it considerable critical and emotional baggage. I would suggest that the history of the peculiar fight to have photography included in the fine arts in the United States created a certain defensive posture among artist-photographers, resulting in the feeling that a distinction was needed."[3] At the same time that this discussion was going on, Mary Ellen Mark, Nan Goldin, David Levinthal, Joel Sternfeld, and other luminaries in the world of art photography produced photographs accompanying fashion and shopping articles, and in one case, in **The New York Times Magazine**.[4] As Haberstich implied, it might make more sense to concentrate on how photographs accomplish what they do than to try to divide them into categories. Nan Goldin, well known in art photography circles for her long, semi-autobiographical work, **The Ballad of Sexual Dependency**, which deals, among other things, with underground sex and drug culture, recently produced photographs for an article on the fashion model industry. Written by Jennifer Egan, the piece focuses on a very young girl, James King, and her life as a model [plate 3]. Goldin used the same **cinéma vérité** style of her previous expressive work to great advantage here. The gritty, off-balance imagery – both in color and gravity – made mostly behind the scenes, contrasts harshly with what we know to be the end-product of the industry.[5] Unlike Goldin, Duane Michals, who has done freelance commercial work during most of his career as an influential artist-photographer, rarely uses his familiar style of sequential imagery with handwritten text for advertising imagery [see plate 4]. His Eveready Battery advertisement is a notable exception [figure 1].

The great value that the photographic image brings to the commercial world is its rhetorical power. The ability of photographs to persuade, dissuade, flatter, tilt, sway, or spin – however ambiguously based on a sliding scale of social conventions and constructions – is

**figure 1**
**Duane Michals**
**Eveready Battery**
**advertisement,**
**1993**
**11½ x 17 inches each**
**© 1993 Eveready**
**Battery Company, Inc.,**
**courtesy Chiat/Day**

**market**
**slemmons**

money in the bank to advertisers, journalists, and studio professionals. Part of this power is based on illusion: photographs always seem to tell us a lot more than they really do. And in turn, this illusion has been strengthened by the fact that in an image-saturated culture, we can no longer see in terms other than photographic. The source of this illusion is no mystery.

While photography had been long used as an evidentiary and documentary tool, the half decade between 1935 and US involvement in World War II witnessed an explosion in the mixing of its rhetorical powers with art strategies in the popular media and advertising. **Harper's Bazaar**, a Hearst publication, under the leadership of editor Carmel Snow, hired the legendary art director Alexey Brodovitch in 1934. Brodovitch, in his amazing way, was able to utilize equally the documentary talents of a Walker Evans and the artistic talents of a Man Ray, who also made a portion of his living as a fashion photographer. Brodovitch would eventually use imagery by fellow Europeans George Hoyningen-Huene, Werner Bischof, Henri Cartier-Bresson, Martin Munkacsi, as well as Americans Richard Avedon, Louise Dahl-Wolfe, Irving Penn (who had been his student at the Pennsylvania Museum School of Industrial Art in the early 1930s), and the Europeanized Man Ray. He purposefully blurred the

3    Nan Goldin
     James King backstage
     at the Karl Lagerfeld show,
     Paris, 1995
     silver dye bleach
     (from color positive) print
     15 13/16 x 23 5/8 inches
     Museum purchase

Nan Goldin is known in the art world for documenting her surrogate family of friends as they engage in intimate, uninhibited, or illicit activities. These unusually lit images are frank confrontations with personal experience, frequently presented in poses that mimic the styles of the fashion world. Goldin visited that world with photographs she took for a

New York Times Magazine cover story – "James Is a Girl," by Jennifer Egan – that appeared on February 4, 1996. King's languid and mature pose in this photograph speaks of a teenager who has experienced much; it appeared in a cropped form on the magazine's cover.

**4 Duane Michals**
Gilles **from the series**
Poetry and Tales,
**1991**
**four silver gelatin prints**
**4 ¹³/₁₆ x 6 ³/₄ inches each**
**Gift of the artist**

Duane Michals has a long and accomplished history of transgressing photography's norms – he has painted over, written on, and arranged photographs into highly personal stories. Evoking the passage of time, Michals's sequenced imagery, such as Gilles, presents arrested moments in time, an interrupted continuity. These tableaus of text and image make real the invisible reality of relationships, emotions, and fantasies. While the themes of his art are generally of the most intimate nature, Michals has also successfully applied his distinctive style to the very public realm of commercial photography. See figure 1.

  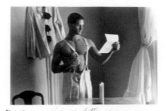 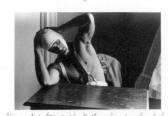

Gilles receives a sea shell from Columbine.
And when he puts it to his ear, he hears her say,
"I love you."

Gilles builds a house of cards
to share with Columbine.

Gilles receives a letter announcing
the marriage of Columbine to Harlequin.

Wounded by grief, Gilles dies of melancholy.

distinctions between commercial and "art" photography by making art strategies, such as Man Ray's Surrealism, work for advertising. When he arrived from Europe in 1930, he brought his own versions of Surrealism and Constructivism, Bauhaus principles of experimentation, and the New Vision, and injected them into his design projects, from which they spread to the minds and practice of the photographers working for the magazine. In 1947 Brodovitch hired Robert Frank, recently arrived from Switzerland, as a fashion photographer. Ten years later Frank would weld the European vision they shared to the strong American documentary tradition in his book **The Americans**, and thereby change the course of American art photography.[6]

Condé Nast's **Vogue** had made the transition from the 1920s soft-focus Pictorial fashion work of Adolf de Meyer and Edward Steichen to a more spare, direct look – Steichen made the move, de Meyer did not – elaborated by Steichen and later by Irving Penn. On the West Coast, also in the mid-1930s, a group calling itself f64, which included Imogen Cunningham and Edward Weston, had made a similar shift from sentimental soft-focus Pictorialism to crisp focus, simple subjects, and elegant simplicity. This new look in art photography, sometimes called Precisionism, and the same shift later in advertising and fashion photography, were both directly influenced by the **Neue Sachlichkeit** photography in Germany (usually translated as "new objectivity," but closer to "new sobriety" or "new seriousness") and **le style modern** in France.

Professional photographic journalism took a leap forward when the first issue of **Life**, November 23, 1936, appeared with an image on the cover of Fort Peck Dam by Margaret Bourke-White, the most successful and famous commercial photographer of her time. Bourke-White had worked previously with expatriate Italian Futurist designers for **Fortune** and was aware of Russian Constructivism. She folded design elements of both into her work and the philosophy of the latter – an extreme confidence in machinery and industry as the saviors of society. Henry Luce, publisher of **Life** (and **Fortune**), was a conservative and not at all supportive of the social reform foundations of Franklin D. Roosevelt's projects to bring the country out of the Great Depression. But he knew the style of the documentary photographs generated by the administration's Farm Security Administration/Historical Section would grab and hold the eye long enough to pass it on to the adjacent advertising.

**Life** coopted the visual authority of the black-and-white documentary photographs as well as the energy surrounding congressional questions about their authenticity as evidence. The text accompanying Bourke-White's photographs, while celebrating the creation of thousands of jobs to build the dam, is critical of the apparent moral turpitude of the construction gangs and their families. The advertisements, on the other hand, make the profound economic depression of 1936 seem very far away, and by extension, would seem to indicate that Roosevelt's solutions were effective. The many car advertisements, often in color, in this first issue, with scrubbed families smiling through the windshields of the lat-

5 An interest in the artistic aspects of her medium led Louise Dahl-Wolfe to introduce a fresh informality into the elegance that dominated fashion photography in the 1930s and 1940s. She was one of the first fashion photographers to use distant locations and natural lighting for her shoots. The resulting images included unexpected and original compositions such as this pairing of grace with destruction. See plate 8 and Parry, plate 10.

6 In a controversial advertising campaign of the early 1990s, international apparel manufacturer Benetton Group SPA used images representing major social issues in an example of tying products to causes. The campaign's photographs showed such subjects as a violent interrogation in the former Soviet Union, an oil-covered bird in the Persian Gulf, a mercenary brandishing a tommygun and a human thigh bone, and an AIDS patient on his deathbed. Their use raised questions about the implications of such advertising strategies. While the impact of the images helped consumers remember the company, critics considered Benetton irresponsible for stripping news images of their contexts.

**market**
**slemmons**

est models, are in stark contrast to the FSA images of jalopies full of desperate people staggering westward out of the battered midsection of the country.

**You Have Seen Their Faces** by Margaret Bourke-White and her husband, playwright Erskine Caldwell, was published in 1937. In 1938 Walker Evans's **American Photographs** book and exhibition were produced by The Museum of Modern Art in New York. **An American Exodus: A Record of Human Erosion** by Dorothea Lange and her husband, the progressive economist Paul S. Taylor, was published in 1939. If one puts all three books on a table along with the 1936 first issue of **Life** and contemporaneous issues of **Vogue** and **Harper's Bazaar**, the 1930s explosion of confidence in the persuasive power of the photograph and its spectrum of uses is astonishing. But perhaps most revealing for the purpose of understanding journalistic and advertising uses of the medium is the evidence that the same kinds of pictures can be used for very different, even opposite, purposes: to sell products in a commercial magazine, to sell government-sponsored programs based on progressive social reform, to decry the condition of a sizable percentage of the population during the Great Depression, and to produce a mythological vision of a unified nation.

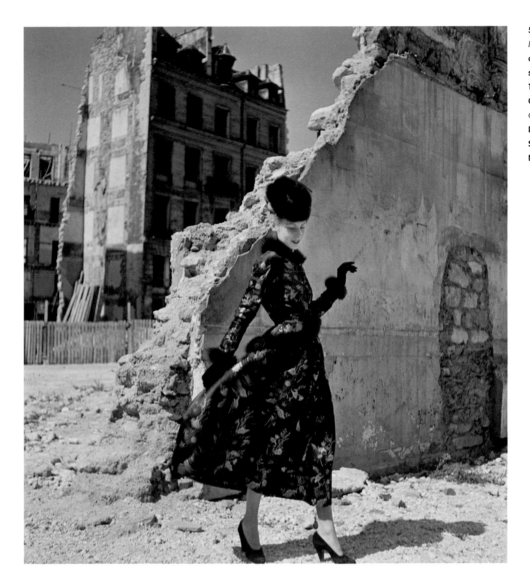

5   Louise Dahl-Wolfe
*Model Amid Ruins, Paris,*
c. early 1950s
silver gelatin print
10 ½ x 9 ½ inches
Gift of the artist
© The Estate of Louise
Dahl-Wolfe, courtesy
Staley-Wise Gallery,
New York

6   "United Colors
of Benetton: Advertising
and Social Issues"
The Museum of Contemporary
Photography exhibition
November 14, 1992–
January 9, 1993
Installation view
Photograph by
Thomas A. Nowak

In the three carefully sequenced books (Lange/Taylor, Bourke-White/Caldwell, and Evans), the visual rhetoric depends on juxtaposition: wealthy and destitute, integral and deteriorated, dignified and hopeless. In several of her images, Bourke-White recorded luxury advertisements, some torn from **Life** and used as decoration or simple wall covering in sharecroppers' shacks, perhaps responding to the irony inherent in the look of the first **Life**. The sequence of images articulated into an argument for humanitarian sympathy, inherited from Jacob Riis and Lewis Hine, is at the heart of these books. The effectiveness of this structure is used in the picture essays in **Life**, and in the series of fashion images for a single designer in **Harper's Bazaar** and **Vogue**. These conventions carry strength and illusion back and forth between the publications.

The books attempt, at least on the surface, to create a holistic visual definition of the United States, although both Taylor and Evans expressed reservations about the possibility and value of doing so. The magazines likewise sought to create and define audiences. The editors' foreword to the first issue of **Life** implies that the magazine will provide a photographic definition of the entire world, selectively edited by them, of course. Luce himself, in his mission statement for **Life**, declared that "To see life; to see the world; to eyewitness great events; to watch the faces of the poor and the gestures of the proud…to see and be amazed; to see and be instructed; thus to see, and to be shown, is now the will and new expectancy of half mankind." The editors' foreword often refers to photography; Luce does not mention it once. The confusion of seeing and photography will sell millions of magazines over the next four decades.

Luce's use of the word "half" reveals another aspect of the illusion created by **Life** and the fashion magazines, and to a certain degree, by the three books. This is the "other half" of Riis's 1890 book, **How the Other Half Lives**, revisited. The three books, and Riis's, create an illusory world in which half of us share humanitarian concerns and decry suffering. **Life** created an illusion in which half of us have an anonymous, undifferentiated curiosity about suffering, war, the exotic and foreign, the famous and infamous, all thrown together on the same page with messages telling us that because we are the half we are, we need to develop the "will and expectancy" to own certain consumer goods. Louise Dahl-Wolfe, in her work for the fashion magazines, extended the success of this formula by placing her models against exotic backgrounds. An early 1950s photograph juxtaposes the pristine dress and scrubbed model with crumbling buildings in Paris that can be read as war damage from just a few years before [plate 5]. This is also reminiscent of Surrealist cinema montage by Luis Buñuel and Sergei Eisenstein. It also replicates the emotional force of **Life**'s style of interspersing stories of disaster with images of the cheerful, privileged life of its ideal subscribers demonstrating products – "our half."

Today, the advertising imagery of United Colors of Benetton has been criticized as exploitative in its use of topical disasters, such as oil spills or the AIDS epidemic, to sell clothing [see plate 6]. **Life** magazine did the same thing – except that the names of the products were separated a little farther from the disaster in the layout. The visual scan of the reader, however, blends the ad and the journalistic photographs, except in the body of a set piece essay by Bourke-White, Smith, and others. In this exception, association of the product with widely held public interest and concern, functions identically.

Celebrities were regularly covered in both **Life** and the fashion magazines. The strongest area of The Museum of Contemporary Photography's commercial collection is celebrity portraiture by George Hurrell [see plate 7], Barbara Morgan, Louise Dahl-Wolfe [see plate 8], Annie Leibovitz, and Victor Skrebneski [see plate 9]. Among the photographs by these artists are striking then-and-now pairings of Orson Welles and Bette Davis, as well as strong portraits of fellow photographers Berenice Abbott and Cecil Beaton, and writers Carson McCullers and W.H. Auden. Photography has been a strong ally of the cult of the celebrity: the mystery and fantasy important to the creation of fame. It provides personal eye contact and the illusion of intimacy that, again, is a strong component of advertising and fashion photography. **Harper's** art director Brodovitch appropriated this power by interspersing his fashion spreads with writing by McCullers and Auden.

7 Starting in the late 1920s, George Hurrell was a studio photographer in Hollywood. His portraits made the beautiful look perfect, and enhanced – or even made – Hollywood careers with shots carefully calculated to match the screen personas of his subjects. This portrait of Bette Davis is from a portfolio of stars including Gary Cooper, Joan Crawford, Clark Gable, Barbara Stanwyck, and Mae West. Its richly smooth texture is evocative of painted portraits and epitomizes what Douglas Fairbanks, Jr., in a statement accompanying the portfolio, referred to as the "honest, yet idealized, glamour" of Hurrell's photographs.

8 Famous for her documentary and fashion photography, Louise-Dahl Wolfe also produced a range of celebrity portraits, photographing such noteworthy personalities as Cecil Beaton, Ingrid Bergman, Margaret Bourke-White, Carson McCullers, Edward R. Murrow, and Paul Robeson. Here, she captured the intensity and originality of Orson Welles's personality through the use of a simple yet cryptic background, and through Welles's own oddly aggressive posture. See plate 5 and Parry, plate 10.

**market**
**slemmons**

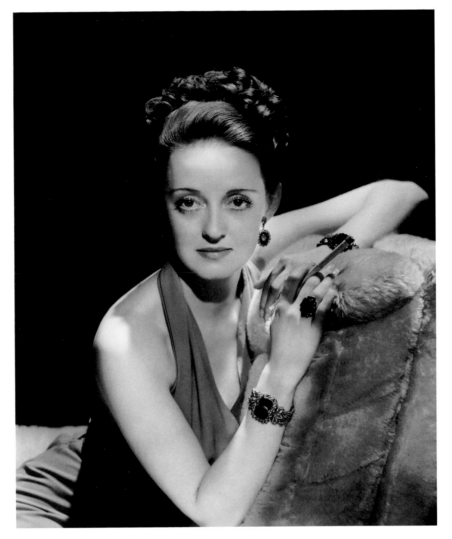

7  **George Hurrell**
Bette Davis,
**from the portfolio**
George Hurrell,
**1938**
**silver gelatin print**
**20 X 16 inches**
**Gift of**
**Michael Wittenberg**

8  **Louise Dahl-Wolfe**
Orson Welles, **1938**
**silver gelatin print**
9 7/16 x 10 13/16 **inches**
**Gift of the artist**
© **The Estate of**
**Louise Dahl-Wolfe,**
**courtesy Staley-Wise**
**Gallery, New York**

9   **Victor Skrebneski**
Orson Welles,
**October 30, 1970
silver gelatin print
52 x 48 inches
Gift of the artist**

**Chicago-based photographer Victor Skrebneski is known for his high-styled and glamorous fashion and advertising photography, for sensuous and sculptural nude studies, and for casually elegant portraits of friends and the famous. This photograph of Orson Welles is typical of the dynamic style Skrebneski employs for his black-and-white portraits. The now famous black turtleneck was subsequently worn by a variety of sitters, including David Bowie, Truman Capote, Bette Davis, and Andy Warhol.**

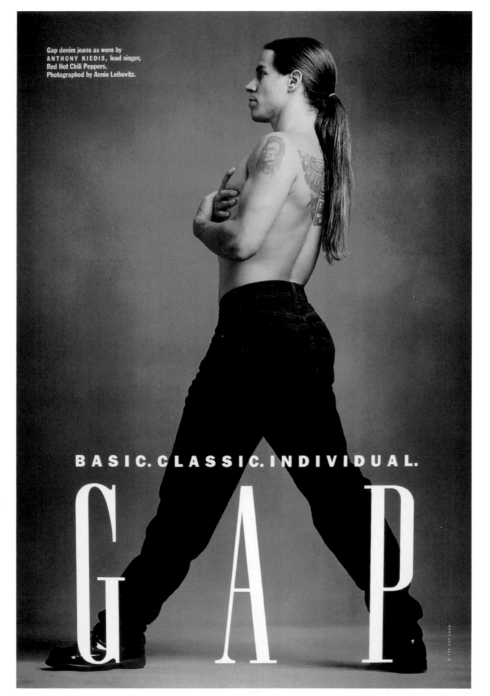

Gap denim jeans as worn by
ANTHONY KIEDIS, lead singer,
Red Hot Chili Peppers.
Photographed by Annie Leibovitz.

BASIC. CLASSIC. INDIVIDUAL.

GAP

10   Annie Leibovitz
GAP denim jeans as worn by
Anthony Kiedis, lead singer,
Red Hot Chili Peppers,
**1992**
transit shelter poster
mounted offset print
**69 x 47 x ¹/₂ inches
Gift of The GAP, Inc.**

**The GAP's "Individuals of
Style" advertising campaign,
which included this photograph
by Annie Leibovitz, debuted
in December 1988. Part of the
well-established method of
using personalities to promote
a certain style, the campaign's
black-and-white portraits
were created by a variety of
famous photographers. Their
subjects included nonmodels,
near-celebrities, and truly
stellar names in the effort to
sell the wear by selling the
wearer. Leibovitz, who began
a significant career in
commercial photography at
Rolling Stone, was already
well known for her energetic
images of rock stars, as
well as for an award-winning
campaign for American
Express, Inc.**

As this essay is being written, tabloid celebrity photographers – paparazzi – are being blamed for the death of Diana, Princess of Wales. As Max Frankel pointed out in **The New York Times Magazine**, no one seems willing to give them credit for having created her. Diana apparently had some substance and wit behind her charming exterior, but it is hard to believe that caused millions to claim bereavement for the beautiful young woman in the photographs.[7]

Celebrity and fashion photography are closely allied: both request that we substitute our personal desires and dreams, and even appearances, for those of another, more public or publicized person. We are asked to devise a new self from the picture. Annie Leibovitz's photograph for The GAP advertisement of the Red Hot Chili Peppers' singer, Anthony Kiedis, is a good example [plate 10]. Pants have nothing to do with Kiedis's talent and skill – he could sing naked, as Leibovitz indirectly implies by showing him bare chested, but partly guarded with his arms. Just as Kiedis has appropriated the power of Chief Joseph of the Nez Percé with his tattoo, we are being asked to appropriate some of Kiedis's power by wearing the same kind of pants. Ultimately a percentage of us comply – this is a multimillion-dollar game that goes back and forth according to the strength of our will and the strength of the advertisers' images. The goal is that at some point the archetype of the celebrity will fuse with the anonymous type of the fashion model and become a stereotype that we all will want to join willfully.

The blending of documentary and personal expression refined by Lange and Evans, and later by Eugene Smith and Robert Frank, should probably be thought of as the source for the new journalistic photography of Mary Ellen Mark, Sebastian Salgado, and Gilles Peress. All three are working journalists and at the same time exhibit their work in art museums. This seems like a contradiction: museum audiences are often more disposed to ignore the political and social implications of images like those of Peress, and more apt merely to enjoy their graphic strength, especially since the original social context is usually omitted. A recent large Salgado exhibition was criticized because the museum context was seen to aestheticize the suffering of his subjects.[8] This issue is neither simple nor new. Beginning with Jacob Riis, those using photography for reportage have realized the need coldly to build a picture that will hold the eye firmly as well as communicate humanitarian concern for the plight of the subject. That this requires the photographers to dehumanize themselves momentarily in order to think clearly about the aesthetics of the shot, and to be invasive enough to make it work, has been a source of great anxiety for some journalists. Eugene Smith probably best articulated this uneasiness when discussing his invasion of the family wake in his 1956 **Life** magazine essay "Spanish Village." He has pointed out in lectures and in his writing that some of the pained expressions of the people were caused by the bright light required to make the photograph. He decried the intrusion, but not as much as he decried the Fascist government in Spain responsible for conditions in the village, which it was his

purpose to report.[9] Mary Ellen Mark, who has also discussed this issue publicly, feels that without her presence, however intrusive, the people she photographs would have no one to speak for them [see plate 11].[10]

The 1974 Peress image of the children of political internees in Northern Ireland, removed from the series it originally fit into, still has great strength just supported by the title [plate 12]. The hatred growing in the children's minds is apparent on their faces, especially the central child who is completely oblivious to the intrusion of the camera. We have trouble believing that whatever is taking form behind those eyes can be dislodged now, twenty-three years later. Susan Meiselas, who has spoken with great passion about her concern that her images be interpreted correctly[11] – echoing Eugene Smith's remarks on the occasion of his numerous resignations from **Life** magazine – placed herself in grave danger to bring back images of war in Nicaragua and El Salvador (see Rosenblum, plate 19). The authenticity of great journalistic photography requires immersion as well as intrusion. Meiselas is more concerned about getting a picture of these terrified children back to the United States than she is about getting blown up herself. Knowing this, we are more likely to believe her version of the story.

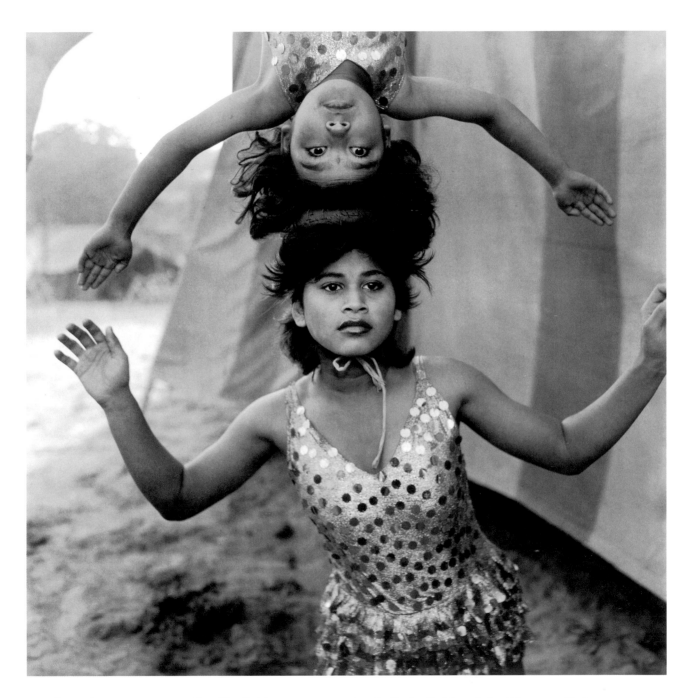

11  **Mary Ellen Mark**
    Acrobats Rehearsing Their Act
    at Great Golden Circus,
    Ahmedabad, 1989, **1989**
    **platinum print**
    **19 x 19 inches**
    **Museum purchase**

Mary Ellen Mark began
working as a professional
photographer in the 1960s,
selling her images to publica-
tions such as Life, Look, and
Esquire. **Documentary**
**assignments and celebrity**
**portraits subsidize her per-**

sonal work, allowing Mark to
travel from continent to con-
tinent capturing the edginess
of unguarded moments. This
photograph of two young
girls rehearsing an acrobatic

feat, which appeared in the
**book** Mary Ellen Mark: Indian
Circus **(1993), is a quintes-**
sential example of Mark's use
of stark circumstances, sym-
bolic power, and a sophisti-
cated sense of composition.

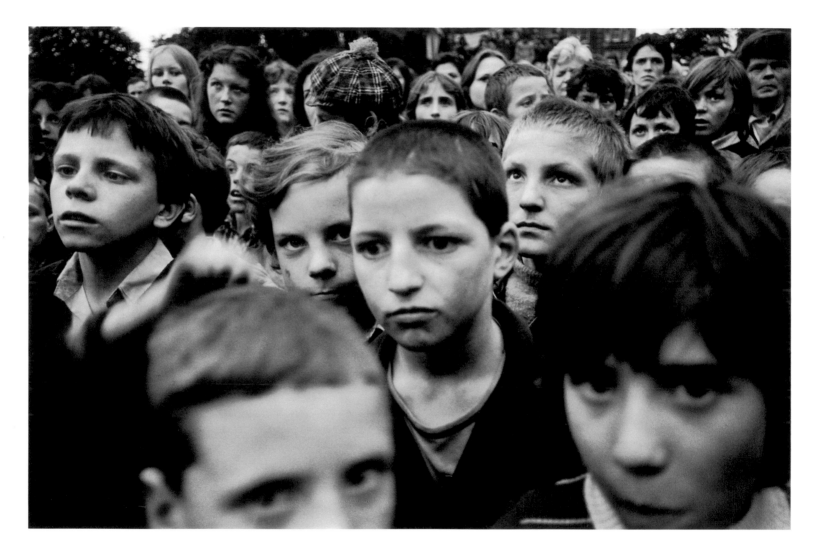

**12  Gilles Peress**
Sons and Daughters
of the Interned,
Dunville Park, Belfast, **1974**
**silver gelatin print**
**23 1/2 x 35 1/4 inches**
**Museum purchase**
**with funds donated by**
**James J. Brennan**

**Over the last two decades,**
**Gilles Peress has documented**
**political struggles in Bosnia,**
**Iran, Northern Ireland, and**
**Rwanda. His black-and-white**
**photographs offer an uncom-**
**promising view of emotionally**
**powerful, turbulent events.**

**The angry, empty, and accus-**
**ing eyes of the children in**
Sons and Daughters of the
Interned, Dunville Park,
Belfast **show Peress' visually**
**gripping style. See Schulze,**
**plate 19.**

The increased use of digital technologies for the production, manipulation, and storage of images has changed the lives of many professionals. The Museum of Contemporary Photography collection contains examples of older mechanical manipulation, such as Barbara Kasten's 1988 composite of the High Museum [see Miller, plate 14], Barbara Morgan's well-known 1938 picture **Hearst Over the People** [plate 13], and Victor Skrebneski's double portrait of John Malkovich. It is interesting to compare these to digitally manipulated work such as John McCallum's paper-shredder ad for Dannich Oticon [plate 14]. Morgan's satirical image took at least several hours to collage with multiple printing and masks. Today it would take a matter of minutes with software such as Photoshop®. While the time to produce such images has been drastically reduced, there has not been a commensurate increase in the imagination that went into Morgan's picture. McCallum's advertisement stands out as a witty and intelligible use of the new tools.

Ed Beardsley, writing in 1994, referred to the new digital tools as the revolutionary equivalent of Johann Gutenberg's adaptation of the wine press to making multiple, identical copies of formerly variable, unique books.[12] Digital technology could also be thought of as similar to Renaissance artists' adaptation of scientific notions of optical perspective to picture-making. In that instance an entirely new mode of two-dimensional representation was born that has become so transparent in the intervening 500 years, chiefly through its descendant, photography, that most of us now refer to it as "seeing." Debate continues in the popular press centered on the ability of Photoshop® and other similar programs of exponentially increasing the likelihood of our seeing falsified news or documentary photographs. This makes older professionals smile. Subtle and seamless manipulation of photographs has been going on since the beginning of photography. Henry Peach Robinson pieced together information from many negatives into single images, such as **Fading Away**, as early as 1858. Beyond this, however, photography is inherently far from experience in its recording ability, in spite of the public perception that it produces the most objective of evidence.

The temptation with digital tools is to base the finished product on the idiosyncrasies of the process. The degree to which picture ideas are process-dependent is ultimately not nearly as interesting as the ways in which a given process can function metaphorically. The eighteenth-century English poet William Blake saw his craft of etching as an analogue for his poetic need to dissolve received, unquestioned wisdom: "First the notion that man has a body distinct from his soul must be expunged. This I shall do by printing in the infernal method by corrosives... melting apparent surfaces away and displaying the infinite which was hid."[13]

While digital technology has allowed for greater ease of collage and montage, possible before by other means, it may have had less real influence on the day-to-day practice of professional photography than other, much less dramatic, technical improvements over the years. Among these are faster and finer grained black-and-white film, color-print and transparency film, the introduction of electronic flash in 1939–40

[see plate 15], better lenses for smaller cameras, and the use of Polaroid products beginning in the 1970s to check on exposure and composition [see plate 16]. Aesthetic studio innovations, such as the "seamless" blank background used by Irving Penn [see plate 17] and later refined by Richard Avedon, have also been important. Penn and Avedon have used the isolating background both for fashion work and their own art. Both Penn's 1974 **Worlds in a Small Room** and Avedon's 1985 **In the American West** continue a tradition begun by popular ethnographers and typologists such as E.S. Curtis, who used similar backgrounds to remove their subjects from the daily flow of their lives and to emphasize their ethnic or cultural individuality – or simply their individual physical characteristics. This cross-breeding of fashion and anthropology has not gone without criticism from cultural historians, but continues to enjoy widespread use.

Beginning in the 1970s contemporary artists using photography began to refer to a bankruptcy in the traditional photographic practice of constantly searching for either new and exciting subjects or new and exciting ways of seeing old subjects – two concepts that had their own feature sections in the early years of **Life**. In discussing the work of Richard Prince, Andy Grundberg has referred to the myth of a

photographic Eden into which Prince's contemporaries assumed they were going with their cameras to produce unique, original, author-specific works. Prince, and others in the early 1980s, began to treat the secondary experience of media culture as primary, because increasingly it is. Forests of picturesque trees were replaced by a forest of mediated signs.[14] The Museum of Contemporary Art, Los Angeles produced an exhibition dealing with this issue in 1989 called "A Forest of Signs." The practice of mining mass-media advertising for references, rhetorical structures, and imagery – loosely referred to as appropriation – soon moved from expressive to commercial photography, just as earlier fashion photographers had borrowed from the conceptual innovations of Surrealism – except this time the conventions were coming back home. This complex feedback is indicative of the oscillation between the real and the simulated that preoccupied photo-theorists such as Jean Baudrillard in the early 1980s.

As we have seen, in the mid-1930s, Evans, Lange, and Bourke-White had skillfully incorporated advertising billboards as a way of layering information about Depression society, usually in the service of irony, into their finished works. "Next time take the train," "Highest standard of living in the World" – these phrases and their attendant images were effectively appropriated from the cheerful media in that dark time. Evans demonstrated his idea of human erosion with torn and deteriorating movie posters. Several decades earlier, Kurt Schwitters, Pablo Picasso, and Georges Bracque had appropriated bits of advertising and other media ephemera into their collages to imply that their practice was grounded in the fragmented present rather than the integrated past. So this was not a totally new idea. But the 1980s saw a much more systematic exploration by appropriation of the photographic face of our culture.

Two good examples of the appropriative approach in photography are provided by Barbara Kruger and Robert Heinecken. Kruger has made a practice of lifting text and images from the river of media breaking around her and recombining them into terse and sharp feminist statements. In the Liz Claiborne ad "Don't Die for Love, Stop Domestic Violence," she combined four clock faces that connect with a text stating that every two seconds a woman is beaten at home and that fifty-two percent of women who are murdered are killed by their husbands [plate 18]. The strength of Kruger's practice is not diminished by association with product promotion, primarily because the message morally outweighs the product, which is going to gain from the transaction anyway.

For the series **Recto/Verso**, Robert Heinecken specifically appropriated advertising imagery to reveal its conceptual source and to examine its motivation [see plate 19]. Heinecken combined two images by the unique method of contact printing a single page from a magazine on positive acting color photographic paper – a page that has advertising on both sides with figures in approximately the same scale. The pages were carefully selected, by holding them up to the light (and tearing them out) wherever he happened to encounter them, so that the final combination

**market**
**slemmons**

13  Initially drawn to photographing Native American dance in the Southwest, Barbara Morgan later photographed the modern dancer Martha Graham and her company over a period of several years. Though her dance photography brought her the greatest acclaim, Morgan worked equally skillfully with abstraction. The sense of rhythm and synthesis she achieved in documenting dancers is evident in such photomontages as Hearst Over the People, one of several of Morgan's images shaped as social commentary and reflecting the influence of John Heartfield and Man Ray. See Csikszentmihalyi, plate 6.

14  One of Chicago's prominent commercial photographers, John McCallum was included in The Museum of Contemporary Photography's 1995 exhibition "Target Market: Professional Photography in Chicago." Starting in 1992 McCallum's interest in delivering a more complete visual product led to work with digital imaging as an alternative to darkroom manipulation. Shredded Paper is among the fruits of such investigations, with the formerly fixed text of a page whimsically released through the computer's capabilities. See plate 2.

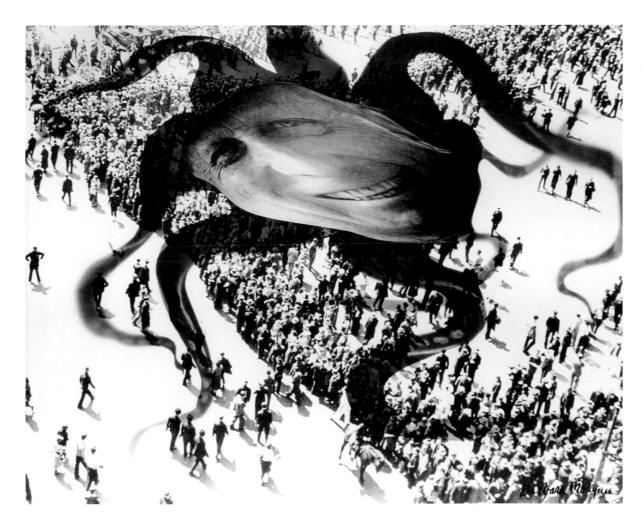

13  Barbara Morgan
*Hearst Over the People,*
**1938/80**
**silver gelatin print**
**12 x 15 inches**
**Gift of David C. and**
**Sarajean Ruttenberg**
**and The Ruttenberg Arts**
**Foundation**
© The Estate of Barbara
**Morgan, courtesy Douglas**
**Morgan**

14  John McCallum
*Shredded Paper,*
**1995**
**transparency**
**4 x 9 inches**
**Gift of the artist**

15   **William Frederking**
*Mark Schulze and*
*Tony Gongora,*
**1997**
**silver gelatin print**
**15 7/16 x 15 1/4 inches**
**Museum purchase**

16   **Kati Toivanen and**
**Andrew Wells**
*Untitled,* **1993**
**internal dye diffusion**
**transfer print**
**24 x 20 inches**
**Gift of the artists**

15   After a casual conversation with a colleague, William Frederking photographed his first of what were to become numerous dance performances. Frederking is drawn to the challenge of making motion interesting through a medium designed to stop it. Though the fleeting gestures of modern dance are arrested in time, a sense of the dancers' energy and movement is preserved through Frederking's careful lighting and skillful timing. In Mark Schulze and Tony Gongora, part of The Museum of Contemporary Photography's dance archive, the intimate gesture of a kiss is presented in mid-flight, with eccentric flair and humor.

16   In this richly colored and sensuous still life, Kati Toivanen and Andrew Wells feigned the style of product design while infusing it with symbolism that is sexual and art historical. Wells has explored the Pop vernacular in his own mixed-media art and Toivanen has a history of exploring body and self through large-format and digitally designed montages. In this collaborative photograph, they have utilized the technology of the diffusion transfer – self-processing instant photography – to reveal a luminosity of surface, texture, and tone.

17   In the realm of commercial photography, Irving Penn is perhaps best known for his celebrity portraits and images of high fashion. In the 1960s and early 1970s, however, Penn turned his attention to so-called "primitive" cultures, those untouched by industrialization. Traveling with a canvas tent for a studio and using his characteristic simple backdrops, Penn revealed an interest not ethnographic or anthropological, but in the aesthetics of these subjects as removed from their surroundings. See Miller, plate 19.

**17   Irving Penn**
Two New Guinea Men
Holding Hands,
**1970/79**
**platinum/palladium print**
**15 ³/₄ x 15 ³/₄ inches**
**Gift of the artist**
**© 1970 Irving Penn,**
**courtesy Vogue**

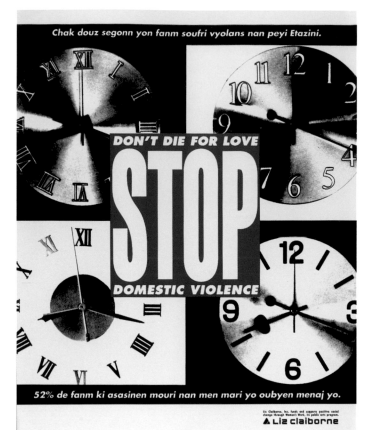

**18  Barbara Kruger**
Don't Die for Love
from "Liz Claiborne:
Women's Work," 1992
offset print
28 x 22 inches
Promised gift of Y-Core,
Chicago
Artwork courtesy of
Barbara Kruger from
a project developed
by Y-Core, Chicago,
for Liz Claiborne
Corporation, USA

Funded by Liz Claiborne, Inc.,
"Women's Work" was a com-
munity-based arts program
designed to draw attention
to issues of concern to women
and their families. With the
goals of raising awareness
about domestic violence and
helping communities respond
to the needs of its victims,
"Women's Work" featured
powerful and instructive
images by Barbara Kruger,
Susan Meiselas, Diane Tani,
Carrie Mae Weems, and Jon
Winet and Margaret Crane.
These works were originally
displayed on nearly 200
billboards and transit shelters
throughout San Francisco and
Oakland, California. Kruger,
recognized for her boldly
graphic combinations of text
and images, has long pro-
duced work with political and
feminist aims. See plate 1.

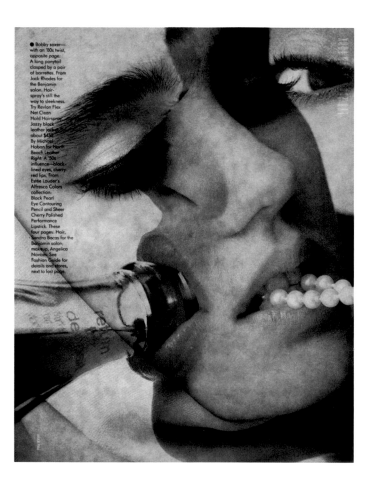

**19  Robert Heinecken**
Untitled #7 **from
the portfolio** Recto/Verso
**(1989), 1988**
silver dye bleach
(from color positive) print
10 3/4 x 8 3/4 inches
Gift of Jeanne
and Richard S. Press

As early as the 1960s, Robert
Heinecken began to experi-
ment with the configuration of
found images. Rather than
creating photographs for a
mass market, Heinecken – in
a precursive Postmodern ges-
ture of appropriation –
recontextualized mass-media
images to suggest new mean-
ings. His unique technique
of contact printing allows the
viewer literally to "see
through" the original advertis-
ing message, focusing
attention instead on the play
of perspective and meaning.
This and the other pho-
tographs in the portfolio
Recto/Verso **reveal disturbing
patterns and significant
combinations shaped out of
the random placement of
commercial photography. See
Peat, plate 3.**

would emphasize the connection between these images intended to sell products to women and the conventions of pornography. This project was completed during the highly charged late 1980s, as liberal theorists, feminists, and other social critics were struggling to decry pornography on one hand, and censorship of the erotic in art at the National Endowment for the Arts on the other – simultaneously.

Heinecken, never content with simply occupying high moral ground, has consistently tracked the exploitation of women in the media, asking hard questions rather than making dialogue-stifling pronouncements. Why are women being asked to respond to these exploitative images of themselves by buying the associated products? How exactly was that convention established? Is it appropriate for women, and men for that matter, to deny sexual fantasies in order to achieve gender equality elsewhere in the society? Asking these questions makes people uncomfortable on both sides of the censorship debate. A small group of conferees pointedly walked out of Heinecken's Honored Educator presentation – a highly contrived satire on contemporary theory-driven practice – at the national conference of the Society for Photographic Education in Washington, DC in 1992. Part of Heinecken's point, to a large audience of teachers and students, some of whom will go on to be fashion photographers, was that despite the high seriousness of the censorship critique, some very important questions are being ignored. Because he asks these questions with his work, and uses sexist, sometimes recycled pornographic imagery to do so, he often comes under attack for simply disseminating more damaging ideas.

A friend born and raised in Hollywood tells a story appropriate to this discussion. The twelve families in his small hillside neighborhood all employed the same Japanese-American gardener. Each yard was different and seemingly designed to fit the owners' personalities and style. The year my friend went to college, the old gardener, fearing he might not see him again (this was Hollywood, remember – the children growing up spent more time with this gardener than with their parents), took him up to an adjacent hill. To my friend's astonishment, all twelve yards were integrated into one balanced, complete landscape.

Photography has created an alternate, semitransparent world so hermetically laminated over the original that we must always see through it. The commercial/professional use of photography, and its use as an expressive tool, may each appear to be whole and integral if seen only in their own back yards. But the success of both depends on seeing them as integral parts of the entire range and use of the medium.

**market**
**slemmons**

1   Sadakichi Hartmann, "A Purist," **Photographic Times** 31 (October 1899), quoted in Weston Naef, **The Collection of Alfred Stieglitz** (New York: The Museum of Modern Art, 1978).

2   Cf. Naef (note 1), pp. 19–21.

3   From a conversation concerning amateur vs. professional photography, August 1997, archived on PHOTOART@LUGB.LATROBE.EDU.A, a listserve dedicated to photography as an art form.

4   **The New York Times Magazine**, Apr. 6, 1997 and Aug. 24, 1997.

5   **The New York Times Magazine**, Feb. 4, 1997.

6   For a full treatment of Brodovitch and the **Harper's Bazaar** contributions, as well as many illustrations of Brodovitch's pastiche of styles and conventions, see Andy Grundberg, **Brodovitch, Documents of American Design** (New York: Harry N. Abrams, Inc., 1989).

7   Max Frankel, "No Pix, no Di," **The New York Times Magazine**, Sept. 21, 1997.

8   "An Uncertain Grace," 1990, a retrospective of Salgado's work organized and circulated by the San Francisco Museum of Modern Art.

9   See Jim Hughes, **W. Eugene Smith: Shadow and Substance** (New York: McGraw-Hill, 1989).

10  See Marianne Fulton, **Mary Ellen Mark: 25 Years** (Boston: Bullfinch/Little Brown, 1991).

11  Lecture to National Graduate Seminar, American Photography Institute, Tisch School of the Arts, New York University, New York, May 28, 1991.

12  E.R. Beardsley, "Digital Gutenberg – Everyperson as Publisher," **Image** 37, 1–2, pp. 3–15.

13  William Blake, **The Marriage of Heaven and Hell** (1790), pl. 14.

14  Los Angeles County Museum of Art, **Photography and Art: Interactions Since 1946**, text by Andy Grundberg and Kathleen Gauss (Los Angeles, 1987), p. 210.

Photography occupies a privileged position within the current debate on the relationship of art and science. Its origins are inexorably linked to both, for its pioneers, including Joseph Nicéphore Niépce, William Henry Fox Talbot, and Louis-Jacques-Mandé Daguerre, firmly had their feet in two camps. Indeed, the nineteenth century itself was the heyday of scientific amateurs whose combination of passion and intellectual openness, along with an enthusiasm for experimentation, produced significant contributions in geology, biology, astronomy, and chemistry. In particular, these inquirers noted the way certain chemical substances darken, or change color, under the influence of sunlight. Inevitably this was associated with the desire to fix and record, for artistic purposes, images produced by the camera obscura and camera lucida. Thus was photography born out of the passionate engagement of art and science, an ardor that persists to the present day.

More than any other of the arts, photography comfortably occupies the scientific fence, being both a tool of science and, to a large extent, one of its technical products. In turn, contemporary photography informs us about our scientific world and, in particular, reflects back to us the technological ambiance in which we live.

Although photography has been around for over a century and a half, its present diversity suggests that it remains young at heart. Photography continually outstrips its own boundaries and bursts through any aesthetic definition imposed upon it. In many ways it is a vulgar art, vulgar in that it is immediately accessible to all, and vulgar because of its enormous energy. Photography cannot be held in check. It is as varied as the photographers who practice it, and in so many ways illuminates the world and our human condition more vividly than any other of the arts.

# PHOTOGRAPHY + SCIENCE

## CONSPIRATORS

### F. DAVID PEAT

1   Harold Edgerton
**Football Kick**,
1938/84
dye imbibtion print
16 3/4 x 14 1/8 inches
Museum purchase
© Harold & Esther
Edgerton Foundation,
courtesy Palm Press, Inc.

In the 1930s Harold Edgerton invented a stroboscopic light that had wide applications in industry as well as the potential to revolutionize photography. This first highly powerful, extremely fast, and reusable flash not only opened new territory for scientific examination, but established a new art form, a new documentary mode, and a new kind of journalism. Edgerton became the first to illuminate nighttime landscapes and darkened interiors, and his technology was capable of freezing the quickest of actions. **Football Kick** is one of the first color photographs made with the use of a strobe.

Photography was adopted as an instrument of science almost from its inception. Fox Talbot found his "pencil of nature" capable of revealing such a wealth of detail as to confound those who first perused his photographic images. People who believed they had been looking carefully at nature now realized how much their acts of seeing had been filtered though the strategies of consciousness and habit. Photography, by contrast, appeared to be showing the world as it really is and, for a time at least, the camera became the ultimate objective observer. In this sense photography was well adapted to the scientific requirements of detailed observation and meticulous classification. With the help of telescopes, microscopes, and fast shutter speeds, it could reveal what lay beyond the human senses [see plate 1]. Photography's abilities further extended until, in our modern age, it tells us about everything from the early state of the universe to the ultimate building blocks of matter.

But as a tool of science, photography goes far beyond the passive action of recording and classifying. The development of scientific theories generally depends upon some form of conceptualization and visualization.[1] Indeed, the word "theory" itself is etymologically related to "theater" and, in this sense, even our most abstract notions about fundamental matter are displayed in "theaters of the mind." It is here that images, diagrams, and other visual displays become invaluable. It is as if a mathematical result remains in some sense purely abstract until it can be cast into the world of the concrete visible. The recent upsurge of interest in chaos and complexity theories, for example, has in part been made possible by science's ability to construct, using high-speed computers, visual models and images of fractals, shock waves, self-organizing systems, and other nonlinear processes. Raw data becomes digestible when it can be displayed according to a diagram or visual scheme. And for scientific thinking to take its next step, some mode of expression external to itself is needed which can then be internalized and manipulated by thought. For this reason science has a need for photography, both as its servant and collaborator.

In exchange, through its appetite for the visual image, scientific technology has vastly extended the nature and range of photography itself from its origins as the record of reflected light focused upon a photosensitive plate. If we are sick, we take it for granted that pictures of our internal organs can be produced through ultrasound scans, magnetic-resonance imaging (MRI), and positron emission tomography (PET). The range of frequencies used in imagemaking includes X-rays, radio waves, and the infrared. Satellite imaging and space probes produce dramatic information about the solar system. Photomultipliers create photographs where just a few photons of light are available. Scanning electron microscopy reveals the world under our fingertips. The fastest of movements can be arrested, and the most "noisy" of images digitally enhanced.

In turn, this technology has been rapidly incorporated into the art of photography, along with the "feel" of the particular images it produces. Photography and scientific technology continue to accelerate into the future, side by side, each feeding off and informing the other.

It is inevitable that an art as potent as photography engender hot debates about its future and its current aesthetics. Some photographers lean toward the medium's objective, documentary ability as a means of reporting on the world and human society. Others argue that photography inevitably selects, frames, and manipulates the images it produces according to the subjective values of individual photographers. Some embrace the most advanced technologies, sampling, selecting, and processing images though digital means. Others return to photography's origins, working directly with light-sensitive materials that involve the minimum of technological interference. In particular, they look for ways in which nature can be persuaded to reveal herself in the gentlest manner possible. Some have even

**SCIENCE**
PEAT

2   Arthur Siegel
**Photogram 1**, 1973
silver gelatin print
15 7/8 x 20 inches
Gift of John B. Hirsch
© The Estate of Arthur
Siegel

Arthur Siegel crafted
intricate photograms and
graphic documentary
photographs early in his
career. In the late 1940s
and 1950s, he introduced
creative methods of back-
lighting and projecting

light onto surfaces, as well
as an innovative use of color
in both experimental and
documentary photographs.
This image from 1973 is
characteristic of Siegel's
later photograms in its
simplicity and conceptual
nature. All of his explo-

rations – with photograms,
applications of Polaroid film,
and combination prints –
were designed to explore
the singular characteristics
of a medium sensitive to,
and based on, light.

become fascinated by the alchemical nature of the photographic processes and by the metaphysical qualities of light and its interactions with matter [see plate 2]. Others seek to project their own particular ways of seeing onto the world, or to treat photography as a branch of Conceptual Art.

An aspect of this debate about the nature of the photographic image can be traced to the origins of Western science at the hands of Galileo. Using his telescope, Galileo not only discovered the existence of sunspots, but deduced from their movement evidence of the sun's rotation, thereby supporting the Copernican heliocentric theory. Attempts to discredit Galileo were directed, in part, to his use of the lens, which came between the eye and its object of perusal. Since the action of a lens is to bend rays of light, that is, to distort their true motion, it could be argued that the resulting image had an ontology different from anything heretofore observed.

If, as certain feminist critics have argued, the masculine reaction to nature is one of projection,[2] then science and its first instrument of extension, the lens, stand as a paradigm example. In this sense the use of the lens – and, indeed, all other forms of scientific apparatus that extend the senses – has an association with that which is indirect, distorted, and untruthful, secondhand. It is possibly for such underlying reasons that imagemakers such as Arnold Gilbert, Abelardo Morell, and Susan Derges have chosen to dispense with the camera's mechanism.

The arguments concerning Galileo's astronomical images echo down to our own time when the physicist Neils Bohr argued that the nature of subatomic matter can be described only in terms of paradoxically and mutually exclusive statements, such as wave and particle. As his colleague in the Copenhagen Interpretation of Quantum Theory, Werner Heisenberg, argued, the meaning of quantum theory lies in the mathematics rather than in the conceptual and visual projections we make about the world. In our present quantum world, the ontology of the image is again being called into question.[3]

This essay has drawn upon the arguments of science because contemporary photography exists within a conceptual ambiance largely informed by science and the Postmodernist thinking associated with it. Photography is now practiced within an arena of slippage, uncertainty, unpredictability, and the denial of closure. In turn, photography crystallizes and reinforces these new sensibilities, enhancing and reflecting them back to us. It is from within this ambiance that I have selected the images that accompany this essay and resonate with the contemporary debates on photography. Some present the public face of science. Others are more concerned with its methodology, concepts, and world-view, or reflect the visual world of contemporary technology.

3  Photograms are made without a camera, simply by placing objects on photographic film or paper and exposing the arrangement to light. Robert Heinecken employs this process to illuminate sexually charged material in the mass media, as in this image of a near-naked woman ominously superimposed with another fully clothed figure. Combining various advertising and news images, the portfolio **Are You Rea** displays Heinecken's mastery of appropriation as well as light manipulation. See Slemmons, plate 19.

4  The collaborative team MANUAL is widely acknowledged as pioneers in the field of digital art photography. Juxtaposing natural objects and scenes with various indicators of industrialization and technology, their work stimulates discussion about environmental issues and contemporary uses of technology. **Maple/PCBs** exhibits the irony and power in MANUAL's use of current technology to comment upon the sometimes damaging applications of that technology.

**SCIENCE**
PEAT

3  Robert Heinecken
**Untitled #12** from the
portfolio **Are You Rea**
(1968), c. 1964–68
lithograph from a silver
gelatin photogram
6 3/4 x 5 3/8 inches
Gift of Alan and Victoria
Cohen

4  MANUAL
**Maple/PCBs**, 1992
silver gelatin on film
and plexiglass with wood
and steel base
54 1/4 x 32 1/4 x 16 1/8
inches
Museum purchase with
funds donated by Sonia
and Theodore Bloch

These images from the art of photography also have a vigorous life of their own. Their potency has a significant influence upon the worlds of advertising, film, television, and the trappings of our domestic surroundings. The work photographers are currently making of our world is exercising an unprecedented influence on a future generation of thinkers, conceptualizers, and imagemakers.

The scientific ambiance: Robert Heinecken and MANUAL    The ambiance in which we live is to a great extent the product of twentieth-century science and late twentieth-century technology. Even the most abstract of scientific concepts make a significant, albeit often unconsciously absorbed, impact upon our daily lives. Both visually and conceptually, science informs the way we experience the world, and in turn it is within this ambiance that the visual arts, including photography, occupy their place.

Our world has become one of surfaces, reflections, fleeting appearances. The modern city is a construction of steel, aluminum, plastics, and large expanses of glass. Scientific advances quickly leave the laboratory bench to be developed as products for general consumption. Computers, audio and video equipment, cellular phones, modems, fax machines, the Internet, cosmetics, materials for construction, and automobiles tend to have a particular look that reflects the technological environment in which they were born. Within such an ambiance inner and outer become overlaid and interpenetrating in a multiplicity of ways. Trees literally grow inside modern buildings, while earth and sky reflect each other in their glass walls. Boundaries become fluid and even paradoxical; certainties are replaced by flux and transformation.

This is also the conceptual vision presented by modern science. Matter is penetrable; the solid table dissolves into empty space traversed by elementary particles and vibrations of energy. Our bodies are transparent to medical imaging techniques and, to a beam of neutrinos, City Hall is as insubstantial as a dream. Both visually and conceptually, the entire reality of our world and of ourselves is thrown into question. Nothing is substantial, nothing is fixed. Culture, values, and truths have become relative in a Postmodern world.

The work of Robert Heinecken [see plate 3], while ostensibly drawing on the raw material of advertising, perfectly reflects this condition. It presents a marriage of the subtle and the gross, spirit and matter, light and molecular structure. Negatives are overlaid and manipulated in a world in which we are no longer sure if the image we read is the direct product of the camera or the artificial creation of computer processing and digital enhancing. Heinecken dramatically evokes such a world of overlaid images and transparencies, of the human form penetrated by X-rays and magnetic fields. The characters of his dramas inhabit a stage in which the ontology of matter has become one of shifting phantoms.

Most of what we have learned about our environment comes from photography. Our planet has become a blue ball seen from space, a planet rising above the surface of the moon, the curiously heightened artificial colors of satellite imaging, the images of environmental photography, the revealed world of atoms and molecules. So MANUAL comments on photography's dual role as the tool of science and its public relations officer, presenting scientific endeavors to the public in an idealized light. Just as photography is undertaken in a rich scientific and technological ambiance, it can also be credited with creating this ambiance in the first place.

Here, MANUAL, the collaborative team who were pioneers in the field of digital imaging, juxtaposed the molecular structure of a PCB (polychlorinated biphenyl) with an image of dead trees [plate 4]. At first sight it is a message about vulnerability; the quality of permanence and protection we associate with a tree can so easily be subverted by something as tiny as a molecule. Yet

**SCIENCE**
PEAT

MANUAL's image functions at several levels: it can be taken as a comment upon the natural versus the artificial, but it also reminds us that a molecule, even one created in the laboratory, is as much a part of nature as a tree. Their work also contrasts two different types of form: the geometry of the tree and the abstract geometrical representation of what, in essence, is an invisible vibrating structure. Again we are led to a visual paradox, for the deceptively simple outline of a molecule is no more than a scientific convention, a pointer to what lies beyond: a quantum mechanical entity, a process, a flux whose very nature transcends our human abilities at visualization. MANUAL's piece is both about the explicit complexity of natural forms and the orders art and science use to underlie their representations.

Revealing nature: Arnold Gilbert, Susan Derges, and Abelardo Morell    Arnold Gilbert, Susan Derges, and Abelardo Morell have returned to the origins of their art in the making of images, favoring directness over the power of technology. Gilbert uses a process of direct contact to transfer Polaroid emulsions onto various types of paper which are then exposed to light [see plate 5]. Their folds and contours evoke the mathematical landscapes of catastrophe theory, nonlinear equations, and chaos theory — a world of higher mathematics tempered by the aesthetics of art.

Is such a correspondence no more than a fortuitous coincidence, that the action of light on folded paper should have such a striking scientific resonance? Possibly not, for the theoretical physicist Eugene Wigner once drew attention to what he termed "the unreasonable effectiveness of mathematics."[4] Again and again it turns out that the purest of mathematics, invented for abstract reasons, has striking correspondences with forms and processes in the natural world. Indeed, it is not altogether far-fetched that science's abstract representations should resonate with those of art, for in both cases aesthetics plays a guiding role. According to the mathematician and theoretical physicist Roger Penrose, "in mathematics aesthetics is not only an end in itself, but it is also a means to that end," while another physicist, Paul Dirac, put it, "You're solving ...a crossword puzzle...and everything fits. You feel great satisfaction. The beauty of the equations provided by nature is much stronger than that. It gives one a strong emotional reaction."[5]

Susan Derges works in an alchemical fashion to create cameraless images. In one series, working on a dark moonless night, Derges laid six-foot sections of photographic paper on a riverbed, and illuminated the scene using a flashlight [see figure 1]. In this way the inner life of the river has been persuaded to reveal itself though the gentle action of light.

figure 1
Susan Derges
**River Taw 12.8.97**, 1997
unique silver dye
bleach print
67 x 24 inches
Collection of the artist

5  Arnold Gilbert
**Untitled**, 1983
solarized silver gelatin print
$10^{1}/_{2}$ x $13^{1}/_{2}$ inches
Gift of the artist

To create his abstractions, Arnold Gilbert uses a variety of effects: photograms, solarization (creating a semi-negative image by allowing light to strike exposed photographic paper), and emulsion transfer (removing the emulsion from a Polaroid print to place it on a differ-ent surface). This untitled image, produced through a combination of such techniques, shows a remarkable range of tones and textures which collaborate to shape a fanciful land- or seascape.

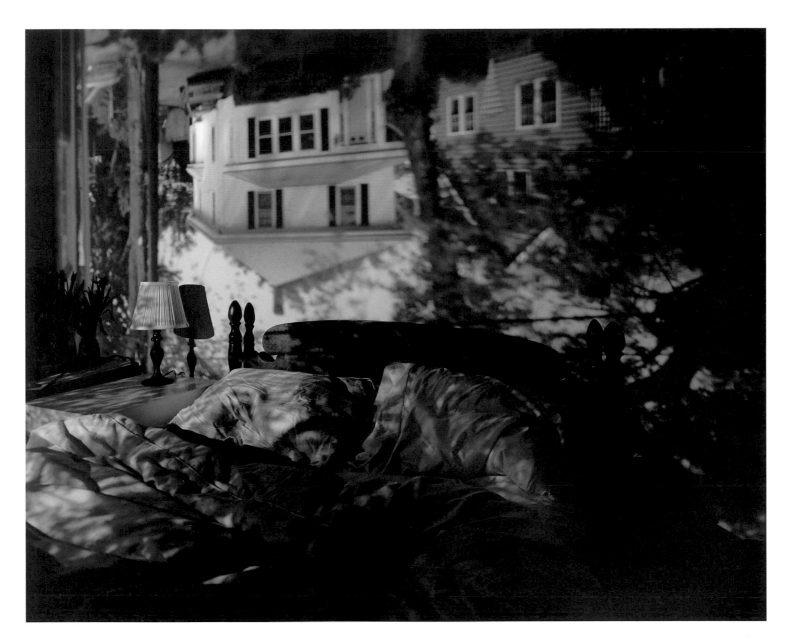

6  Abelardo Morell
   **Camera Obscura Image
   of Houses Across the
   Street in Our Bedroom**,
   1991
   silver gelatin print
   17 7/8 x 22 7/16 inches
   Museum purchase

The camera obscura is one
of various early sighting
devices that enabled the
realistic copying of the land-
scape and human subjects.
Used since the Renaissance,
it was originally a dark room
with a hole in one wall
through which light passed

to project on an inside sur-
face an image of the subject
outside. In **Camera Obscura
Image of Houses Across the
Street in Our Bedroom**,
Abelardo Morell employed
the early principles of optics
to bring the outside world
into an intimate interior.
Fashioning an entire room

into a camera, Morell
exposed the fundamental
and sometimes strange
power of his medium. See
Parry, plate 4.

7 Berenice Abbott
**Magnetic Field** from the
portfolio **The Science
Pictures** (1982), c. 1958
silver gelatin print
19 1/2 x 15 inches
Museum purchase
© Berenice
Abbott/Commerce
Graphics Ltd., Inc.

Already known for her pho-
tographs of New York,
Berenice Abbott – who had
also occasionally pho-
tographed science subjects
for **Life** magazine – dis-
played a significant under-
standing of how scientific
principles could be photo-
graphically illustrated. In
1950 she was commissioned
to depict principles of
physics for a Massachusetts
Institute of Technology text-
book. The photographs from
the portfolio **The Science
Pictures**, including this
exquisitely composed
arrangement of metal filings
and a key, reflect the formal
clarity and precision
that were always Abbott's
artistic goals.

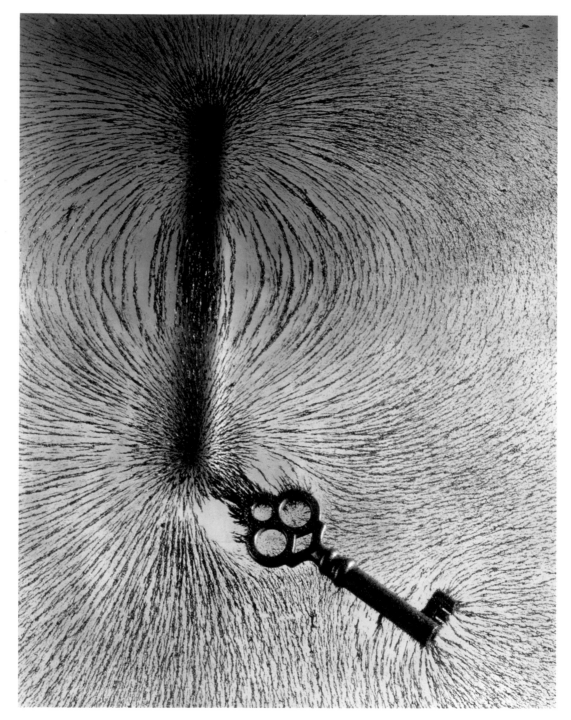

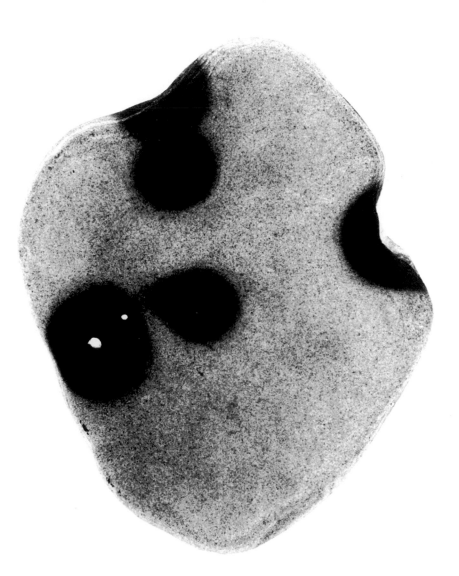

8   Alice Hargrave
**Found Stone/Gallstone**,
1994
silver gelatin print
15 5/8 x 15 5/8 inches
Museum purchase

The extraordinary abilities
of contemporary medical
imaging technology make
visible the previously invisi-
ble. Alice Hargrave uses a
range of these technological
innovations as well as com-

puter software, a standard
enlarger, and a copy stand
to create interesting,
romantic views of the body's
hidden landscapes. Like

much of Hargrave's organic
subject matter, this gall-
stone has become unrecog-
nizable and unfamiliar
through the highly manipu-
lated view she presents of it.

Abelardo Morell's camera obscura returns us to the roots of photography. The result is an image that hovers between dream and reality, liberating the imagination and possibly inviting it to dwell upon the dreamlike world in which observer and observed, subjectivity and objectivity, are inexorably entwined [see plate 6].

A mirror to science: Berenice Abbott, Alice Hargrave, Catherine Wagner, Lynne Cohen, and Catherine Chalmers    Some photographers have chosen the daily business of science as a subject of investigation. Berenice Abbott reflected that aspect of science which rises above human pettiness by asking nature to be the arbiter of its theories. Abbott's images are perfect examples of the idealization present in science, the way science abstracts from the particular to the general by ignoring effects of friction, air resistance, wind currents, random temperature fluctuations, and the like.

Abbott believed that photography can be the "friendly interpreter between science and the layman" because it is "the mechanical, scientific medium which matches the pace and character of our era....The artist through history has been the spokesman and conservator of human and spiritual energy and ideas. Today science needs its voice. It needs the vivification of the visual image, the warm human quality of imagination added to its austere and stern disciplines."[6]

Abbott's images depict the portal through which each science graduate must pass in order to fulfill his or her apprenticeship. It is a familiar and comfortable classical world in which light, electricity, magnetism, and the pushes, pulls, and impacts of matter are introduced by means of carefully controlled benchtop experiments. Thus there is almost a hint of nostalgia in her work, or a glance backward at that more secure world that existed before the revolutions of quantum theory and relativity. Even the key resting in a magnetic field is curiously Victorian, a clear anachronism within a modern scientific laboratory [plate 7]. Where did it come from? It is an oddly romantic conceit, inviting narrative. Is it perhaps the key Alice found resting on the table of glass that opened for her the doors of Wonderland? Has it been placed there to remind us that Albert Einstein's passion for science was fired while playing, as a boy, with a magnet? Or that Isaac Newton's genius lay in a mind that retained the childlike ability always to be asking questions?

Alice Hargrave's vision – and the professional life of every individual scientist – begins with a sense of wonder. For science this is both a celebration of the uniqueness of each object and at the same time a realization of the unity concealed within the diversity of the cosmos. Hargrave has approached the commonplace with such tact and respect that she has perfectly revealed the boundless inscape within a simple found stone [plate 8].

9   Catherine Wagner
**Sequential Molecules**,
1995
grid of nine silver
gelatin prints
24 x 20 inches each
Museum purchase

With observational skills equal to those of a scientist, Catherine Wagner constructs still lifes from scientific experiments in progress. Her work reveals a careful protocol of selection and rejection in subjects that range from ordinary beakers and flasks to DNA sequencing and radioactive cell growth. **Sequential Molecules** is exemplary of Wagner's clarity and formalism, with images organized in a methodical gridded arrangement to create an order and repetition that mimic the routines of scientific investigation.

**SCIENCE**
PEAT

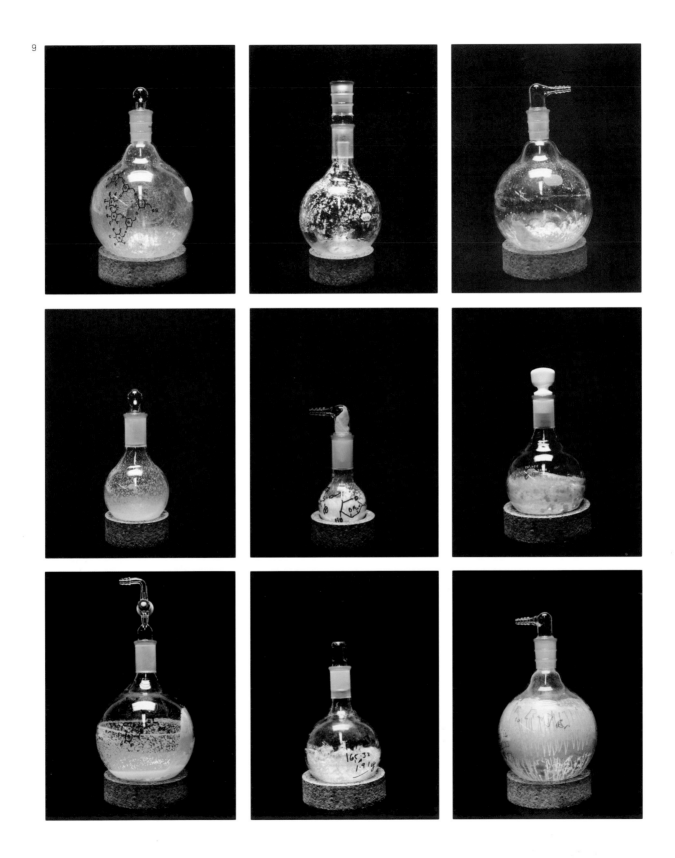

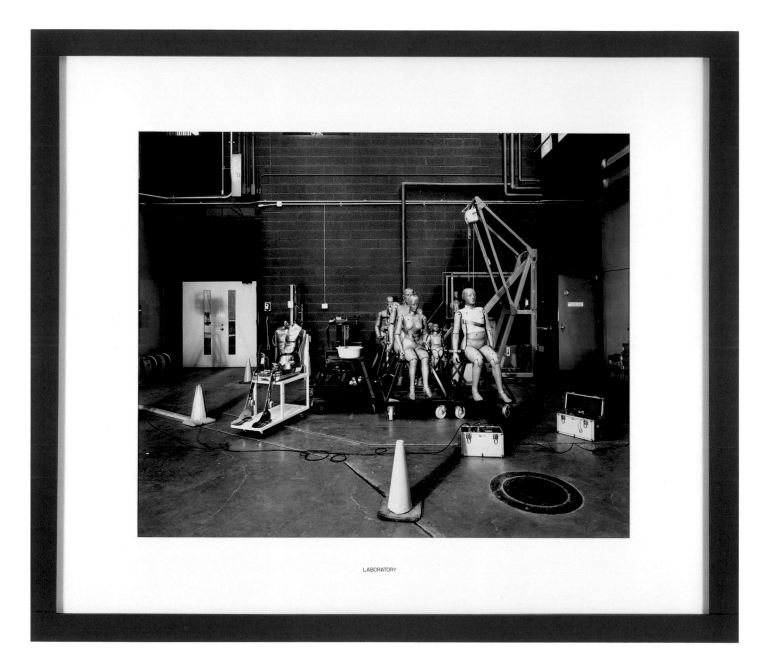

LABORATORY

10 Lynne Cohen
**#2964 Laboratory**, n.d.
framed silver gelatin print
43 ¾ x 50 ½ inches
Museum purchase

Lynne Cohen addresses found scenes in a manner reminiscent of Eugène Atget's photographs of Parisian crime sites. Almost frightening in their stillness, the abandoned laboratories, classrooms, and military training grounds Cohen photographs suggest activities that have already happened or might yet happen. In **#2964 Laboratory**, this lifelessness is underscored by the presence of mannequins – the "crash test dummies" designed to stand in for their human counterparts – which provide for another, more profound, level of emptiness.

11  Catherine Chalmers
    **Praying Mantis Eating a**
    **Caterpillar**, 1996
    chromogenic development
    (from color negative) print
    20 x 30 ³/₈ inches
    Museum purchase

Catherine Chalmers photographs a variety of insects and amphibians as they move through the natural cycles of life, including those of reproduction and sustenance. For her series on the food chain, from which **Praying Mantis Eating a Caterpillar** is taken, such events were photographed in vivid color against a stark white ground. The sterile background implies an atmosphere of objectivity and observation, and what happens in front of it – and in front of Chalmers's camera – are events not normally witnessed by human eyes.

12  Susan Rankaitis
**DNA #10**, 1992
mixed media on
photographic paper
mounted on steel
45 x 35 inches
Gift of the artist and
Robert Mann Gallery,
New York, in honor of
James J. Brennan

Although Susan Rankaitis
works on standard rolls
and sheets of commercial
black-and-white photo-
graphic paper, she
explores the properties of
photography's chemistry
from a painter's perspec-
tive. Images such as **DNA
#10**, with its careful chaos
of form, figure, and color,
are altered through a
variety of chemical and
other processes. Photo-
graphic negatives,
brushed-on emulsions,
photograms inspired by
those of Lázsló Moholy-
Nagy, graphite, and acrylic
and industrial paints all
conspire to produce sur-
faces that defy a strict
cataloguing of materials
and techniques.

Catherine Wagner has chosen an ordinary piece of laboratory equipment as her representative of science, but in doing so has endowed it with the pristine quality normally associated with a religious object [plate 9]. In order to emphasize its particular present, Wagner has abstracted it from its normal context of the laboratory bench. Chemistry, along with much contemporary science, is about reaction, transformation, change, complexity, nonlinearity, and, above all, open systems. But here Wagner has chosen the static endpoint of this process. Her flask has become a sealed, closed system. Unconnected to other flasks, retorts, and sources of heat, the chemical contents have ceased to react. Indeed, her image resonates with the very notion of photography itself, for both represent that particular moment when a dynamical process has completed itself and thereby entered the domain of timelessness.

Lynne Cohen's engagement with science, on the other hand, is playful. She seeks out the drama of those ambiguously scaled and curiously lit environments in which scientific mysteries are played out. The high priests of science are absent in her photographs. Like the crew of the sailing ship Marie Celeste, they have inexplicably vanished, leaving behind their props: Styrofoam coffee cups, name tags, and the curious anthropomorphic dummies that have been the center of their experiments [plate 10].[7] Cohen unnerves us because she knows that the cunning of a Caravaggio shatters the illusion of the picture plane by causing a bowl of fruit to spill from the painting or the back of a chair to push into our own space. Appropriating pictorial devices from the Baroque painting that she loves, Cohen uses natural and ambient lighting to draw us into her spaces until we find ourselves glancing over the shoulder to double check that we are still standing in the picture gallery.

Photography has an ability not only to reveal new worlds, but to give a magical presence to the commonplace. Yet for many amateurs and indeed a few professionals, it can become a filter, a medium of mediation placed between the eye and the external world. But Catherine Chalmers's gaze reveals life in all its beauty while at the same time respecting its integrity. It also hints at an idealized scientific vision of the natural world that is similar to that found in the work of Berenice Abbott. Chalmers's mantis hovers in a bleached-out universe [plate 11]. It has been removed from the everyday contingency of its natural surroundings, and isolated from Charles Darwin's Great Chain of Being. Thus the mantis hovers safely but impotently in a no man's land remote from its natural habitat, fixed in a constant drama of death and ingestion.

Concept and image: Susan Rankaitis, Todd Watts, and Nancy Burson
**While Berenice Abbott, Catherine Wagner, and Lynne Cohen have portrayed the environment in which science is carried out, some**

photographers and artists prefer to explore its underlying concepts. Susan Rankaitis's preoccupations, for example, include the world of genetics and chaos theory. The term "DNA" in her title of one series [see plate 12] refers, of course, to the genetic instructions that switch on and off the manufacture of proteins in a developing cell and express an organism's particular potential for growth and life. But every gene must be expressed within a contingent environment, which biologists call its epigenetic landscape. This is where chaos theory enters, for while our genetic inheritance may appear deterministic, the actuality of our individual lives must unfold within the complex and unpredictable flux of the world. And thus necessity and chance, determinism and uncertainty, engage each other. By working directly at the level of the photographic emulsion — rubbing, painting, and gluing — Rankaitis creates images that perfectly reflect this conceptual encounter.

The artist Todd Watts uses the medium of photography to pose questions about our nature as human beings in an accelerating world of science and technology. Landscape is a traditional pictorial device of the artist, but what meaning does it have, and how shall we come to recognize it,

**SCIENCE**
PEAT

when it is projected into the environment of another planet circling our sun? And how will we recognize our basic human physicality when genetic engineering has been pushed to its limits? And is our very conception of order, fundamental to both art and science, genetically innate, or socially conditioned? In Passenger Pigeon [plate 13], Watts has confounded our most basic desire to seek familiarity, repetition, and pattern in the world. A flock of birds swoop into the air after having been startled by the passing of a car. For an instant their silhouettes are frozen in the sky so that the entire pattern appears random. Yet within the apparent operation of pure chance lies a strict mathematical order, one that prevents the human visual system from resting. And so Watts has worked a subtle spell upon the cortex's desire for order, as well as satisfying art's need to balance symmetry with asymmetry. As a final irony, we recall that the skies of North America are no longer darkened for days by these migrating flocks, for human greed, another kind of desire, has brought about the mass destruction of the passenger pigeon.

Time and change figure as well in the work of Nancy Burson. The face in Evolution II [plate 14] could be taken for a latter-day Janus, since it appears to look both toward the future and the past. Is it some missing link in our human ancestry, or an evolving human form for the next millennium, perhaps one adapted to life within an alien atmosphere and under a different force of gravity? Burson has used computer morphing to create this image, yet this process too seems to refer back to Francis Galton's use of composite negatives in his research on genetic variation.[8] Galton's dream of racial improvement belongs to a naive and innocent age; Burson's image has been created in the context of a science that has known hubris.

Evidence: Patrick Nagatani    It is no coincidence that Patrick Nagatani lives and works in New Mexico, the site of the world's first atomic tests. Nagatani's preoccupation with nuclear technology carries an ironic bite in a technological world that often takes itself too seriously. Here a rabbit pulled out of a magician's hat is equated with the recording of the track of an elementary particle [plate 15]. Both refer to a combination of magic and trickery. For in order to extract a rabbit from an apparently empty hat, the magician must first place it there by sleight of hand. Likewise, when physics asks nature to reveal itself at its most fundamental level of being, it does so by building elementary particle accelerators. Yet in asking its grand questions of nature, science has already prejudged the answer: What do magician's hats produce other than rabbits? How else can nature answer when interrogated with a particle accelerator than by producing elementary particles?

13  Fascinated by evidence of random patterns revealed in nature, Todd Watts studies the formal properties of life forms and events occurring in the world around us. His installation **Passenger Pigeon**, created for The Museum of Contemporary Photography exhibition "Scientia Artifex" (1997), was inspired in part by the concept of populations and their movements as formally significant. Using installation techniques and the photographic process as tools of inquiry, **Passenger Pigeon** positions small black silhouettes of leaping and falling human figures over desolate, surreal, and unnaturally bright photographic landscapes.

14  Nancy Burson produced some of the earliest computer-generated portraits, and in collaboration with MIT engineers Richard Carling and David Kramlich, became one of the first pioneers in the now familiar territory of computer-manipulated imagery. In this image she combined the face of a man with that of a monkey to produce an imaginary portrait of a species (as well as a technology) in transition. This image was published in a series of manipulated portraits, reproduced in **Composites** (1986).

**SCIENCE**
PEAT

13  Todd Watts
**Passenger Pigeon**,
1997
view of mixed-media
installation
Museum commission
with purchase
Photograph by
Thomas A. Nowak

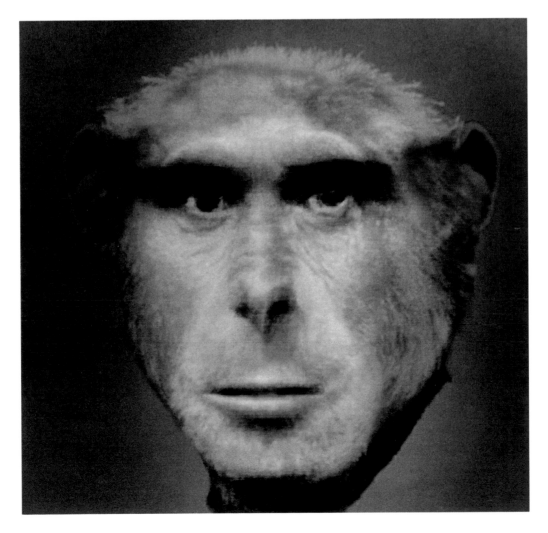

14  Nancy Burson
**Evolution II**, 1984
silver gelatin print
7 x 7 1/4 inches
Purchase through the
Museum Membership Fine
Print Program

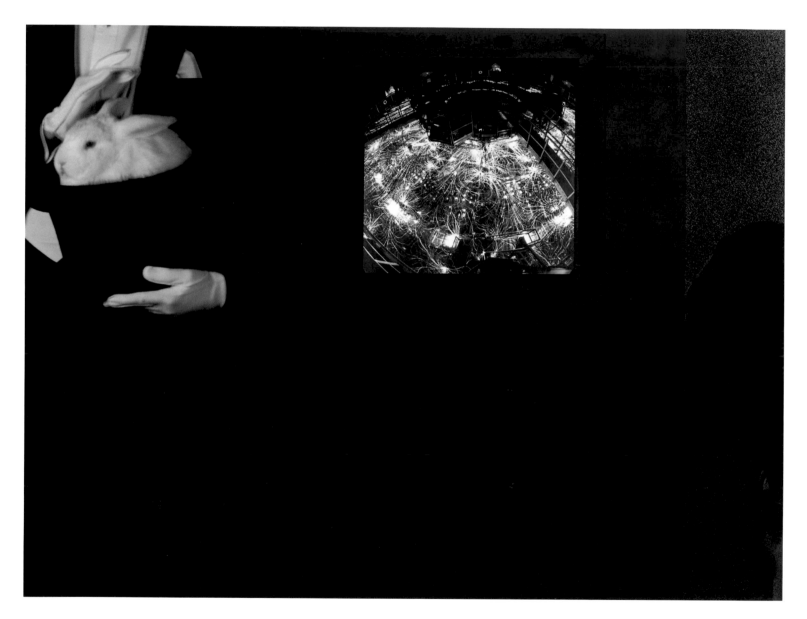

15   Patrick Nagatani
**Magic/Myth/Megation, Particle Beam Fusion Accelerator II, Sandia National Laboratories, Albuquerque, New Mexico**, 1990
chromogenic development
(from color negative) print
17 x 22 1/2 inches
Museum purchase

A master of fabricated photo-dramas, Patrick Nagatani stages elaborate tableaus to pursue the issue of nuclear power with a sense of irony. With thorough disregard for the traditional role of photography as an objective documentation of reality, especially scientific reality, Nagatani's narratives offer an animated, color-saturated view of the nuclear and military sites of New Mexico. **Magic/Myth/Megation** presents a magician next to a particle accelerator in a sardonic comment on faith and illusion in the arena of scientific expertise. This image and the others that appeared in the book **Nuclear Enchantment** (1991) reveal Nagatani's wry sense of humor, mastery of the constructed set, and concern for social issues.

But Nagatani's reference to elementary particle tracks opens up another debate, that of the nature of evidence, both photographic and scientific. Because of its objective feel, photography has always been associated with the notion of evidence. We carry in our purses and wallets photographs that establish our identity and offer evidence of our youth, marriage, children, a holiday romance. As a record of singular instances, these images develop the resonance of memories.

Photographic evidence in science is a way of preserving the unique event and thereby giving it a sense of objective universality. It is often said that science demands repeatability, yet a combination of telescopes and advanced computer programs provides us with the evidence of singular astronomical events that took place at the edge of space and time. Indeed, the farther and farther we look into space, the closer we come to that ultimate photo shot — the Big Bang origin of the cosmos! And that tiny fraction of a second when two high-energy protons collide head-on produces a starburst of other elementary particles, including perhaps one observed for the very first time. Images of these rarely observed events take on an iconic quality and radically change, or confirm, our notion of the underlying structure of reality.

Such photographic evidence in science has resonances with photography's use in the type of minimal and transitory intervention within the environment characteristic of some contemporary artists. Yves Klein dropped gold bars into the Seine in exchange for the sale of a "Zone of Immaterial Pictorial Sensibility." Andy Goldsworthy throws colored mud into a river or builds a spiral icicle that rapidly melts in the rising sun. Richard Long walks across a field to create a fleeting record of his passage in bent grasses. In each case the only objective record that remains is the photograph, an instant of captured time.

The material evidence of the birth and death of an elementary particle, and of an artist's passage through the landscape, have similar hovering ontologies. An elementary particle track is not, in fact, an image of its being, as is a photograph of a face. Rather it is the record of processes associated with a sequence of quantum events. Quantum theory dictates that in the absence of an act of observation, it is not even possible to say that an elementary particle has a track, or even that it took a particular path between A and B. At every instant of its existence, the position of an elementary particle and the direction of its motion are incommensurables. Given an act of observation, however, it becomes possible to pin down one variable at the expense of a degree of uncertainty in the other. The photographic plate is the witness that fixes the action. The photograph is not simply a piece of documentary evidence, but an active partner whose physical presence caused the particle to define its particular mode of existence. It is by virtue of the photographic presence that the particle has a track.

Similarly photographs of environmental art have their own shifted ontology. They are not by themselves works of art, yet neither are they simply passive records of art acts. They are active witnesses that assist as the act comes into existence. Just as the image of the elementary particle is something more than a photograph, for it is the participator in a process, so the environmental photograph has slipped from the domain of pure photography. Its mode of existence has changed and it would not therefore find its place in a gallery among the other photographs, but above an arrangement of sticks, a pattern of leaves, or a spiral of stones. On the wall it hovers between evidence and actuality. In a sense it would like to join the other arrangements of natural forms on the gallery floor, yet as the active witness, it must preserve its distance. It is suspended between being a pure photograph and escaping into another mode of existence.

But once this hybrid nature is admitted, photography itself has entered a dangerous and troublesome area. It ceases to be the detached

**SCIENCE**
PEAT

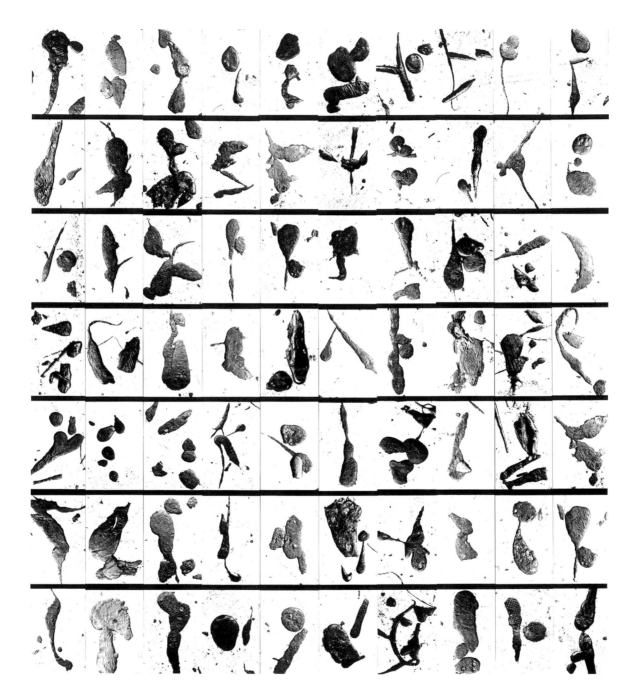

16  Barbara Crane
**Tar Findings**, 1975
silver gelatin print
10 5/16 x 9 1/2 inches
Museum purchase

An interest in the natural world is evident in much of Barbara Crane's photography. Looking for patterns in both the urban and rural environments, she has turned her camera toward pedestrians and their surroundings in Chicago, and to forests and their elements in Michigan. **Tar Findings** offers a mysterious taxonomy of a substance, a careful examination of an unusual subject in all its tactile richness. It also testifies to the influence of Abstract Expressionism on photography, as well as that of Crane's teacher, Aaron Siskind. See Schulze, plate 21.

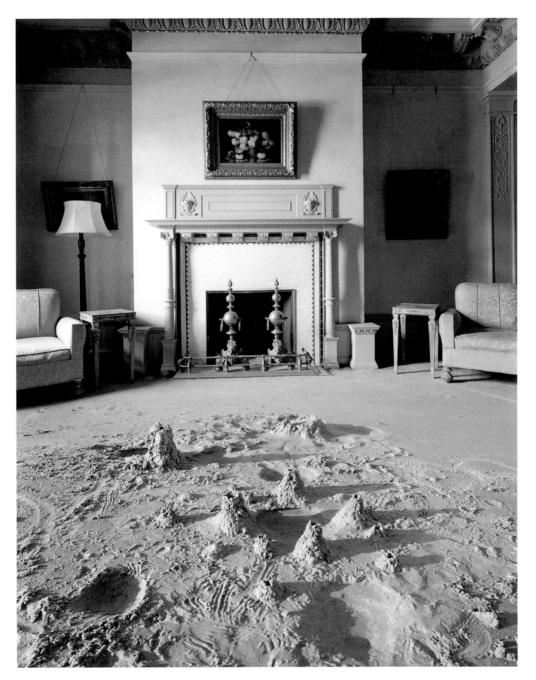

17 Douglas Prince
**Untitled**, 1979
silver gelatin print
9 x 7 inches
Museum purchase

An example of a multiple image – one created from more than one negative – this untitled interior by Douglas Prince shows off photography's ability to shape a wholly fictional environment. Prince seamlessly joins the familiar with the unspecified, as he dissolves the carpeted floor of an inviting living room into a sandy surface that is perhaps even that of the moon.

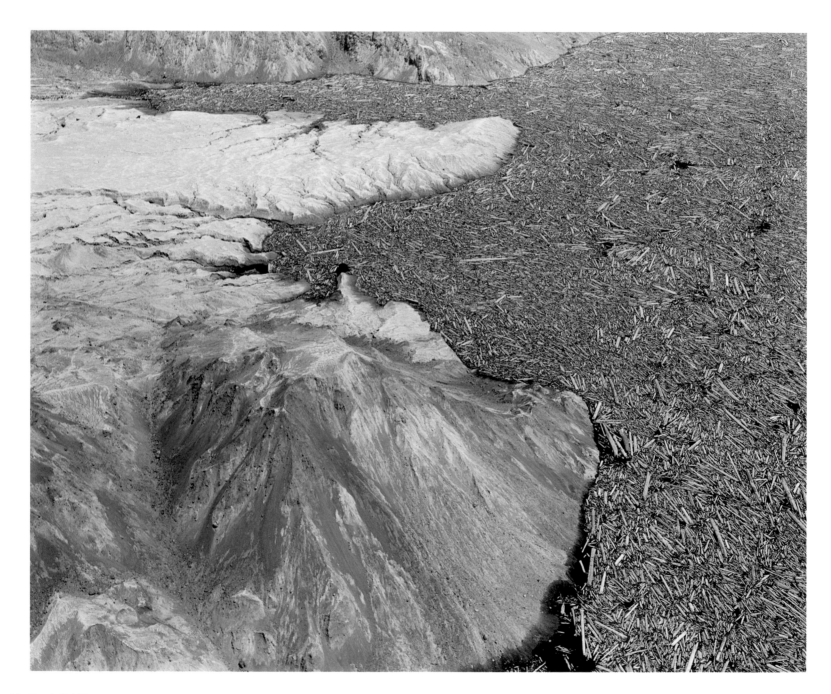

18  Frank Gohlke
**Young trees killed by heat and**
**downed by blast – valley of**
**Hoffstadt Creek, 13.5 miles NW of**
**Mt. St. Helens, Wash., 1981**, 1981
silver gelatin print
17 7/8 x 22 1/8 inches
Museum purchase

In the years following the
eruption of Mount Saint
Helens, Frank Gohlke,
whose work is perhaps more
concerned with art than
documentation, produced
quietly dramatic pho-
tographs of this natural
disaster. Gohlke used non-

classical printing tech-
niques to convey the devas-
tated environment: the
flatness of tone in this print
is specific to his subject,
appropriately reflecting
an environment saturated
with ash and fallen trees.
A precise description of a

postapocalyptic landscape,
**Young trees killed by heat**
**and downed by blast** docu-
ments destruction as well as
the photographer's concern
for the fragility of the earth.
See Rosenblum, plate 15.

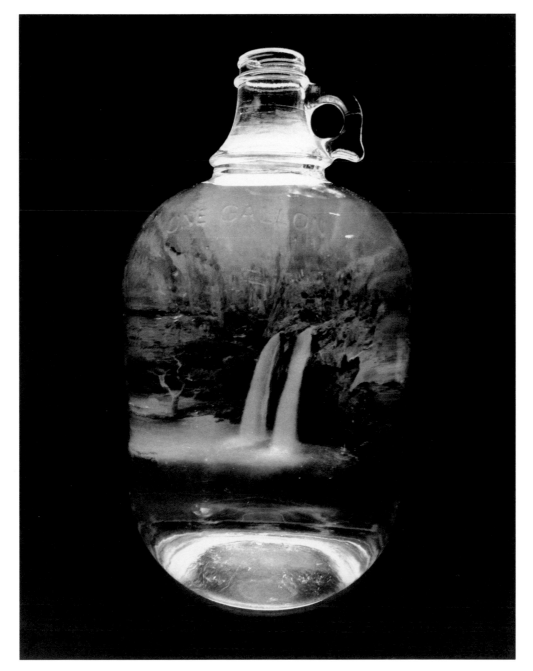

19 Derek Johnston
**Landscape Specimen 004,**
**Havasu Falls,** 1996
hand-coated platinum/
palladium print
13¼ x 10½ inches
Gift of the artist

In **Landscape Specimen
004, Havasu Falls,** Derek
Johnston has lyrically pack-
aged a waterfall and its
surroundings. An amateur
naturalist, Johnston seeks
to create work that serves
as a catalyst for the reen-
chantment of nature.
Exhibiting a debt to Surre-
alism – and perhaps an
environmentalist agenda –
this image depicts nature as
specimen, or as product to
be consumed.

document and becomes an agent provocateur, an instigator of violent confrontation and riot. Just as the photographic plate produces the particle track, so too the presence of the camera forces reality to choose its moment-to-moment mode of expression.

Observation and classification: Barbara Crane, Douglas Prince, and Frank Gohlke    It would be difficult to imagine science without its orders, classifications, and family trees. Seeking to partition the natural world into taxonomies, and, likewise, dividing up our internal mental world into distinct concepts, is as old as Greek philosophy. Photography, with its ability to capture and isolate, becomes the perfect partner for this aspect of the scientific enterprise, and Barbara Crane's image [plate 16] displays all the obsessiveness associated with a science that seeks to codify the world in terms of similarities and differences.

Our visual senses evolved upon planet Earth in response to a strictly limited range of electromagnetic vibrations, and within a relatively narrow range of physical scales. How will vision change when we walk on the surface of other planets, or live out our lives in outer space? The artistic imagination responds to such a question, and photography is a ready tool. Todd Watts has created a series of imaginary surfaces for each of the solar system's planets, as well as speculative images of humankind's future form as a result of genetic engineering. Douglas Prince [plate 17] presents another imaginative exploration: the striking juxtaposition of a formal domestic setting with...what? The surface of the moon? Some distant asteroid? The lack of interior scale becomes so ambiguous as to disorient. Yet the entire scene is unified by light that enters from the left, reassuring us that both scenes are taking place within a room on the surface of our own planet – or at least somewhere within the confines of our solar system illuminated by our single sun!

Frank Gohlke demonstrates the way William Henry Fox Talbot's "pencil of nature" draws the natural world in such striking detail. Gohlke's image [plate 18] becomes even more penetrating when we realize the power of natural devastation: the energy released in the eruption of a volcano, an earthquake, or tidal wave, exceeds the potential of our own technology. The fallen tres also evoke the currently fashionable topic of chaos theory, and of fractals in which particular patterns repeat at ever decreasing scales. Mathematicians have argued that fractals, and other forms particular to chaos theory, are a more appropriate way of describing the natural world than is Euclidian geometry, with its straight lines, regular curves, and solids. Photography has played a significant role in forging the link between the forms of nature and mathematical fractals, and in this manner has transformed a complex branch of theoretical physics into a widely used contemporary metaphor.

Nature contained: Derek Johnston    Nature has been captured and bottled for our consumption [plate 19]. The Sublime is tamed and confined behind glass, like a baby in an incubator. What an ironic comment upon the entire scientific enterprise! Indeed, until relatively recently (that is, until the rise of chaos and complexity theories, far-from-equilibrium thermodynamics, and the theory of open and self-organizing systems), science preferred to deal with a simpler nature, one confined and isolated from its wider context of complex interactions.

Yet Derek Johnston's waterfall also evokes one contained within Marcel Duchamp's Etant Donné. In Duchamp's last work the viewer peers though a spy hole to see a broken wall behind which lies a naked woman, a gas mantle, and a picture-postcard waterfall. In this correspondence, Johnston's image is as much a comment on the erotic voyeurism inherent in art as it is about the desire of science to encapsulate and tame nature though the power of reason.

**SCIENCE**
PEAT

1 Martin Kemp, "Seeing and Picturing: Visual Representation in Twentieth Century Science," in J. Krige and D. Pestre, eds., **Twentieth Century Science** (Amsterdam: Harwood Academic, 1997), pp. 361–90.

2 See, for example, Susan Griffin, **Woman and Nature, the Roaring Inside Her** (New York: Harper and Row, 1980); Camille Paglia, **Sexual Personae: Art and Decadence from Nefertiti to Emily Dickinson** (New York: Penguin Books, 1990).

3 See, for example, David Bohm and F. David Peat, **Science, Order and Creativity** (New York: Bantam Books, 1987).

4 Eugene P. Wigner, "The Unreasonable Effectiveness of Mathematics in the Natural Sciences," **Commun. Pure Appl. Math. XIII** (1960), pp. 1–14. A reprint of this article, along with others on the same subject, can be found in Ronald E. Mickens, ed., **Mathematics and Science** (Teaneck, NJ: World Scientific, 1990).

5 Both quotations can be found in Paul Buckley and F. David Peat, eds., **Glimpsing Reality: Ideas in Physics and the Link to Biology** (Toronto and Buffalo: University of Toronto Press, 1966).

6 Berenice Abbott, 1939, quoted in **Berenice Abbott Photographer: A Modern Vision,** ed. Julia Van Haaften (New York: The New York Public Library, 1989), p. 58.

7 In 1872 the US brig **Marie Celeste** was discovered in the mid-Atlantic. Although in perfect condition, and with food still on the dining table, the entire ship was deserted.

8 The British biologist Francis Galton investigated the genetic basis of intelligence, suggesting that it could be generally increased in the population through the operation of selective parenthood. To this end Galton developed the original IQ test. He also overlaid photographic images to produce an average composite of particular "types" to demonstrate, for example, the supposed difference between officers and enlisted men in the British army. Presumably, Galton hoped that while the numbers of the former could be enhanced, the latter could be eliminated. If Galton's philosophy appears repugnant to our modern sensibilities, one should recall that notions of selective parenthood, together with the elimination of what were taken to be genetically inherited mental and physical defects, were fashionable in the early decades of this century.

Author's note: I would like to thank Lynne Cohen, Susan Derges, Andrew Lugg, Terry Ann R. Neff, Ann Thomas, and Todd Watts for helpful discussions. I also thank the staff of The Museum of Contemporary Photography, Columbia College Chicago, for their informative answers to all my queries.

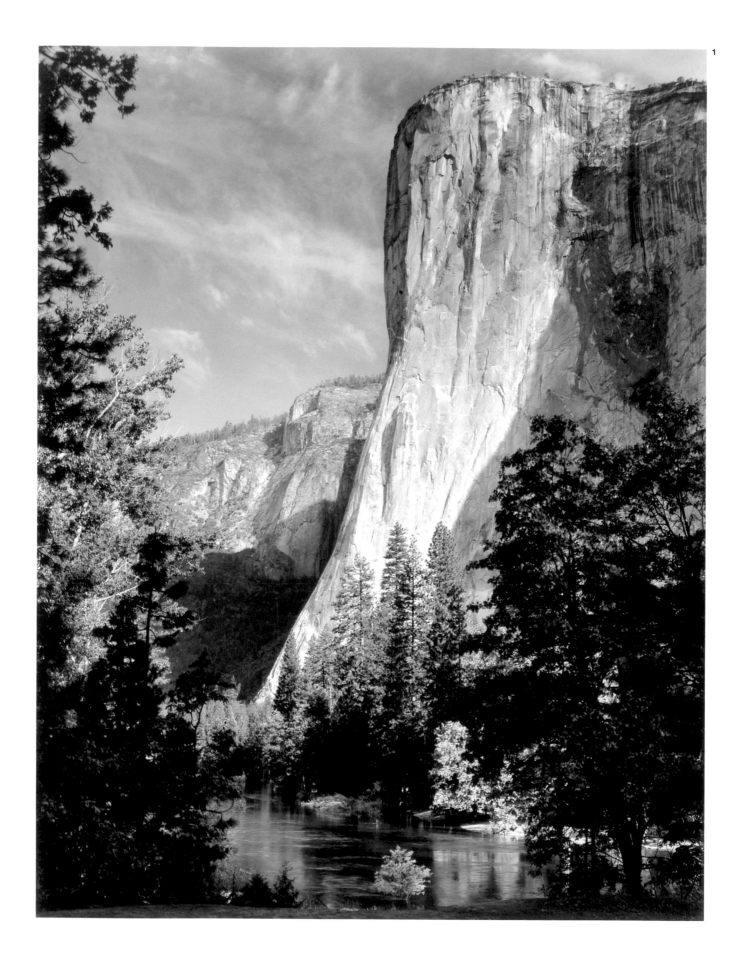

The history of visual representation can be seen as a constant effort to build concrete signs of our relationship with the world – both with the physical world of suns, mountains, and beasts, and with the numinous world of gods, spirits, and ideas. The earliest cave paintings show humans involved in the activities that mattered most to them, such as the hunt and ceremonial performance. Ever since those early beginnings, visual art has helped us keep priorities in order by providing models of the concepts that mattered most at the given historical moment. The intricate tattoos covering the bodies of natives of the Brazilian jungle express their relationship to ancestors and the tribe.[1] The scenes depicted on early Greek vases remind the viewer of the heroic virtues of a warrior aristocracy; the pattern of oriental carpets originally represented a map of the Garden of Eden; and the innumerable portraits of European princes and merchants over the last four hundred years celebrated the spiritual and temporal powers valued ever since the Renaissance.

Mihaly Csikszentmihalyi

# Spaces for the self

## The symbolic imagery of place

Visual art has also often been used as a vehicle for more or less sophisticated forms of magic, or attempts to control events through symbolic representation. It is widely believed that the oldest forms of cave painting and of sculpture served this purpose. As late as the seventeenth century, the Italian scholar Giulio Mancini could still write the following about why one should hang sexy pictures on bedroom walls:

Lascivious things are to be placed in private rooms, and the father of the family is to keep them covered, and only uncover them when he goes there with his wife, or an intimate who is not too fastidious. And similar lascivious pictures are appropriate for the room where one has to do with one's spouse; because once seen they serve to arouse one and to make beautiful, healthy, and charming children...because each parent, through seeing the picture, imprints in their seed a similar constitution which has been seen in the object or figure.[2]

Tattoos, vases, rugs, and pictures serve as media that connect biological existence with the world of ideas that our ancestors have created, and which are transmitted through time as part of the culture – the symbolic environment that coexists with and interpenetrates the physical environment in which we also live. Without such visual reminders of the things we value, the world would be an even more cold and alien place than it already is.

Ansel Adams's documentation of the Western landscape has taken on iconic significance as one of the defining purist visions of both the American West and of the photographic medium. Images such as this one, taken within the National Park System, have frequently been used to promote both tourism and preservation of the landscapes they portray. El Capitan is a subject Adams photographed repeatedly, using the mountain's towering presence to signify the sublime and unfathomable vastness of nature.

171

**The uses of photographs in everyday life**    If you ask average urban Americans to tell what are the most special objects in their homes, chances are that they will mention photographs. Photographs are the third most often mentioned category of significant household objects (after furniture and paintings). Children and adolescents are less likely to find photographs special; for the younger generation, they are down at the sixteenth position in importance among meaningful things in the home. But for their parents photos move up to the sixth rank, and for grandparents they are on top of the list, in first place. Another interesting difference is that women mention photos as being important to them in the home at twice the rate of men.[3] Why do people, especially older persons and women generally, cherish photographs so highly? The answer has little to do with artistic values, with aesthetic considerations. Photographs are valued by average people because they are the visual medium that best preserves memories of a person's past, and of his or her immediate family. Of all the things kept in the home, they are seen to be the least replaceable. Without memories of the past, we would lack a self; we would be blank slates without history, thinking machines without identity.

Viewpoint
Csikszentmihalyi

Throughout history people have surrounded themselves with objects that represented visually their connection to the past. In ancient Rome, as in ancient China, the most important corner of the house was the ancestral shrine, where masks, statuettes, or paintings stood for the memorable individuals from whom the current generation was descended. An individual's identity derived its depth and weight from these ancestors. In our own days, photographs are perhaps the most important vehicle to serve a similar function.

**Varieties of the aesthetic experience**    This domestic, popular function of photography is only one reason for creating and responding to photographs. Like other visual art, photography over time develops its own peculiar raison d'être, an existence independent of its primary use as a concrete representation of the self and its connection to the past. It becomes a much more complex medium, with a variety of rules and potential messages never apparent in earlier stages. When approached as works of art, photographs are created to express an individual vision that ranges far beyond the recording of personal history. And viewers may decode the message of art photographs along many more dimensions than they can snapshots pasted in family albums. While domestic pictures are likely to have stronger meanings and a more important place in a person's identity, photography as art is likely to provide a broader range of experiences, and lead to a more diverse growth of perceptual and cognitive abilities.

There are many ways of looking at any work of art. They vary from a passing glance to a deep involvement of the senses, the mind, and the emotions. What is usually called an "aesthetic experience" is simply an intense involvement between a viewer and a work. Aesthetic experiences can be briefly described as having four dimensions: *perceptual responses*, which refer to visual elements such as balance, form, and harmony; *emotional responses*, which emphasize personal reactions to the feelings embedded in the work; *intellectual responses*, which include theoretical and art historical questions; and, finally, what might be called *communicative responses*, wherein there is a desire to relate to the artist, or to his or her time, or to his or her culture, through the mediation of the work of art.

In what follows, I shall summarize what studies have shown about how experienced viewers – artists, curators, and collectors – encounter a work of art. While their responses are based on long training and experience, what they say illustrates dimensions of aesthetic experience available to everyone, regardless of previous exposure.[4]

**The perceptual dimension**    Of all the aspects of the aesthetic experience, experts usually mention the perceptual one first and most often. The most general aspect refers to sensing the overall physicality of the work – its concreteness, its original presence. But the majority of perceptually oriented statements are more specific than simple remarks on the totality of the object. They involve appreciation of how the elements are organized in terms of form, line, color, and surface.

The response may involve well-defined classical conceptions of beauty. That is, a viewer might respond in terms of the ways the works reflect or embody certain traditional principles of order, harmony, balance, and the like – aspects of a particular canon of beauty. "Beauty" may refer to strictly formal or compositional elements that are present even in objects that depict unpleasant subject matter. There is often a related concern with the appreciation of the quality of the work, with "how well [the object] was made," and with how one is drawn to objects that are "the finest examples of their type," reflecting a "purity or excellence in their specific category."

One need not subscribe to classical notions of what is beautiful to enjoy the perceptual properties of a work of art. One can still appreciate the form, color, and textural quality of the object even without any formal aesthetic training.

Sometimes one can discern in the work the gesture of the artist making it, and so one gets a direct access to the art-making process. Interaction of this kind can have an immediate impact:

**It had a certain crudity which is actually enormously appealing. You can almost see the wood carver, you know, attacking that piece of wood with the**

kind of fervor and creativity of the moment....You can see the cut marks of the chisel and the knife on the torso.[5]

It is apparent that the perceptual dimension of the aesthetic encounter is as varied as it is central. For whatever reason, the form and the surface of a work of art can have a strong impact on the mind. Certain perceptual "gestalts" have a more powerful appeal to our nervous system than others, and when we see them we pay attention and are moved by them.[6]

**The emotional dimension**    Strong feelings are involved in almost every aesthetic experience. Typical positive responses include emotions such as joy, delight, inspiration, and love. Negative ones include anger, hate, and frustration. Some viewers are most affected by works that are surprising, while others prefer familiar works evoking comfort or even nostalgia. In the latter cases, there is almost always some connection to personal feelings, an association to past experiences.

Some works produce tension, excitement, or intrigue. Others are valued for bringing about a composed, contemplative state. Occasionally a purely visceral or physical reaction is reported. More often people use phrases such as "I was struck by it" or "It grabbed me," and then go on to describe a more intellectual mode of apprehending the work. Generally people describe a development over time, from an initial reaction (which is usually an emotional impact) to the involvement of thought and perceptual appreciation.

An initially positive reaction is not necessary to have a significant experience with art. Sometimes viewers are frustrated or disappointed at first, or actually hate a work they will later admire. One museum curator recounted her interaction with Jackson Pollock's painting *Number One* as just such an encounter:

I was just indignant, furious. And my reaction was very strong – I really was quite convinced that this was a joke. But it was interesting enough that I kept seeing it over time, and by the time I had gone through part of college I was quite enthusiastic about it and I found it very exciting.[7]

Sometimes the emotions one feels are awe and inspiration at the ability or genius of an artist:

Truly great works of art, no matter how familiar you become with them, never fail to mean something. How often have I picked up something like Rembrandt's *Three Crosses*? You might do it automatically once or twice, and then you give it a look again, and you say, "My God!... How did he?... What?... How wonderful this is!"[8]

The emotional dimension, like the perceptual, lurks behind every encounter with a work of art; if one is open to it, it can transform the experience in important ways. Emotion constitutes a highly salient feature of the overall aesthetic experience, yet considerable variation exists with respect to the positive or negative valence of feelings produced, and in the general level of intensity or excitation. The quality of emotional response may vary depending on how much time is spent with the work. It is also apparent that this variance is related to the interplay of affective and intellectual modes of apprehending the object.

**The intellectual dimension**    We tend to distinguish the arts from the sciences in part because we assume that the former appeal to emotions, while the latter address the intellect. Sophisticated members of either realm, however, tend to recognize the broad overlap between the arts and sciences and to acknowledge that the two human capacities through which these disciplines have been created, emotion and intellect, are not only compatible, but perhaps in certain respects indistinguishable. Therefore it is not surprising that when experienced viewers describe their encounters with works of art, in ninety-five percent of the cases they make reference to intellectual or cognitive dimensions. Moreover, just over half of the time, the intellectual aspect is primary.

It is true that people sometimes feel that thinking too much about a picture, or knowing too much about its background, can get in the way of an emotionally satisfying aesthetic experience. But more often than not, experts say something like the following:

Maybe it's too strong a statement to say that people who are totally untrained can't have an aesthetic experience, but generally, I think developing knowledge of technique and knowledge of the subject matter [is necessary]. For most modern people, mythological subject matter is completely lost. So they have very few grounds upon which they respond. I suppose people can have a kind of visceral response to a Gothic cathedral or the Sistine ceiling. But to proceed from that to a deeper understanding of technique, of the intellect behind the work of art, is for the most part learned. So awe is a more general response, but to really have the object hold for long periods of time, that's more a learned thing. You only see what you are taught to see. You have to be taught to see a certain amount before you can go from that and develop a more sustained and creative process of seeing.[9]

Some viewers claim that what they seek from a work is meaning or understanding. Others search for information, exhibiting a desire to resolve a puzzle, a problem, a specific question. Such an approach aims to discover not only the artist's intentions, but the work's own history, its place in the culture that produced it, and its function. Just as one can ferret out secret messages hidden in a work, so one can sleuth out a work's history or nature.

Often there is an urgency to categorize, to attach a label, to place a work within a historical, art historical, or biographical context. A few viewers experience a sense of mastery and accomplishment: "It's conquer-

ing the object, having the power over it, not allowing the artist to put something over on you or keep a secret from you. In a certain sense, I hate to admit it, but there is the sense of power, in having an insight, having information."[10]

For some, sleuthing after origins, meanings, or history is crucial to the appreciation of a work, so much so that if the object does not raise such questions or problems, or if it yields answers too easily, interaction with the work is less satisfying:

**A lot of pieces…are very straightforward, and you get them into shape and you don't find anything exciting about them, but there are pieces that have some sort of challenge; [they] are the ones that stay in your mind and are the most interesting.[11]**

A work of art that compels attention tends to be complex, containing many levels of information. There are limitless possibilities for understanding the content and the context of works of art. Some individuals approach art objects in ways that might best be described as academic; others develop a broad understanding of a work through a sustained dialogue with it.

Viewpoint
Csikszentmihalyi

**Communication as a dimension of the aesthetic experience** Often the encounter with a work of art is a form of communication. Communication with a work of art is, of course, often a multidimensional experience, one that integrates the visual with the emotional and the intellectual. One man described the difference between instantaneous reactions and the continual exchange of thoughts and feelings that occurs over time by saying, "It's not just a blast, it's a dialogue." Another makes the same point: "At least in my experience it isn't just this object that sits there, but it does have something to give to you."

These "dialogues" most often fall into one of three general categories: communication with an era or culture, communication with an artist, and communication within the viewer. There are often recurring metaphors, such as "The work spoke to me," "It tells me about…," or even "The museum absolutely sang to me." There are also many instances of referring to the intention of the artist: "He was trying to make a statement about…." The prevalence of this metaphorical language indicates that the process of communication is an important part of the aesthetic experience.

Communication with an era or culture has two main modes: one emphasizes the differences between the past and the present, while the other is more taken with the continuities. The first mode may be exemplified by a woman talking about her reaction to the "femaleness" of eighteenth-century art and the communication that takes place between herself and the artist:

**The nineteenth century is a very male century, and I was responding to the femaleness of the eighteenth century…. Let's assume that the picture is an expression of [the artist's], as your response to it is an expression of yourself… and there's a kind of conversation through the ages.[12]**

While the difficulties of communicating across the boundaries of time are evident when considering the differences between certain eras, other aspects of communication across the ages are based on similarities, whether those of symbolic intention and usage or the simple facts of a shared humanity. Occasionally the encounter with a work of art is expressed in terms of being put on "a plane above things," where one gets "a sense of the absolute."

**Very great objects give one a sort of a transcendent experience. It takes you out of the realm of everyday life. You lose the sense of where you are and become absorbed in the object. When that happens, whether it's theater, or looking at art pictures, or reading a beautiful piece of prose, it moves you and transcends you. I think that's part of what art is. It's not common experience, it doesn't happen that often, but it does happen with regularity.[13]**

The communicative aspects of the aesthetic experience include a number of possibilities. They start with communication across the boundaries of time, from era to era or culture to culture. From there they lead to communication across interpersonal boundaries, that is, from artist to viewer or vice versa. Communication within personal boundaries takes place within the minds of the viewers as they contemplate fantasy, past experiences, or their own development over time. Finally, it includes transcendent experiences, which are as much a deepening of the self as a loss of the self in an ageless, perhaps timeless, realm of the absolute.

Of course, none of these experiences actually involves real communication, since they all take place only in the minds of viewers as they focus attention on the art object. But the fact that this interaction is purely intrapsychic does not make it any less real. That such experiences do exist provides convincing evidence for the capacity of human consciousness to transcend the limitations imposed upon it by objective conditions. With the help of information, imagination, and empathy, the viewer can in fact share the dreams, the emotions, and the ideas that artists of different times and places have encoded in their work.

**Meaning and environment** Whether intentional or not, the photographic images artists make provide a multidimensional commentary on the world in which we live. One of the intriguing challenges of looking at these images as art is to decode the various levels of meaning that, consciously or not,

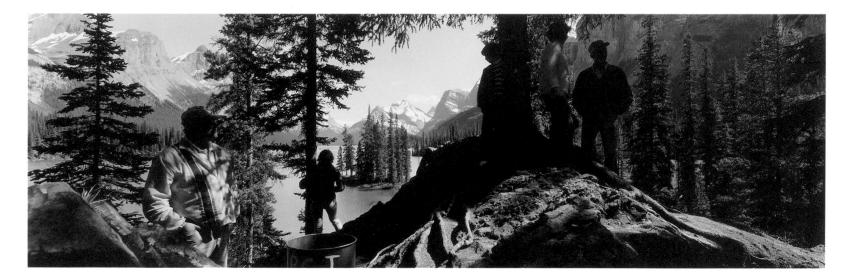

2   David Avison
    *Tourists, Jasper*, 1974
    silver gelatin print
    13 x 33 $^5/_8$ inches
    Gift of Sonia and Theodore
    Bloch

After experimenting and becoming disappointed with the panoramic equipment available on the market, David Avison resorted to engineering his own hand-crafted cameras to suit his interest in capturing the greater context of a subject's surroundings. In Avison's *Tourists, Jasper*,

the scale of human figure to mountainous backdrop is reversed; instead of the insignificant specks of humankind hidden amongst the awesome terrain, the figure of the modern tourist looms in the foreground, slouching with hands in his pockets.

3  Eliot Porter
*Spruce Trees and River,*
*Colorado*
from the portfolio
*The Seasons* (1964), 1959
dye imbibtion print
$10^{1}/_{2}$ x $8^{1}/_{4}$ inches
Museum purchase
© 1990, Amon Carter
Museum, Fort Worth,
Texas, Bequest of
Eliot Porter

Until he saw the pho-
tographs of Ansel Adams,
Eliot Porter was a scientist
and teacher. Influenced by
Adams and Alfred Stieglitz,
Porter decided to devote
himself to photography
and eventually became one
of the best-known docu-
menters of the unspoiled
outdoor world and its
creatures, especially birds.
*Spruce Trees and River,*
*Colorado* attests to
Porter's profound interest
in – and mastery of – the
exquisite color and
patterns found in the
natural world.

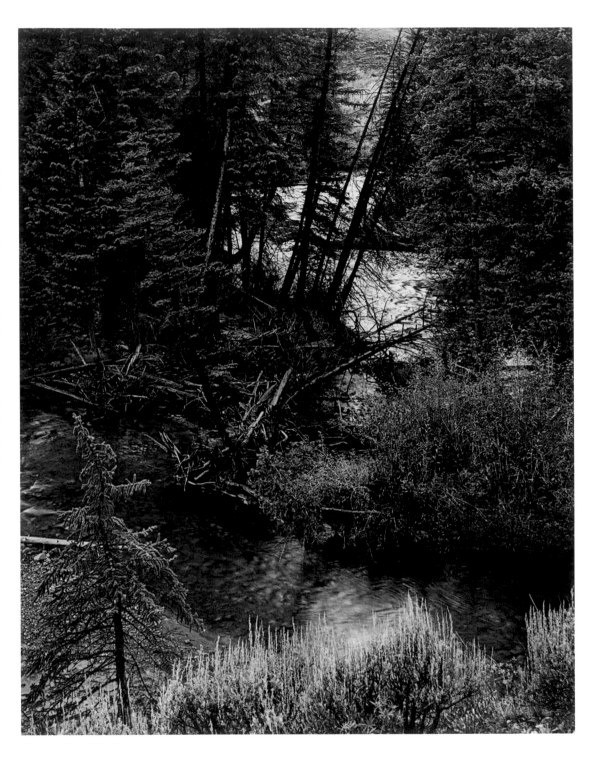

have been embedded in them. What do photographers imply about our relationship to nature, to cities, to our homes – in short, to the found and to the artificial environments we have created? The world has no meaning in and of itself. It is we who attach meanings to the things we see and sense, so how do we see the world when we see it through the eyes of photographers?

**Nostalgia for Eden**    *El Capitan, Yosemite National Park, California* by Ansel Adams [plate 1] makes an immediate visual impact. Shaded foreground and light background, delicate tracery of branches surrounding the dramatic diagonal slab of rock, hard stone entering flowing waters – these and other textural juxtapositions create a kind of visual music which reverberates within the frame. One can forget everything else, and relate to the picture just through these strong visual elements.

But one might also respond to the idyllic scene in terms of personal experiences with nature. The shimmering waters summon the memory of a refreshing dip on a hot summer afternoon; the shady meadows look inviting and serene. The huge rock connecting the clouds with the lake suggests an organic form; with a little imagination one can see in it the profile of an ancient elephant. The picture suggests a sense of peace, of awe, of humble gratitude for being a part of such a lovely world.

At the same time, we might acknowledge that mankind has learned to admire mountains and wild forests only recently. To hunters and shepherds, they were abominations where deer disappeared and sheep were lost. To farmers, mountains were wasted land where nothing grew. The Swiss, who lived surrounded by them, wished they would just go away. It took the romantic British travelers of the late eighteenth century, dismayed by the filth and smoke of Manchester and Liverpool, to appreciate the serene purity of the Alps. Mountains gained their current reputation as a reaction to industrialization. Both the German philosopher Emmanuel Kant and the British art critic John Ruskin found beauty in the exhilaration of snowy peaks and rocky crags. They felt that a pretty landscape confirms only what we already know, and teaches us nothing new. The dreadful peaks, on the other hand, force us to come to terms with our preconceptions, and make us see more clearly what we value and why.

A viewer who knows something about photography and its history might have a number of more academic or technical responses when viewing the pic-

ture. Did Adams use the usual f.64 lens stop in taking the photograph? Was it one of the prints included in his *My Camera in the National Parks* of 1950? Some viewers may feel a brief stirring of sympathy for the photographer's values, and for his life as an ardent environmentalist. None of these considerations, however, is part of the aesthetic content of the work. Nevertheless, these and many other ideas are all potentially a part of the image, and viewers respond to them just as much as to the perceptual aspects.

At the same time, questions about the geographical setting, the kind of trees growing along the water, may occur to the viewer interested in such things. Or one might remember that Yosemite has changed considerably since the picture was taken, and is now a busy tourist destination, with traffic jams and smog spewing over the canyon's walls. El Capitan, the rock at the center of the picture, is a popular challenge for climbers, and its granite sides are spiked with abandoned metal pitons. Such reflections may in turn stimulate reflections about our relationship to nature, and about the vulnerability of its beauty.

An even more direct expression of the ambiguity of the relations between man and nature is David Avison's *Tourists, Jasper* [plate 2]. Mysteriously shaded figures stand around with a listless, bored demeanor. Although the magically beautiful national park opens up behind them, the tourists turn their backs to the landscape, looking away from the mountains and the lake. Are these people overwhelmed by the majestic vista? Are they ignoring it? Have they become so urbanized that the outdoors no longer means anything to them, and they are just waiting to get back to a cozy cabin where they can turn on the TV and tune out the alien natural world?

In Avison's *Jasper*, as opposed to Adams's *Yosemite*, the emotional and cognitive messages may take precedence over the perceptual dimension. Yet here, too, the visual appeal of the image is strong – otherwise our attention would not be attracted to it. Even if there were no human figures in the picture, the alternating areas of strong light and shadow, the recurring rhythm of peaked masses moving from the foreground rock to the background summits, would be sufficient to create an intriguing perceptual interaction between the viewer and the work.

Eliot Porter's *Spruce Trees and River, Colorado* from the portfolio *The Seasons* [plate 3], also evokes strongly ingrained responses to the natural environment. Woods have traditionally aroused both awe and fear. On the one hand, in many societies trees were sacred. The inhabitants of the Ituri forest in Africa believed that everything desirable in their lives was a gift of the forest. If someone became ill or if there was not enough food, the tribe brought out ceremonial bugles carved from wood and blew on them night and day to wake up the forest. They assumed that misfortune was caused by the forest's having fallen asleep; if they woke it up, good times would certainly return.[14] In Norse mythology many of the gods lived in forests. If we dote on fir trees at Christmas, it is because our ancestors worshipped them.

At the same time, woods are fearsome. This is where the Wild Man lives, where the witch builds her lair, where Dante lost his way at the midpoint of his life. In Italian a foreigner is called "forestiero," or "man of the

Viewpoint
Csikszentmihalyi

forest." The Wolf Man lives in the woods, where the id rules and instincts run amok. But even though the tangled forest may represent disorder, there can also be an opposing message in the smooth trunks of well-spaced trees. The soaring arches of Gothic cathedrals are said to have been inspired by them. Elias Canetti wrote that the Germanic love of order, of marching columns of soldiers, grew together with their love of forests and worship of trees.[15]

According to some psychologists, we prefer landscapes that show the edge of a forest where grasslands begin. This preference exists because for thousands of generations our ancestors watched the savannah from the safe shadow of trees, in order to avoid the big cats and catch the stray antelope. Somewhere in the jungle of our nerves, we have developed a predilection for open vistas seen from cover; even now we feel most comfortable in such settings.[16]

These are some of the thoughts and emotions one might have while viewing Porter's picture. But again, the visual elements are strong enough to keep our attention focused even without the intrusion of thoughts and emotions. The aerial view adds a sense of mystery to the vertical trunks of the fir trees erupting from the grasses and bushes. Greens and yellows alternate in subtle harmony. The winding river, which forms the backbone of the picture, adds a soothing serenity to the intricacy of vegetable forms. With one's eyes half closed, the landscape disappears and gives way to a powerful abstract image.

**Marks of human habitation** Tombs were mankind's first permanent traces on earth. Other species do not bury their dead, presumably because they cannot visualize what the end of life means. Because we can, and it frightens us, we have tried to create spaces where the departed could live on. Mongol chieftains were laid out in golden caskets, with all their jewels and weapons. The tombs of Chinese emperors were like underground cities. Egyptian pharaohs have rested for thousands of years in the largest structures built by men.

In *Van Ness Parsons Pyramid, Green Wood Cemetery, Brooklyn, New York* [plate 4], Harold Allen captured a bizarre mixture of symbols erected to keep the dread of death at bay. Egyptian symbols of immortality – the sphinx, the pyramid – are uneasily merged with statues of the Christian Holy Family. How can these two dramatically different narratives of life and death be rec-

onciled? Is this a way to cover one's bets, to double one's chances for eternal life? The conceptual clash is further reinforced by the disproportion of the figures: Mary and Joseph are half as high as the pyramid, and the sphinx looks like a large pet next to them. This photograph also generates a strong visual impact, with the smooth triangular form rising among the trees, the darkness inside spilling out of the ominous door. But its main effect probably is that of providing an ironic social commentary by focusing a dispassionate eye on our absurdities.

Structures erected to worship supernatural powers were difficult to distinguish at first from tombs. But eventually we began to honor gods with the most magnificent buildings ever created. The Greeks raised temples to the gods of the sea on beautiful promontories. Mary Peck's series on these shrines attract the viewer's attention initially because of their bland strangeness. There is something old-fashioned, almost amateurish, about *Temple of Poseidon* (1979): the picture is too small, there is too much foreground, too much background, and the arches and columns that should be the centers of the image are almost crowded out by rock, sky, and sea. To achieve this effect, the photographer has purposefully used a simple technique: by printing a 4x5 negative directly on contact, without enlarging the image, she invited the viewer to draw closer to the landscape, and in so doing, to become aware that the borders of the picture cannot contain the enormity of space.

All around the world, the natural landscape is punctuated by temples, domes, cathedrals, and spires pointing to heaven, in an effort to add meaning to a physical world that, in the words of the biologist Jacques Monod, threatens to become otherwise a "frozen universe of solitude."[17] Sacred structures not only point outward and upward, they also help focus attention inward. The soaring naves of cathedrals, the dark silence of crypts, move our thoughts toward our relationship with the supernatural. But beliefs do not last forever. As faith loses hold, the proud buildings erected to celebrate it gradually crumble back into the landscape, and nature regains its dominion. Ruins of temples are a favorite subject of artists; nothing illustrates as well the ancient saying: *Sic transit gloria mundi* (Thus does the glory of the world disappear).

Tombs and temples brought a sense of order to the wilderness. Lately, however, the marks of human activity have tended to disfigure rather than adorn the landscape. When the land is seen from a plane, it is clear that most of the continent is no longer free, but boxed in by human plans. Ironically, the fences that mark the limits of possession, the furrows indicating our mastery over the earth, have a way of turning around to control our minds and experiences. The hunters and nomads roamed across the land feeling free and at one with their environment. As soon as they discovered farming, our ancestors had to settle down to protect the crops into which they had poured so much labor. Life became more comfortable, meals more predictable. People became tied down to the soil, and their thoughts began to run in straight lines. They also learned to exploit the labor of the masses to increase the wealth of those more fortunate.

Viewpoint
Csikszentmihalyi

4   Harold Allen
    *Van Ness-Parsons Pyramid,*
    *Green-Wood Cemetery,*
    *Brooklyn, New York*, 1969/81
    silver gelatin print
    14 x 18 inches
    Museum purchase with
    matching funds from the
    Illinois Arts Council

As a student of art history at the University of Chicago, Harold Allen began to research the influence of Egyptian aesthetics on Western art and design. His earlier studies in photography at Chicago's School of Design under Gyorgy Kepes and László Moholy-Nagy may have encouraged him to develop the documentary approach to art and architectural history evidenced in this image. *Van Ness-Parsons Pyramid, Green-Wood Cemetery, Brooklyn, New York* exemplifies the pastiche of styles and funerary symbolism from ancient Egyptian and Judeo-Christian traditions – paganism and Christianity united in memorium – that fascinated Allen. See Schulze, plates 6 and 7.

One of the greatest accomplishments of mankind has been the skill to shape matter to suit our fancy. The great epochs of human civilization were named after the materials used to make things: the Stone Age, the Bronze Age, the Iron Age – and now, the Plastic Age? Metals especially were sought out, first, because their shiny surfaces could be made into bracelets and breastplates that attracted envious admiration; and second, because eventually we learned to make weapons with them. And then we needed coal and oil to fuel our dreams. But in order to exploit what the earth has to give, we had to disfigure it. Emmet Gowin's aerial picture of an open pit coal mine, *Mining the Coal Seam, Open Pit Strip Mine, Bohemia, Czech Republic* [plate 5], is a candid commentary on this cruel treatment. At first the circular shape and wavy textures produce a pleasing, almost mandalalike impression of completion and serenity. Then one notices the tiny trucks and cranes, and realizes the outrage being committed. A shaft of sunlight crosses the pit: it is a weak, tired blessing, but it brings a note of hope into the desolate landscape.

## Viewpoint
Csikszentmihalyi

**The city** Six thousand or so years ago, intensive farming made it possible for the first time for people to live together in large numbers, and so brought about the first urban revolution. Cities changed not only the outer landscape, but they also drastically altered the human mind. Cities allowed people to specialize, forced them to tolerate diversity, created opportunities for learning and for culture to evolve. At the same time, it became possible for individuals to become lost in the crowd. Loneliness and spiritual isolation were the shadow of cosmopolitanism.

Barbara Morgan's *City Shell* [plate 6], a composition consisting of a gigantic seashell floating over a skyscraper, with tiny figures superimposed on the shell, condenses the human journey from nature to culture into a powerful image. It is a good example of a picture worth a thousand words. The puny figures walk tentatively, cautiously, on the rounded natural surface, but soon they must slip off into the rigidly hurried grooves of urban life. And if one ignores the figures to look at the overall effect of the composition, the movement seems to be reversed, and the organic shape appears to take off, like a rocket, into the dark. The viewer is likely to wonder also about what it takes to produce such a multilayered composition. Thus technique, form, emotion, and thought build on each other to provoke a complementarily complex response in the viewer.

One aspect of the urban environment comes through with stark power in Bob Thall's *Chicago (Near O'Hare)* [see Schulze, plate 9], which shows the rather artificial configuration of a suburban Chicago skyline. The sleek, massive buildings, covered with curtains of sightless windows, turn away from each other. The open sky and the solitary car in the foreground emphasize the emptiness, the oppressive loneliness, that surrounds an individual alone in the city. The other side of the urban milieu appears in Garry Winogrand's staged view of a happening in an urban park from his *Women are Beautiful* portfolio. A multicultural crowd presses around a model in order to get a good look at her exposed breasts. The face of each voyeur bears a slightly different expression: amusement, disgust, embarrassment, curiosity, feigned indifference, lust…welcome to the city with a thousand faces!

**Moving on** Cities all around the globe have grown to absorb more and more inhabitants. At the same time, mobility has increased, as people travel ever greater distances to work and to relax. In the last century, the railroads changed the social fabric by making it possible for people to move easily to where the opportunities were. In the present century, the car has cut the last knots that kept us tied to a particular location. The automobile offered freedom; the price was the destruction of communities.

O. Winston Link's vision of a ghost town in Virginia is a beautiful comment on the ambivalent gift of easy locomotion. *NW 1345 – Ghost Town, Stanley, Virginia, January 31, 1957* [plate 7] is highly staged. The two sides of a typical, small-town Main Street recede toward a distant vanishing point. In the gap between the storefronts, at the focal point of the picture, a locomotive spewing a lusty panache of smoke crosses the street. It is nighttime, and the facades of the houses are lit by an eerie, theatrical light. There is only one car parked at the curb, and a single figure in the distance walks toward the viewer. The town is deserted, its tired houses mocked by the

5  Emmet Gowin
*Mining the Coal Seam,
Open Pit Strip Mine,
Bohemia, Czech Republic*,
1994
toned silver gelatin print
13$^{15}$/$_{16}$ x 13$^{7}$/$_{8}$ inches
Museum purchase
© Emmet Gowin, courtesy
PaceWildensteinMacGill,
New York

In addition to his acclaimed portraits of his wife, Edith, and other family members, Emmet Gowin also frequently photographs the uninhabited landscape. To the viewer familiar with both modes of Gowin's work, the dialogue between the two reveals his interest in larger, global issues as they connect on a personal level. Gowin identified the landscape pictured here as part of the "black triangle" that produces acid rain across much of the European continent – a commentary on the ways we use – and abuse – our environment.

6  Barbara Morgan
*City Shell*, 1938/80
silver gelatin print
24 x 20 inches
Gift of David C. and
Sarajean Ruttenberg
and the Ruttenberg
Family Limited
Partnership

An experimental photog-
rapher in the Modernist
tradition, Barbara Morgan
is known for presenting
some of the first and most
indelible images of mod-
ern dance. Less known,
perhaps, are Morgan's
photomontages. In *City
Shell*, the superimposition
of the Empire State Build-
ing and a conch shell
probes the idea of inhab-
ited objects and spaces
in a surreal manner.  See
Slemmons, plate 13.

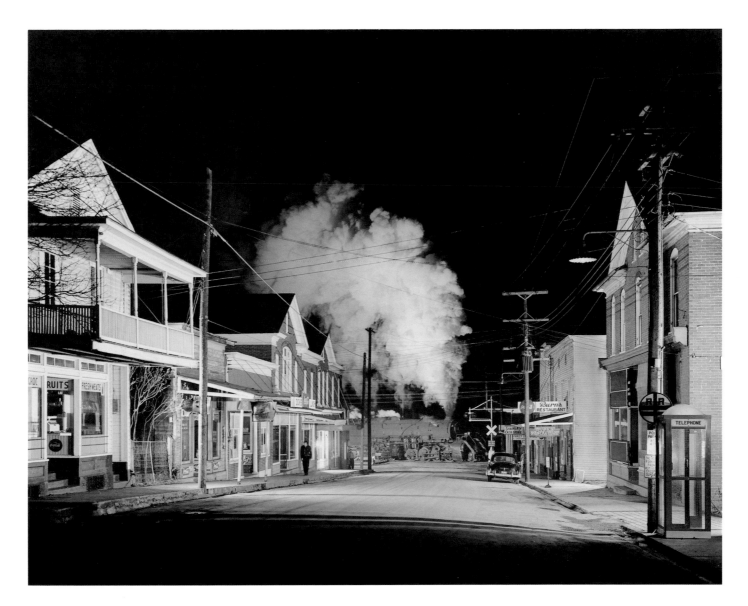

7   O. Winston Link
*NW 1345 – Ghost Town,*
*Stanley, Virginia,*
*January 31, 1957*, 1957
silver gelatin print
16 x 20 inches
Gift of James J. Brennan,
Brennan Steel
© O. Winston Link, courtesy
Robert Mann Gallery,
New York

The beauty and magic of O. Winston Link's photographs of the last days of the steam engine can be attributed to two factors: the intricate and monumental lighting situations and his uncanny ability to crowd the frame with the most telling details. Link not only captured the final glory of an important mode of transportation, but recorded a very specific time and space in the cultural landscape of the United States. This image in particular – the town emptied and ghostlike – is prescient of the changes taking place in small American towns across the nation as they gave way to the suburb beginning in the late 1950s.

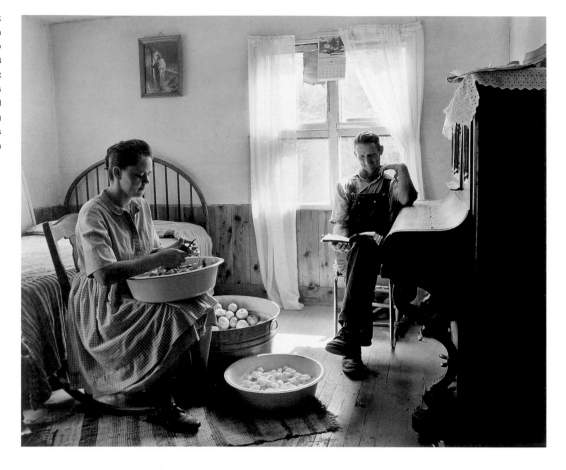

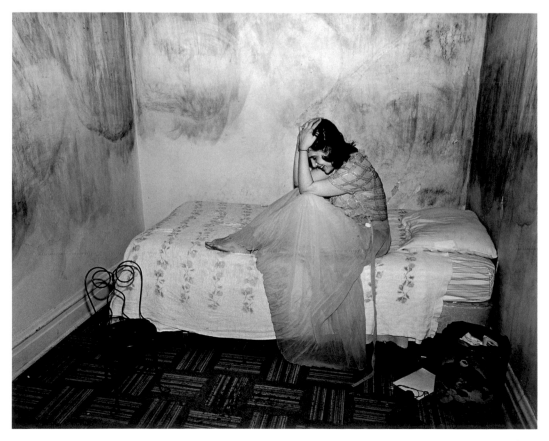

8 Roger Minick works in a documentary mode that emphasizes people, their lifestyles, and their environment. The meticulously printed black-and-white photographs of *The Ozark Portfolio* document life in rural Arkansas with sensuous details and subtle tonalities. Minick clearly demonstrates a personal interest in the people he carefully observes, whether recording them in close-up portraits or in the midst of everyday activities, as in *Ed and Eliza Stilley*.

9 Taken at the former Chrysalis Learning Center in Chicago, where Angela Kelly recorded a small slice of the city's history for the project *Changing Chicago*, this photograph offers a glimpse of a unique "home away from home" for girls with special needs. *Monica Dressing Up* not only depicts remarkably diverse textures in a relatively bare space, but also portrays the persistence of a girl's laughter, even when seemingly trapped in a small and cell-like room.

# Viewpoint
## Csikszentmihalyi

modern telephone booth right of center. It is clear that life has moved on. The train has emptied the old town; yet if you miss this train, perhaps you will have to stay with the dusty ghosts forever....

**Home, sweet home**    As humankind has more or less settled into an urban existence, the home has become increasingly the center of life. Nomadic hunters and pastoralists roamed across the landscape without a fixed dwelling, but we have become dependent on a permanent abode. Becoming homeless is one of the greatest fears of our time. Yet until very recently, for most people home was just a bare shelter, without windows or furniture, where one went to eat and fall asleep, exhausted.[18] Only in the last few centuries has the possibility of a comfortable home arisen in the West, first in the Netherlands, then England, then in the rest of Europe and in America.

But in acquiring a comfortable personal space (now equipped with family rooms, dens, workout, media, and entertainment centers, and so on), we have also increased the potential for loneliness and alienation. In his *Ozark Portfolio*, Roger Minick showed us an idealized version of what a home was meant to be [plate 8]. In this image of a bedroom in a poor farmhouse, the upright piano makes a strong claim to refined sensibility. Light shines through the lace curtains, and the window frame forms a cross, to echo the cross carried by Jesus in the print on the wall. The couple in the room look serious and serene; she is preparing fruits for canning, and he – still dressed in overalls – is immersed in a good book. Culture, religion, loving care, and hard work are neatly tied together in an interior space suffused with gentle light and warm shadows.

But home is not always a safe refuge where people return to cultivate their souls. Angela Kelly's *Monica Dressing Up* [plate 9] shows one variation: home as a haven of privacy – perhaps a hole in which to hide from the world. In a bare, cramped space filled by a single bed, a girl sits on the mattress holding her head. She is smiling, and she has on an old-fashioned evening gown, but one gets a sense of profound loneliness. The cubicle is a vehicle for introspection, for spacing out, for depression. The extreme pathology of privacy is illustrated with clinical detachment in the portfolio *Tulsa* by Larry Clark. In one image from this series on addiction and petty crime, we see a wounded man lying on an unmade bed; his features are distorted by pain. Next to him sits a woman hunched in defeat, her face covered in shadow. The only shape that looks strong and together is the cute, small gun sitting on a chair in the foreground – the cool trickster that lured them into this mess with promises of a quick, painless solution.

**What next?**    It would seem that photographers are limited to representing what is, and cannot comment on what could be. But this is not necessarily true: the camera is flexible enough to create images of alternative realities, some terrifying, some hopeful. Of course, we cannot expect literal descriptions of what the environment will look like in the future. Only a very few people – such as Leonardo da Vinci, Jules Verne, H.G.Wells – have ever had any idea of what sort of a world lies beyond the next few decades.

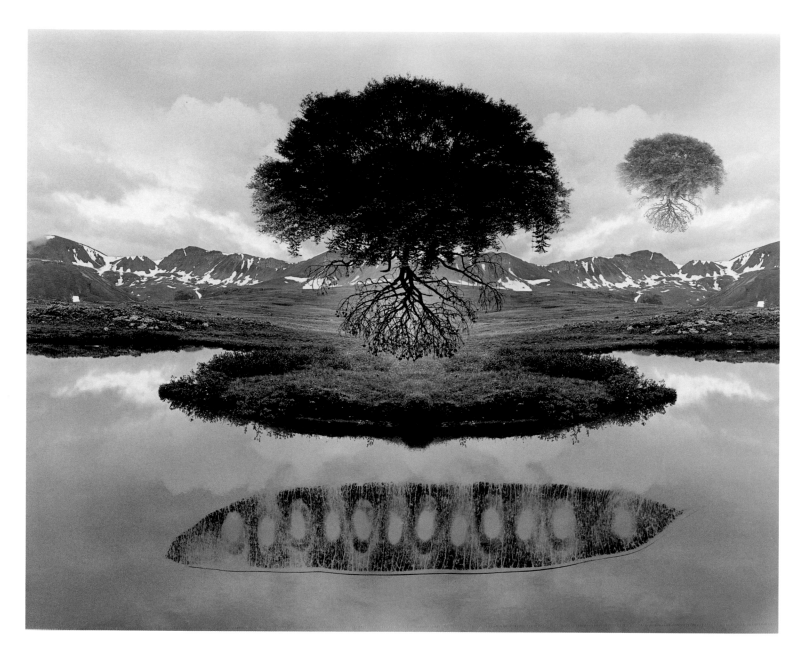

10  Jerry N. Uelsmann
*Untitled*, 1969
silver gelatin print
16 x 20 inches
Gift of Jack A. Jaffe

Jerry N. Uelsmann began his photo-manipulations in an era defined by the pristine straight image. His experimentation in combination printing broke with this ideal and helped define a new tradition of Surrealist photography. Uelsmann's "mindscapes" are carefully crafted metaphors combining common symbols in uncommon ways. In this, one of Uelsmann's more subtle, mysterious images, a tree – symbolic of life or of knowledge – hovers above a pool of water, its roots suspended and withheld from sustenance. The image sparks a multiplicity of meanings, and remains free of the traditional photographic anchoring of photo to fact.

Instead of realistic renditions, perhaps the best contribution of photography is to give us a hint of the spiritual forces that might see us through the dangers and dislocations that our own ingenuity has brought about. For it is clear that taming the earth has raised the specter of planetary destruction; that breaking the web of community has introduced alienation and conflict; that making privacy possible has exacerbated loneliness and despair. None of these ills is new to our times, but the symptoms are different in every age, and new cures are needed as times change.

One possible response is a new planetary consciousness, a realization that the strivings of the universe, from the smallest cells to the farthest galaxies, are connected and might be brought in harmony with each other. The notion of Gaia, of the earth as a unique organism with its own needs that must be respected, is one metaphor for this emerging sensibility.[19] It is difficult to represent visually a change in the way we think of our relationship to the universe. Symbols can express a feeling, an intuition that eludes words.

Jerry N. Uelsmann's *Untitled* [plate 10], an image of trees floating above a lake against a backdrop of mountains, inspires that awe our ancestors used to feel in the face of nature, and which we may have to rediscover in order to continue on this earth. It is true that in looking at the picture we can see the artifice: the symmetrical doubling of the image along a central vertical hinge, the superimposition of the trees on the sky, and the substitution of upturned small trees for the roots of the large ones. Artists must always meddle with reality, or they could not make us see it. But once we do, we may get a clearer picture of where we have been, where we are, and where we may be headed.

## Viewpoint
## Csikszentmihalyi

1 See Claude Lévi-Strauss, *Tristes Tropiques* (New York: Atheneum, 1967).

2 Giulio Mancini, *Considerazioni sulla Pittura* (Rome: Adriana Marucchi, Editore, 1956), p. 143. See also David Freedberg, *The Power of Images: Studies in the History and Theory of Response* (Chicago: The University of Chicago Press, 1989).

3 See Mihaly Csikszentmihalyi and Eugene Rochberg-Halton, *The Meaning of Things: Domestic Symbols and the Self* (Cambridge, England and New York: Cambridge University Press, 1981), pp. 58, 95, and 107; and Floyd W. Rudmin, ed., *To Have Possessions* (Corte Madera, CA: Select Press, 1991).

4 The section that follows is based on a study of art "experts" reported in Mihaly Csikszentmihalyi and Rick Emery Robinson, *The Art of Seeing* (Malibu, CA: The J. Paul Getty Museum, 1990).

5 Ibid., p. 33.

6 For some classic examples of "gestalt" explanation as to why certain percepts are preferred by the brain, see Rudolf Arnheim, *The Power of the Center* (Berkeley: University of California Press, 1982); Ernst Hans Gombrich, *The Sense of Order* (Ithaca, NY: Cornell University Press, 1979); and Gyorgy Kepes, ed., *Education of Vision* (New York: Braziller, 1965).

7 Csikszentmihalyi and Robinson (note 4), p. 37.

8 Ibid., p. 38.

9 Ibid., p. 42.

10 Ibid., p. 44.

11 Ibid.

12 Ibid.

13 Ibid., p. 69.

14 See Colin M. Turnbull, *The Forest People* (New York: Simon & Schuster, 1962).

15 See Elias Canetti, *Crowds and Power* (New York: Farrar, Straus and Giroux, 1984).

16 See Rachel Kaplan and Stephen Kaplan, *Cognition and Environment: Functioning in an Uncertain World* (New York: Praeger, 1989).

17 See Jacques Monod, *Chance and Necessity* (New York: Random House, 1979).

18 See, for instance, John Gloag, *A Social History of Furniture Design* (New York: Bonanza Books, 1966); Emmanuel Le Roy Ladurie, *Montaillou: The Promised Land of Error* (New York: Vintage, 1979); and Irwin Altman and Carol M. Werner, *Home Environments* (New York: Plenum, 1985).

19 See Lawrence E. Joseph, *Gaia: The Growth of an Idea* (New York: St. Martin's Press, 1990); and Rosemary Ruether, *Gaia and God: An Ecofeminist Theology of Earth Healing* (San Francisco: Harper, 1994).

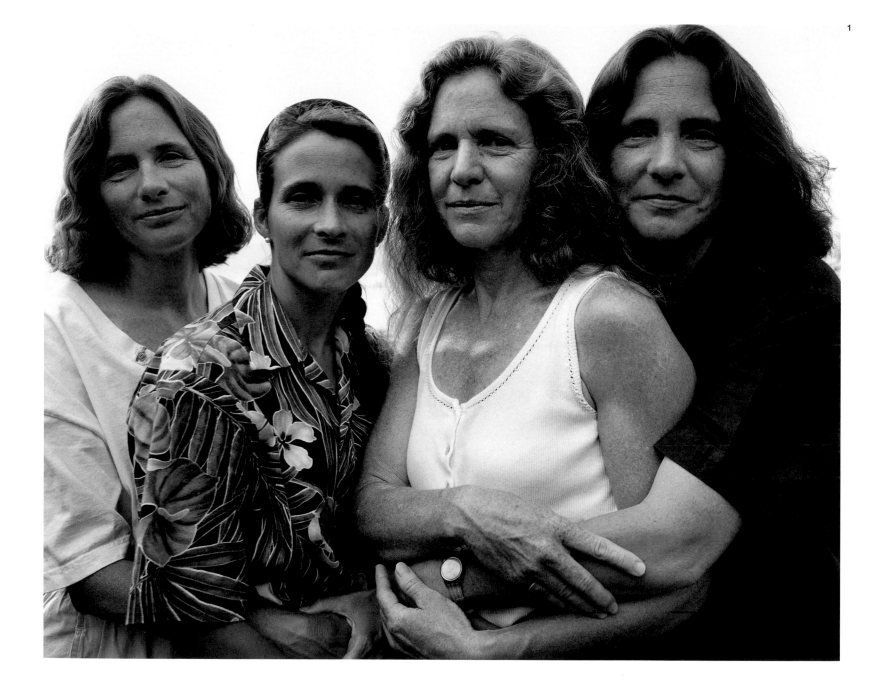

The opportunity to select an exhibition of photographic portraiture represents a unique and unsettling challenge to a painter. I am not a professional historian; neither am I a sociologist nor a psychologist. Like most other individuals, I have taken many photos over the years. I have even put together a few primitive motion pictures. The purpose of my guest-curating the exhibition "Portraiture: A Process of Self-Discovery" (1996), however, is to discover what perspective and judgment a painter might bring to such an endeavor. It is my hope that the experiment will bring new insights both to me and to an audience more accustomed to viewing exhibitions put together from within the field, rather than by an outsider.

My own paintings have always investigated issues of identity and the relationship of elements or components within that same identity. I have also painted several commissioned portraits of patrons and friends, but had never until recently had the courage to examine my own identity through self-portraiture. Painting what is outside is one thing.

Ed Paschke

# Portraiture
## A process of self-discovery

Painting what is inside is very different. The questions of self, ego, and how to cope with personal fears and prejudices are very challenging and contribute greatly to the classic problem of a portrait directed at one's self. Why had I avoided it for so long? Was it the fear of disclosure and intimacy? How we define ourselves, as opposed to how others perceive us, illustrates the eternal dialogue between subjectivity and objectivity. In 1993 I began a series of self-portraits which were subsequently shown at the Phyllis Kind Gallery in Chicago. Crossing that introspective line was a new and unsettling experience that will deepen my self-understanding into the future.

The idea of what a portrait actually is could be a subject of considerable debate. *Webster's Dictionary* defines it as "a painting, photograph or other likeness of a person, especially showing the face. A verbal picture or description, especially of a person." How do we define it? What point of view do we take and when do we take it? Each one of us could be portrayed in a wide variety of contrasting modes depending upon when and where we are photographed. The notion of identity cannot be fixed except according to considerations of specific time and place. In photography, when the shutter snaps, the results can be influenced by many variables. Any portrait has as much to do with the circumstances of a situation as it does with a particular

1  Nicholas Nixon
*Brown Sisters, Marblehead,
Massachusetts*, 1995
silver gelatin print
8 x 10 inches
Museum purchase
© Nicholas Nixon, courtesy
Fraenkel Gallery,
San Francisco

Since 1975 Nicholas Nixon has photographed his wife and her three sisters with a view camera, annually producing a single photograph featuring the sisters in the same line-up in various locations. From left to right we see Heather, Mimi, Bebe (his wife), and Laurie as they change and grow from image to image, year to year. The *Brown Sisters* series functions as an ever-evolving portrait of the siblings and their relationship to one another over the passage of time. See Rosenblum, plate 23.

2 Helena Chapellín Wilson
*Untitled #93574,*
1993
gum bichromate print
18 x 12 inches
Gift of the artist

3 Anne Noggle
*Face Lift No. 3,*
1975
silver gelatin print
14 x 17 inches
Gift of Jeanne and
Richard S. Press

individual within that same situation. Time is perhaps the greatest factor. What individual has a constant, never changing mood, attitude, or personality that is immune to alterations and changes – to say nothing of physical transformation?

The choice of medium can also influence how we process subject matter. Paintings and drawings can be viewed as fictional interpretations, as opposed to the believability of factual information recorded in a photo. In its most simplistic and mechanical terms, a photograph records what is placed in front of the camera, whereas a painter selects, interprets, and processes that same information.

As I looked through the many hundreds of "portrait-related" photographs in the permanent collection of The Museum of Contemporary Photography, I began to realize that there are numerous ways in which a portrait may be approached and that it need not be confined to the traditional close-up of a human face. Indeed, issues of identity seem to be expressed through additional factors, such as how we play, how we earn a living, what we carry around in our pockets, what our spiritual and political beliefs are predicated on – all or any combination of these variables can be more revealing than the outer physiognomy.

## Viewpoint
### Paschke

The photographs in the exhibition represent several general categories of definitions of what I consider portraiture. Identity to me may be expressed through individuality or through affiliation with a group of individuals who fall into a similar class – that is, a like kind, rather than a social class. This latter identity, a collective identity, may be expressed through cultural codes and signals associated with that group or organization. For some strongly determining classifications, such as race, gender, and age, there is an obvious and direct package of information available for psychological and sociological interpretation. Less overweening categories are more subject to a range of readings. A number of classifying determinants emerged during my review of the images at hand: 1. Age, 2. Masks, 3. Body, 4. Doubles, 5. Celebrity, 6. Group, 7. Lifestyle, 8. Place, and 9. Race. In many cases these so-called categories overlap and combine with one another so that a particular image might contain a mixture of classifying information.

Although the following works fall into the above categories, I do not intend for them to be seen as illustrations of particular themes. I have selected the categories rather as an armature on which to organize my own feelings and document my own thought process as it developed during the period of selecting work for the exhibition.

**1. Age**  Age is just a fact of identity, much as any other material fact. When age makes reference, however, to the aging *process*, the fact is transformed into the defining dynamic of life itself. The process of aging and its effects on the human body is a phenomenon we all experience. The physical presence we see before us is literally the embodiment of how and where we have lived; stress, excessive exposure to sunlight, and gravity all take their toll and record their history.

Nicholas Nixon's fascinating *Brown Sisters* series documents the aging process systematically over a period of time that has now exceeded twenty years. Each year he has gathered together his wife's family for a photograph in which each member is posed in the same left-to-right order. Although The Museum of Contemporary Photography owns the complete series, for the 1996 exhibition I selected the first and most recent images [see plate 1]. By bracketing the series in this way, the transformation appears sudden and jarring; in the entire series, the evolution of hair styles, clothing, and attitudes toward one another is more gradual. We can almost decipher the complexities of sibling rivalry as it changes through the years. The sociological climate of the time and the family dynamic are recorded in each subject's presentation of self. How we react to the aging process can be just as revealing as the physical changes it imposes: the evolution of personal identity through time is an aspect of portraiture that I find particularly fascinating.

**2. Masks**  The ability to cloak one's identity or exchange it with another has probably intrigued mankind since the beginning of time. The theatrical masks of comedy and tragedy come to mind as classic examples of how the desire to experiment with role-playing has found a creative outlet in society. Some masks have a practical origin: designed for protection in work (such as welding) or play (as in hockey). Nevertheless, they can be appropriated and recon-

2  For more than twenty years, Helena Chapellín Wilson has created a body of images with figure, object, and spatial relationships that arrest moments from the rhythm of reality. Utilizing the nineteenth-century process of gum bichromate printing. Wilson shapes compositions based on nature, dreams, and the passage of time. *Untitled #93574*, with its intricate layers of natural elements and a woman's partially obscured face, is at once cryptic and romantic.

3  Anne Noggle's work consistently challenges the stereotypes and standard mythologies of women. She herself began her artistic career at age forty-three, to complement her already-established profession as a pilot. Frequently using the format of self-portraiture, Noggle speaks directly to issues of self, identity, and the female body. *Face Lift No. 3* appears in Noggle's book *Silver Lining* (1983). See Rosenblum, plate 25.

4 Danny Lyon
*Sparky and Cowboy,*
*Shereville, Indiana*
from the portfolio
*Danny Lyon* (1979),
1965–66
silver gelatin print
11 x 14 inches
Museum purchase
© Danny Lyon, courtesy
Magnum Photos,
New York

5 Dennis Stock
*Untitled* from
*James Dean:*
*A Memorial Portfolio*
(1979), c. 1955
silver gelatin print
11 x 14 inches
Gift of
Douglas Kenyon, Inc.

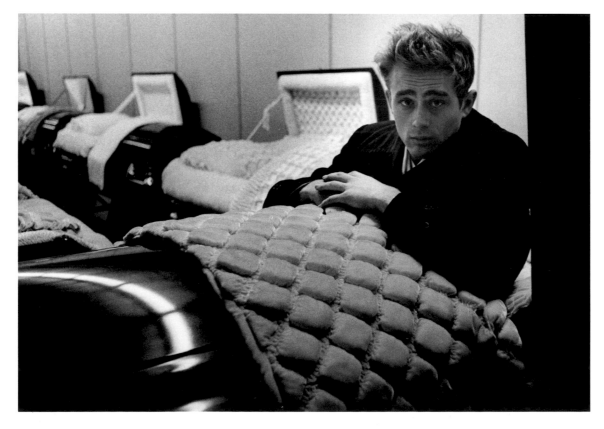

4 Danny Lyon's early documen-
tary career was established
and defined by his gritty pho-
tographer-as-participant
approach. In the *Bikeriders*
(1968), from which this image
is taken, he rode and lived
with the bikers he photo-
graphed. His first book, *The
Movement* (1964), evolved
from his experiences as a staff
photographer for the Student
Non-Violent Coordinating
Committee during the Civil
Rights Movement. Lyon's
work belies the standard
detachment of documentary
humanism and objectivism in
favor of a more complicated
subjective involvement.
See Parry, plate 2 and Rosen-
blum, plate 20.

5 The images in *James Dean:
A Memorial Portfolio* were
initially taken as a biographic
photo-essay for *Life* maga-
zine shortly before the
actor's death in 1955. Dennis
Stock is a photojournalist
who works primarily in the
format of multiple-picture
essays. In addition to having
held the first exclusive photo
rights on James Dean, Stock
has extensively documented
the behind-the-scenes milieu
of Hollywood stars and jazz
celebrities.

## Viewpoint
### Paschke

textualized to inspire fear, as in the film series *Friday the 13th*. By obscuring the self and providing a new layer of identity, masks can present an opportunity to experience a different personality while keeping our own safely hidden [see plate 2].

Nancy Burson's *Evolution II* [see Peat, plate 14] presents a synthesis of animal and human fea-tures. In this instance the composite makes a statement not only about identity, but about ancestral origins. In an image that can be associated with Charles Darwin's The-ory of the Origin of the Species, this riveting and unsettling imaginary portrait serves to remind us of who we are and where we came from. This metamorphosis and transfor-mation process create a biological composite that reveals as it conceals the nature of man.

**3. Body**   The human body is an expressive vehicle: each gesture carries associations and information we can decode and interpret. Actors and dancers regard their bodies as malleable tools through which ideas and thoughts can be communicated. But even for the untrained, how we use or alter a particular part of our body

can express unique and specific personality traits. In its close affinities with the determining category of age, the body can also provide a historical record of life experiences that have helped to shape the individual.

Anne Noggle's *Face Lift No. 3* [plate 3] reads as a painful reminder of the importance some people place on youth and physical beauty. The hand, poised in a gesture of uncertainty, combines with the sad, swollen eyes as a testament to an identity crisis. Beyond the documentation of per-sonal transformation, the image resonates with commentary on contempo-rary society.

**4. Doubles**   The persistent idea that somewhere in the world each of us has a mirror image or double can probably be traced back to cell division. Recog-nizing our links to others might be connected to early childhood when we see our reflection for the first time. Duplicates, whether they be twins, clones, or kindred spirits, are one way of examining who and what we are. This notion of a twin can be a positive one, replete with feelings of full communication and sharing. Sharing experiences with others can be a way of validating our self-image. But the double can have more sinister connotations, such as the con-cept of the Doppelgänger or even the out-and-out incarnation of evil. Whether it is Joseph Conrad's "Secret Sharer" or Dr. Jekyll's Mr. Hyde, the bond between doubles appears to be almost unbreakable.

While literature has explored the darker side of doubling, pho-tography has concentrated on the more purely visual phenomena of physical similarity. The possibility of knowing ourselves through the existence of some-one similar may be seen as a form of narcissism, and offers a rich and fertile area of photographic portraiture. For example, Danny Lyon's *Sparky and Cowboy, Schereville, Indiana* [plate 4] and *New Arrivals from Corpus Christi* provide excellent opportunities to examine the phenomenon of double iden-tity. In each case the wall behind the couple establishes a context in which the duplicate sets of traits and features can be evaluated. Hair style, costume, body adornment, and expressions all attest to a commonality of philosophy and experience. These pairs share a set of values and a lifestyle that are at odds with mainstream society: we are as much outside their world as they are outside of ours.

**5. Celebrity**   Celebrity portraits present an interesting set of questions relat-ing to the issue of style versus substance. The public persona (style) of a well-known individual is often different from the actual, private self (substance). The celebrity portrait can reinforce or validate what we think we already know about the subject, or it can reveal a more private dimension and furnish us with new insights. This distinction raises an intriguing curatorial dilemma: the presentation and recognition of a cliché can be a source of comfort and reas-surance. Does this count as a greater or lesser achievement than a fresh examination of private identity? In making a curatorial judgment, do I penalize the familiar by excluding it from the exhibition, or reward it by inclusion?

Some of the following celebrity portraits are famous photographs in their own right and have experienced public recognition similar to that of

6   Neal Slavin
    *International Twins*
    *Association, Muncie, Indiana*
    from the portfolio
    *Groups in America*, 1979
    chromogenic development
    (from color negative) print
    11 x 14 inches
    Gift of David C. and Sarajean
    Ruttenberg and the Ruttenberg
    Family Limited Partnership

In the 1970s Neal Slavin con-
centrated on capturing the
spectrum of American hobby
groups, social clubs, profes-
sional societies, sports
associations, and other gath-
erings of people. The
resulting book, *When Two or
More are Gathered Together*

(1976), is a study of the
impulse to form and ritualize
groups of people around
shared activities or interests.
The group portrait *Interna-
tional Twins Association,
Muncie, Indiana* offers
another layer of interpreta-
tion to the idea of two-ness.

7  Diane Arbus
*Hermaphrodite and a dog in a carnival trailer, Md., 1970*, 1970
silver gelatin print
14½ x 14½ inches
Gift of Larry Deutsch
© 1972 The Estate of Diane Arbus

Diane Arbus was one of the first photographers to confront the mainstream viewer with the spectacle of society's underbelly, wherein, as Naomi Rosenblum states, "the malformed are given grace and the ordinary are seen as terrifying and alienated." In this portrait, Arbus allows the direct gaze of the subject to question viewers about their expectations of gender, beauty, and normalcy.

8 Sandy Skoglund
*Ferns*, 1980
silver dye bleach (from color positive) print
30 x 40 inches
Gift of David C. and Sarajean Ruttenberg and the Ruttenberg Family Limited Partnership

Like her contemporaries Patrick Nagatani and Joel-Peter Witkin, Sandy Skoglund engages with the arranged image, laboriously constructing environments that are complicated and claustrophobically mono-chromatic. Firmly in the camp of the fictional photograph, Skoglund's images variously present a flood of orange-red foxes in a restaurant, the horror of dozens of babies dropping from the sky, or the pallor that permeates *Ferns*. With their unnerving proliferation of objects, creatures, and colors, Skoglund's images open a dialogue between photography, sculpture, and installation art.

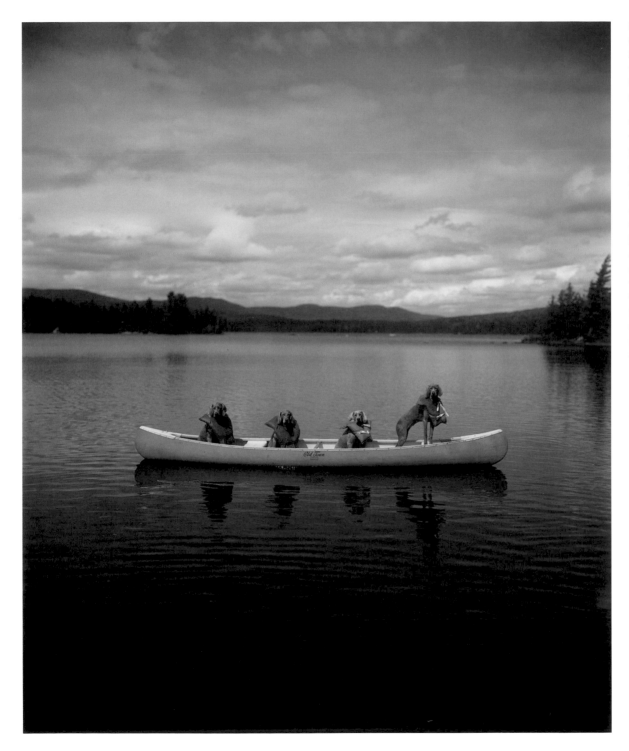

9  William Wegman
*Stabled*, 1990
internal dye diffusion
transfer print
24 x 20 inches
Museum purchase

William Wegman's
Weimaraners – Man Ray,
Fay Ray, and their
puppies – have become
a part of the standard
iconography of contempo-
rary photography. For over
twenty years Wegman
has painted, photographed,
and created videos of his
dogs in a wide variety of
witty, anthropomorphic
tableaus. *Stabled* takes
his "actors" out of the
standard studio setting and
places them within an
equally unexpected scenic
landscape.

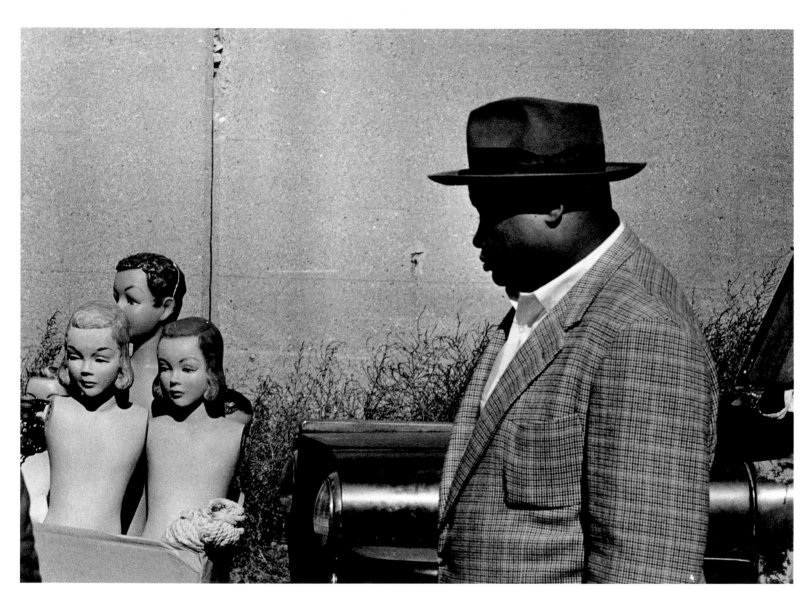

10  Yasuhiro Ishimoto
    *Untitled* from the series
    *Chicago, Chicago*,
    c. 1960
    silver gelatin print
    11 x 14 inches
    Gift of Jack A. Jaffe

A student of Harry Callahan and Aaron Siskind, Yasuhiro Ishimoto is an important figure in the cross-pollination of photographic ideas and styles between American and Japanese photography. His portrait of a city,

*Chicago, Chicago*, published as a book (1969), is a rich study full of the details of time and place. The cluster of white mannequin busts in the background of this image highlights Ishimoto's strength in using environmental details to

question or add subtle commentary about the individuals portrayed – and about their relationship to society at large. See Rosenblum, plate 3.

their subjects: Barbara Morgan's *Martha Graham – Letter to the World*, Louise Dahl-Wolfe's *Edward R. Murrow*, and Philippe Halsman's *Dali's Mustache* are popular examples of how images saturate our visual culture. Arthur Shay's *Hefner and Marilyn Monroe*, Danny Lyon's *Untitled (Tony Curtis and Janet Leigh)*, and Dennis Stock's *Untitled* from *James Dean: A Memorial Portfolio* [plate 5] are lesser known, but noteworthy, examples of how a photograph can provide different and sometimes prophetic insights into a well-known subject. The composed public persona can reveal a refreshing or shocking underside if caught in an unguarded moment.

**6. Group**   Group portraiture creates a situation in which individuals are absorbed into a collective identity. The commonality of thoughts, beliefs, and experiences projects a sense of power through belonging: there *is* strength in numbers. Whether the link be sports, politics, or religion, groups are bound by a common philosophy.

Neal Slavin's portfolio *Groups in America* produced two significant studies: *International Twins Association, Muncie, Indiana* [plate 6] and *Women's Intramural Softball Team of Warner Communications, Inc.* Both photographs are posed, premeditated presentations. By contrast, Manuel Carrillo made a literal and informal statement about the so-called "herd instinct" in his overhead shot of a group of dogs – *Mexico City, D.F.* This bonding, evident even in animals, as well as sports fans, theater-goers, prison inmates, and so on, speaks to a basic desire to be with others like ourselves.

**7. Lifestyle**   The term "alternative lifestyle" can refer to anything that departs from what the majority engages in and therefore perceives to be "normal." Body language, skin adornment, and the sociological implications of fashion can reveal a great deal about lifestyles. In fact, the presentation of self could be looked upon as a form of performance art, sometimes bearing messages that are exaggerated or over the top, and intended as acts of proud defiance. Because alternative minorities may be viewed as odd or abnormal by mainstream society, their very differences may render them exotic and therefore highly desirable as subject matter for some artists. Human oddities and abnormalities had special appeal for Diane Arbus and continue to attract the attention of Joel-Peter Witkin. Arbus's *Hermaphrodite and a dog in a carnival trailer, Md., 1970* [plate 7] and Witkin's *John Herring,*

*Person with AIDS Poses as Flora with Lover + Mother* seem to challenge our judgmental bent as well as our scrutiny. Both are bold celebrations of the outsider as a counter-culture icon.

**8. Place**   Place or location – a chief factor in the contextualization of the subject – can be a revealing component of portraiture. A particular space can interact with the subject, casting an atmosphere over the individual. An especially dominant personality, however, can likewise affect and alter the circumstances of place. The dialogue can move in both directions.

In Sandy Skogland's *Ferns* [plate 8] or William Wegman's *Stabled* [plate 9], context is predetermined and orchestrated in a laborious and calculated way. By contrast, Leland Rice's *Covered Chair and Stick with String* presents a situation in which the subject's residual presence is felt through the things he or she has left behind. Another strong example of the symbiotic relationship between subject and context is Jane Wenger's untitled photograph in which the top of a man's shaved head, veins bulging, is pictured against a sky filled with soft, puffy clouds. The formal relationship seems tweaked by the incongruous juxtaposition of implied violence and lyrical tranquility. And in Anne Noggle's *Moonlight over Albuquerque*, the sense of place is established through light, the most fundamental element in the photographic process. Here a low point of view and an other-worldly, supernatural light playing across an older woman's face and a nearby collapsed umbrella, transform a mundane situation into one of high drama and suspense. The stark patterning of light and shadow is similarly powerful in Stephen Marc's *Untitled* from *Urban Notions*, in which the looming head of a man seems almost imprisoned in the foreground, virtually camouflaged by its context.

**9. Race**   Race is certainly a conspicuous characteristic in the visual make-up of any individual. Racial generalities and cultural stereotypes can provide automatic sets of information we might use in forming impressions or judgments. Are such impressions valid? Are they reliable if the viewer is prejudiced in some way or even simply unfamiliar with a different racial type? Do layers of cultural conditioning make accurate – even honest – readings impossible? When interpretations differ, whose reading is valid? Is objectivity ever really attainable?

Yasuhiro Ishimoto's *Untitled* from the series *Chicago, Chicago* [plate 10] captures a moment of racial irony in which a pedestrian glances at a group of amputated mannequins perched on a cardboard box. The lifeless personages are immobilized through the removal of their limbs and their frozen existence in a world of hardened plaster. The symbolic overtones regarding race relations and the dynamics of contemporary urban life are presented for our consideration: the black man's freedom and mobility are in stark and ironic contrast to the dead stiffness of the incarcerated white statues.

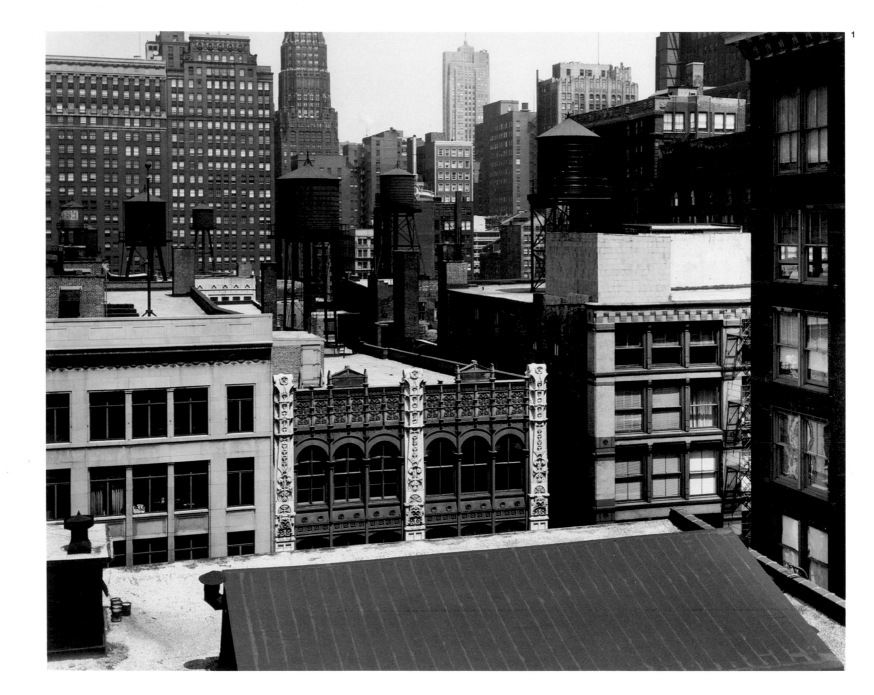

**Introduction** Some 10,000 years – a wink of an eye in the history of mankind and less than that in the history of the world – have passed since the onset of a social revolution that even today has no rival among the numerous profound changes the species as a whole has experienced in the course of its time on earth. When man learned to domesticate animals and cultivate crops, following millennia of hunting for food wherever he could find it, he was obliged to settle down, to stay close by the tracts of land on which he tilled his fields and kept his livestock. There he could plan for his food supply and measure it, eventually doing so with such efficiency that some of his fellows were enabled to take up other forms of labor, to make pottery, weave fabrics, build permanent shelters, keep records. Mathematics and writing were natural responses to the needs of this revolutionary new way of life, as the group – people have proved to be a gregarious lot – shaped itself in collectives of increasing size and complexity. What once were farms became towns, what

Franz Schulze

# The city
## Harbor
### of humanity

once were towns grew into communities identifiable as cities.

There is a paradox of sorts here. When people settled down, they moved forward at an unprecedentedly rapid rate. Events prompted by human activity transpired quickly enough to be differentiated, within the span of a generation or two, and thus remembered by the race. It may be argued that history, the record of human affairs, began with the development of cities.

So did culture. While nearly all the arts have been practiced in one way or another by prehistoric folk and contemporary rural peoples, it is hard to imagine the development of sophisticated expressive idioms, each with an ever-changing history of its own, outside an urban context. In cities minds sharpen themselves on other minds in an exchange that forever hones the human impulse to creativity, the urge to find meaning in life and appropriate forms to depict it.

Much the same applies in the realms of technology and social organization. Cities stimulated the invention and refinement of building materials, architectural types, means of transportation, and tools both constructive and destructive. Politics, moreover, grew into a city business and law into a necessary social instrument. States consorted or vied with other states, treaties were concluded and wars fought, from early times to the present, on a larger scale than anything known to prehistoric man.

1 **Richard Nickel**
***Rothschild Store, Chicago,***
**c. 1960s**
**silver gelatin print**
**7⅝ x 9⅝ inches**
**Gift of Robert Kostka**
**© The Estate of**
**Richard Nickel,**
**courtesy John Vinci,**
**Richard Nickel**
**Committee Secretary**

**Richard Nickel's elegant photographs express his admiration for Chicago's historic architecture. He was particularly devoted to the buildings of American architect Louis Sullivan, not only photographing their grandeur, but salvaging original ornaments from them. This photograph shows Adler and Sullivan's Max M. Rothschild Building, from which Nickel – with the help of wreckers – salvaged four of the cast-iron panels that frame the upper windows.**

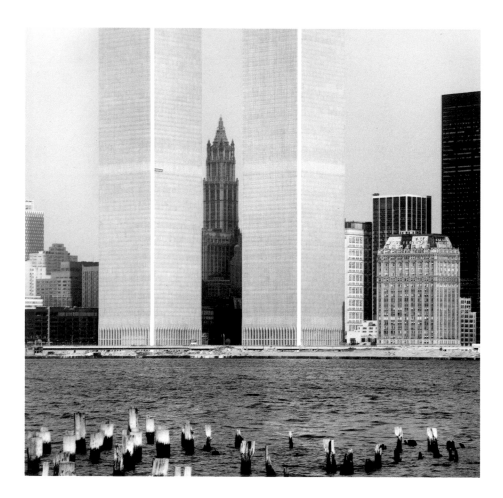

2   David Plowden
*World Trade Center,
New York City*, 1972
silver gelatin print
10 1/2  x  10 3/4 inches
Gift of Alvin Gilbert

3   Walker Evans
*Brooklyn Bridge, New York,*
1929
silver gelatin print
6 5/8 x 4 5/8 inches
Anonymous gift
© The Walker Evans Archive,
The Metropolitan
Museum of Art, New York

2 David Plowden has been on the road for years, photographing small towns and industrial sites. His camera gravitates towards intersections across America: bridges and railroad tracks, steam engines and ferry slips. A stillness prevails even in these images of mobility as Plowden, preferring to photograph on cloudy days, achieves the cool poetry evident in *World Trade Center, New York City*. Here, his framing of lower Manhattan allows the decades-old Woolworth Building to emerge from between the towering forms of its more modern counterparts.

3 Possessed of a sensibility that found complexity and rhythm in a precisely measured view, Walker Evans photographed the quotidian. His documents of American towns and cities reflect the ironic as well as the iconic: *Brooklyn Bridge, New York* shows the looming underside of a massive urban landmark. See Rosenblum, plate 2.

# Viewpoint
## Schulze

Such a summary only begins to describe, without enlarging upon, the many meanings of the historical city. Moreover, while it is a creation of man that everywhere bears his signature, it invariably generates a momentum of its own that is likely to be as indifferent to its creator as accommodating of him. Large or small, ancient or contemporary, wealthy or impoverished, a garden or a rubbish heap – or both – it is a phenomenon of endless variety, open to innumerable interpretations.

Thus, the exhibition "The City: Harbor of Humanity" (1997) sees the city from as broad a perspective as possible, concentrating on its modern form but embracing all things animate and inanimate and extending the dimensions of the place physically and spiritually. The formal quality of the photographs is a major criterion for their inclusion, and indeed this writer believes, contrary to much current theory, that a work of art *necessarily* gains in effectiveness in proportion to the success of its formal organization – and *necessarily* fails inversely. Nonetheless, this much acknowledged, the show draws heavily on the story line of the images, out of a conviction that has only been nourished by the virtually unique capacity of the art of photography to address the city.

What can the other arts do with the same subject? Architecture designs the physical city, erects its buildings, plots its thoroughfares, and configures the relation of both to each other and to other of its districts. That activity is both creative and critical. Architecture is a form of self-portraiture, and as such, judgmental. Chicago building says something about the character of the city it has made and occupied. It is declarative, compact and straightforward, seldom self-consciously poetic or rambling, ambiguous, or experimental. New York's architecture is nearly the opposite: messy, purposely artful but only in spots and moments, willing to try anything, enormously vital in its vast scale and unruly heterogeneity. London sees itself as a metropolitan collection of villages, while Paris treats Paris like a royal monument, and the Los Angeles urbanscape is as cinematic as the motion pictures, reflecting the restless movement that city takes on through the glass of its cherished vessel, the automobile.

Architecture, however, is too big an art form to burrow into the crannies of the city where people confide to each other at tables or just sit by themselves on porch fronts. Painting can do that; it can penetrate the psychology of the human subject as readily and at the same time as it discloses the passions and prejudices of the painter himself. In this respect, because it is capable of expressing itself in figurative terms, painting is akin to photography, a genre with the same capacity. Even so, painting in the twentieth century has broken free of the confines of its historically descriptive role, busying itself instead with abstract form or form not at all, preferring at times to experiment with the function of art as concept, performance, or installation – and in this last sense coming curiously closer to architecture than does photography, its younger historical partner in figuration. Photography, certainly in the present day, has become unsurpassed as a medium capable of recording life both macro- and microscopically, and it can exercise that ability with more freedom, not less, in an urban setting.

4 Michael A. Smith
*New Orleans*
*(N82-8504-42/61 #7),*
1985
silver gelatin print
13 x 25 inches
Gift of
Thomas Uhlmann

Working with view cameras, Michael A. Smith shifts with ease between photographing the isolated as well as the densely populated landscape. Like David Plowden, Smith travels the country to find his subjects, presenting both the rural and the urban realms in refined, well-ordered visual relationships. *New Orleans (N82-8504-42/61 #7)* offers a typical city activity – the ball game – from the surprisingly rich vantage point of standing behind the crowded bleachers.

5  Beaumont Newhall
*Chase National Bank,
New York*, 1928/81
silver gelatin print
8$\frac{1}{2}$ x 8$\frac{1}{2}$ inches
Gift of Richard Templeton
© 1928 Beaumont
Newhall, The Beaumont and
Nancy Newhall Estate,
courtesy Scheinbaum
and Russek, Ltd.,
Santa Fe, New Mexico

An unusual and rewarding
perspective on urban space
is evident in Beaumont
Newhall's *Chase National
Bank, New York*. Offering
a purely geometric
experience of urban archi-
tecture, this photograph
asserts Newhall's skill as a
practicing photographer.
Better known for his work in
the history of photography,
Newhall authored numerous
publications, including
several editions of *The His-
tory of Photography*.

**The place**   The most obvious remembered vision of the city is its outward appearance. Some of the works in this exhibition see it as a full-scale metropolis, unmistakably big, hardly a town, much less a village. Richard Nickel's rooftop panorama titled *Rothschild Store, Chicago* [plate 1], leaves no doubt of Chicago's size; the cluster of buildings and the daunting height of those in the distance attest to that. Americans, so accustomed to the skyscraper, tend to forget that it is our singular national architectural invention. Chicago was deeply involved in its birth and growth, but New York lays a similar claim, evident enough in Todd Watts's *World Trade Center #2*, which views those towers at the end of a long perspective down Manhattan Island past the massive boat piers that are a further sign of a huge city.

The two behemoths of Minoru Yamasaki's World Trade Center appear in another photograph, taken not too far away from Watts's vantage point. David Plowden has situated himself in the one narrow place that allows him to fix Cass Gilbert's Woolworth Building exactly between the towers, producing a remarkable, vertically layered architectural sandwich [plate 2]. After one is drawn to so diverting a composition, the recollection dawns that the Woolworth Building at the time of its completion in 1913 was the world's tallest building. The World Trade Center (1966–71) dwarfs it while, in this instance, granting it center stage. Or is it Plowden who pays the homage? In either case, he has more to offer here, including testimony to the great architectural change wrought by sixty years: in style, not only between Gilbert's historicist neo-Gothic and Yamasaki's lean Modernism, but in technological virtuosity, with the towers at 1,300 feet almost twice as high as the Woolworth. Moreover, while all the buildings in the photograph are clearly stationary, the image of them would change with the slightest shift of the camera, a reminder that architecture is an art meant to be seen and grasped in time.

A comparable inference can be drawn from one of the most unusual views ever shot of the Brooklyn Bridge. Everyone is familiar with the aerial perspectives of the span, whose historic length was made possible by suspending the roadbed from steel cables. No less identified with the bridge are the great stone pylons that help to anchor the cables. Walker Evans, apparently presuming that the majesty of the structure could be conveyed from another point of view, stationed himself below the bridge. He looked up at it, aimed his camera accordingly, and took in a portion of the towers of lower Manhattan across the East River. The resultant photograph is as striking an example of minimalist abstraction as it is visual proof of the force of modern technology in giving shape and scale to one of the world's greatest cities [plate 3]. In Evans's photograph, like Plowden's, movement is implicit. We know that the objects seen and the forms they assume will change in a moment, but we are also aware of the eternity of automotive traffic on the bridge above us, invisible though it is from our vantage point.

For all the urban vastness suggested by Evans, his photograph shows only a part of New York, even only a part of the bridge, suggesting that fragments can often say more about wholes than fully encompassing images can. They can also be as complex as Evans's is simplified. Several of Michael A. Smith's views of New Orleans teem with data, sometimes consciously contrasted, just as often dense with a near sameness of texture. In his *New Orleans (N82-8504-51/70 #7)*, the side of a church appears next to several ranks of warehouse roofs – the spiritual connected to the commercial. On the other hand, perhaps not connected so much as divided: the difference between the two components of the foreground seems strong enough to have cut the photograph precisely in half. Contrarily, Smith's *New Orleans (N82-8602-04/243 #9)* consists almost wholly of an unpatterned, uniformly textured tumult of people seen at a distance, their reaction to a passing parade giving the scene a more, not less, citified look. In *New Orleans (N82-8504-42/61 #7)* [plate 4], among the people scattered on a grandstand and seen from behind, one exquisitely subtle detail turns into the pictorial center of gravity: the profile of the head of a ball player perceptible in the slender slot between two of the bleacher platforms.

One could argue, of course, that all the photographs in the 1997 exhibition are fragments rather than wholes, since most cities are big enough to defeat most panoramic treatments. The fragments, moreover, vary in physical and psychological scale. By showing only parts of bridges (Baltimore and Ohio Railroad Bridge, Bloomfield Bridge), David Plowden leads us to imagine their extensions outside the picture, while his comprehensive shot of Johnstown, Pennsylvania, which takes in a row of houses and a good deal of the Bethlehem Steel Mill, confines our attention within the limits of the frame.

As with Plowden, Beaumont Newhall also used conjoined fragments, not just to illustrate the style or function of a city's architecture but to comment deftly on the issue of social class. *The Plaza Hotel, New York* features a building celebrated for its history of catering to people of wealth, but Newhall obliged us to see it also and in a sense only as a backdrop to a purely vernacular environment: the rear of a nameless old structure hung with a metal fire escape and even – in a touch that underscores the knack of New Yorkers to utilize every available space for all kinds of activity – a sheltered, knockabout rooftop area with a function all its own. Newhall's versatility of response to the city he knew so well is clear from his *Chase National Bank, New York* [plate 5], where, forswearing his descriptive approach to

6   Harold Allen
*Subway Vista, Chicago,*
1969/81
silver gelatin print
14 x 18 inches
Gift of the Reva and
David Logan
Foundation

Harold Allen has taken
advantage of the documen-
tary possibilities of the
camera to illustrate his
passionate interest in archi-
tectural photography. A
former photographer with
the Historic American Build-
ings Survey in Chicago, Allen
focused most extensively
on recording Egyptian-style
buildings in the United

States. All of his photographs
communicate what makes
civilization's structures
important and intriguing. The
careful symmetry of *Subway
Vista, Chicago*, for example,
reveals the visual appeal of
an ordinary and purely func-
tional space. See plate 7 and
Csikszentmihalyi, plate 4.

7   Harold Allen
    *Burlington Railroad*
    *Bridge over Washtenaw*
    *Avenue, Chicago,*
    1969/81
    silver gelatin print
    14 x 18 inches
    Museum purchase with
    matching funds from
    the Illinois Arts Council

Straightforward architectural photography documents a structure for the specific needs of its builders, or in the service of historical record. Photographing corners of America from New York cemeteries to historic Illinois towns, Harold Allen often brings an interpretive approach to his documents of our constructed environ-ment. The composition of *Burlington Railroad Bridge over Washtenaw Avenue, Chicago*, in which the under-side of a bridge is brought together with slices of street, sidewalk, and wall, creates varied and smoothly layered planes. See plate 6 and Csikszentmihalyi, plate 4.

8   Nathan Lerner
*Roundhouse, Chicago,*
1936
silver gelatin print
15 1/16 x 12 1/16 inches
Gift of David C.
and Sarajean Ruttenberg
and the Ruttenberg Arts
Foundation

Nathan Lerner was an influential student and teacher in the early years of Chicago's New Bauhaus, founded by László Moholy-Nagy. The institution's first year, 1937–38, was one of extraordinary artistic innovation, and Lerner was responsible for a lasting contribution: the use of a light box in conducting experiments with controlled light. His experiments are significant in the history of modern American abstract photography. Lerner's documentary work, exemplified by *Roundhouse, Chicago*, combines a powerful graphic style with a focus on the common man characteristic of the Bauhaus formula of "straight" image-making.

9  Bob Thall
   *Chicago (Near O'Hare),*
   1991
   silver gelatin print
   13 5/8 x 16 15/16 inches
   Gift of the artist

A gifted documenter of the urban environment, Bob Thall has for years recorded the visual quality of Chicago, on bright days and in the dark, snow, and fog. In 1994 these images were presented in the book *The Perfect City*. The photograph *Chicago (Near O'Hare)* is part of Thall's continued work focusing on so-called "edge cities," the too-quickly constructed suburban communities surrounding all major American cities. Capturing the sleek artificiality of these recent rootless developments, the image conveys the power, beauty, and emptiness of suburban corporate architecture.

10  Harry Callahan
*New York*, 1980
silver gelatin print
6 7/16 x 6 3/8 inches
Gift of the Reva and David
Logan Foundation
© Harry Callahan, courtesy
PaceWildensteinMacGill,
New York

Harry Callahan explored subjects that captured his imagination, subjects close at hand. His photographs of his wife, Eleanor, and their daughter, in addition to cityscapes and other street scenes, display the mastery of extreme contrast, rich textures, subtle tones, and precise framing that has made Callahan's work central to the evolution of the art of photography. The expressive power of Callahan's street work is seen in *New York*, with its aggressively towering building which dwarfs the few randomly scattered pedestrians. See plate 13 and Miller, plate 3.

the Plaza Hotel, he has turned a pair of tall towers into forms so geometrically abstract that one cares not at all about what the buildings are for or who does what inside them.

As Newhall has looked up, Harold Allen has looked down, or at least to a lower level. The city is never more itself than in its underground spaces or heavily roofed-over areas. Allen's *Subway Vista, Chicago* [plate 6] and *Burlington Railroad Bridge over Washtenaw Avenue, Chicago* [plate 7] are compelling as records of modern engineering devices, but perhaps more important, as scenes in which people play a crucial role even if there is not a soul in sight. No people on a downtown subway platform? As illogical a thought as it is unavoidable here, yet no more disturbing than the gang graffito, "Satans Disciples," that Allen dramatizes by concealing part – a fragment again, this time unseen – of its secretive menace behind the cold formal symmetry of the bridge structure.

Two classes of photographs are brought to mind in turn by bridges: transportation, since bridges serve as vehicular conduits, and architecture, since they are structures dependent on rational design. Yasuhiro Ishimoto has managed to unite bridge, train, and buildings in a single shot, untitled, adding a poetic haze to soften the resolute geometry of the Chicago cityscape. *Roundhouse, Chicago*, by Nathan Lerner [plate 8], portrays a mechanism that was once as commonplace as it is outmoded today, having been superseded by more efficient ways of altering the direction of a locomotive, but it remains a potent photographic image sixty-odd years after it was produced. The Hoboken Ferry still crosses the Hudson River and, although it too seems quaint to a contemporary eye accustomed to faster and flashier ways of getting about, David Plowden's treatment of its upper saloon deck conveys a strength comparable to that in Lerner's photo.

Most of the artists in this exhibition have addressed the subject of transportation in subtler ways than simply showing an object in motion. Robert Adams's *Expressway Near Colton, California* [see Parry, plate 9] seems at first glance to be about foliated landscape, and perhaps it is mostly about that, but the title prompts a more careful look. Sure enough, there it is, way out there, the multilaned highway, the altar at which Americans take daily communion with that body and blood of their undying faith, the automobile. In Adams's

shot only one car shows, but it is enough to stand for all the others, for the endless ribbon of concrete on which it rolls and, no less, for the suburban developments it has created, also visible in the background.

Those developments have a substance and a momentum of their own that together have earned them a collective name and identity, controversial but ever so real. They are called "edge cities," at least when they are separated from the metropolises they surround and when their components are loosely composed and large enough to be distinguishable from the traditional residential suburbs they usually lie beyond or between. They are, of course, unthinkable without the generating force of the automobile, although that is only hinted at by the single car and the absence of humanity that endow Bob Thall's *Chicago (Near O'Hare)* [plate 9] with a weird atmosphere suggestive of the proto-Surrealism of the Italian painter Giorgio de Chirico, updated. Looking more familiar and less like a giant stage set is another piece by Thall, *Route 59 Near Route 34, Naperville, Illinois*, in which the displacement of the old (the barn) by the new (the strip mall across the road) is an ironic record of the swiftly changing look – and pace – of contemporary America. And is it stretching things to add two more intriguing works by Walker Evans to the classification of transportation? The association is hard to resist, since the old ruin in *Untitled* and the only slightly younger one in *Trailer Park, Florida* seem proof in their dilapidated condition that America's obsession with motor cars has a fairly lengthy history. These wrecks no longer move, but in their respective pasts they did, which is exactly what Evans seeks to recall.

The city is by definition a built community, and building is, or wants to be, architecture. Training the camera on a great piece of architecture does not guarantee a great photograph, but several of the pictures in this exhibition are worthy of the structures that inspired them. The late Richard Nickel of Chicago literally died for architecture, having perished in falling debris during the demolition of a building he labored in vain to preserve, the Adler & Sullivan Stock Exchange that once occupied a proud place on Chicago's LaSalle Street. Even so, his enthusiasm for salvaging the best of our architectural heritage gained him the lasting esteem of scholars and connoisseurs, and his gift for recording those devotions is apparent in this exhibition. It is enough to mention his *Auditorium Building*, a lucidly perceived document of one of Adler & Sullivan's, and Chicago's, most splendid and venerable architectural treasures.

History, so obviously recalled by the Auditorium, is itself a subtopic of this exhibition, not only because some of the buildings and scenes on view reflect the past, but because the very notion of history is held up to question in at least one instance. Michael A. Smith's *New Orleans (N82-8510-11/103 #7)* is a shot of the Piazza d'Italia (1975–78) in New Orleans, a work by Charles Moore that was inspired by two related motives. One was to appeal to the people of the neighborhood, mostly of Italian extraction, by employing an architectural style they would recognize as close to the vocabulary of the Italian Renaissance. The other was to use that very historical reference as a way of criticizing the presumably ahistorical

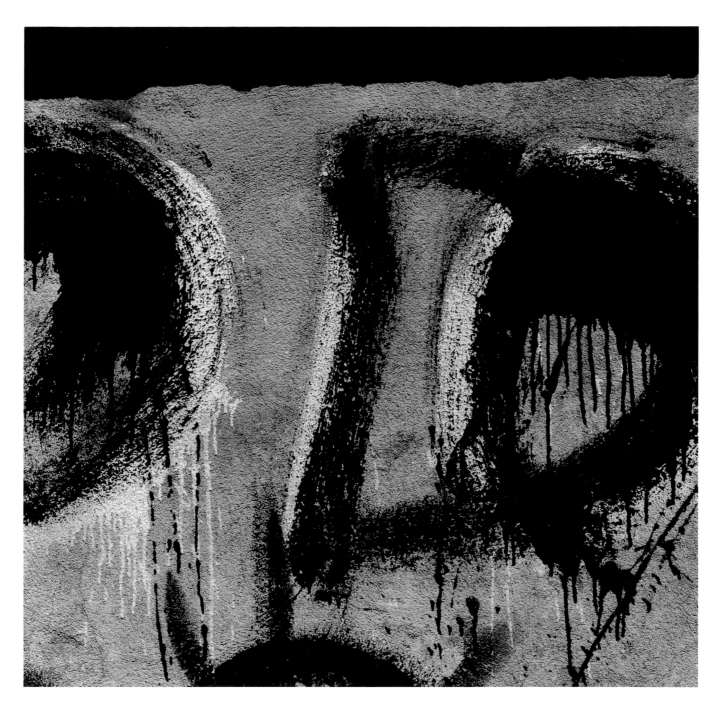

11  Aaron Siskind
    *Jalapa 66* from *Homage to Franz Kline*, 1974
    silver gelatin print
    6 3/4 x 6 7/8 inches
    Gift of the Reva and David Logan Foundation
    © The Aaron Siskind Foundation, courtesy Robert Mann Gallery, New York

Aaron Siskind explored the urban landscape to uncover accidental arrangements of elements such as paper, paint, and brick. His relationship to Abstract Expressionism is particularly clear in *Jalapa 66*, which reveals formal and relational aspects parallel to those in the paintings of Franz Kline and others of this era. See plate 12; Parry, plate 1; and front cover.

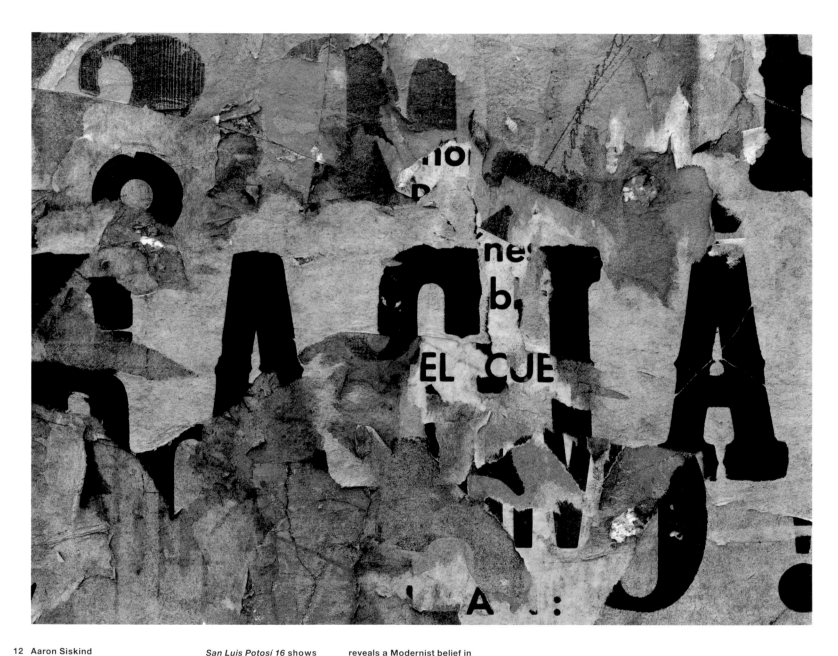

12 Aaron Siskind
*San Luis Potosí 16*, 1961
silver gelatin print
9 3/8 x 12 7/16 inches
Gift of Suzanne and
Waldo Fielding
© The Aaron Siskind
Foundation, courtesy Robert
Mann Gallery, New York

*San Luis Potosí 16* shows
Aaron Siskind's use of iso-
lated objects – in this case,
peeling signs on a wall – to
shape intriguing abstract
compositions. With a con-
cern for an object's formal
characteristics rather than
the reality of its common-
place context, Siskind

reveals a Modernist belief in
the photograph as an object
in itself – an attitude that
is a milestone in twentieth-
century art photography.
See plate 11; Parry, plate 1;
and front cover.

13 Harry Callahan
*Cuzco, Peru*, 1974
silver gelatin print
9 3/4 x 9 9/16 inches
Museum purchase
© Harry Callahan, courtesy
PaceWildensteinMacGill,
New York

In *Cuzco, Peru*, Harry
Callahan turned a truly
simple form into a
deceptively simple formal
problem. The plane of an
ancient wall, through
Callahan's controlled
camera, becomes a
composition of strength
and balance. Callahan
reveals the precision and
elegance possible in his
medium. See plate 10 and
Miller, plate 3.

14  Henry Wessel, Jr.
*Albany, California*, 1972
silver gelatin print
10 3/8 x 15 5/8 inches
Gift of Cornelia Bryer
© Henry Wessel, Jr.,
courtesy Fraenkel Gallery,
San Francisco

Unwaveringly straightfor-
ward, Henry Wessel, Jr.'s
*Albany, California* presents
the prosaically familiar: a
house on a street. In a
number of unpretentious
photographs of vernacular
America taken over twenty
years, Wessel has depicted
the personality evident

on a home's exterior. His
studies of these average
American houses, in black
and white and later in color,
incorporate the individuality
of his subjects, as well as
an understanding of how they
manifest a complex social
fabric.

15  Paul D'Amato
*Girl in Shopping Cart,*
*Chicago*, 1990
chromogenic development
(from color negative) print
14½ x 18 inches
Gift of Sonia and Theodore
Bloch

Paul D'Amato draws on
the tradition of street
photography and his intimate
familiarity with the history
of painting to create color
photographs of urban human
drama. Attracted to what
he terms "the vividness of

emotion," D'Amato pho-
tographed in the Mexican
communities in Chicago,
in neighborhoods that
make up the second largest
Mexican population
in the United States. The
unmediated emotion of
the child in *Girl in Shopping*

*Cart, Chicago* is a testament
to D'Amato's success in
conveying the passion of the
moment.

16  Robert Frank
*Woolworth,*
*New York City,* 1955
silver gelatin print
13 5/8 x 9 inches
Museum purchase
© Robert Frank, courtesy
PaceWildensteinMacGill,
New York

Robert Frank divulged the
apprehension and alien-
ation in the America of the
1950s. In *Woolworth,*
*New York City*, a woman
appears lost in the para-
phernalia of a consumerist
environment. Her surround-
ings, a jumble of artificial
lighting and blurred infor-
mation, contribute to
the chaotic feel of a rapidly
transforming culture. See
Miller, plate 1 and Rosen-
blum, plate 5.

17  Declan Haun
*Smithfield Baptist Church,*
*Charlotte, North Carolina,* 1963
silver gelatin print
6 7/8 x 10 1/16 inches
Gift of Jack A. Jaffe,
Focus/Infinity Fund
© The Estate of Declan Haun

A quiet grace permeates
Declan Haun's *Smithfield*
*Baptist Church, Charlotte,*
*North Carolina.* Taken
during a time of fundamental
change in the South while
Haun was a photographer for
the *Charlotte Observer*,
this photograph captures
an atmosphere that is

spiritual and contemplative.
The setting, formal dress
of the subjects, and light-
flooded window in the
background lend the image
an inspired dignity.

and anonymous character of Modernist architecture. Hence the term Postmodernism, a latter-day movement of which the Moore work is a perfect example, just as its ideal Modernist counterpart, featured in Harry Callahan's *New York* [plate 10], is a head-on view of the base of Mies van der Rohe's famous Seagram Building.

Not unmindful of buildings in his own right, Aaron Siskind gained a substantial reputation as a photographer of the scarred and scrawl-ridden surfaces of city walls, witness his *Jalapa 66* from *Homage to Franz Kline* [plate 11] and *San Luis Potosí 16* [plate 12], which remind us more of Abstract Expressionist painting than of architecture. Yet Siskind could be equally responsive to walls free of graffiti or decaying posters. His *Gloucester 5* is a model of texture and value contrasts, while his *People's Savings Bank* attests as surely to his own sense of proportion as to that of the building's designer, Louis Sullivan. Siskind's old Chicago colleague Harry Callahan – the two of them occupy a high place in the history of photographers associated with that city – has also contributed the image of a wall, *Cuzco, Peru*, one of the most extraordinary pieces in the show [plate 13]. That is all it is, a tall blank rampart that seems to go on and on and on, and curiously, on that very account, arrests our attention.

How large must a collective be to qualify as a city? And is the difference between a city and a town sufficient to disqualify an image from a show like this one that includes good photographs of modern human habitations of all shapes and sizes? Does the question even matter? Certainly the principles enunciated earlier here, about the importance of the developed community to the history of mankind, have been met in all the images so far cited and those yet to be discussed.

Examples: If David Plowden's engaging view in *Main Street, Cazenovia, New York* is obviously taken from a small town, is it any less a sign of the magnetic forces that draw people together in a community? And is the larger locale of Walker Evans's *Store Display, Florida* the outskirts of a big city or just the tired old middle of a forgotten seaside hamlet? Surely one glance at the empty diver's outfit slumped in a chair, and another at the sign over the shop, affirm that the scene is virtually unimaginable outside a people-gathering context.

More examples: Plowden's *Cape May, New Jersey* – sheer architectural fantasy to someone from Gary, Indiana, though not necessarily to the population of Cape May, where it is familiar, standard stuff. Lee Fried-

lander's *Phoenix*: is this an urban scene, almost all palm trees and cactus, and only two buildings, both at the margins of the picture frame [see Rosenblum, plate 6]? Yes. It has the requisite statue of a famous man on a pedestal, placed there – discovered there – by Friedlander's unrequisite but fitting sense of the absurd. As to Henry Wessel, Jr.'s *Albany, California* [plate 14], it is so obviously what it is that no arcane meaning need be found in it.

**The people**    The ultimate category of subject matter that defines a city is the humanity that created it, lived in it, wrapped themselves in it or it in themselves, making it a better place or, just about as often, a worse one. But whatever else the species is, it has seldom been dull, and even when dull by most standards, interesting enough to anyone with the appropriate artist's eye.

Some images are bold enough either in form or content to stop the viewer in his tracks. Others require a moment's reflection, and still others conceal nearly as much as they disclose. Three photographs by Paul D'Amato of Chicago girls cover the spectrum. The shriek uttered by the *Girl in Shopping Cart, Chicago* [plate 15] is sudden and startling, almost literally audible. If the *Girl in Rain, Chicago* seems at first to have inexplicably toppled over onto her back, a second look leaves little doubt that she is simply and voluntarily luxuriating in the cool of all that water. Further to this, D'Amato evidently felt a need for the title, *Girl with Lingerie Catalogue*, to urge us to pay attention to what we might otherwise have missed.

There is, on the other hand, no way of missing the horn in Robert Frank's *Political Rally, Chicago* [see Rosenblum, plate 5], which may be another example of sound emerging from a photograph, in this case probably a ponderous sound, quite unlike the complex orchestration of the surface of his *Woolworth, New York City* [plate 16].

Some of the photographs in the exhibition raise questions rather than resolve them. Exactly what is going on in Declan Haun's *Smithfield Baptist Church, Charlotte, North Carolina* [plate 17]? Has a funeral service just concluded, or is one imminent, or have we happened to walk in on several people who are independently lost in thought and part of no other narrative? If the setting of Joel Sternfeld's *Canyon County, California* [plate 18] is clearly suburban, what is the less-than-clear relationship between father and daughter? Is it purely parental affection and filial devotion? Nothing more?

Consider too the question of urban types, people who seem to belong nowhere but in cities. While the splendid face in Taber Chadwick's *Grant Park, April 7, 1984* might be that of a weather-beaten farmer (we know it's Chicago because of the famous Ivan Mestrovic equestrian sculpture in the background), there is no doubt that the men in Bruce Davidson's *Untitled* from *The New Jersey Meadows* series are hard as pavement cement, and probably much accustomed to walking on it. Some faces, moreover, appear to owe their allegiance to specific decades. Yasuhiro Ishimoto's *Untitled* from *Chicago, Chicago* may have been shot in 1960, but the profile of the man at the right belongs to the 1930s, maybe the 1920s, but surely not the 1960s or any time since. Generically speaking, he is history. He is also

18 Joel Sternfeld
*Canyon County,*
*California*, 1983
chromogenic development
(from color negative) print
13 x 16½ inches
Museum purchase
© Joel Sternfeld, courtesy
PaceWildensteinMacGill,
New York

Joel Sternfeld photographs
the US landscape, both
mundane and glorious. He
seeks the unusual or unset-
tling within the everyday –
an elephant collapsed in the
middle of a rural highway,
a firefighter purchasing
pumpkins while a building
burns in the background,
the unmarked and nonde-

script sites of violence and
criminal acts. The setting of
*Canyon County, California*
is simple: middle-class
American suburbia. Its sub-
text of family dynamics,
however, is more compli-
cated and mysterious.

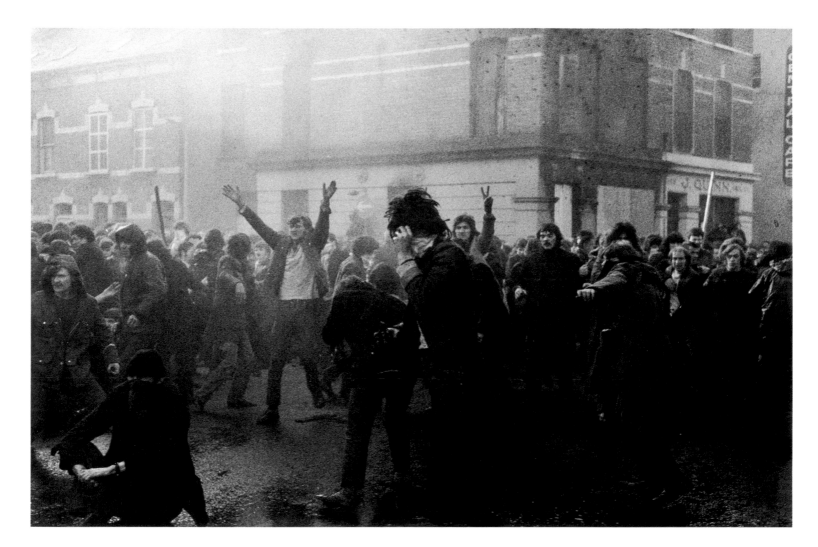

19  Gilles Peress
    *Bloody Sunday, One Minute*
    *before British Paratroop*
    *Fires*, 1972
    silver gelatin print
    23 1/2  x  35 3/8 inches
    Museum purchase with funds
    donated by James J.
    Brennan, Brennan Steel

The allure of photojournalism
is its ability to satisfy our
hunger for events we would
otherwise not see. With his
documents of revolution, war,
and rebellion from around
the world, Gilles Peress pre-
sents an unflinching view of
such events. The tension
apparent in *Bloody Sunday,*

*One Minute before British*
*Paratroop Fires* is created
through the dynamics of the
crowd and augmented by a
title that leaves no doubt as
to this image's violent con-
text. See Slemmons, plate 12.

20  Arthur Shay
*Nelson Algren at Division
Street Y*, 1951
silver gelatin print
10 7/16 x 13 3/8 inches
Gift of Sonia and Theodore
Bloch

In the book *Nelson Algren's
Chicago*, Arthur Shay's pho-
tographs capture the darker
sides of a rough city, one
loved by Shay and Algren.
*Nelson Algren at Division
Street Y* shows the energy
and focus of the author in an
arena very different from

writing. Algren, who loved
fights and fighters, worked
out almost every day at the
Division Street Y while
working on his award-win-
ning novel *The Man with
the Golden Arm*.

**21  Barbara Crane**
*Untitled*
from the series
*People of the North
Portal,* 1970
silver gelatin print
14 x 11 inches
Gift of Jeanne and
Richard S. Press

In 1970 Barbara Crane
began a project of observa-
tion – she turned her
camera on a single Chicago
doorway, observing the
myriad types who passed
through its opening. An
entertaining series of over
150 photographs resulted,
a record of the artist's
numerous anonymous
muses. The family mem-
bers shown in this image
appear variously ambiva-
lent, suspicious, unaware,
and unconcerned about
the photographer who
has claimed this common
territory as her own. See
Peat, plate 16.

22 Stephen Marc
*Between 61st and 62nd and Rhodes ("Fresh" Block Party Talent Show)* from *Changing Chicago* (1989), 1988
silver gelatin print
7 3/4 x 11 1/2 inches
Gift of Jack A. Jaffe, Focus/Infinity Fund

Adept at photographing the mood of a moment, Stephen Marc's body of work from the 1989 project *Changing Chicago* presents a portrait of one of the city's many diverse communities. A photographer interested in exploring cultural cues and social interactions – especially within the African-American community – Marc captured the camaraderie and pure fun found on a South Side Chicago street. See Rosenblum, plate 12.

unmistakably Chicago, just as the three riveting street scenes by Gilles Peress are difficult to imagine anywhere but in the gritty Irish cities where they were photographed [see plate 19].

Some of the images attract us because they touch a nerve of recognition, others for the opposite reason of their uncommonness, yet in either case it is the photographer who is the principal stimulus of our response. The subjects in Roy DeCarava's two pieces, *Dancers, New York* and *Man in Window, New York*, come as no surprise. We have seen them or something similar many times before. What prompts us to study them now is partly the fact of their familiarity, but mostly the elegantly dim-lit mood that DeCarava casts over them. Contrarily, there is no denying the surreality of Walker Evans's untitled convocation of pelicans and alligator (artificial), seated woman and photographer (real), plus heaven knows what else. In yet another instance, however, strangeness itself is relative. Evans's shot of the man sitting on the porch of his little house on "Lot 14" may seem as natural to the man as it is bizarre to the majority of the rest of us.

Among the most notable works in the exhibition are the pieces whose commonality qualifies them as a series. Again, some of these are united by recognizability, others by diversity. Everyone knows who the people are in Arthur Shay's photographs: they are famous, either as individuals or as groups. That is usually enough to draw us to them, yet central to Shay's art is his way of enveloping subjects in data that correspond with our notion of them, making them look, as it were, intriguingly more like themselves. How else might we better know who the great orchestral conductor George Szell was and, no less important, what he did, than by equipping him with a lighted baton and recording his movements in a time-lapse exposure? And isn't the warmth of communal spirit among *Elijah Mohammed's Black Muslim Sisters* heightened rather than diminished by the fact that his own grandchild, in their very midst, has decided that something interesting to them interests him not at all?

Shay knows his Chicago as intimately as anyone who ever pointed a camera at it. The city's unofficial poet laureate Nelson Algren is seen two ways: typically walking the neighborhoods, solitary and brooding, coat collar turned up against Chicago's savage winter winds, and, no less typically, working the sulk off against a punching bag at the Division Street YMCA [plate 20]. Architect Harry Weese is shown as the reflective idealist he

was; real-estate developer Arthur Rubloff as the dandy he unashamedly knew himself to be; Anna Freud as a unique and distinguished guest at the city's renowned Institute for Psychoanalysis.

Barbara Crane found another way to illuminate the same multifaceted Chicago, using the simplest of recipes to reveal the most diversely composed collective portrait of American urban humanity. She set up her camera just outside a portal at Chicago's Museum of Science and Industry and recorded the people who entered and left [see plate 21]. Some who came and some who went: a hipster in a cocky skimmer and tie-dyed pants, a somber mother on the arm of a more somber son, a cool dude and a cooler fox, a handsome young woman with arms folded but yielding to her companion's charms, a mother and child, a cop and a kid, a man on crutches, an upbeat greeter, arms spread, happy to be photographed – the whole gamut, restless, restrained, romantic, riotous, of city folk.

Yasuhiro Ishimoto found more than city folk in Chicago, albeit he was possessed by them as well. In his series *Chicago, Chicago*, a man in profile stops to examine a trio of mannequins that he has a right, we feel, to be mystified by [see Paschke, plate 10]. An older woman is worried about something, while two African-American youths appear brightly alive and confident. Confidence of a different sort, qualified by the obvious intensity of the moment, informs his portrait of Martin Luther King, Jr. together with friends. Yet for all Ishimoto's sensitivity to people, as a photographer he was unsurpassed in his feeling for the way light and darkness together clarify the urban character of the buildings and streets of Chicago.

Like Barbara Crane, Enrico Natali has concentrated on a closely circumscribed venue in order to deepen his understanding of the people who make use of it. It is the New York subway, a world far different from its humbler counterpart in Chicago or for that matter any subway, anywhere. It is a community, a group of beings who share something, even if it is only movement through the darkness of underground tunnels or a brief stillness on the waiting platforms. In fact, most of the riders are voluntarily cut off from each other, partly out of self-protection, partly because they are sure to be in each other's company only briefly, as if their time together is in its very nature fugitive and socially untenable. It is a reality meaningful to Natali rather than to them, and he used it to reveal more about themselves than they can know, since they are bent largely on self-concealment.

Among the most memorable lessons of Jed Fielding's studies of life in Mexico and Italy is the reminder that, despite the endless contemporary talk of global oneness, human beings are still local, bound to places very different from other places. Blessed with a terrific natural feel for what the camera can uncover and record, he has affirmed that the inhabitants of Naples handle their food, hold their babies, sit next to their relatives, and even display their badges of puberty, in manners unlike the ways of their counterparts in the urban centers of the United States. Yet another paradox: these very dissimilarities only tighten the bond of humanity with the people we call foreigners. They are sometimes more beautiful than we are, sometimes less, now and then smarter, occasionally dumber. Call it Jed Fielding's doctrine of common clay.

Much the same lesson of locality can be learned from Stephen Marc, who teaches it without even leaving Chicago. Marc is African American, a fact worthy of observation here chiefly because it is difficult to imagine anyone not African American being so at home, so expressively in tune with the spontaneous actions of this community. There is not a soul in any of the photographs in this exhibition so totally and unself-consciously immersed in what she is doing as the street dancer in *Between 61st and 62nd and Rhodes* [plate 22]. No one could have set up the gesture of the woman in *45th and Cottage Grove*. Marc did not need to; he had the credentials, not to mention a keen eye and a quick shutter hand. In his own way, moreover, the bridge game in the parlor at *87th and Dorchester* is as natural as the *Chess Game on the Hood of the Car at 62nd Between Langley and Champlain* or the skateboard acrobatics at *87th and Constance*, or the little boy, defiant of gravity, at the *57th Street Beach*.

And who, finally, in all the rich, convoluted history of the city, has better summed up what this special exhibition means to say, and what most of its role-players act out with feeling, than the children [see Rosenblum, plate 12] whom Marc came upon as they were in the midst of composing their sidewalk love song: "Chicago the Beautiful, I love Chicago."

**Berenice Abbott**

Born in 1898 in Springfield, Ohio, Berenice Abbott traveled to Paris in 1918 with the intention of becoming a sculptor. Instead, she became Man Ray's photographic assistant and by 1925 was a professional portrait photographer in her own right. Known for her systematic and richly detailed photographs of New York, Abbott also photographed scientific subjects for *Life* and for three secondary school physics textbooks. Abbott founded the photography program at The New School for Social Research (where she taught for over twenty years), was a prolific writer, and held four US patents for photographic and other devices. By purchasing Eugène Atget's archive in 1928 and essentially functioning as its curator until its sale to The Museum of Modern Art, New York, in 1968, Abbott can also be credited with preserving this important body of work. She died in 1991.

**Ansel Adams**

Ansel Adams's large body of work has come to represent a purist approach to photography, and to define in imagery the landscape of the American West. Born in San Francisco in 1902, Adams began working as an official photographer for the Sierra Club in 1928. In 1932 he and other California-based photographers founded the group f64, which maintained an interest in the technically perfect photographic print. Adams developed a means of explaining exposure and development control known as the "zone system," publishing his first book on mastering photographic technique in 1935. His photographs of Yosemite Valley – a lifelong inspiration to Adams – and other subjects have been frequently reproduced, published as portfolios, and exhibited internationally. Adams was elected a Fellow of the American Academy of Arts and Sciences, and was key to the founding of The Friends of Photography, now The Ansel Adams Center for Photography, San Francisco. He died in 1984.

**Robert Adams**

Born in Orange, New Jersey in 1937, Robert Adams has spent much of his life photographing the developed American West. A writer as well as an artist, he earned a BA in English from the University of Redlands, California and a PhD in English from the University of Southern California. Adams has published a number of books featuring his writing and photographs, including *West from the Columbia: Views at the River Mouth* (1995), *Listening to the River: Seasons in the American West* (1994), *To Make It Home: Photographs of the American West* (1989), and *Beauty in Photography: Essays in Defense of Traditional Values* (1981). His work has been widely exhibited, including in a major retrospective exhibition at The Philadelphia Museum of Art (1989). Adams is also the recipient of two National Endowment for the Arts Photographer's Fellowships, two John Simon Guggenheim Memorial Foundation Fellowships, and the Peer Award of The Friends of Photography.

**Shelby Lee Adams**

Shelby Lee Adams was born in 1950 in the Appalachian Mountains of Eastern Kentucky. He now lives there as well as in the Berkshire Mountains of Western Massachusetts. Appalachia is not only Adams's birthplace, but the subject of his photographs as well. His images, focusing on the lives of the people of Appalachia, have been shown in one-person exhibitions at the Cleveland Museum of Art; the International Center of Photography, New York; Light Work, Syracuse, New York; and the Visual Studies Workshop, Rochester, New York. His work is also included in the collections of many major museums, including The Art Institute of Chicago; the National Gallery of Canada, Ottawa; the San Francisco Museum of Modern Art; and the Stedelijk Museum, Amsterdam, among others. Adams's photographs have been published in two volumes – *Appalachian Legacy* (1998) and *Appalachian Portraits* (1993).

# Photographers'
## biographies

AnJanette Brush

**Harold Allen**

Born in Portland, Oregon in 1912, Harold Allen came to Chicago in 1937 to study industrial design and photography at the School of the Art Institute, and later to study with László Moholy-Nagy at the School of Design (predecessor of the Institute of Design). After serving as an Air Force photographer in World War II, Allen returned to Chicago and pursued an interest in architecture through his skills in documentary photography. His photographs have been widely written about and exhibited, and are included in the collections of The Art Institute of Chicago; the International Museum of Photography, George Eastman House, Rochester, New York; The Library of Congress, Washington, DC; the Museum of Contemporary Art, Chicago; and The Metropolitan Museum of Art, New York. The catalogue *Harold Allen: Photographer and Teacher* was published in 1984 in conjunction with an exhibition at The Art Institute of Chicago.

**Diane Arbus**

One of the leading photographers of her generation, Diane Arbus presented a compelling look at society's outcasts in the United States at the end of the 1960s. She confronted the complexities of human experience through her portraits of individuals on the fringes of society – dwarfs, hermaphrodites, transvestites, the mentally disabled, and others. According her subjects dignity and photographing them with compassion, Arbus imbued her work with power derived from the contrast between her sometimes shocking subjects and their calm, matter-of-fact demeanor. Arbus was born in 1923 and raised on Manhattan's Upper West Side. Her first published photographs appeared in *Esquire* in 1960, and she was awarded Guggenheim Fellowships in 1963 and 1966. Arbus died in 1971. Retrospective exhibitions of her work have traveled to museums throughout Australia, Canada, Europe, Japan, and the United States. *Diane Arbus: An Aperture Monograph* (1972) remains one of the seminal photographic books in history.

**Thomas Frederick Arndt**

Born in Minneapolis in 1944, Thomas Frederick Arndt received his BFA from the Minneapolis College of Art and Design in 1968 and undertook graduate studies at the University of Minnesota (1969–71). Arndt is known for his documentary photographs of the Midwest, and especially for his images of human interaction on the streets of Chicago. Arndt has received a variety of honors, awards, and fellowships, including grants from the Minnesota State Arts Board. His photographs have been exhibited at The Art Institute of Chicago; Louisiana State University, New Orleans; the Minneapolis Institute of Arts; and The Walker Art Center, Minneapolis, and were included in the photodocumentary project *Changing Chicago*. His book of photographs *Men in America* was published in 1995.

**David Avison**

David Avison's panoramas have been exhibited in the United States at the Addison Gallery of American Art, Phillips Academy, Andover, Massachusetts; The Art Institute of Chicago; Grey Art Gallery, New York University; Northlight Gallery, Arizona State University, Tempe; and The Philadelphia Museum of Art, as well as other international sites. Avison's educational background reveals a mixture of interests and experience; he holds his ScB from the Massachusetts Institute of Technology in theoretical acoustics (1959); a PhD in theoretical high-energy nuclear physics from Brown University (1966); and an MS in photography from the Institute of Design, Illinois Institute of Technology, Chicago (1974). Avison's photographs are included in the collections of The Art Institute of Chicago; the International Museum of Photography, George Eastman House, Rochester, New York; The Museum of Fine Arts, Boston; and The Museum of Modern Art, New York. Born in 1937, Avison today lives and works in Boston.

**Aziz + Cucher (Anthony Aziz and Sammy Cucher)**

Anthony Aziz (born Lunenburg, Massachusetts, 1961) and Sammy Cucher (born Lima, Peru, 1958) met as graduate students and started collaborating in 1990. Their large-scale, digitally manipulated images have been exhibited internationally, including at the Frankfurter Kunstverein, Frankfurt; New Langton Arts, San Francisco; The New Museum of Contemporary Art, New York; The Photographer's Gallery, London; and the Venice Biennale (Venezuelan Pavilion, 1995). Among their grants and awards is the Ruttenberg Award from The Ansel Adams Center for Photography, San Francisco. Aziz earned his BA from Boston College (1983); Cucher received a BFA from New York University's Experimental Theater Wing (1983). Both received MFAs from the San Francisco Art Institute (Aziz, 1990; Cucher, 1992).

**Uta Barth**

Born in Germany in 1958, Uta Barth lives and works in Los Angeles. Her photographs – blurred images generated by focusing the camera on an unoccupied foreground – have been included in one-person exhibitions at the Addison Gallery of American Art, Phillips Academy, Andover, Massachusetts; London Projects, London; the Museum of Contemporary Art, Chicago; and the Museum of Contemporary Art, Los Angeles. Barth's work has also been included in numerous group exhibitions and is held in the collections of The Solomon R. Guggenheim Museum, New York; The Museum of Fine Arts, Houston; The Museum of Modern Art, New York; and the Whitney Museum of American Art, New York, among others.

**Zeke Berman**

Born in New York in 1951, Zeke Berman is a graduate of New York's High School of Music and Art and the Philadelphia College of Art (BFA in sculpture, 1972). His constructions of string, wood, clay, water, paper, and glass challenge visual interpretation of the two-dimensional photographic surface. Included in many major museum collections, Berman's photographs have been exhibited at The Art Institute of Chicago; The Cleveland Center for Contemporary Art; The Friends of Photography, San Francisco; The Hirshhorn Museum and Sculpture Garden, Smithsonian Institution, Washington, DC; The Metropolitan Museum of Art, New York; and The Museum of Modern Art, New York. Berman is the recipient of grants and fellowships from the John Simon Guggenheim Memorial Foundation, the McDowell Colony, The National Endowment for the Arts, and the New York Foundation for the Arts.

**Dawoud Bey**

Dawoud Bey's prolific career displays a complex relationship to the portrait as a category of imagemaking. His photographs have earned him a variety of fellowships, awards, and commissions. Born in 1953 in New York, Bey received his BA from Empire State College, State University of New York, and earned his MFA from Yale University. His work has been presented in one-person exhibitions at the Addison Gallery of American Art, Phillips Academy, Andover, Massachusetts; the Fogg Art Museum, Harvard University, Cambridge, Massachusetts; Light Work, Syracuse, New York; the Studio Museum in Harlem, New York; and The Walker Art Center, Minneapolis, which toured a mid-career retrospective. Bey's work is also included in the collections of the Bibliothèque Nationale, Paris; The Brooklyn Museum, New York; The Museum of the City of New York; The Museum of Modern Art, New York; and The Schomburg Center for Research in Black Culture, New York. Bey is a professor of photography at Columbia College Chicago.

## Photographers' biographies

**Marilyn Bridges**

Known for her aerial views of man-made landscapes, from those marked by contemporary agriculture to those showing ancient constructs and patterns, Marilyn Bridges is a pilot as well as a fine-art photographer. She was born in New Jersey in 1948 and educated at the Rochester Institute of Technology (MFA, 1981; BFA, 1979). Her work has been exhibited internationally at a variety of venues. Bridges's photographs are represented in the collections of the Addison Gallery of American Art, Phillips Academy, Andover, Massachusetts; The American Museum of Natural History, New York; The High Museum of Art, Atlanta; the International Center of Photography, New York; and The Metropolitan Museum of Art, New York, among many others. Her work has been published in the monographs *This Land Is Your Land: Across America by Air* (1997), *Egypt: Antiquities from Above* (1996), *Planet Peru: An Aerial Journey Through a Timeless Land* (1991), and *Markings: Aerial Views of Sacred Landscapes* (1986), and as a CD-ROM entitled "Sacred and Secular: The Aerial Photography of Marilyn Bridges" (1996).

**Nancy Burson**

Nancy Burson was born in St. Louis in 1948 and attended Colorado Women's College in Denver. Her photographs and video work have been exhibited widely, and are in the collections of the International Museum of Photography, George Eastman House, Rochester, New York; the Los Angeles County Museum of Art; the National Museum of American Art, Smithsonian Institution, Washington, DC; and the San Francisco Museum of Modern Art, among many other private and international public collections. Burson has frequently collaborated with her husband, David Kramlich; the two developed a significant computer program which gives the user the ability to age the human face and subsequently has assisted the FBI in locating missing persons. Burson's computer generated portraits, published in *Composites* (1986), predate the concept of morphing in advertising. Nancy Burson lives and works in New York.

**Debbie Fleming Caffrey**

Since the early 1970s, Debbie Fleming Caffrey has photographed workers from the sugarcane fields and sugar mills in rural Louisiana, where she was born in 1948. She received her BFA in photography from the San Francisco Art Institute in 1975, and since then has received numerous fellowships and awards. Caffrey's work has been exhibited in one-person and group shows worldwide, and is included in the collections of the Bibliothèque Nationale, Paris; the International Museum of Photography, George Eastman House, Rochester, New York; The Metropolitan Museum of Art, New York; and The Museum of Modern Art, New York. In 1990 a monograph of her work entitled *Carry Me Home: Photographs by Debbie Fleming Caffrey* was published by Smithsonian Press.

**Harry Callahan**

Born in Detroit in 1912, Harry Callahan is a self-taught photographer. He first worked as a photographic technician for General Motors, but was hired in 1946 to teach photography at the Institute of Design, Chicago. In 1948 Callahan met Edward Steichen, who responded strongly to his work, including it in numerous shows at The Museum of Modern Art, New York. Callahan left Chicago and his position as head of the Department of Photography at the Institute of Design (1949–61) to head the photography department at the Rhode Island School of Design, Providence. He stepped down from the chairmanship in 1973, but continued teaching at the school until his retirement in 1977. Among his monographs are *Harry Callahan* (1996), *Water's Edge* (1980), *Harry Callahan: Color* (1980), *Callahan* (1976), *Photographs: Harry Callahan* (1964), *The Multiple Image* (1961), and *On My Eyes* (1960). Callahan lives in Atlanta.

**Ellen Carey**

Ellen Carey holds an MFA degree from the State University of New York at Buffalo and a BA from the Kansas City Art Institute. Born in New York in 1952, Carey now lives and works in New York and Hartford, Connecticut. Her often manipulated and usually abstacted images have been shown in many solo and group exhibitions, including at The Ansel Adams Center for Photography, San Francisco; The Art Institute of Chicago; The Baltimore Museum of Art; CEPA Gallery, Buffalo; The National Academy of Sciences, Washington, DC; and at Real Art Ways, Hartford, Connecticut. The recipient of numerous awards, Carey is currently an associate professor at Hartford Art School, Hartford, Connecticut.

**Keith Carter**

Keith Carter, who was born in Wisconsin in 1948, earned a BBA in business management from Lamar University, Beaumont, Texas (1970) and studied at The New School for Social Research, New York. Carter also studied photography with Paul Caponigro and Wynn Bullock at the Yosemite Workshops. He has taught a variety of photography workshops and since 1988 has been an assistant professor at Lamar University. Carter's work has been exhibited in many one-person and group exhibitions, including at the Art Museum of South Texas, Beaumont; The Director's Guild, Los Angeles; the Houston Center for Photography; The Museum of Fine Arts, Houston; and Vision Gallery, San Francisco. Carter's photography has also been documented in several monographs, including *Keith Carter: Photographs Twenty-Five Years* (1997), *Bones* (1996), *Heaven of Animals* (1995), and *Mojo* (1992), and is represented in the collections of The Museum of Fine Arts, Houston; The Art Institute of Chicago; the San Francisco Museum of Modern Art; and the International Museum of Photography, George Eastman House, Rochester, New York, among others.

**Catherine Chalmers**

Catherine Chalmers was born in San Mateo, California, in 1957. Before she received an MFA degree in painting from the Royal College of Art, London, Chalmers earned her BS in engineering from Stanford University. Her background in science continues to be apparent in her sequential images of insects in the acts of eating, reproducing, or otherwise illustrating the cycles of life. Chalmers's photographs have recently been exhibited at The Ansel Adams Center for Photography, San Francisco; The New Museum of Contemporary Art, New York; the Reykjavik Municipal Art Museum, Iceland; White Columns, New York; and the Yukon Arts Center, Whitehorse, Canada, among others. In 1999 her work will be featured in the exhibition "The New Natural History" at the National Museum of Photography and Film, Bradford, England.

**William Christenberry**

With the encouragement of noted photographer Walker Evans, William Christenberry began to pursue photography seriously and focus on the landscape of Hale County, Alabama, which he has photographed for more than twenty-five years. Christenberry, who was born in Alabama in 1936, works in a variety of media, including photography, painting, drawing, and sculpture. He received his BFA and MA degrees in painting from the University of Alabama and is currently a professor of art at the Corcoran School of Art in Washington, DC. Christenberry's work has received honors and awards, and has been exhibited extensively throughout the United States and Europe. His work is included in numerous prominent collections, and featured in the publications *Christenberry Reconstruction: The Art of William Christenberry* (1996) and *Of Time and Place: Walker Evans and William Christenberry* (1990).

**Larry Clark**

Born in Tulsa in 1943, Larry Clark has documented the youth culture of his hometown and other cities in photographs, including in the portfolio *Tulsa*, and in film, including the feature *Kids*. His work has been shown in one-person and group exhibitions throughout the world, including Anderson Ranch Public Gallery, Aspen, Colorado; The Institute of Contemporary Art, Boston; The Museum of Contemporary Art, Los Angeles; the San Francisco Museum of Modern Art; The Philadelphia College of Art; and the Whitney Museum of American Art, New York. Clark's work is represented in important collections worldwide, including The Museum of Modern Art, New York; Rhode Island School of Design, Providence; the Museum of Contemporary Art, Chicago; the San Francisco Museum of Modern Art, California; and the Australian National Gallery, Canberra.

## Photographers' biographies

**Chuck Close**

Chuck Close was born in Monroe, Washington, in 1940. He earned his BA from the University of Washington, Seattle, and a BFA and MFA from the School of Art and Architecture, Yale University. His work has been featured in more than one hundred solo exhibitions in the United States and Europe, including three major traveling retrospectives, the most recent organized in 1998 by The Museum of Modern Art, New York. Close's paintings and photographs have also been included in major group exhibitions, including "Documenta V" (1972) and "Documenta VI" (1977) in Kassel, Germany, and in the Whitney Museum of America Art biennial exhibitions in 1969, 1977, 1979, and 1991. Close has been awarded numerous honorary degrees, and was recognized in 1992 by The American Academy and Institute of Arts and Letters, of which he is now a member.

**Lynne Cohen**

Lynne Cohen attended the Slade School of Art, University of London before receiving her BS from the University of Wisconsin (1967) and MA from Eastern Michigan University (1969). Her austere photographs of uninhabited interiors have been exhibited at the Corcoran Gallery of Art, Washington, DC; the International Center of Photography, New York; Light Work, Syracuse, New York; Manes Gallery, Prague; and the San Francisco Museum of Modern Art, among other prestigious venues. Cohen's work is featured in the monographs *Lost and Found* (1993) and *Occupied Territory* (1988), and included in the collections of many significant international institutions. Born in Racine, Wisconsin in 1944, Cohen today lives in Ottawa, Canada.

**Linda Connor**

Since 1967 Linda Connor has traveled to both distant and familiar places to photograph various lands and their people. Her formal photographic education came under the instruction of Harry Callahan at the Rhode Island School of Design, Providence, and Aaron Siskind at the Institute of Design, Illinois Institute of Technology, Chicago (MS, 1969). Born in New York in 1944, Connor has taught photography for many years in California, primarily at the San Francisco Art Institute. Her work has been represented in numerous exhibitions and catalogues, and in the monographs *Spiral Journey* (1990) and *Solos: Photographs by Linda Connor* (1979). Her photographs are also included in significant collections, including The Art Institute of Chicago; The Museum of Fine Arts, Boston; The High Museum of Art, Atlanta; the International Center for Photography, New York; The Museum of Modern Art, New York; and the Victoria and Albert Museum, London.

**John Coplans**

John Coplans, the founding editor of *Artforum* magazine, began photographing his aging body when he turned sixty. Born in London in 1920, Coplans was educated in South Africa and England; after immigrating to the United States in 1960, he began teaching at the University of California at Berkeley. Coplans worked as the senior curator of the Pasedena Art Museum from 1967 to 1970 and as the director of The Akron Art Museum in 1978. He has published numerous articles of art criticism, and his books include *Weegee: Tater und Opfer* (1978), *Ellsworth Kelly* (1973), *Roy Lichtenstein* (1972), *Andy Warhol* (1970), *Serial Imagery* (1968), and *Cézanne Watercolors* (1967). Coplans's extremely close-up and anonymous self-portraits have been exhibited at numerous institutions worldwide. He received the Frank Jewitt Mather Award of the College Art Association for services to art criticism in 1974; John Simon Guggenheim Memorial Foundation Fellowships in 1969 and 1985; and National Endowment for the Arts Fellowships in 1975, 1980, 1986, and 1992.

**Eileen Cowin**

Eileen Cowin employs artifice and theatricality to produce large-scale images of suspense and seduction. Since 1970 Cowin's photographs have been featured in over twenty-five one-person exhibitions in Europe, Japan, and the United States, including at The Cleveland Museum of Art; the Los Angeles County Museum of Art; and The Museum of Contemporary Photography, Columbia College Chicago. Her work is also highlighted in various publications, including *A History of Women Photographers* (1994) and *Something's Out There: Danger in Contemporary Photography* (1992). Born in 1947, Cowin studied with Aaron Siskind and Arthur Siegel at the Institute of Design, Illinois Institute of Technology, Chicago, where she earned an MS degree in photography in 1970. Eileen Cowin is a professor of art at California State University, Fullerton.

**Barbara Crane**

Barbara Crane began her career as a self-taught photographer and today is known as an innovative, diverse, and prolific artist. Born in 1928, she received her education in art history at New York University (BA, 1950) and in photography at the Institute of Design, Illinois Institute of Technology, Chicago (MS, 1966). She is a professor emeritus at The School of The Art Institute of Chicago, and has also taught as a visiting professor at Bezalel Academy of Art and Design, Jerusalem; Cornell University, Ithaca, New York; and The School of The Museum of Fine Arts, Boston. Her photographs have been featured in many publications, and in retrospective exhibitions organized by Catherine Edelman Gallery, Chicago; the Center for Creative Photography, University of Arizona, Tucson; and The Museum of Contemporary Photography, Columbia College Chicago; and traveling exhibitions organized by the Polaroid Corporation, Cambridge, Massachusetts.

**Susan Crocker** Susan Crocker's photographs have been exhibited at the Chicago Cultural Center; Fogg Art Museum, Harvard University, Cambridge; the Illinois State Museum, Springfield; Queensland Art Gallery, Brisbane, Australia; and the Santa Fe Contemporary Art Gallery. Among the numerous collections that include her work are The High Museum of Art, Atlanta; the Los Angeles County Museum of Art; The Metropolitan Museum of Art, New York; The Museum of Modern Art, New York; and The Walker Art Center, Minneapolis. Crocker's photographs were part of the exhibition project and publication *Changing Chicago* (1989) and are included in Naomi Rosenblum's *A History of Women Photographers* (1994). Crocker was born in New York in 1940; today she lives in New Mexico.

**Paul D'Amato** Paul D'Amato was born in Boston in 1956 and attended Reed College, Oregon (BA, 1980) and Yale University School of Art (MFA, 1985). His photographs have earned him numerous prestigious awards, including a grant from the Rockefeller Study Center in Bellagio, Italy, and a John Simon Guggenheim Memorial Foundation Fellowship. D'Amato's photographs have appeared in *Harper's Magazine, Life,* and *Utne Reader*. *Barrio*, his series of photographs taken in Chicago's Mexican neighborhoods, was featured in *DoubleTake* and *The Chicago Tribune Magazine*. His work is in many significant collections and has been included in exhibitions at the Directors Guild, Los Angeles; Grand Central Station, New York; The Museum of Modern Art, New York; Northlight Gallery, Arizona State University, Tempe; the Photographic Resource Center, Boston; and the Portland Museum of Art, Portland, Maine.

**Louise Dahl-Wolfe** As one of the preeminent fashion and celebrity portrait photographers of the late 1930s through the 1950s, Louise Dahl-Wolfe (1895–1989) produced more than six hundred color editorial pages, eighty-five covers, and countless black-and-white images for *Harper's Bazaar*. Born and raised in San Francisco, she studied design and painting at the California School of Fine Arts (later renamed the San Francisco Art Institute) and design and architecture at Columbia University, New York. Her work has appeared in numerous exhibitions, including the first photography exhibition at The Museum of Modern Art, New York ("Photography 1839–1937," 1937) and in a major traveling show organized by the Smithsonian Institution, Washington, DC. The Fashion Institute of Technology in New York has a large selection of Dahl-Wolfe's photographs in its collection.

**Bruce Davidson** Born in Oak Park, Illinois in 1933, Bruce Davidson was introduced to photography at age ten when he purchased a camera with money earned from a paper route. Influenced by the photojournalistic and documentary work of W. Eugene Smith and Henri Cartier-Bresson, Davidson is well known for his photographs of East 100th Street in Harlem, of circus dwarfs, and of Welsh coal miners and village life. A member of the prestigious Magnum Photos agency, Davidson studied photography at the Rochester Institute of Technology and Yale University. His photographs and films have been exhibited internationally. Exhibition venues include the International Center of Photography, New York; The Museum of Modern Art, New York; and The Walker Art Center, Minneapolis. Davidson's monographs include *Central Park* (1995), *Subway* (1986), *Bruce Davidson Photographs* (1979), and *East 100th Street* (1970).

**Philip-Lorca diCorcia** Philip-Lorca diCorcia's photographs are silent, elegant witnesses to the spontaneity and reality of urban public spaces. The monograph *Streetwork* (1998) collects diCorcia's recent photographs taken in cities around the world, showing his dexterity at producing richly cinematic lighting effects. His work has been widely collected and included in exhibitions at Artists Space, New York; Burden Gallery, Aperture Foundation, New York; The Museum of Modern Art, New York; the Netherlands Photo Institute, Rotterdam; and the Whitney Museum of American Art, New York, among other venues. Born in 1953 in Hartford, Connecticut, diCorcia earned his Diploma (1975) and Post Graduate Certificate (1976) from The School of The Museum of Fine Arts, Boston and an MFA from Yale University (1979).

**Jeanne Dunning** Chicago-based Conceptual artist Jeanne Dunning abstracts ordinary and intimate human body parts with extreme close-up and surprising framing. Born in 1960, Dunning was educated at Oberlin College, Oberlin, Ohio (BA, 1982) and at The School of The Art Institute of Chicago (MFA, 1985). Her work has been included in exhibitions such as "Feminin-Masculin," Centre Georges Pompidou, Paris (1995); "Identity and Alterity," Venice Biennale (1995); and "The Whitney Biennial," the Whitney Museum of American Art, New York (1991). In 1994 a retrospective prepared by the Hirshhorn Museum and Sculpture Garden, Smithsonian Institution, Washington, DC traveled to the Museum of Contemporary Art, Chicago. *Jeanne Dunning: Bodies of Work* was published in 1984.

## Photographers' biographies

**Harold Edgerton**

Born in Fremont, Nebraska, in 1903, Harold Edgerton received a BS degree (1925) in electrical engineering from the University of Nebraska, and his MS (1927) and DSc (1931) in electrical engineering from the Massachusetts Institute of Technology. In 1931 Edgerton developed the stroboscope, the flash mechanism that revolutionized high-speed and stop-motion photography. The photographs he began taking with this invention have been widely exhibited, published, and collected. An esteemed educator, Edgerton received several honors and awards, including the Medal of Freedom from the War Department (for achievements in nighttime aerial photography), the National Medal of Science, and the Progress Award of the Society of Motion Picture and Television Engineers. He also worked with Jacques-Yves Cousteau and developed flash equipment for underwater research. Edgerton died in 1990.

**Elliott Erwitt**

Born in Paris in 1928, Elliott Erwitt immigrated to New York with his family in 1939. He started working as a freelance photographer at age sixteen and later met Robert Capa, Edward Steichen, and Roy Stryker. In 1953 Capa invited Erwitt to become a member of Magnum Photos; he has since served several terms as president. Erwitt's photographs have been published in numerous volumes, including *Between the Sexes* (1994), *Elliott Erwitt: To the Dogs* (1992), *Elliott Erwitt: On the Beach* (1991), and *Recent Developments* (1978), among many others. In addition to producing photographic essays, illustrations, and advertisements for publications around the world, Erwitt has produced numerous films.

**Walker Evans**

Walker Evans was born in 1903 in St. Louis; he died in 1975. He studied at Phillips Academy, Andover, Massachusetts and at Williams College, Williamstown, Massachusetts, auditing classes at the Sorbonne in Paris as well. He gained recognition for his clear and unsentimental approach to his subject matter, adopting a view that elevated the banal to the beautiful. Evans is perhaps best known for his work for the US government's Farm Security Administration in the 1930s, which documented the plight of rural farmers. His work has been widely exhibited and collected, and is also the subject of several publications, including *The Last Years of Walker Evans: A First-Hand Account* (1997), *Walker Evans: A Biography* (1995), *Walker Evans: The Hungry Eye* (1993), *First and Last* (1978), *Walker Evans: Photographs for the Farm Security Administration: 1935–38* (1973), *Message from the Interior* (1966), and *American Photographs* (1938).

**Jed Fielding**

Born in Boston in 1953, Jed Fielding received a BFA degree in photography in 1975 from the Rhode Island School of Design, Providence, where he studied with Aaron Siskind and Harry Callahan. He received his MFA degree in 1980 from The School of The Art Institute of Chicago. Fielding has traveled and photographed extensively in Egypt, Greece, Italy, Mexico, Spain, and the United States. His work is featured in the monograph *City of Secrets: Photographs of Naples by Jed Fielding* (1997), and represented in numerous public and private collections, including The Art Institute of Chicago; the Center for Creative Photography, University of Arizona, Tucson; the International Center of Photography, New York; and The Museum of Modern Art, New York. Fielding lives and works in Chicago.

**Larry Fink**

Larry Fink was an early admirer of Henri Cartier-Bresson's work and studied in the 1960s with Lisette Model, who encouraged him to pursue a career as a photographer. Born in Brooklyn in 1941, Fink looked to the city of New York for his photographic subject matter. Today he is perhaps best known for work produced in the 1970s documenting parties in New York, and for photographs of his friends and neighbors in Martins Creek, Pennsylvania. An influential educator, Fink has taught at the Yale University School of Art, New Haven; Cooper Union School of Art and Architecture, New York; Parsons School of Design, New York; and the Tyler School of Art, Temple University, Philadelphia. His work has been widely exhibited in the United States, including solo exhibitions at Light Gallery, New York; the Massachusetts Institute of Technology, Cambridge; The Museum of Modern Art, New York; and the San Francisco Museum of Modern Art. Fink's work is highlighted in the monographs *Boxing: Photographs by Larry Fink* (1997) and *Social Graces* (1984).

**Robert Frank**

Born in Zurich in 1924, Robert Frank emigrated from Switzerland in 1947 at the age of twenty-two and worked in New York with considerable commercial success. In search of something more, however, he traveled from New York to South America, Paris, Spain, London, and Wales, and worked on a variety of ambitious projects. In 1953 he returned to the United States and embarked on the now epic series *The Americans*. Frank's snapshot aesthetic, utilizing blurred form, grainy film, and a tilted perspective, revolutionized and shaped the course of modern photography. After the publication of *The Americans*, however, Frank felt he had exhausted the possibilities for expressing himself with the still photograph and began making films. His work in this medium ranges from the experimental *Pull My Daisy* to *Cocksucker Blues*, the controversial documentary of the Rolling Stones' 1972 US tour, and a series of emotional self-studies – *Conversations in Vermont, Life Dances On*, and *Home Improvements*. His monograph *Moving Out* was published in 1994 by SCALO, in conjunction with a traveling exhibition organized by the National Gallery of Art, Washington, DC, where his archive is now stored.

**William Frederking**

Born in 1955 in Effingham, Illinois, William Frederking received his BA in English from The University of Notre Dame, South Bend, Indiana (1977) and his MFA in photography from The University of Illinois at Chicago (1983). Since 1988 Frederking has been a professor of photography at Columbia College Chicago and is also active as a professional photographer. His photographs have been exhibited at the Chicago Cultural Center; Creative Arts Gallery, Purdue University, West Lafayette, Indiana; the Illinois State Museum, Springfield; and New Works Gallery, The University of Illinois at Chicago. His work has earned awards from the Chicago Dance Coalition (Ruth Page Award for his dance photography) and the Illinois Arts Council, among others, and is included in a variety of public and private collections.

**Lee Friedlander**

Lee Friedlander was born in 1934 in Aberdeen, Washington. He studied photography at the Art Center School in Los Angeles (1953–55) and worked as a freelance photographer. Friedlander has been awarded John Simon Guggenheim Memorial Foundation Fellowships and a National Endowment for the Arts Fellowship. His work has been widely exhibited and is included in the collections of The Baltimore Museum of Art; The Museum of Fine Arts, Boston; the Center for Creative Photography, University of Arizona, Tucson; the Corcoran Gallery of Art, Washington, DC; The Museum of Fine Arts, Houston; The Museum of Modern Art, New York; and the Smithsonian Institution, Washington, DC, among other international collections. Friedlander's photographs are the subject of several monographs, including *Lee Friedlander: Self Portraits* (1998), *The Desert Seen* (1996), *Letters from the People* (1993), *Maria* (1992), *Nudes* (1991), *Like a One-Eyed Cat* (1989), and *The American Monument* (1976). Friedlander additionally is credited with saving the work of New Orleans photographer E. J. Bellocq.

**Arnold Gilbert**

Chicago-based artist and collector Arnold Gilbert studied at the University of Chicago in the 1940s. His work has been exhibited in solo and group exhibitions at the Chicago Gallery, The University of Illinois at Chicago; the John Michael Kohler Art Center, Sheboygan, Wisconsin; Monterey Peninsula Museum of Art, Monterey, California; Nihon University, Tokyo; and Photo Gallery International, Tokyo, among other venues. Gilbert's photographs are also included in the collections of The Museum of Fine Arts, Houston; the Museum of Contemporary Art, Chicago; The Museum of Modern Art, New York; the National Museum of Modern Art, Kyoto; and the Victoria and Albert Museum, London. Gilbert was born in 1921 in New York.

**Frank Gohlke**

Frank Gohlke is the recipient of numerous grants, awards, and honors, including John Simon Guggenheim Memorial Foundation Fellowships in 1975 and 1984, and National Endowment for the Arts Photographer's Fellowships in 1976, 1977, and 1986. Born in 1942 in Texas, Gohlke received his BA in English literature from the University of Texas, Austin; his MA in English literature from Yale University in 1966; and studied with photographer Paul Caponigro in 1967 and 1968. His work is represented in numerous national collections and has been exhibited in solo exhibitions at the Amon Carter Museum of Western Art, Fort Worth, Texas; Light Gallery, New York; The Museum of Modern Art, New York; and the traveling exhibition "Landscapes from the Middle of the World" (catalogue, 1988), organized by The Museum of Contemporary Photography, Columbia College Chicago. Gohlke is the first American photographer to be commissioned by the French government–sponsored landscape survey, La Mission Photographique de la DATAR. His work is also documented in the book *Measure of Emptiness: Grain Elevators in the American Landscape* (1992).

**Judith Golden**

Judith Golden's photographs are imbued with legend, mystery, and metaphor. Born in 1934, she was educated at The School of The Art Institute of Chicago (BFA, 1973) and the University of California, Davis (MFA, 1975). After retiring from teaching at the University of Arizona, Golden continues to live in Tucson. Her photographs are represented in the collections of The Art Institute of Chicago; the Center for Creative Photography, University of Arizona, Tucson; the Los Angeles County Museum of Art; and the Museum of Photographic Arts, San Diego, among others. Golden has received a variety of honors and awards, including an honorary PhD from Moore College of Art, Philadelphia, and has exhibited her work at numerous international venues. A monograph of her work, *Cycles: A Decade of Photographs*, was published in 1988.

**Nan Goldin**

Nan Goldin has spent more than twenty years photographing her surrogate family and friends. In 1996 these startlingly direct color images were the subject of a mid-career retrospective organized by the Whitney Museum of American Art, New York, which traveled to Winterthur, Germany; Vienna; and Amsterdam, among other international venues. Goldin's work is the subject of the books *Nan Goldin: Ten Years After* (1998), *I'll Be Your Mirror* (1996), *Tokyo Love: Spring Fever 1994* (1995), *Double Life* (1994), and *The Ballad of Sexual Dependency* (1986), among others. She has earned the Mother Jones Photography Award, a grant from The National Endowment for the Arts, and the Maine Photographic Workshop Book Award for Documentary Book of the Year. Born in Washington, DC in 1953, Goldin earned her BFA (1977) and 5th Year Masters Certificate from The School of The Museum of Fine Arts, Boston.

**John Gossage**

Born in New York in 1946, John Gossage studied with Lisette Model, Alexey Brodovitch, and Bruce Davidson in the 1960s. In 1973, 1974, and 1978, he received National Endowment for the Arts Photographer's Fellowships. His photographs have been exhibited internationally, and are showcased in the monographs *There and Gone* (1997), *Stadt des Schwarz* (1987), and *The Pond* (1985). Gossage's work is included in the collections of the Bibliothèque Nationale, Paris; the Center for Creative Photography, University of Arizona, Tucson; the Corcoran Gallery of Art, Washington, DC; and The Museum of Modern Art, New York. He has worked for many years in Berlin, and his images have been exhibited widely in Europe and the United States, including at The Art Institute of Chicago; Light Work, Syracuse, New York; Sprengel Museum, Hannover, Germany; the Victoria and Albert Museum, London; and the Werkstatt für Photographie, Berlin.

**Emmet Gowin**

Emmet Gowin's best-known work uses his family, their home, and the surrounding landscape as subject matter; his more recent work involves aerial photographs of nuclear sites and agricultural landscapes. Born in 1941 in Virginia, Gowin earned a BA in graphic design from Richmond Professional Institute (Virginia Commonwealth University) in 1965 and studied photography with Harry Callahan at the Rhode Island School of Design (MFA, 1967). He is the recipient of a John Simon Guggenheim Memorial Foundation Fellowship, two National Endowment for the Arts Fellowships, and a Pew Fellowship in the Arts. In 1990 Gowin's work was presented in a major retrospective organized by The Philadelphia Museum of Art which traveled to The Columbus Museum of Art, Ohio; The Detroit Institute of Arts; The Ansel Adams Center for Photography, San Francisco; the Los Angeles County Museum of Art; The Minneapolis Institute of Arts; and the Museum of Contemporary Art, Chicago.

Photographers' biographies

**Jan Groover**

Jan Groover is skilled at creating complex, abstract spatial arrangements in her still-life, portrait, and landscape photography. Groover received her BFA in 1965 from the Pratt Institute, Brooklyn, and her MA from Ohio State University in 1970. Her work has been the subject of one-person exhibitions at The Baltimore Museum of Art; The Cleveland Museum of Art; the Corcoran Gallery of Art, Washington, DC; the International Museum of Photography, George Eastman House, Rochester, New York; and The Museum of Modern Art, New York. Groover, who was born in New Jersey in 1943, is also the recipient of fellowships from The National Endowment for the Arts and the John Simon Guggenheim Memorial Foundation. Groover's photographs are the subject of several monographs, including *Jan Groover: Photographs* (1993); *Pure Invention: The Tabletop Still Life, Photographs by Jan Groover* (1990); and *Jan Groover Catalogue: Photographs* (1989).

**Peter Bacon Hales**

University scholar and associate professor of art at The University of Illinois at Chicago, Peter Bacon Hales is an accomplished cultural historian and a former Associated Press photographer. Born in Evanston, Illinois in 1950, Hales received a PhD in American civilization from the University of Texas, Austin. His documentary photography reflects his interest in the American cultural landscape and has been exhibited at The Art Institute of Chicago; the Dallas Museum of Art; The Center for Photography at Woodstock, New York; the Chicago Historical Society; and the San Francisco Museum of Modern Art. The author of *Atomic Spaces: Living on the Manhattan Project* (1997), *William Henry Jackson and the Transformation of the American Landscape* (1996), *Constructing the Fair* (1993), and *Silver Cities: The Photography of American Urbanization* (1984), Hales has received numerous fellowships and awards for his work as a writer, photographer, and teacher.

**Alice Hargrave**

Born in 1962, Alice Hargrave received her MFA in photography from The University of Illinois at Chicago in 1994 and a BA from Tulane University, New Orleans. Hargrave, who studied and worked as a professional photographer in Europe, teaches photography and digital imaging at The School of The Art Institute of Chicago and Columbia College Chicago. Her editorial photography has appeared in *ArtNews*, *Fortune*, *Le Figaro*, *Newsweek*, *Time*, and *U.S. News and World Report*, among other major publications. Hargrave's images have appeared in exhibitions at the Hyde Park Art Center, Chicago; the Museum of Contemporary Art, Chicago; Randolph Street Gallery, Chicago; and the Syracuse University Gallery, Florence, Italy.

**Declan Haun**

Declan Haun was born in 1937 in Detroit and attended the University of Detroit, the Lawrence Institute of Technology, and the Art School of the Society of Arts and Crafts, all in Detroit. Haun worked as a freelance photographer for publications such as *Life*, *Newsweek*, *People*, *Sports Illustrated*, *The Saturday Evening Post*, *Time*, and *U.S. News and World Report*. In the 1960s Haun's documentary photographs of the civil rights movement gained national attention. Later in his career, Haun worked on documentary films, designed and curated exhibitions, and served as illustration editor of *National Geographic* and photo editor of *Smithsonian*. Haun, who died in 1994, was an award-winning member of the National Press Photographers Association. His photographs are represented in the collections of The Art Institute of Chicago and The Museum of Modern Art, New York, among others.

**Robert Heinecken**

Robert Heinecken's photographs have been exhibited in over sixty one-person shows since 1964, at such venues as the Center for Creative Photography, University of Arizona, Tucson; the International Museum of Photography, George Eastman House, Rochester, New York; and the San Francisco Museum of Modern Art. His work appears in the monograph *Heinecken* (1980) and a major retrospective is scheduled for fall 1999 at the Museum of Contemporary Art, Chicago. The recipient of three National Endowment for the Arts Individual Artist grants, Heinecken has also been honored for his work as an educator, writer, and curator. Born in Denver in 1931, Heinecken was a fighter pilot in the US Marine Corps from 1953 to 1957 and studied at UCLA (BA, 1959; MA, 1960). He developed the provocatively experimental photography program at UCLA where he taught for thirty years (1961–91). He now lives and works in Chicago.

**George Hurrell**

George Hurrell was born in Covington, Kentucky in 1904. He studied at The School of the Art Institute of Chicago in the early 1920s, moving on to California where he was commissioned to photograph artists working in Laguna Beach. Hurrell soon discovered that he could make a living taking portraits, and by the 1930s he was photographing Hollywood's major movie stars. His photographs, showcased at museums throughout the world and in numerous publications, are also represented in the collections of the J. Paul Getty Museum, Los Angeles; the International Center for Photography, New York; the National Museum of American Art, Smithsonian Institution, Washington, DC; the San Francisco Museum of Modern Art; and the Victoria and Albert Museum, London, among many others. Hurrell died in 1992.

**Yasuhiro Ishimoto**

Born in San Francisco to Japanese parents in 1921, Yasuhiro Ishimoto grew up in Kochi City, Japan, and returned to the United States in 1939. He studied agriculture at the University of California, only to be interned at the relocation camp in Armach, Colorado (1942–44). After World War II, Ishimoto moved to Chicago to study architecture at Northwestern University, then transferred to the Institute of Design to study photography under Harry Callahan and Aaron Siskind. His work was exhibited in "The Family of Man" show at The Museum of Modern Art in 1955, and in numerous one-person international exhibitions. Several books containing his imagery have been published: *Hana* (1989), *Chicago, Chicago* (1983), *Katsura: Tradition and Creation in Japanese Architecture* (1972), *Chicago, Chicago* (1969), and *Someday, Somewhere* (1960). Ishimoto became a Japanese citizen in 1969; he lives and works in Japan.

**Alfredo Jaar**

Born in 1956, Chilean artist Alfredo Jaar currently lives in New York. Among his site-specific, politically charged installations are *Let There Be Light* (1997); *Real Pictures* (1995), a memorial to the people of Rwanda commissioned by The Museum of Contemporary Photography, Columbia College Chicago; *Fading* (1991), which examined the situation of Vietnamese refugees detained in Hong Kong; *Geography = War* (1990); and *A Logo for America* (1987), which appeared on the spectacolor sign in New York's Times Square. Jaar's work has been exhibited worldwide, in Kassel's "Documenta" and the Venice Biennale, and numerous institutional venues, including The Hirshhorn Museum and Sculpture Garden, Washington, DC; the Museum of Contemporary Art, Chicago; and the San Diego Museum of Contemporary Art. His publications include *Alfredo Jaar Is It Difficult?* (1998), *Let There Be Light: The Rwanda Project* (1998), and *Europa* (1995), among others.

**Joseph D. Jachna**

Joseph D. Jachna was born in 1935 in Chicago. He attended the Institute of Design on a newspaper carrier's scholarship, but left after one year to work at Eastman Kodak processing in Chicago. He returned to the Institute of Design in 1955, earning a BS degree in art education in 1958 and an MS in photography in 1961. He studied with both Harry Callahan and Aaron Siskind, and taught alongside Siskind at the institute from 1961 until 1969. In 1969 Jachna joined the faculty at The University of Illinois at Chicago, where he still teaches. His work has been widely exhibited and collected, and he is the recipient of numerous awards, including a John Simon Guggenheim Memorial Foundation Fellowship and a National Endowment for the Arts Photographer's Fellowship. Monographs of Jachna's work include *Joseph Jachna: the line where the grass overlaps the sidewalk* (1996) and *Light Touching Silver* (1980).

**Derek Johnston**

Derek Johnston was born in Lewiston, New York in 1969. He received his BFA in photography from the Rochester Institute of Technology, Rochester, New York, and has been active in the field of photography in a number of different roles. Johnston has been a curator for The Center for Photography at Woodstock, New York and the Catskill Gallery, Catskill, New York; his writing on landscape art has been published in *Photography Quarterly*; and he has worked as an arts administrator and photography instructor. His photographs of the natural environment have been exhibited at The Carnegie Museum of Natural History, Pittsburgh; Lubbock Fine Arts Center, Texas; Moore College of Art, Philadelphia; and San Francisco Camerawork, among others.

## Photographers' biographies

**Kenneth Josephson**

Kenneth Josephson was born in 1932 in Detroit. In 1951 he enrolled at the Rochester Institute of Technology, New York, where he received technical training in photography and an Associate in Applied Science degree (1953). Drafted after graduation, he served in Germany in a US Army photolab. In 1955 Josephson returned to RIT, studying under Minor White and Beaumont Newhall; he received a BFA degree in 1957. At Minor White's urging, Josephson went to the Institute of Design, Chicago, to work with Harry Callahan. After graduation in 1960, he was appointed the first full-time instructor in photography at The School of The Art Institute of Chicago. The program grew under his leadership and became a department in 1968. The Art Institute of Chicago will present a major retrospective of his work in 1999. Josephson lives and teaches in Chicago.

**Barbara Kasten**

Barbara Kasten was born in 1936 in Chicago. She received her BFA in painting and sculpture from the University of Arizona in Tucson and her MFA from the California College of Arts and Crafts in Oakland. Kasten is known for her transformations of architectural sites into abstract still lifes through careful arrangements of mirrors, glass, geometric forms, and colored gels. Kasten is the recipient of many prestigious awards, and her work has been widely exhibited by major museums in the United States, Europe, and Japan. Her photographs are in the collections of The Art Institute of Chicago; the International Center of Photography, New York; The Metropolitan Museum of Art, New York; The Museum of Modern Art, New York; The Museum of Modern Art, Lodz, Poland; and the Victoria and Albert Museum, London, among others. Kasten is a professor of photography at Columbia College Chicago.

**Angela Kelly**

An associate professor at the Rochester Institute of Technology, New York, Angela Kelly is also active as a curator in the field of art. Her work has been seen in a variety of international exhibitions, including at The Art Institute of Chicago; the Chicago Cultural Center; The Kansas City Art Institute; the Museum of Contemporary Art, Chicago; and the Santa Fe Center for Photography, New Mexico. Kelly's photographs are highlighted in numerous articles and in the books *A History of Women in Photography* (1994) and *Approaching Photography* (1982). Born in 1950 in Belfast, Ireland, Kelly holds her MA in photography from Columbia College Chicago (1989); she earned a Fellow of the Institute of Incorporated Photographers and Diploma in Creative Photography from Trent Polytechnic University, School of Fine Arts, Nottingham, England (1975).

**Mark Klett**

Mark Klett was born in 1952 and holds a BS in geology from St. Lawrence University, Canton, New York (1974), and an MFA in photography from the State University of New York at Buffalo, Program at the Visual Studies Workshop, Rochester, New York (1977). His documentary photographs reveal the diversity of the land of the Southwestern United States. His work has been shown in one-person exhibitions at the Addison Gallery of American Art, Phillips Academy, Andover, Massachusetts; the Los Angeles County Museum of Art; the National Museum of American Art, Smithsonian Institution, Washington, DC; and the Phoenix Art Museum. His books include *Revealing Territories: Photographs of the Southwest by Mark Klett* (1992) and *One City/Two Visions: Eadweard Muybridge & Mark Klett: San Francisco Panoramas, 1878 and 1990* (1990), among others. Klett lives in Arizona, where he teaches photography at Arizona State University, Tempe.

**Barbara Kruger**

Born 1945 in Newark, New Jersey, Barbara Kruger studied at Syracuse University and with Diane Arbus and Marvin Israel at the Parsons School of Design, New York. Kruger worked in New York as a graphic designer before turning to the art world in 1969. Her large, bold artworks assimilate information from the mass media in a critique of gender roles. Kruger has created photographs, billboards, posters, book covers, and illustrations that have been widely exhibited and collected. She has served as editor, curator, and teacher, and is an accomplished writer as well. Books featuring Kruger's imagery, text, or editorial direction include *Love for Sale: The Words and Pictures of Barbara Kruger* (1996); *Remote Control: Power, Cultures, and the World of Appearances* (1993); *Beyond Recognition: Representation, Power, and Culture* (1992); and *Barbara Kruger: 5 January to 26 January 1991* (1991).

**Dorothea Lange**

Dorothea Lange, who was born in Hoboken, New Jersey in 1895, is best known for her portrayals of rural farm families photographed during the Depression for the Farm Security Administration. She contributed photographs to other government agencies as well, including the War Relocation Authority and the Office of War Information. Monographs of Lange's work include *The Photographs of Dorothea Lange* (1996), *Dorothea Lange: American Photographs* (1994), and *Dorothea Lange: Photographs of a Lifetime* (1982). Her photographs are held in a variety of notable collections, including The Metropolitan Museum of Art, New York; The National Archives, Washington, DC; The New York Public Library; The Oakland Museum of California; and the San Francisco Museum of Modern Art. A substantial collection of over 400 of Lange's photographs and work prints is held in the permanent collection of The Museum of Contemporary Photography, Columbia College Chicago. Dorothea Lange died in 1965.

**Annie Leibovitz**

Annie Leibovitz's career began in 1970 when, as a student at the San Francisco Art Institute (BFA, 1971), she began working as a freelance photographer for *Rolling Stone*. By 1973 she was the magazine's chief photographer, a position Leibovitz held for ten years. She has since designed distinctive advertising campaigns for American Express and The GAP, Inc., among numerous clients; and shot portraits for such varied organizations as the American Ballet Theater and the San Francisco AIDS Foundation. Today she serves as principal photographer for *Vanity Fair*. In 1991 the International Center of Photography in New York and the National Portrait Gallery at the Smithsonian Institution, Washington, DC organized the first museum exhibition of Leibovitz's work, which traveled through 1993. Her photographs are featured in the monographs *Olympic Portraits* (1996), *Dancers (Photographers at Work)* (1992), and *Photographs: Annie Leibovitz 1970–1990* (1992), and the videotape *Leibovitz: Celebrity Photographer* (1988). Leibovitz was born in Waterbury, Connecticut in 1949 and currently lives in New York.

**Nathan Lerner**

Nathan Lerner was born in 1913 in Chicago. He studied at the National Academy of Art and The School of The Art Institute of Chicago before becoming one of the thirty-three initial students at László Moholy-Nagy's New Bauhaus in 1937 and among the five BS graduates of its successor, the School of Design, in 1941. After graduation he became head of the school's photography program, and eventually became the head of production design at the Institute of Design (formerly School of Design). When Moholy-Nagy died, Lerner became acting educational director for the school (1946–47). He left the Institute of Design in 1949 to found Lerner Design Associates. He was later named professor of art at The University of Illinois at Chicago (1967–72). Numerous gallery and museum shows have showcased Lerner's work. *Nathan Lerner: Fifty Years of Photographic Inquiry* was produced by The Museum of Contemporary Photography, Columbia College Chicago, with the Chicago Cultural Center in 1994. Lerner died in Chicago in 1997.

**O. Winston Link**

An American photographer internationally renowned for his images of railroad life, O. Winston Link was born in Brooklyn in 1914. Trained as a civil engineer at Brooklyn's Polytechnic Institute, Link developed a pioneering, synchronized flash system that enabled him to capture dramatic high contrast scenes of railroads at night. His historically significant body of work documents the last steam-powered railroad in America and is featured in the monographs *The Last Steam Railroad in America: From Tidewater to Whitetop* (1995); *Steam, Steel & Stars* (1987); and *Ghost Trains: Railroad Photographs of the 1950s* (1983). A major exhibition of Link's work, organized by the Sheldon Memorial Art Gallery and Sculpture Garden, University of Nebraska, Lincoln, will travel to numerous US venues through 2000.

**Danny Lyon**

Born in 1942 in Brooklyn, Danny Lyon received a BA from the University of Chicago in 1973. As a photographer and filmmaker, Lyon has shown insight into the worlds of those who live outside the mainstream of society. He documented the civil rights movement in the 1960s as a freelance photographer; in 1967 he was given unrestricted permission to photograph the lives of convicts in Texas prisons, resulting in the portfolio *Conversations with the Dead* (1971). Lyon's other projects are featured in the monographs *I Like to Eat Right on the Dirt: A Child's Journey Back in Space and Time* (1989), *Merci Gonaves: A Photographer's Account of Haiti and the February Revolution* (1988), *The Paper Negative* (1980), *The Destruction of Lower Manhattan* (1969), and *The Bikeriders* (1968). His films include *Little Boy* (1977), *Los Niños Abandonados* (1975), and *Social Sciences 127* (1969). Lyon's work has been frequently exhibited and collected; he is the recipient of a John Simon Guggenheim Memorial Foundation Fellowship and of National Endowment for the Arts grants in both film and photography.

**Sally Mann**

Sally Mann was born in 1951 in Virginia, where she currently lives and photographs. Best known for her photographic documents of many aspects of childhood and adolescence, Mann pays particular attention to how role-playing becomes a mirror for adult behavior and sexuality. Her work has been honored with numerous grants and awards, and is featured in the publications *Sally Mann: Motherland* (1997), *Sally Mann: Still Time* (1994), *Immediate Family* (1992), and *At Twelve, Portraits of Young Women* (1988). Mann's photographs have also been the subject of numerous solo and group exhibitions throughout the world, including "Hospice: A Photographic Inquiry," the Corcoran Gallery of Art, Washington, DC (1996); "Picturing the South," The High Museum of Art, Atlanta (1996); "The Whitney Biennial," the Whitney Museum of American Art, New York (1991); and "Pleasures and Terrors of Domestic Comfort," The Museum of Modern Art, New York (1991).

**MANUAL**

**Suzanne Bloom and Ed Hill**

Known collectively as MANUAL, Suzanne Bloom (born 1943, Pennsylvania) and Ed Hill (born 1935, Massachusetts) have worked collaboratively since 1974. They have incorporated various media in their works, from drawing and painting to photography, video, computer imaging, and sound systems. Pioneers in the realm of digital art photography, MANUAL has had solo exhibitions at the Contemporary Arts Museum, Houston; The Museum of Contemporary Photography, Columbia College Chicago; The Museum of Fine Arts, Houston; Northlight Gallery, Arizona State University, Tempe; and at the Visual Studies Workshop, Rochester, New York. Hill and Bloom have co-authored numerous articles and have received several shared and individual grants. They live in Houston, where they are professors of art at the University of Houston.

**Stephen Marc**

Stephen Marc is an accomplished documentary photographer who has recently turned to an exploration of digital montage. His work is featured in two monographs, *The Black Trans-Atlantic Experience* (1992) and *Urban Notions* (1983), and is included in the collections of the Bibliothèque Nationale, Paris; the California Museum of Photography, Riverside; The Field Museum of Natural History, Chicago; The Museum of Fine Arts, Houston; and the National Museum of American Art, Washington, DC. Marc was born in Rantoul, Illinois in 1954 and attended Pomona College, Claremont, California (BA, 1976) and Tyler School of Art, Temple University, Philadelphia (MFA, 1978). After teaching photography for twenty years at Columbia College Chicago, Marc moved in 1998 to Arizona to teach at Arizona State University, Tempe.

**Mary Ellen Mark**

Born in 1946, Mary Ellen Mark attended the University of Pennsylvania, receiving her BFA in painting and art history (1962) and an MA in photojournalism (1964). She is the recipient of many awards for her photojournalism as well as for her artwork, including the Erna and Victor Hasselblad Foundation Grant, two National Endowment for the Arts Photographer's Fellowships, the Professional Photographer of the Year Award (1994), and a John Simon Guggenheim Memorial Foundation Fellowship. Widely exhibited and collected, Mark's photographs are featured in several publications, including *Portraits* (1997), *A Cry For Help: Stories of Homelessness and Hope* (1996), *Mary Ellen Mark: Indian Circus* (1993), *Mary Ellen Mark: 25 Years* (1991), and *Falkland Road: Prostitutes of Bombay* (1981).

**María Martínez-Cañas**

María Martínez-Cañas weaves totemic designs and organic forms into powerful graphic patterns; her multilayered works are webs of cultural metaphor. Martínez-Cañas received her BFA from the Philadelphia College of Art (1982) and her MFA in photography from The School of The Art Institute of Chicago (1984). She was the recipient of a Fulbright-Hays Grant in 1986, and of a National Endowment for the Arts Photographer's Fellowship in 1989. Her work has been exhibited throughout the world and is included in prominent public collections, including the Bibliothèque Nationale, Paris; the Center for Creative Photography, University of Arizona, Tucson; the Los Angeles County Museum of Art; and The Museum of Modern Art, New York. Born in Havana in 1960, Martinez-Cañas currently resides in Miami.

**John McCallum**

John McCallum was born in Royal Oak, Michigan in 1959. The son of an advertising art director and an English teacher, McCallum began to study photography at the age of fourteen. After further study of photography at Arizona State University, Southern Illinois University, and The Art Center College of Design in Pasadena, California, McCallum assisted various advertising photographers in Los Angeles and Chicago before settling in Chicago. Specializing in product and food photography, he has earned awards from the magazines *Communication Arts*, *Graphis*, and *Print*, as well as two first-place Mobius statuettes. His advertising work is most often seen in consumer print magazines for clients such as Philip Morris, Coors Brewing, Discover, and the New York Stock Exchange, among many others.

**Susan Meiselas**

Born in 1948 in Baltimore, Susan Meiselas grew up on Long Island and attended Sarah Lawrence College (BA, 1970) and Harvard University School of Education (EdM, 1971). Her social documentary photography has been featured in the publications *Kurdistan: In the Shadow of History* (1997), *Nicaragua* (1981), and *Carnival Strippers* (1976). A member of Magnum Photos, Meiselas has received many grants and awards, including the Hasselblad Foundation Prize, the Robert Capa Gold Medal for Outstanding Reportage, and fellowships from The John D. and Catherine T. MacArthur Foundation and The National Endowment for the Arts. Her photographs have been exhibited at The Art Institute of Chicago; Camerawork, London; Centre Georges Pompidou, Paris; the International Museum of Photography, George Eastman House, Rochester, New York; and the Museum of Photographic Arts, San Diego, among other venues.

**Ray K. Metzker**

Ray K. Metzker has dedicated his career to exploring the formal potentials of black-and-white photography. Born in Milwaukee in 1931, Metzker began to photograph at age fourteen, studied art at Beloit College, Wisconsin (BA, 1953), and studied photography with Harry Callahan at the Institute of Design, Illinois Institute of Technology, Chicago (MS, 1959). Metzker's photographs have been shown in many one-person exhibitions at such venues as The Art Institute of Chicago; The Cleveland Museum of Art; The High Museum of Art, Atlanta; The Museum of Fine Arts, Houston; and The Museum of Modern Art, New York. His work is the subject of the monographs *Earthly Delights* (1988), *Unknown Territory: Photographs by Ray K. Metzker* (1984), and *Sand Creatures* (1979). Metzker lives in Philadelphia and Moab, Utah.

**Joel Meyerowitz**

Born in New York in 1938, Joel Meyerowitz studied painting and medical illustration from 1956 to 1959 at Ohio State University, Columbus, where he received his BFA. Working in advertising and design in New York, Meyerowitz became a photographer after completing an advertising assignment with Robert Frank. A pioneer of color street photography, Meyerowitz began in the 1970s to create color landscapes that reveal the intricacies of changing light. His work has been exhibited at the Corcoran Gallery of Art, Washington, DC; the International Center of Photography, New York; the International Museum of Photography, George Eastman House, Rochester, New York; The Museum of Fine Arts, Boston; and The Museum of Modern Art, New York. Meyerowitz's publications include *At the Water's Edge* (1996), *Bystander: A History of Street Photography* (with Colin Westerbeck, 1994), *Bay/Sky* (1993), *Wildflowers* (1983), and *Cape Light* (1978), among others.

**Duane Michals**

Duane Michals was born in 1932 in Pennsylvania. He received a BA degree from the University of Denver in 1953, and since 1958 has worked as a freelance photographer. Michals has worked extensively as a commercial photographer; as an artist he is perhaps best known for his sequenced black-and-white images. His photographs are presented in numerous books, including *The Essential Duane Michals* (1997), *Now Becoming Then* (1990), *Portraits* (1988), *The Nature of Desire* (1986), and *Duane Michals Photographs/Sequences/Texts 1958–1984* (1984), among others. Michals's work is included in numerous international collections; exhibition venues include The Museum of Fine Arts, Boston; Centre Georges Pompidou, Paris; the Los Angeles County Museum of Art; The Museum of Modern Art, New York; White Columns, New York; and the Whitney Museum of American Art, New York.

**Roger Minick**

In 1969 Roger Minick earned a BA in history from the University of California, Berkeley, where he also apprenticed in photography; he earned his MFA from the University of California, Davis (1986). Minick, whose award-winning documentary work emphasizes people and their environment, was a photographer for the Mexican American Legal Defense and Educational Fund in the late 1970s. His work has been frequently exhibited, and published in the monographs *The Oakland Paramount* (1981), *Hills of Home: The Rural Ozarks of Arkansas* (1975 and 1976); and *Delta West: The Land and People of the Sacramento – San Joaquin River Delta* (1969). Born in Oklahoma in 1944, Minick grew up in the Arkansas Ozarks and today lives in California.

**Richard Misrach**

Richard Misrach has worked in the deserts of the American Southwest for the past two decades, compiling a sequence of monumental photographic studies that scan the ebb and flow of human intervention in this once unsoiled landscape. Born in 1949, Misrach received his BA in psychology from the University of California, Berkeley. Misrach's work is represented in over fifty institutional collections, including that of The Metropolitan Museum of Art, New York; The Museum of Modern Art, New York; and the Musée National d'Art Moderne, Paris. His photographs have also been exhibited worldwide, including his first major retrospective, a touring exhibition organized in 1997 by The Museum of Fine Arts, Houston. Monographs of Misrach's work include *Crimes and Splendors: The Desert Cantos of Richard Misrach* (1996), *Violent Legacies: Three Cantos* (1992), *Bravo 20: The Bombing of the American West* (with Myriam Weisang Misrach, 1990), and *Desert Cantos* (1987).

**Abelardo Morell**

Photographic explorations by Abelardo Morell have transformed ordinary rooms into cameras obscura, offered dramatic close-up views of books, and shown water from puzzling perspectives. His diverse photographs have been showcased in many one-person and group exhibitions at such venues as The Art Institute of Chicago; The Museum of Fine Arts, Boston; The Brooklyn Museum, New York; the International Museum of Photography, George Eastman House, Rochester, New York; The Metropolitan Museum of Art, New York; the Museum of Photographic Arts, San Diego, California; the San Francisco Museum of Modern Art; and the Smithsonian Institution International Gallery, Washington, DC. Born in 1948 in Cuba, Morell teaches at the Massachusetts College of Art, Boston. His book of camera obscura photographs, *A Camera in a Room*, was published in 1995.

**Barbara Morgan**

Barbara Morgan is known for her photographs of dancers; for several years she photographed Martha Graham and her company in New York. Influenced by László Moholy-Nagy, Morgan also worked with techniques of photomontage and modes of abstraction, producing several well-known photomontages of New York as well as more politically oriented compositions. Her extensive body of work has been the subject of numerous publications, including *Barbara Morgan* (1998); *Barbara Morgan: Prints, Drawings, Watercolors & Photographs* (1988); and *Barbara Morgan: Monograph* (1972). She exhibited widely, including one-person shows at the Institute of American Indian Art, Santa Fe; the International Museum of Photography, George Eastman House, Rochester, New York; and The Museum of Modern Art, New York, among others. Born in 1900 in Buffalo, Kansas, Morgan studied art at the University of California, Los Angeles (1919–23). Barbara Morgan died in 1992.

**Patrick Nagatani**

Born in Chicago in 1945, Patrick Nagatani has made his home in New Mexico and turned his attention to this region's atomic history in the series *Nuclear Enchantment*. His work has recently been presented in one-person exhibitions at The Albuquerque Museum; the California Museum of Photography, University of California, Riverside; CEPA Gallery, Buffalo, New York; Isla Center for the Arts at the University of Guam, Mangilao; and at the Royal Photographic Society, Bath, England, among other venues. Nagatani has received numerous honors and awards for his work. His monographs include *Nuclear Enchantment* (1991) and *Patrick Nagatani/Andree Tracey: Polaroid 20 x 24 photographs: 1983–1986* (1987).

**Joyce Neimanas**

For many years Joyce Neimanas has experimented without a camera. Her computer-generated images use advertisements, art reproductions, and comic books to create humorous collages that explore contemporary gender roles. Born in 1944, Neimanas received her BAE and MFA degrees in 1966 and 1969 respectively from The School of The Art Institute of Chicago, where she is currently a professor. Neimanas is represented in many major collections and has received numerous awards, including a National Endowment of the Arts Visual Artists Fellowship and an Illinois Arts Council Artist Fellowship. Since 1966 her work has been exhibited in many solo and group exhibitions worldwide, including at the Center for Creative Photography, University of Arizona, Tucson; The Center for Photography at Woodstock, New York; the Contemporary Arts Center, New Orleans; and Presentation House, Vancouver. *Joyce Neimanas* (1984) was published in conjunction with an exhibition at the Center of Creative Photography, University of Arizona, Tucson.

## Photographers' biographies

**Beaumont Newhall**

Beaumont Newhall was born in Lynn, Massachusetts in 1908 and studied art history at Harvard University. One of the most prominent historians of photography as well as an artist in his own right, Newhall made significant contributions to the field. The founding director of the photography department at The Museum of Modern Art, New York, he also served as the curator and director of the International Museum of Photography at George Eastman House, Rochester, New York during the formative years of that institution. The author of a great many books, exhibition catalogues, and articles on photography, Newhall also published several editions of the classic text *The History of Photography*. Newhall was honored by institutions such as The American Academy of Arts and Sciences, The Royal Photographic Society, and The Guggenheim Foundation. He died in 1993.

**Richard Nickel**

Richard Nickel was born in 1928 on Chicago's West Side, where he grew up. He became interested in photography during his service in the Army, when he photographed bridges and other structures in Korea so there would be a record if they were destroyed. Nickel later studied at the Institute of Design, Chicago, and concentrated on photographing Chicago's landmark buildings as a way to preserve them, especially those of Adler and Sullivan, at a time when Chicago was trying to renew itself through development. He died while salvaging material from Louis Sullivan's Stock Exchange Building in 1972 when the partially demolished structure collapsed. His life and photographs are recorded in the volume *They All Fall Down* (1994).

**Nicholas Nixon**

Nicholas Nixon was born in 1947 in Detroit. He studied American literature at the University of Michigan, Ann Arbor, and photography at the University of New Mexico, Albuquerque. Nixon has worked as an independent photographer since 1974; he is the recipient of two John Simon Guggenheim Memorial Foundation Fellowships, three National Endowment for the Arts Photographer's Fellowships, and a Massachusetts Council for the Arts "New Works" Grant. His photographs have been exhibited at many international museums and galleries, including The Art Institute of Chicago; The Cleveland Museum of Art; the Corcoran Gallery of Art, Washington, DC; and The Museum of Modern Art, New York. His work is also featured in several monographs, including *People with AIDS* (1991), *Family Pictures* (1991), *Nicholas Nixon: Pictures of People* (1988), and *Nicholas Nixon: Photographs from One Year* (1983). Nixon teaches photography at The Massachusetts College of Art, Boston.

**Anne Noggle**

Born in Evanston, Illinois, in 1922, Anne Noggle served as a Woman Airforce Service Pilot (1943–44) and as a captain in the US Air Force (1953–59) before studying art and art history at the University of New Mexico, Albuquerque. Since 1970 she has been an adjunct professor of art at the University of New Mexico, and has worked as well as a curator of photography. Her photographs are showcased in the books *A Dance with Death: Soviet Airwomen of WWII* (1994), *For God, Country and the Thrill of It: Women Airforce Service Pilots in WWII* (1990), and *Silver Lining: Photographs by Anne Noggle* (1983). Noggle has received numerous awards for her photographic work, including several National Endowment for the Arts grants in photography, and a John Simon Guggenheim Memorial Foundation Fellowship.

**Barbara Norfleet**

Born in 1926, Barbara Norfleet served from 1981 to 1996 as a senior lecturer in visual and environmental studies at the Carpenter Center for the Visual Arts at Harvard University, where she is still curator of photography. She received her BA from Swarthmore College, and her MA and PhD in social relations from Harvard University and Radcliffe College. Her publications include *Archives and Archetypes: Photographs by Barbara Norfleet* (1997), *Looking at Death* (1993), *Manscape with Beasts* (1990), *All the Right People* (1986), *Wedding* (1979), and *The Champion Pig* (1979). Her works have been widely shown in the United States and Europe, with exhibitions at the Corcoran Gallery of Art, Washington, DC; the Institute of Contemporary Art, Boston; the International Center of Photography, New York; The Museum of Fine Arts, Boston; and The Museum of Modern Art, New York.

**Irving Penn**

Irving Penn's images have defined an entire generation of fashion and portrait photography. Penn, who was born in 1917 in New Jersey, studied at The Philadelphia Museum School of Industrial Art in the 1930s, worked in New York as a graphic artist, and spent a year painting in Mexico before starting work at *Vogue* magazine. Since his photographs first began to appear regularly in *Vogue* in the 1940s, his work has been characterized by technical excellence and a demanding standard of style, whether his subject is fashion, ethnographic studies, or still life. His photographs have been widely exhibited, included in major retrospective exhibitions, and are in the collections of The Art Institute of Chicago; The Metropolitan Museum of Art, New York; The Museum of Modern Art, New York; and the Moderna Museet, Stockholm, among many other museums. Penn's work has also been published in numerous books, including *Irving Penn: A Career in Photography* (1997); *Passage* (1991), which was awarded the Prix Nadar; *Issey Miyake* (1988); *Flowers* (1980); and *Worlds in a Small Room* (1974).

**Gilles Peress**

Born in 1946 in Neuilly, France, Gilles Peress studied at the Institut d'Etudes Politiques, and the Université de Vincennes before joining Magnum Photos in 1972. Soon after becoming part of Magnum, Peress traveled to Northern Ireland to begin an ongoing project about the Irish political scene and struggles with England. With this project and his other work, Peress documents revolution, intolerance, and nationalism in various parts of the world. His photographs have been presented in the monographs *The Silence* (1995), *Farewell to Bosnia* (1994), and *Telex: Iran: In the Name of Revolution* (1988). Peress's work has been presented at The Alternative Museum, New York; The Art Institute of Chicago; Burden Gallery, Aperture Foundation, New York; the Corcoran Gallery of Art, Washington, DC; the International Museum of Photography, George Eastman House, Rochester, New York; The Museum of Modern Art, New York; the Museum of Photographic Arts, San Diego, and numerous international venues.

**David Plowden**

David Plowden, already holding a BA in economics from Yale University (1955), entered into private study with Minor White in Rochester, New York, in 1959–60. Plowden's experience in the field of photography is extensive and varied; he worked as O. Winston Link's assistant, taught for many years, and since 1962 has been self-employed as a photographer and writer. Plowden has been awarded many grants, fellowships, and commissions. One-person exhibition venues include The Albright-Knox Art Gallery, Buffalo; The Bayly Museum, University of Virginia, Charlottesville; Beinecke Rare Book and Manuscript Library, Yale University, New Haven, Connecticut; the California Museum of Photography, University of California, Riverside; the Chicago Historical Society; and The Cleveland Children's Museum. Plowden has published twenty books over a forty-year period, including, most recently, *Imprints: The Photographs of David Plowden* (1997). Born in Massachusetts in 1932, Plowden lives today in Winnetka, Illinois.

**Eliot Porter**

In 1979 the work of Eliot Porter was exhibited in "Intimate Landscapes," the first one-person show of color photography at The Metropolitan Museum of Art, New York. This exhibition earned Porter praise as the individual who brought credibility to color photography as a medium of fine art. Porter developed new technical methods of photographing animals, birds, and insects. He was a scientist as well as an artist: he graduated from Harvard's School of Engineering in 1924, and from Harvard Medical School in 1929. His work has been published in *A Passion for Birds: Eliot Porter's Photography* (1997), *Eliot Porter* (1991), *Intimate Landscapes* (1979), *Birds of North America – A Personal Selection* (1972), and *In Wilderness Is the Preservation of the World* (1962). Born in 1901 in Winnetka, Illinois, Porter died in 1990.

**Douglas Prince**

Born in Des Moines, Iowa in 1943, Douglas Prince attended the University of Iowa, where he received his BA in fine arts in 1965 and MA in photography in 1968. His work has been included in many group exhibitions and has been the subject of several one-person shows at such venues as the Addison Gallery of American Art, Phillips Academy, Andover, Massachusetts, and The Print Club, Philadelphia. Prince, whose work is represented in such collections as The Museum of Modern Art, New York and The Art Institute of Chicago, is the recipient of a Light Work grant, two National Endowment for the Arts Photography Fellowships, and a New York Foundation for the Arts Artist's Fellowship.

**Susan Rankaitis**

Susan Rankaitis's work combines painting techniques with photographic processes. Rankaitis, born in 1949 in Cambridge, Massachusetts, earned her BFA (1971) in painting from the University of Illinois, Champaign, and her MFA (1977) in painting and photography from the University of Southern California, Los Angeles. She has had one-person exhibitions at the Center for Creative Photography, University of Arizona, Tucson; the International Museum of Photography, George Eastman House, Rochester, New York; Light Gallery, New York and Los Angeles; the Los Angeles County Museum of Art; and The Museum of Contemporary Photography, Columbia College Chicago, as well as numerous group exhibitions. Her work is in the collections of the Santa Barbara Museum of Art; the Minneapolis Institute of the Arts; The Museum of Fine Arts, Santa Fe; the Museum of Contemporary Art, Los Angeles; and the San Francisco Museum of Modern Art, among many others. Rankaitis holds the Fletcher Jones Chair in Art at Scripps College, Claremont, California.

**Photographers' biographies**

**Eugene Richards**

A member of Magnum Photos, Eugene Richards is known for his socially aware documentary photographs. A former VISTA volunteer and civil rights activist in the 1960s, Richards earned a BA in English from Northeastern University and did graduate work at the Massachusetts Institute of Technology under the direction of Minor White. His highly personal and often frighteningly compelling imagery has been frequently exhibited and published. His books include *The Knife and Gun Club: Scenes from an Emergency Room* (1995), *Americans We* (1994), *Cocaine True, Cocaine Blue* (1994), *Below the Line: Living Poor in America* (1987), *Exploding into Life* (1986), and *Few Comforts or Surprises: The Arkansas Delta* (1973). Born in 1944 in Boston, Richards lives in New York.

**Art Shay**

Born in 1922, Art Shay grew up in the Bronx and has lived and worked around Chicago since 1948. A former *Time-Life* staff reporter, Shay became a full-time photojournalist in the 1950s. Thousands of his photographs have since appeared in a wide variety of publications, including *Forbes*, *Fortune*, *Life*, *The New York Times*, and *Sports Illustrated*. Also an accomplished writer, Shay has authored several children's books and a variety of sports instructional manuals. His work has been widely exhibited and collected. Shay also has authored several photography books, including *Nelson Algren's Chicago* (1988). He was awarded *Life*'s Picture of the Year in 1959 for his well-known photograph of Nikita Krushchov on an Iowa farm.

**Fazal Sheikh**

Born in 1965 in New York, Fazal Sheikh photographs residents of Africa's refugee communities, working extensively in Ethiopia, Sudan, and Somalia. Sheikh considers his portraits collaborations between himself and his subjects, who are portrayed in the photographs with great dignity and respect. His work has been supported by many grants and awards, including a National Endowment for the Arts Photography Fellowship and a Fullbright Fellowship in the Arts. His first book, *A Sense of Common Ground,* was published in 1996 in conjunction with an exhibition organized by the International Center of Photography, New York. His photographs have been featured in numerous group and one-person exhibitions, and are included in the collections of the International Museum of Photography, George Eastman House, Rochester, New York; The Metropolitan Museum of Art, New York; the National Museum of Health and Medicine, Washington, DC; and the Schomburg Center for Research in Black Culture, New York.

**Arthur Siegel**

Arthur Siegel was born in 1913 in Detroit. He studied at the University of Michigan and Wayne State University, Detroit (BA, 1936), then taught photography at Wayne State. In 1937 he was awarded a scholarship at The New Bauhaus (later renamed the Institute of Design, Illinois Institute of Technology) to study photography with László Moholy-Nagy and Gyorgy Kepes. Returning to Detroit in 1938, Siegel worked as a freelance photographer for such important publications as *Life*, *Fortune*, and *Colliers*, and also worked for the Farm Security Administration, the Office of War Information, and the US Army Air Corps. In 1945 Moholy-Nagy hired Siegel to head the newly formed photography department at the Institute of Design, and to develop the pioneering course "New Visions in Photography." In 1965 Siegel published the book *Chicago's Famous Houses*. He died in Chicago in 1978.

**Aaron Siskind**

Aaron Siskind was born in 1903 in New York. He received a literature degree from City College of New York (1926), and was a self-taught photographer. He was a member of and teacher at the New York Photo League and a New York public school teacher for twenty years. Siskind taught photography at Black Mountain College in North Carolina with Harry Callahan and Arthur Siegel in 1951, and that same year went to the Institute of Design (ID) in Chicago as a professor of photography and later a department head. Following mandatory retirement at ID, Siskind became a professor of photography at the Rhode Island School of Design, Providence (1971–76). He had an extensive record of museum and gallery shows, and has been the subject of numerous books, including *Harlem: Photographs 1932–1940 Aaron Siskind* (1991), *Road Trip: Photographs 1980–1988* (with Charles Traub, 1989), *Aaron Siskind: Pleasures and Terrors* (1983), and *Harlem Document Photographs 1932–1940: Aaron Siskind* (1981). Siskind died in 1991.

**Sandy Skoglund**

Born in Quincy, Massachusetts in 1946, Sandy Skoglund attended Smith College (BA, 1968) and the University of Iowa (MA, 1971; MFA, 1972). Her elaborately staged, color-saturated scenes have been presented in one-person exhibitions at the Addison Gallery of American Art, Phillips Academy, Andover, Massachusetts; the Columbus Museum of Art, Columbus, Ohio; the Minneapolis Institute of Arts; and the Staatsgalerie Erlangen, Germany, among other significant venues. Group exhibitions include "To Be and Not to Be," Centre d'Arte, Barcelona (1990); "Constructed Realities," Kunstverein, Munich (1989); "L'Invention d'un art," Centre Georges Pompidou, Paris (1989); "Fabricated Photographs," The Carpenter Center, Harvard University, Cambridge (1988); and "The Whitney Biennial," the Whitney Museum of American Art, New York (1981). Skoglund's photographs have been featured in several books, including *Sandy Skoglund: Reality Under Siege: A Retrospective* (1998) and *Focus: Five Women Photographers: Julia Margaret Cameron/Margaret Bourke-White/Flor Garduño/Sandy Skoglund/Lorna Simpson* (1994).

**Victor Skrebneski**

Born in 1929, Victor Skrebneski attended The School of The Art Institute of Chicago (1943) and the Institute of Design, Illinois Institute of Technology, Chicago (1947–49). Perhaps most famous for his commercial work for the cosmetic company Estée Lauder, Skrebneski has also photographed for *Town & Country* and *Fitness* magazines, and for Chanel, Grosvenor Furs, Kohler, Northwestern Mutual Life Insurance, and Saks Fifth Avenue, among many other clients. His publications include *The Art of Haute Couture* (1995), *Bravi: Lyric Opera of Chicago* (1994), *Five Beautiful Women* (1989), and *Skrebneski: Black White and Color: Photographs: 1949–1989* (1989), among others. His photographs are exhibited and collected widely; a major fifty-year retrospective of his work is being organized by The Museum of Contemporary Photography, Columbia College Chicago, for 1999 (with publication).

**Neal Slavin**

Neal Slavin works in both large and small formats and is known for his photographs of groups of people. Born in Brooklyn in 1941, Slavin earned a BFA from the Cooper Union School of Art and Architecture in New York (1963). His work is represented in such major collections as the Center for Creative Photography, University of Arizona, Tucson; the International Center of Photography, New York; The Metropolitan Museum of Art, New York; The Museum of Modern Art, New York; and the New York Public Library, Photography Archive. His work has been featured in numerous exhibitions, and is the subject of the monographs *The Britons* (1986), *When Two or More Are Gathered Together* (1976), and *Portugal* (1971).

**Michael A. Smith**

Michael A. Smith was born in Philadelphia in 1942. After earning a BS in pre-law from Temple University (1963), Smith taught himself photography. Since the 1960s he has worked as a freelance photographer and instructor of photography, receiving a variety of awards for his work. Smith has also received numerous commissions to photograph US cities, including New Orleans; Princeton, New Jersey; Toledo, Ohio; and Broward County, Florida. His work has been exhibited in one-person shows at The Fort Lauderdale Museum of Art, Florida; the International Museum of Photography, George Eastman House, Rochester, New York; The Herbert F. Johnson Museum of Art, Cornell University, Ithaca, New York; Northlight Gallery, Arizona State University, Tempe; and The Photography Center of Atlanta.

**Doug and Mike Starn**

Identical twin brothers, Doug and Mike Starn were born in New Jersey in 1961. At the age of thirteen they began exploring photography, and eventually attended The School of The Museum of Fine Arts in Boston (MFAs, 1985). Their efforts to "relax" photography include using scotch tape to create their collaged work and pushpins to attach it to gallery walls. In 1988 the Starn twins exhibited their work in major solo shows in New York, and their first survey exhibition traveled to museums in Chicago, San Francisco, Hartford, and Honolulu. Today their work is widely exhibited throughout the world, and represented in the collections of the Baltimore Museum of Art; The Art Institute of Chicago; The High Museum of Art, Atlanta; the Los Angeles County Museum of Art; The Metropolitan Museum of Art, New York; and the Whitney Museum of American Art, New York, among many others. *The Starn Twins*, a monograph of their work, was published in 1990.

**Joel Sternfeld**

Joel Sternfeld was born in 1944 in New York. Since first receiving a John Simon Guggenheim Memorial Foundation Fellowship in 1978, he has traveled widely to document what he sees as the increasingly uniform, technological, and disturbing landscape of the United States. His photographs have been exhibited in one-person shows at The Art Institute of Chicago; The Detroit Institute of Arts; The Museum of Fine Arts, Boston; The Museum of Fine Arts, Houston; and the Visual Studies Workshop, Rochester, New York. Sternfeld has been awarded two John Simon Guggenheim Memorial Foundation Fellowships, a National Endowment for the Arts Photographer's Fellowship, and the Prix de Rome. His work is included in numerous international collections and in the books *On This Site: Landscape in Memoriam* (1997), *American Prospects* (1994), and *Campagna Romana: The Countryside of Ancient Rome* (1992).

**Dennis Stock**

Dennis Stock was born in New York in 1928 and currently resides in Menerbes, France. Stock has been a member of Magnum Photos since 1951. His well-known work *James Dean: A Memorial Portfolio* (1979) features photographs of the actor taken for *Life* magazine shortly before Dean's death in 1955. Stock's photographs have appeared in other major publications, including *Paris Match* and *Stern*. Stock worked as a writer, director, and producer for television and film, and has exhibited his work at The Art Institute of Chicago; the International Center of Photography, New York; the Musée d'Art Moderne, Paris; Schirm Kunsthalle, Frankfurt; and the Whitney Museum of American Art, New York. His book *Made in the USA: Photographs 1951–1971* was published in 1995.

**Margaret Stratton**

Margaret Stratton was born in 1953 in Seattle. She received her MFA and MA in art from the University of New Mexico, and has received numerous grants and awards, including two national and three regional National Endowment for the Arts fellowships. Stratton works in photography as well as video to explore sexuality, religion, and icons of contemporary culture. Exhibition venues include The Atlanta Gallery of Photography; Camerawork, San Francisco; the Houston Center for Photography; Randolph Street Gallery, Chicago; The Smithsonian Institution, Washington, DC; and The Nathan Cummings Foundation, New York, as well as at many international film and video festivals. Her critical writing has been published in *Afterimage* and *Camerawork Quarterly*, and her photographs and videoworks are represented in many collections, including The Art Institute of Chicago; London Video Archive; Seattle Arts Commission; Video Data Bank, Chicago; and the University of New Mexico Museum of Art, Albuquerque. Stratton is an associate professor in the Department of Art and Art History at the University of Iowa.

**Photographers' biographies**

**Bob Thall**

Bob Thall is known for clear and elegant portrayals of the urban and suburban landscape. Thall was born in 1948 in Chicago and received a BA and MFA in photography from The University of Illinois at Chicago. He has been a professor of photography since 1976 at Columbia College Chicago. Thall is a recipient of a 1998 John Simon Guggenheim Memorial Foundation Fellowship. His photographs are included in many collections, including the Bibliothèque Nationale, Paris; the Canadian Centre for Architecture, Montreal; the J. Paul Getty Center for the History of Art and the Humanities, Los Angeles; the Library of Congress, Washington, DC; The Museum of Modern Art, New York; and the Victoria and Albert Museum, London. His work is featured in the monographs *The Perfect City* (1994) and the forthcoming *The New American Village* (1999).

**Ruth Thorne-Thomsen**

Ruth Thorne-Thomsen primarily uses a pinhole camera to create surreal landscapes by juxtaposing real environments with collaged images and objects. Born in New York in 1943, Thorne-Thomsen received a BFA in painting from Southern Illinois University, Carbondale (1970), a BA in photography from Columbia College Chicago (1973), and an MFA in photography from The School of The Art Institute of Chicago (1976). Her images have been shown internationally at venues including The Alternative Museum, New York; The Art Institute of Chicago; the Houston Center for Photography; the Musée d'Arles, France; and The Museum of Fine Arts, Santa Fe, among numerous others. Thorne-Thomsen's work was also featured in a major traveling exhibition organized by The Museum of Contemporary Photography, Columbia College Chicago in 1993, which was accompanied by the monograph *Within This Garden: Photographs by Ruth Thorne-Thomsen*.

**Kati Toivanen**

Kati Toivanen was born in Finland in 1964. After studying art history and philosophy at the University of Helsinki, she earned her BFA degree from Clark University in Worcester, Massachusetts (1989) and her MFA from The School of The Art Institute of Chicago (1992). Toivanen, whose abstract and Surrealist-influenced images offer various explorations of the human form, has exhibited her work widely and organized exhibitions and events focusing on digital photography. She has also received numerous awards, including from The Ansel Adams Center for Photography, San Francisco, and the Illinois Arts Council. After teaching photography at Columbia College Chicago for five years, Toivanen moved in 1998 to Missouri to teach at The University of Missouri at Kansas City.

**Jerry N. Uelsmann**

Over the past thirty years, Jerry N. Uelsmann's work has been presented in more than one hundred solo exhibitions and featured as the subject of nine books. His photographs are in museum collections worldwide, including The Art Institute of Chicago; Fogg Art Museum, Harvard University, Cambridge, Massachusetts; The Metropolitan Museum of Art, New York; The Museum of Fine Arts, Boston; and The Museum of Modern Art, New York. Uelsmann is a founding member of the American Society for Photographic Education, a Fellow of the Royal Photographic Society of Great Britain, and a trustee of The Ansel Adams Center for Photography, San Francisco. He earned a BFA from the Rochester Institute of Technology (1957) and MS and MFA degrees from Indiana University (1960). Born in Detroit in 1934, Uelsmann has taught at the University of Florida, Gainesville since 1960, where he is currently a graduate research professor.

**Catherine Wagner**

Catherine Wagner was born in 1953 in San Francisco, where she lives today. Wagner attended the Instituto del Arte, San Miguel de Allende, Mexico and the San Francisco Art Institute before receiving her BA (1975) and MA (1977) from San Francisco State University. Her recent project *Art & Science: Investigating Matter* has been widely exhibited, as well as published in a monograph of the same title (1996). Wagner's work has been collected internationally and shown in one-person exhibitions at The Ansel Adams Center for Photography, San Francisco; the International Center of Photography, New York; the Los Angeles County Museum of Art; and the Saint Louis Art Museum, which prepared the touring exhibition "Art and Science: Investigating Matter." Wagner is the recipient of an Aaron Siskind Foundation Fellowship, a John Simon Guggenheim Memorial Foundation Fellowship, and two National Endowment for the Arts Visual Artists Fellowships in Photography. She is a professor of photography at Mills College, Oakland, California.

**Todd Watts**

A graduate of the High School of Music and Art and the School of the Visual Arts, both in New York, Todd Watts has worked in a variety of capacities in the field of photography, including a commission by Berenice Abbott to print limited editions of her photographs. His own work has been featured in one-person exhibitions at the Grey Art Gallery, New York University, and P.P.O.W., New York, as well as in group exhibitions at venues including The Art Gallery of Ontario, Canada; The Art Institute of Chicago; The Center for Photography at Woodstock, New York; the Museum of Contemporary Art, Chicago; and the National Museum of American Art, Smithsonian Institution, Washington, DC. Watts was born in 1949; he lives and works in New York.

**Alex Webb**

Alex Webb was born in San Francisco in 1952. He studied literature and history at Harvard University (BA, 1974) and photography at Harvard's Carpenter Center for the Visual Arts. Webb attended the Apeiron Workshops in photography in 1972, began working as a professional photojournalist in 1974, and joined Magnum Photos in 1976. His photographs have appeared in *The New York Times Magazine*, *Life*, *Geo*, and *National Geographic*. Since 1979 Webb has traveled and photographed throughout the Caribbean, Latin America, and Africa, and has published several books of photographs based on these explorations, including *Amazon: From the Floodplains to the Clouds* (1997), *Under a Grudging Sun: Photographs from Haiti Libéré 1986–1988* (1989), and *Hot Light/Half-Made Worlds: Photographs from the Tropics* (1986). Webb's images have been exhibited at The High Museum of Art, Atlanta; the Museum of Photographic Arts, San Diego; the Southeast Museum of Photography, Daytona Beach, Florida; and the Whitney Museum of American Art, New York, among other venues.

**Carrie Mae Weems**

Carrie Mae Weems was born in Portland, Oregon in 1953. She received her BA from the California Institute of the Arts, Valencia (1981), her MFA from the University of California, San Diego (1984), and studied in the Graduate Program in Folklore at the University of California at Berkeley (1984–87). Since then Weems has been active as a teacher and an artist, and is the recipient of numerous fellowships and residencies. Weems's photographs weave text and images into comments on race, gender, and identity; they have been exhibited in one-person exhibitions at the Dakar Biennial, Dakar, Senegal; The Institute of Contemporary Art, Philadelphia; the National Museum of Women in the Arts, Washington, DC (traveling); The Museum of Modern Art, New York; the Sarah Moody Gallery of Art, University of Alabama, Tuscaloosa (traveling); and the San Francisco Museum of Modern Art.

**William Wegman**

Since the late 1960s, William Wegman has been creating works in a variety of media: photography, painting, drawing, and video. He has won acclaim for his humorously theatrical Polaroid photographs of his Weimaraners Man Ray, Fay Ray, and her puppies. Born in Massachusetts in 1943, Wegman recieved his BFA from the Massachusetts College of Art, Boston, and his MFA from The University of Illinois, Champaign. His work has been showcased in solo exhibitions at the Centre Georges Pompidou, Paris; the International Museum of Photography, George Eastman House, Rochester, New York; the San Francisco Museum of Modern Art; the Stedelijk Museum, Amsterdam; The Walker Art Center, Minneapolis; and the Whitney Museum of American Art, New York, among other venues. Wegman's photographs appear in several publications, including *William Wegman Puppies* (1997) and *Man's Best Friend* (1982), and in the children's books *ABC* (1994) and *Cinderella, Fay's Fairy Tales* (1993).

**Andrew Wells**

Born 1968, Andrew Wells received his BFA from Clark University, Worcester, Massachusetts in 1990, and an MFA in photography from The School of The Art Institute of Chicago in 1994. His mixed-media work is influenced by popular culture and has been exhibited at a variety of venues, including the Center for Photography at Woodstock, New York; the Fine Arts Gallery, University of Maryland, Baltimore County, Baltimore; Helen Lindhurst Gallery, University of Southern California, Los Angeles; and the Ukrainian Museum of Modern Art, Chicago. Wells, also a performance and visual artist, has presented several solo performances in Chicago. In 1998 he began teaching at The University of Missouri at Kansas City.

**Henry Wessel, Jr.**

Henry Wessel, Jr. was born in Teaneck, New Jersey in 1942 and attended Pennsylvania State University (BA, 1966) and the State University of New York at Buffalo, Program at the Visual Studies Workshop, Rochester, New York (MFA, 1972). He has received awards from the John Simon Guggenheim Memorial Foundation and The National Endowment for the Arts. His photographs are represented in notable public collections, including the Australian National Gallery, Canberra; The Metropolitan Museum of Art, New York; the National Gallery of Canada, Ottawa; the Seattle Art Museum; and the Victoria and Albert Museum, London. Wessel's work has been widely exhibited over the past twenty-five years, including several one-person exhibitions at international venues, among them The Museum of Modern Art, New York; the International Museum of Photography, Osaka, Japan; and the San Francisco Museum of Modern Art.

**Minor White**

Influenced by close personal relationships with Ansel Adams, Alfred Stieglitz, and Edward Weston, Minor White is best known for sharply focused, tonally beautiful black-and-white prints which function as metaphors. First hired as a creative photographer for the US government's Works Progress Administration, White became a teacher of photography, a curator, and a founding member of the Society for Photographic Education. His works are in the collections of The Art Institute of Chicago; Fogg Art Museum, Harvard University, Cambridge, Massachusetts; the International Museum of Photography, George Eastman House, Rochester, New York; and the New York Public Library, among many other prestigious institutions. Born in Minneapolis in 1908, White died in 1976; his archive is located at the Princeton University Art Museum, Princeton, New Jersey.

## Photographers' biographies

Helena Chapellín Wilson was born in 1941 in Caracas, and is known for her elegant and painterly images produced through the nineteenth-century process of gum-bichromate printing. Chapellín Wilson received her university training in architecture in Venezuela and Italy, and holds a BA degree in photography from Columbia College Chicago. Her work is included in numerous collections, including The Art Institute of Chicago; the Illinois State Museum, Springfield; the International Center of Photography, New York; The National Gallery of Art, Caracas; and The New Orleans Museum of Art. Her photographs have also been exhibited at such venues as The Art Institute of Chicago; The National Gallery of Art, Caracas; The New Orleans Museum of Art; and Northlight Gallery, Arizona State University, Tempe.

**Helena Chapellín Wilson**

Garry Winogrand was born in 1928 in New York, where he studied at City College, Columbia University, and with Alexey Brodovitch at The New School for Social Research. Winogrand's photographs have been widely exhibited, including a major retrospective organized in 1988 by The Museum of Modern Art, New York, which traveled to the Archer M. Huntington Art Gallery, University of Texas, Austin; The Art Institute of Chicago; the Carnegie Mellon University Art Gallery, Pittsburgh; the Center for Creative Photography, University of Arizona, Tucson; the Museum of Contemporary Art, Los Angeles; and the San Francisco Museum of Modern Art. His monographs include *The Archive 26: Garry Winogrand, Early Work* (1990), *Winogrand: Figments from the Real World* (1988), *Public Relations* (1977), *Women are Beautiful* (1975), and *The Animals* (1969). Winogrand died in 1984.

**Garry Winogrand**

Born in 1939 in Brooklyn, Joel-Peter Witkin studied at the Cooper Union School of Art and Architecture, New York (BFA, 1974) and the University of New Mexico, Albuquerque (MFA, 1986). His work has been featured in numerous international exhibitions, including solo shows at The Brooklyn Museum, New York; Interkamera, Prague; Picture Photo Space, Osaka, Japan; the Museum of Modern Art, Haifa, Israel; the San Francisco Museum of Modern Art; and a major retrospective at The Solomon R. Guggenheim Museum, New York. Represented in significant museum collections worldwide, Witkin's photographs are also the subject of several monographs, including *Joel-Peter Witkin, A Retrospective* (1995); *Harms Way* (1994); *Joel-Peter Witkin, Twelve Photographs in Gravure* (1994); and *Gods of Earth and Heaven* (1989).

**Joel-Peter Witkin**

# Index

**Photography's multiple roles:**
**art, document, market, science**

Edited by Terry Ann R. Neff,
t.a. neff associates, inc.,
Tucson, Arizona

Designed and typeset by
studio blue, Chicago,
in the following five sections:
**art + idea, viewpoints:** Helvetica Neue
**art:** Berthold Bodoni Antiqua,
Monotype Bodoni, and ITC Bodoni 72
**document:** Geometric 415
(based on Metro)
**market:** VAG Rounded
**science:** Foundry Gridnik

Duotone, tritone, and four-color
separations scanned from the
original images, installations, and
objects by Professional Graphics,
Rockford, Illinois

Printed by Meridian Printing,
East Greenwich, Rhode Island
on 100 lb. Aberdeen text

106